# SEAN SCULLY

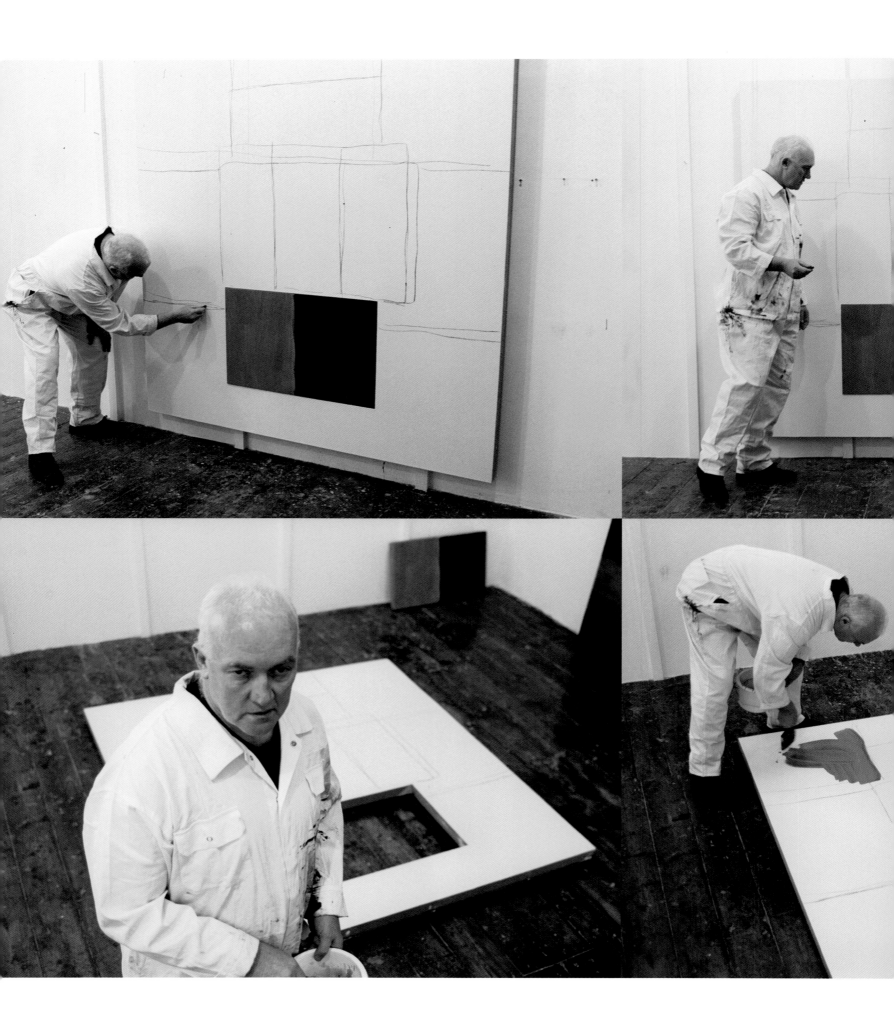

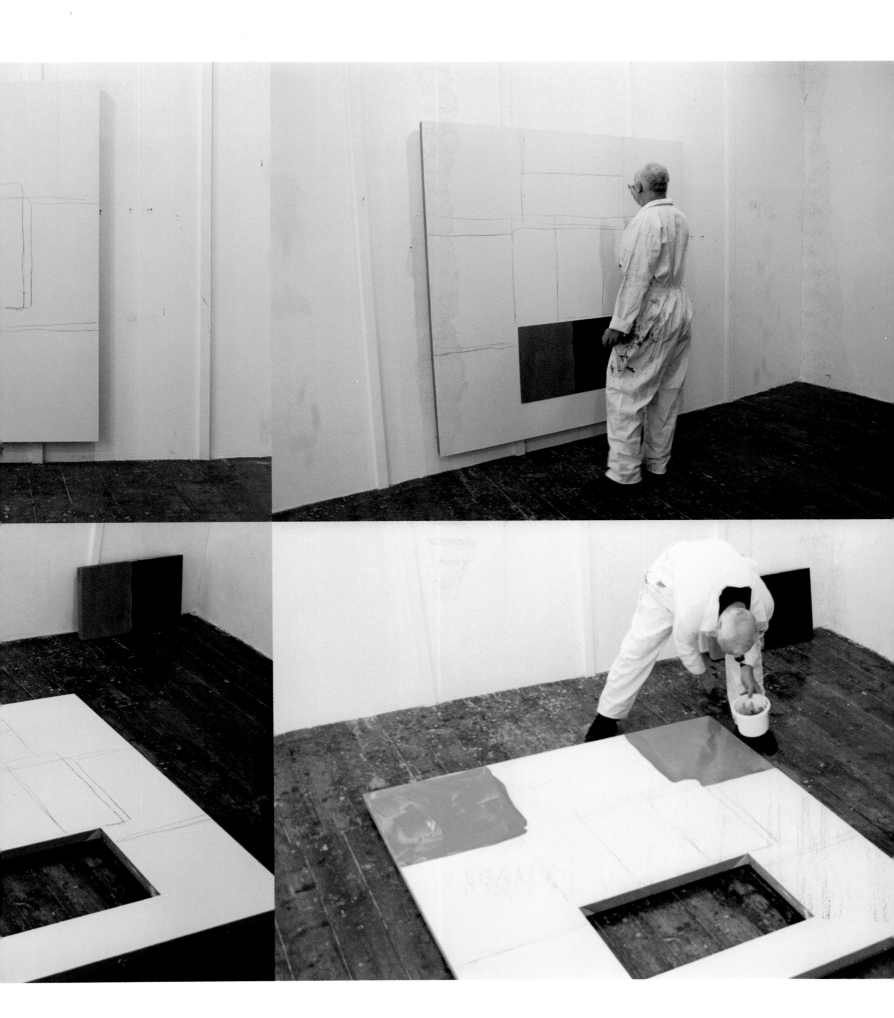

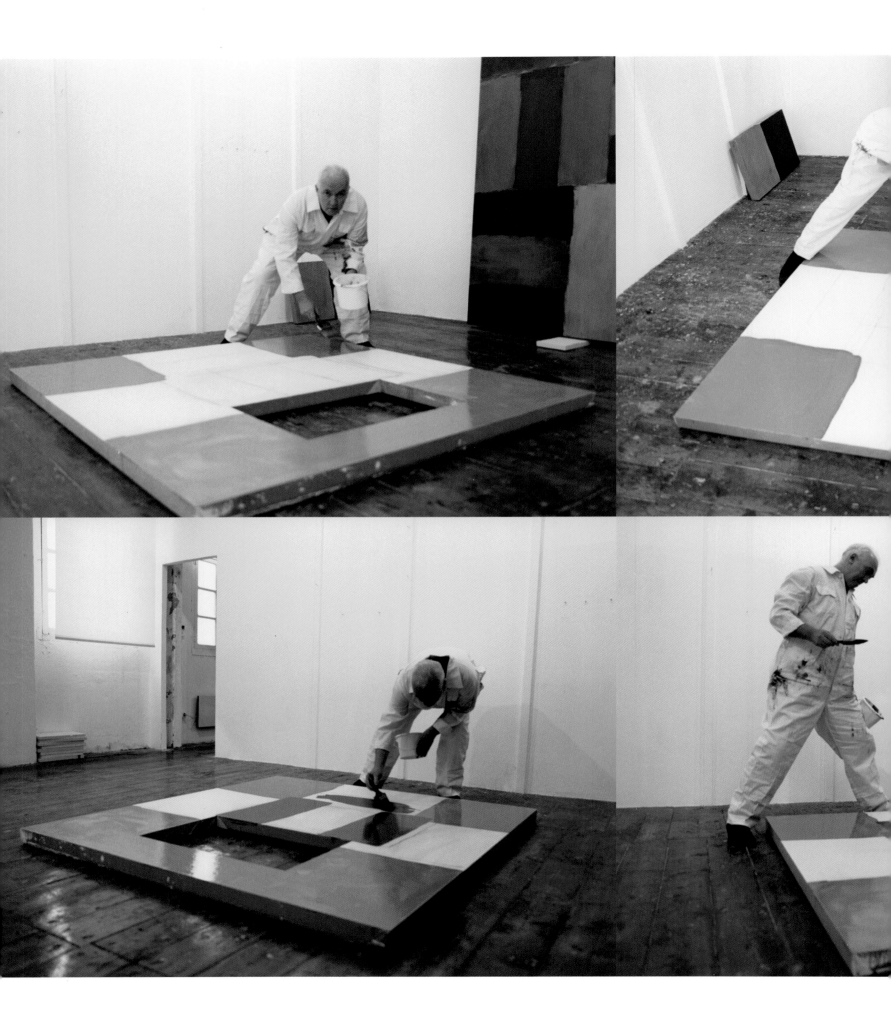

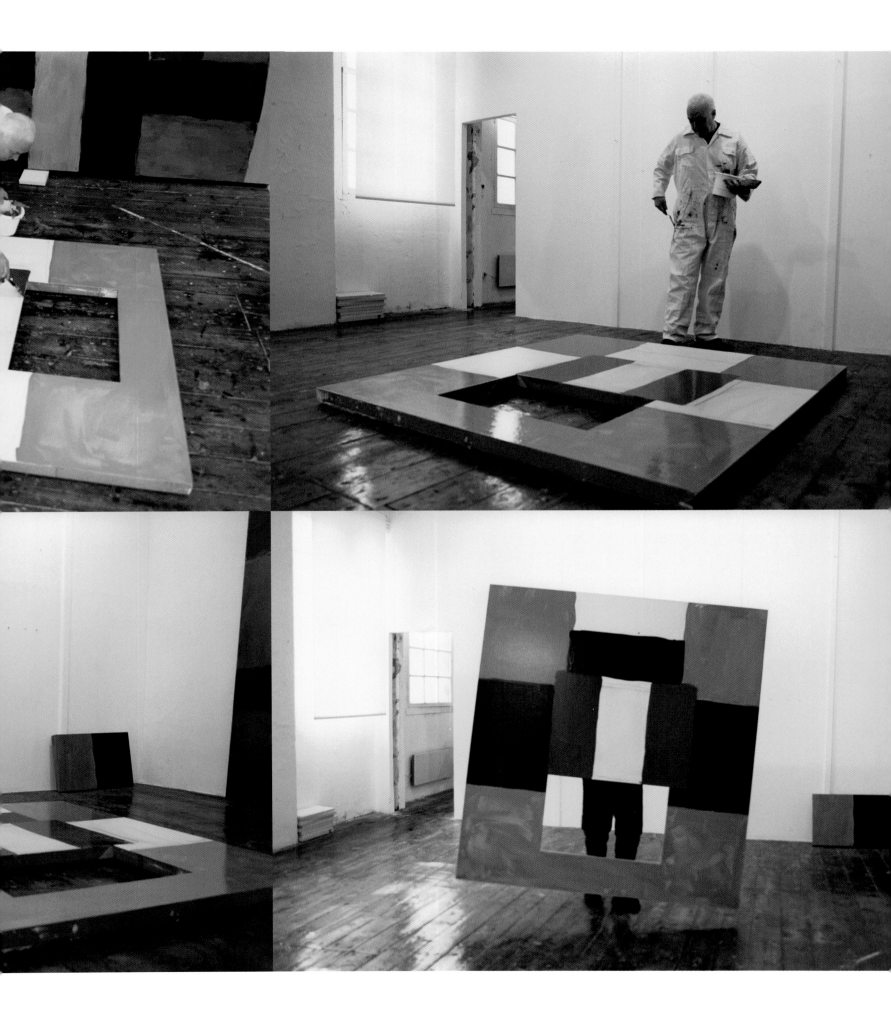

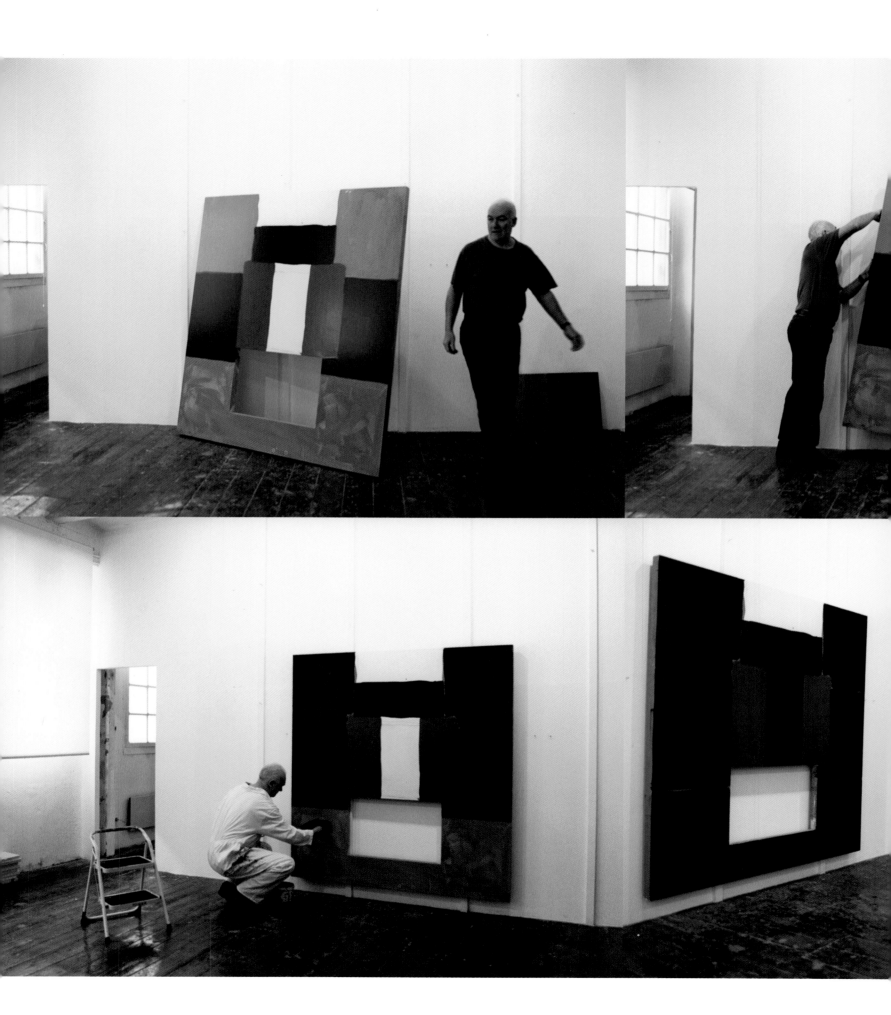

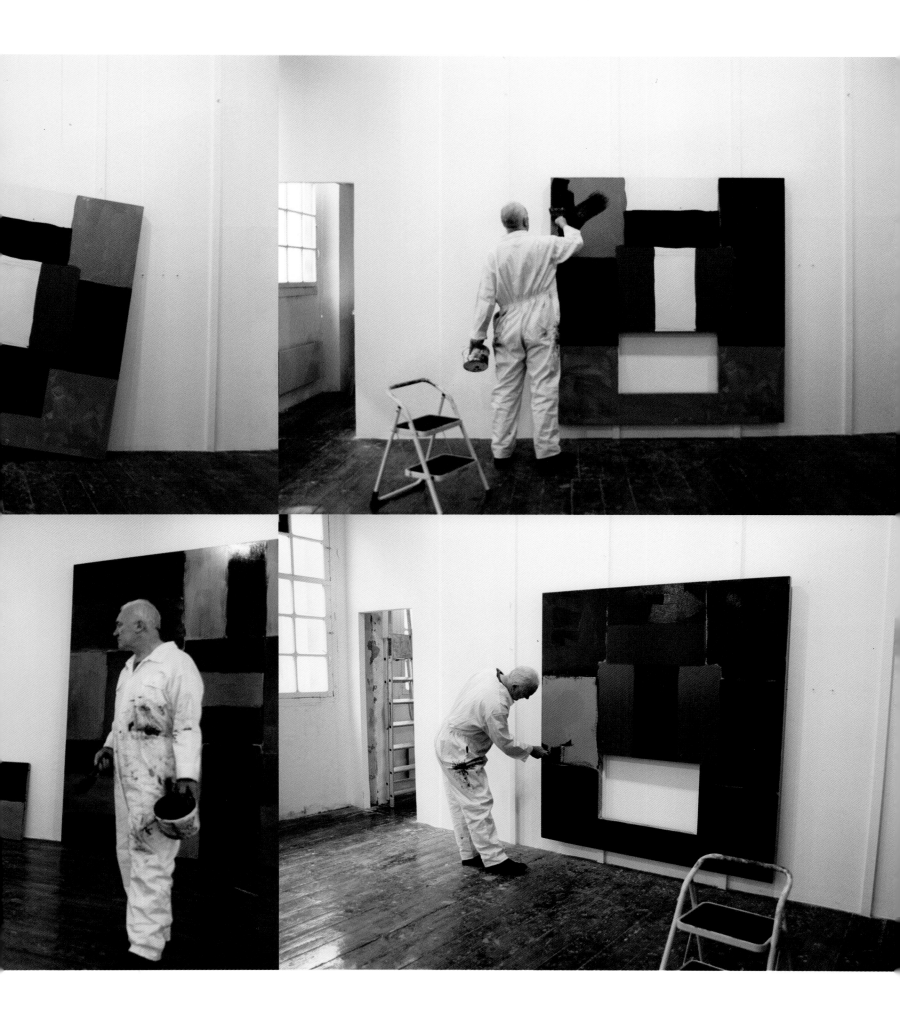

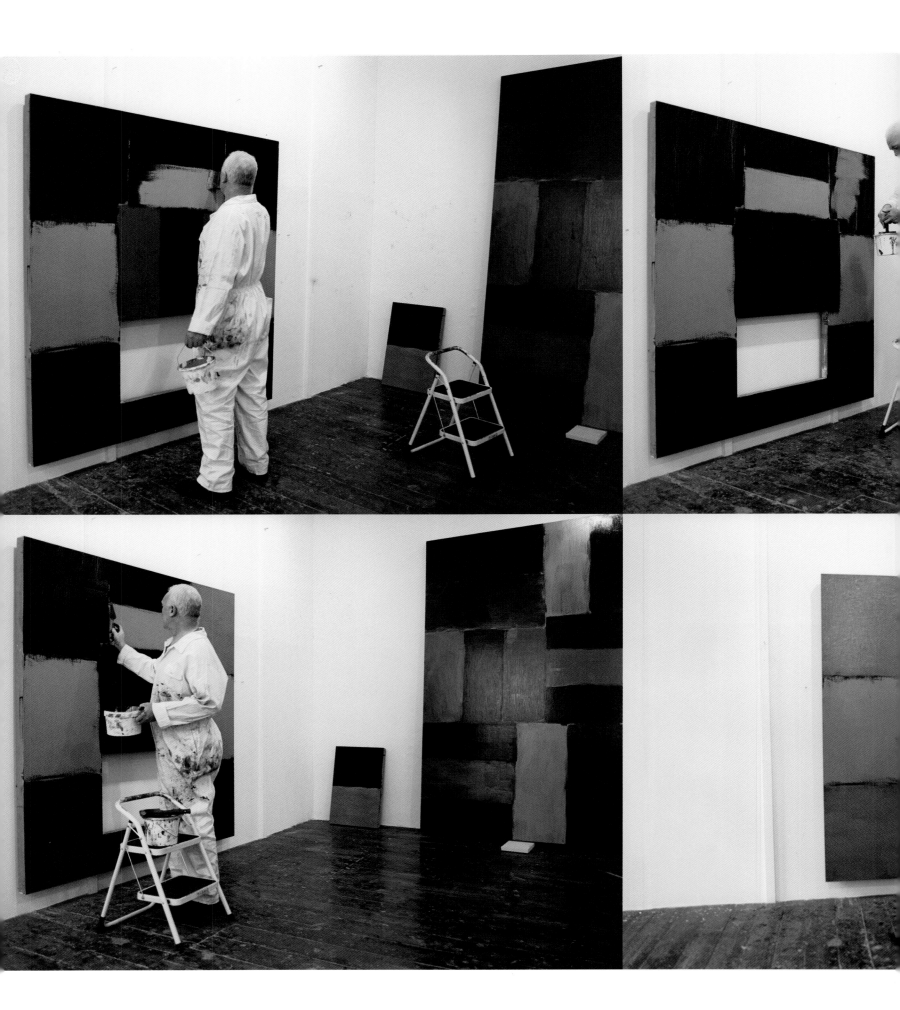

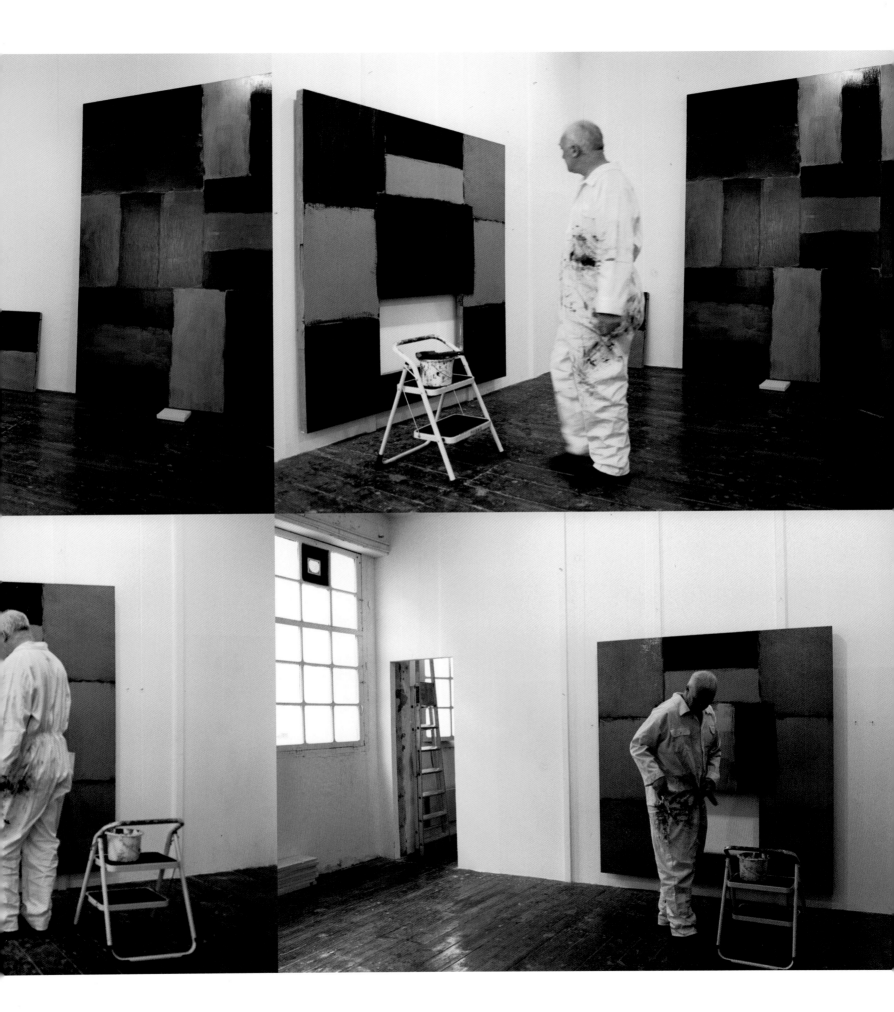

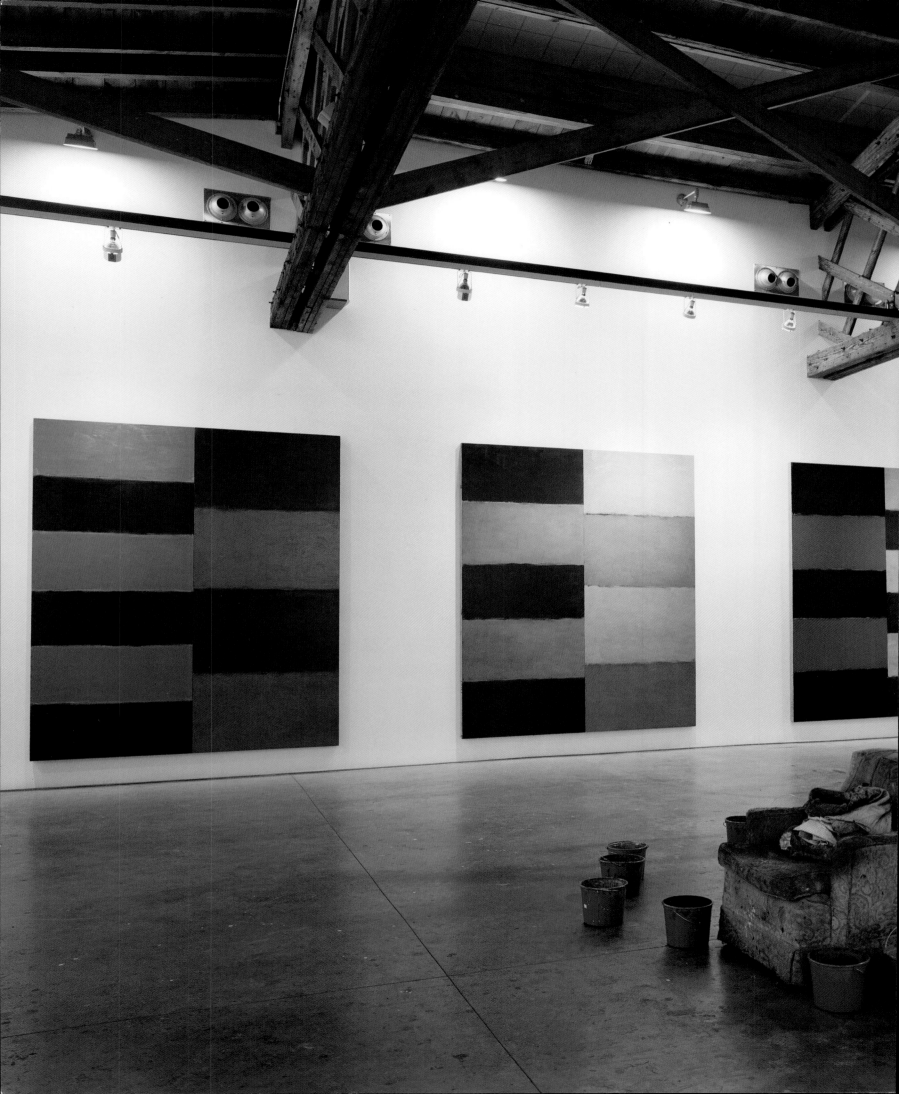

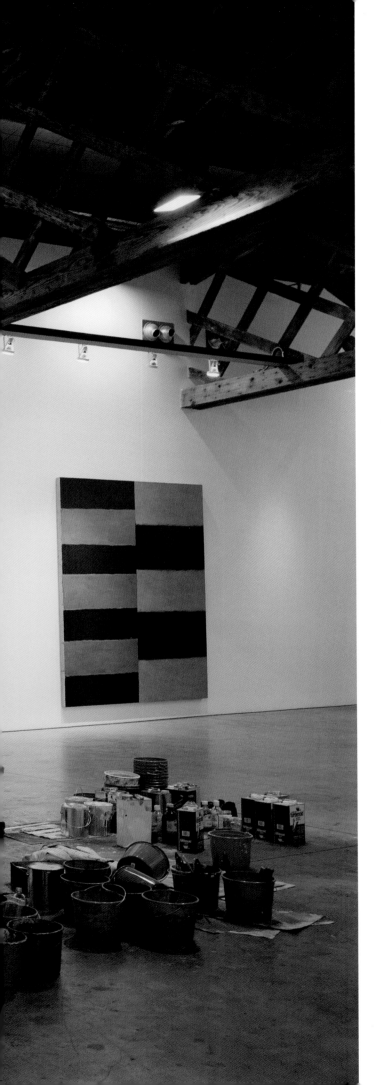

# SEAN SCULLY

David Carrier

With 200 illustrations, 190 in colour

Thames & Hudson

This book is for Barbara Westman and Arthur Danto

*As I was about to leave Scully's studio, he pointed to a characteristically large
painting, leaning against the wall, composed of two adjacent checkerboards....*
"That's a couple," *Scully said*, "Just like you and Barbara."　　　Arthur Danto

First published in the United Kingdom in 2004 by Thames & Hudson Ltd,
181A High Holborn, London WC1V 7QX

www.thamesandhudson.com

British Library Cataloguing-in-Publication Data
A catalogue record for this book is available from the British Library

ISBN-13:  978-0-500-28626-5
ISBN-10:  0-500-28626-4

Designed by Maggi Smith

Printed and bound in Germany by Steidl, Göttingen

# CONTENTS

# Acknowledgments

*Your constant, I might even say relentless, support has been at the back of me like a shadow that is made of light.*   Sean Scully

Sean Scully once wrote to me: "I think my work is really quite autobiographical. I allow my situation to affect the temperature of the work." Providentially we met twenty-one years ago, just when he had made the breakthrough into his mature style. We have kept in close touch ever since. Often he writes just before going into the studio.

> *I do lots of things before I paint. Nervous things…. Reassure myself I'm not alone in the universe. You have to be ready to paint something as stripped down as the stripe. Getting ready is incredibly important for me. Because I'm working with my body, not just my head.*

Frequent faxes, which almost constitute a diary, have made his beautiful handwriting very familiar to me. And in 1996, for ten days I recorded our conversations in Morocco. Most of the Scully quotations in this book come from these conversations, our correspondence, or transcriptions of his lectures; the remainder come from published interviews. I build upon, analyze, and occasionally argue with his claims. He gets right to the point because he has a passionate desire to be understood. Some strong personalities resist acknowledging legitimate disagreements. The closer I get to Scully, the more apparent are our true differences. Teaching friends to find their own authentic selves, that's part of his gift.

Scully never has time to write much for publication, which is unfortunate – he is a gifted prose stylist. The epigraph introducing these acknowledgments, is it not magnificently paradoxical? When in his blurb for my *High Art: Charles Baudelaire and the Origins of Modernism* (1996) Scully says that the book brings "together the two disciplines of art writing and philosophy and use … one to illuminate and deepen the understanding of the other in an organic cyclical exchange that seems to have no limits," he alludes also to *his* aesthetic. And when he adds that my writing builds "a domain outside narrow thinking, where horizons are wide and open, as befits an authentic explorer," he also describes *his* painting. In his 1998 commentary on Mark Rothko, he wrote:

> *In my view, a great abstract painting offers one the possibility to travel without having to endure the tedium of a journey. Now the question can be put: Does art like his make a difference to the world, as he would have wished? Or to phrase it another way, Would the world be less without it? The answer to both questions is very simple: yes.*

Here, again, surely he is also thinking of his own painting.

I have learned much from the commentaries by Daniel Abadie, Michael Auping, Neal Benezra, Ian Bennett, Ulrich Bishoff, Paul Bonaventura, Ronaldo Brito, John Caldwell, Victoria Combalia, Lynne Cooke, Arthur Danto, R. Eric Davis, Aidan Dunne, Danilo Eccher, William Feaver, Jean

Frémon, Helmut Friedel, Xavier Girard, Mark Glazebrook, Jürgen Habermas, Hans-Michael Herzog, Judith Higgins, Robert Hughes, Sam Hunter, Francisco Jarauta, Enrique Juncosa, Kazu Kaido, Pepe Karmel, Bernd Klüser, Julia Klüser, Donald Kuspit, Amy Lighthill, John Loughery, Luis-Martin Lozano, Edward Lucie-Smith, Steven Henry Madoff, Joseph Masheck, Maria Müller, William Packer, Kevin Power, Mari Rantanen, Carter Ratcliff, Ned Rifkin, John Russell, Irving Sandler, Jean Louis Schefer, Michael Semff, Deborah Soloman, Colm Tóibín, Marina Vaizey, Mario-Andreas von Lüttichau, Dorothy Walker, Stephen Westfall, Peter Winter, John Yau, and William Zimmer.

Scully's 1992 BBC television movie *Artist's Journey: Matisse*; Robert Gardner's films *Sean in Malaga* (1997) and *Passenger* (1998); Anna Johnson's 1994 interview for Australian Television; and the 1999 Irish television movie *Sean Scully: American Beauty* helped. And Maurice Poirier's *Sean Scully* (1990), *Sean Scully: Prints. Catalogue Raisonné 1968–1999* (1999), and *Sean Scully: Works on Paper 1975–1996* (1996) were essential references.

I owe much to James Beck's account of urban art, Mark Cheetham's study of abstraction, Arthur Danto's art criticism and philosophy, Ernst Gombrich's analysis of expression, Lawrence Gowing's *Matisse*, Meyer Schapiro's and Danto's descriptions of the Vincent van Gogh painting discussed in chapter one, Richard Wollheim on visual metaphor, and Armin Zweite's Scully catalogue essays. All of my books acknowledge Scully's influence – this one builds upon that argumentation. I warmly thank Scully's secretaries, Per Haubro Jensen, William Petroni, and Carrie Chamberlain; John Giachetti and Bernd Klüser, who accompanied Scully and me in Morocco; and Scully's collaborator, the master printer Garner Tullis. Marianne Novy, my wife, and our daughter Liz Carrier have been lovingly supportive. Paul Barolsky read one draft of this book and made many suggestions. Danto and Catherine Lee gave much needed advice. Thanks are due, also, to the editors of art journals who published my reviews of Scully's exhibitions: Michael Peppiatt at *Art International*; Caroline Elam and Richard Shone of the *Burlington Magazine*; and Simona Vendrame, editor of *Tema Celeste*. But of course my largest debt is to Scully himself, whose patience and willingness to respond to questions has been exemplary.

What historian, aware of how little we know about past masters, has not fantasized about meeting his favorite artist? But often relationships between artists and critics are difficult and so my solid connection with Scully makes me tremendously privileged. No hero, it has been said, is a hero to his valet; perhaps few artists are heroes to their commentators. But Scully has always been my hero. I have been lucky, for few critics collaborate with a major artist developing his critical vocabulary. Speak, memory! For two decades I have been preparing to write this book. Almost the same age, Scully and I have to some extent grown up together. He once wrote to me: "Your interpretation of my work is embedded in the history of its making, and that cannot be taken out. So in my mind it is part of it." I know many wonderful artists, but in twenty years of publishing art criticism I have never met anyone remotely like him.

Pittsburgh, December 2000 – Cleveland, October 2002

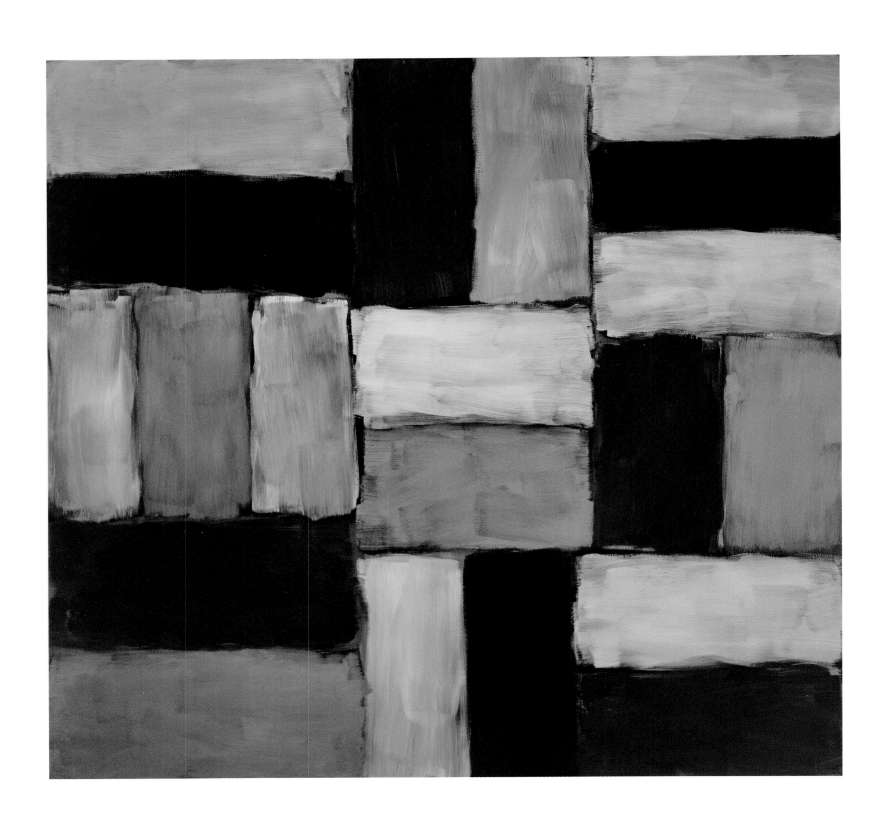

# Introduction    The sources of Sean Scully's style

*I will try until I drop to restore to painting its primary,*
*its profound human pleasure and importance. It has to be*
*built back up again. That is serious work. Heroic work.*

*Niels*
2001
Oil on linen
75 x 85 in.
190.5 x 215.9 cm

A personal style is an unmistakably individual way of making art. By discovering and then system-atically exploiting an original style, a major painter expresses his or her own interpretation of art's history and suggests possibilities for its future. Once a personal style is developed, generally one work of art leads to the next in a logical process of development. In one particularly pronounced example of this process, Sean Scully has singlehandedly taken Abstract Expressionism into the twenty-first century. A great conservative, he is also a radical revolutionary, for, in giving tradition new life, he has dramatically transformed his inherited ways of thinking. His art uses the stripe, a simple boring form, to create intensely emotional pictures. His extremely physical paintings are sacred art for our secular world. And yet his style depends upon a surprisingly short list of essential influences. In England and then in America, he experienced the banal rhythms of urban life. In art school he learned about high modernism. As an adolescent, he discovered African-American pop music, and then trips to Morocco and Mexico showed him the tempos of Third World life. He learned from film how to create narratives. And then photography changed his thinking about abstraction. The importance of urban rhythms, high modernism, pop music, and travel were fully apparent, already, when Scully was twenty-five; his uses of film and photography came later. In the 1980s, he developed storytelling abstract paintings. And in the 1990s, in dialectical response, he created "Mirrors," "Plaids," and "Floating Paintings," and then the utopian "Walls of Light."

None of Scully's early sources is particularly unusual. We all see urban rhythms; and in the 1960s, everyone young listened to rock music, many English tourists went to Morocco, and most art students learned about modernism. But no one else used these resources to make abstract nar-rative paintings.

> *What one has to do is tie abstraction into one's life in the way that Rothko managed to do, and in*
> *the way that Suprematism was tied into the utopian political outlook of the Russian Revolution.*
> *That connection must be rebuilt.*

Scully's style is a creative, essentially unpredictable synthesis.

> When I asked him what "style" meant to him, he gave a long, richly suggestive response:
> *I think we define genius as the gift of seeing into the future.... There's also one's own future, and I*
> *struggle at that ... to find a way of doing things that you can recognize as having the potential not*
> *only to reach a point of expression, but also one that would be pliable enough to yield further*
> *development.*

He links his future with the future of art because he knows that his artistic development will always respond to both changing forms of contemporary visual arts and his own life. His painting is highly personal. As he says: "Painting will always reflect your nature without mercy." Having style, Scully adds, requires understanding of both what you can and what you cannot do.

> *It's a question of knowing yourself or something fundamental to yourself and recognizing what you have chosen to do.... It's very important to be able to understand limitation, and to be able to accept it while you work and struggle to overcome it.*

But that is not the whole story. An artist with a style may struggle against his limitations, but sometimes he learns with age to acknowledge the essential boundaries of his personal talent. When he was fifty-one, he said:

> *One advantage of getting older is that you can see what possibilities are not open to you, and where your gifts do not lie, and you are liberated because you can turn all your ambition onto what you do have.*

Drawing attention to his limitations is not mere modesty: management of his talent was essential for success.

*Long Night*
1985
Oil on canvas
96 x 120 in.
243.8 x 304.8 cm

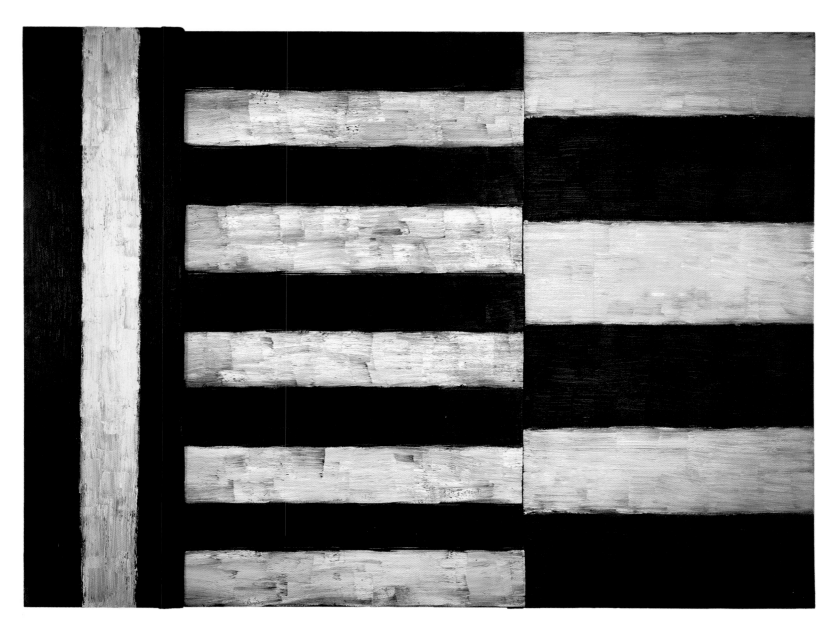

In the 1980s and early 1990s, after a day spent visiting the New York galleries, I often walked downtown to 110 Duane Street, just west of Broadway, a few blocks south of Canal Street. Scully's long narrow loft on the second floor ran through an entire city block. I rang the doorbell and he turned off the burglar alarm and threw down the key. After a cup of tea in the front-room kitchen, we went into his studio. At the front, high windows let in streetlight, but the studio, with dust-covered windows on the far back wall, depended upon fluorescent lighting. Sometimes that large room was filled with art about to be shipped. Over the years, more and more space was occupied by the paintings that Scully refused to sell. For a long time, a big color photograph of Matisse's *Large Reclining Nude* (1935) was on the table near Scully's works on paper.

I would sit in the broken-down old stuffed chair between buckets of oil paint and big cleaned brushes and Scully would move paintings or lay out pastels. Handling his big heavy paintings was not easy. Once, early on, when he asked me to help, I got red paint on my hands. After that, I decided to remain seated in the chair. Most of the published studio photographs show this room cleaned up. In my memory, the chaos was often striking. Usually we would talk before going out to dinner. Sometimes he sought my opinion of work in progress. "What do you

*Remember*
1986
Oil on canvas
96 x 125 in.
243.8 x 317.5 cm

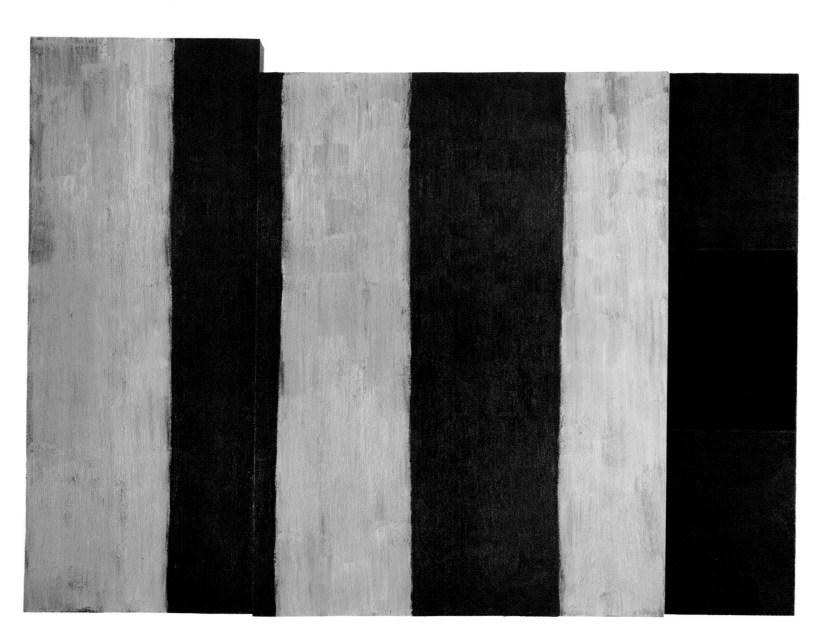

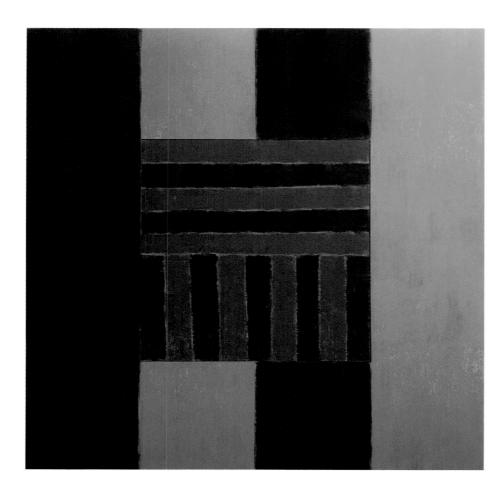

*A Happy Land*
1987
Oil on canvas
96 x 96 in.
243.8 x 243.8 cm

*Green Gray*
1988
Oil on canvas
72 x 72 in.
182.8 x 182.8 cm

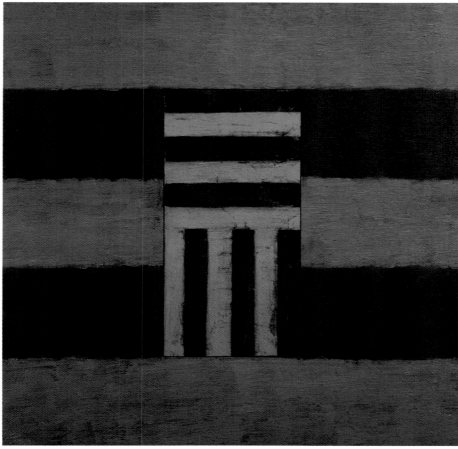

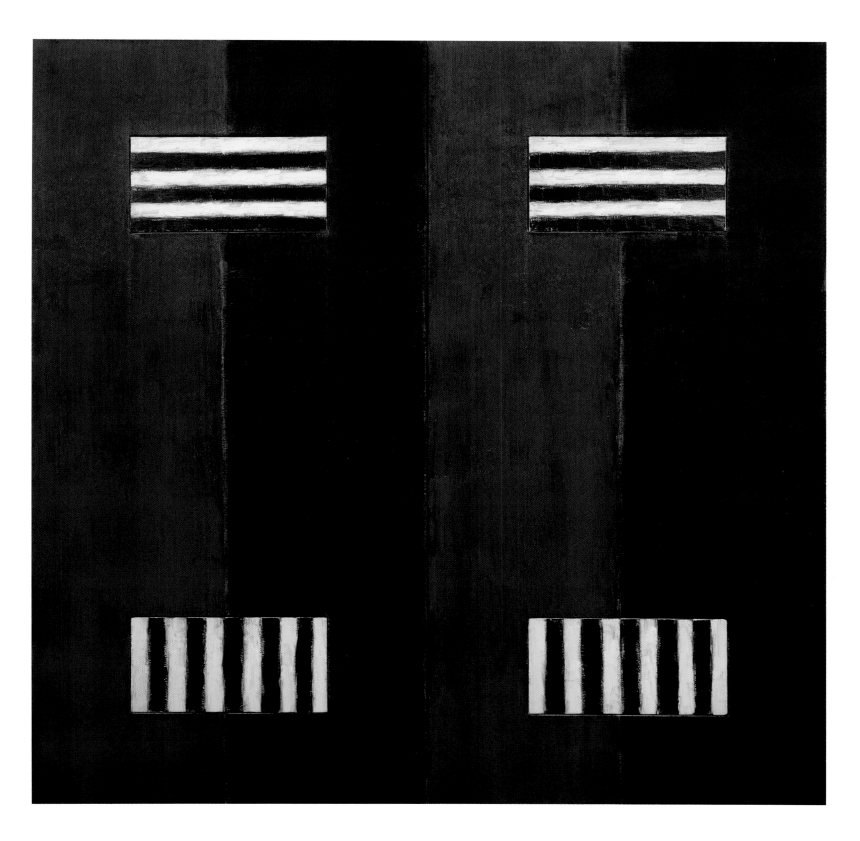

*Backwards Forwards*
1988
Oil on canvas
80 x 80 in.
203 x 203 cm

think of this color?" he would ask. Or "What about setting that insert into this panel?" Scully didn't talk a lot, but he listened very intently. It was abundantly obvious that every word mattered. I felt that he really learned by seeing his art through my eyes. I soon discovered that his compositions in progress were often provisional. And some paintings had been reworked repeatedly. When I saw how many tubes of oil paint Scully mixed to get his colors, I understood why his paintings were the despair of restorers.

Occasionally, I met other critics on my way in, but Scully and I were always alone in the studio. When we left, often to be joined by other people for dinner, the discussion shifted entirely. We talked about everything but the paintings that I had just seen. Once on the way out, Scully joked about how much he missed working from models. Only years later did I understand why his desire to paint figuratively remained very important.

Robert Gardner's short film about Scully, *Passenger* (1998), presents more studio activity than I ever witnessed. You see him painting and stepping back to look critically. And you watch him removing and reworking a stubborn insert. Sometimes impatient about small things, Scully is extraordinarily persistent in dealing with large problems. In *Passenger*, the act of painting goes quickly, but that rapid movement is followed repeatedly by agonizing rethinking and repainting. Unlike most very successful artists, Scully doesn't rely upon assistants.

*I'm like a bear, you know, they laze around a lot, and you think they're never going to do anything but when they have a purpose, they're like a train. You can't stop them. So I laze around getting ready to make a painting.*

Karate is important to him – it aids focus on the physical act of art-making. He once compared himself to the cleaning man who, like him, had to look at the floor. Karate keeps him from getting away from what he calls "the brutality of the real." Scully's studio clothes were always paint-spattered, and so he changed before we went out. Although I arrived very late in the afternoon, he never seemed exhausted. I thought, rather, that he gained energy from working.

In his studio I would tell Scully about the exhibits I had just viewed and he, in turn, would discuss his forthcoming shows. Only once did we go out to see art together. Scully was to appear in a colloquium held in conjunction with the "Richard Pousette-Dart" exhibition at the Metropolitan Museum and so we visited the galleries together. After viewing the show, we went into the shop. The clerk at the cash register, a young artist, told Scully how much he admired him, looked around, and then said, "I'm not supposed to do this, but could I have your autograph?" No doubt such attention was gratifying, but I could see why Scully often holed himself up in his studio.

Once I was the first person to arrive after Scully received a major award. I had never seen anyone so happy. When on another occasion I got there just as disaster occurred, it was as if a neutron bomb had gone off. It was always obvious that these moods were being expressed in his art. In one crisis, Scully stopped painting for some months because he didn't know what he wanted to express. But although acutely sensitive to depression and loss, he does not focus primarily on the tragic sense of things.

*I think that the human condition has a lot of tragedy in it, that's inescapable: but that's not all it is – no matter how strongly we might feel and might want to surrender to its seductive force.*

After identifying this commonplace fascination with tragedy, he immediately undercuts that way of thinking:

*My work, I think, has much pathos in it: because of the difficulty and complexity of the relationships, its absurd sense of scale, its constant almost implausible attempt to represent personages and figures, and the uncertainty and total lack of dogma in the colors.*

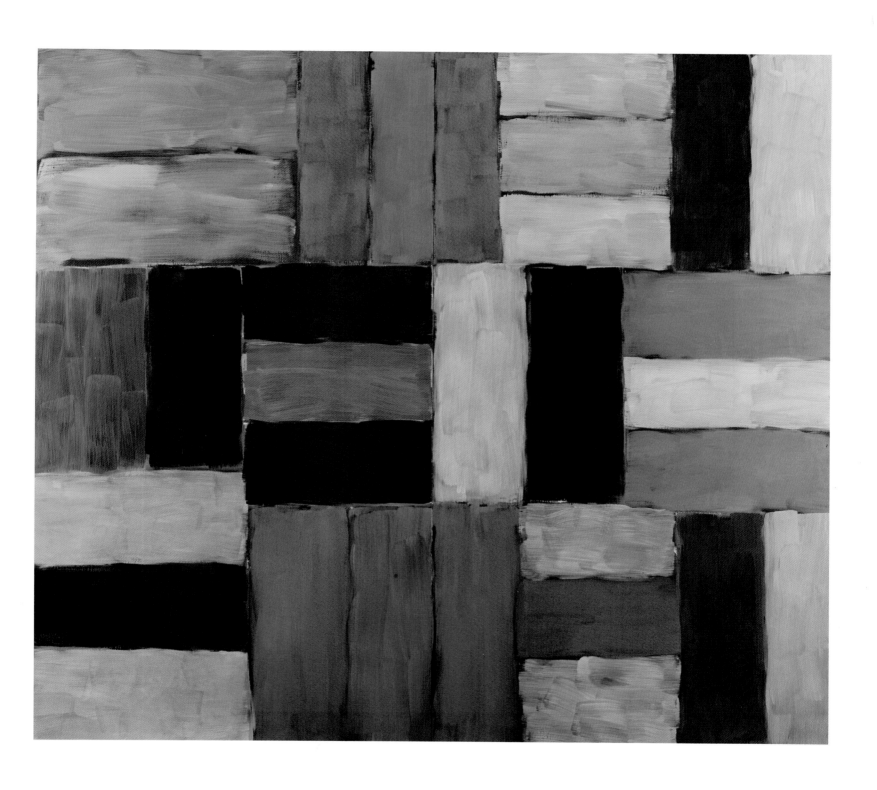

*Wall of Light Light*
1999
Oil on linen
108 x 120 in.
274.3 x 304.8 cm

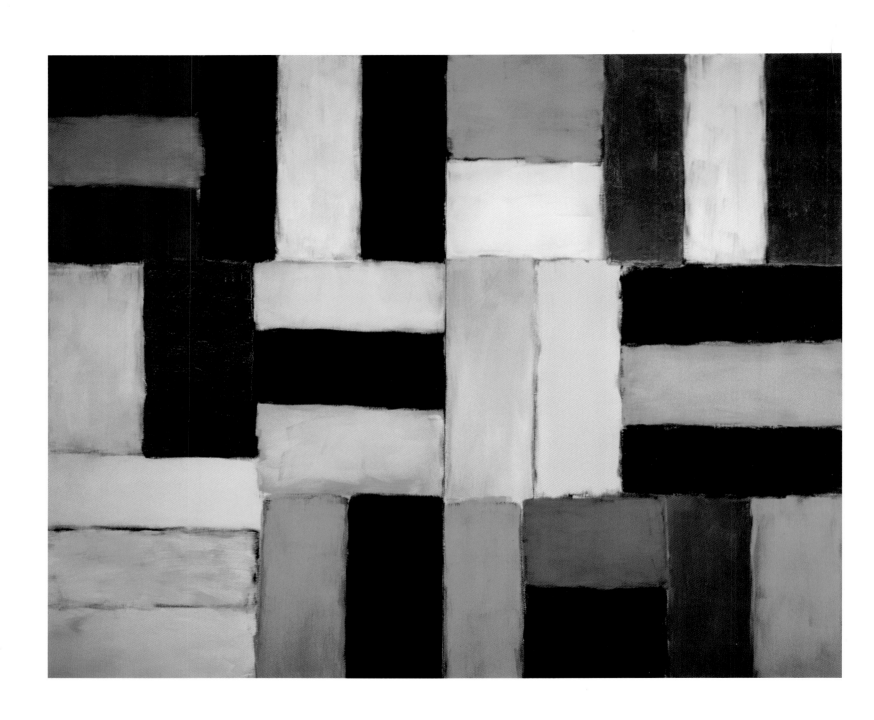

*Wall of Light Fall*
1999
Oil on canvas
110 x 132 in.
279.4 x 335.3 cm

He is passionately determined to reach the larger public. One time as we were leaving the Duane Street studio, he gave a copy of Maurice Poirier's *Sean Scully* to the salesman in the hardware store downstairs who seemed interested in art.

Scully, always generous with his time, could also be extremely moody. So too, sometimes, was I, and when I asked for help at one unique moment of extreme crisis, he spent a long time at two o'clock in the morning telling me that my art writing mattered. My dark mood dispelled; I slept soundly and never looked back. Not for anything would I live through that moment again, but I am immensely grateful for what I learned. Scully's painting, I realized, has always had an amazing ability to get under my skin – and I have learned from him to have faith in myself. I now trust my eyes without worrying about public opinion. Once he remarked how pleased he was that over many years I had devoted so much attention to his stripes. I was surprised – I thought their power was self-evident. Sometimes when he was away, I stayed in his apartment. Late at night I went into the studio alone. And the next morning, after I made myself breakfast, I looked hard at the paintings in the living room. I loved momentarily having his art all to myself. Whenever I now see significant art, I ask myself how it relates to his.

Because Scully and I talked so often, it's hard to recall exactly what he said when. Ultimately that doesn't matter, for in this book I describe the slow development of his visual aesthetic. We didn't always talk just about art. Watching boxing on television, speaking unreflectively, I scorned that sport. "What they are trying to do," Scully replied, "is what we're doing, but of course on a lower level." After that, I looked occasionally at boxing with new respect and thought more about the risks of painting and art writing. We also talked outside his studio. In Pittsburgh, when Scully once stayed with me, we walked for miles. After he pointed out the analogy between the window inserts in his paintings and the bricked-in windows in many walls, I looked more attentively. He spoke with immense pleasure about the beauty of these banal buildings. Every house was truly interesting in its own way, he told me. As he said that, I realized that Scully saw everything in the terms of his style of painting. Now, so do I. When I drive across bridges or travel in unfamiliar cities, I see Scullyesque stripes everywhere. And I view homely provincial architecture with greater affection.

\* \* \*

On 8 March 2001 Sean Scully's exhibition "Light and Gravity" opened at Knoedler & Company, New York. This grand Upper East Side townhouse was very well suited to his art. In the large square room on the ground floor were three big new "Walls of Light." The eleven-foot-long *Wall of Light Fall* was on the far wall. Philip Guston's abstractions, Scully has argued, use paint "to tell a story, while maintaining a relationship with its own origin as stuff taken out of the ground." The same is true of Scully's "Walls of Light," which have the painterly brushwork and scale of Guston's Abstract Expressionist pictures. "His color isn't nuanced like mine," Scully notes, "though it has a shared relationship to body and light." With its weathered-looking colors, this autumn painting is built of two- and three-stripe patterns. These bricks, broad stripes, not long enough to be true verticals or horizontals, are locked into place like heavy stones in a wall. It's hard to find a fixed point of focus: *Wall of Light Fall* is full of energy.

Walls are solid but light is weightless, so is not a "wall of light" a contradiction in terms? That apparent contradiction is resolved when we learn that Scully's inspiration came in Mexico.

*These places in the Yucatan were cities, now you see a wall, what remains, a wall transformed by light, the walls change color, from pink to blue to red. I would get up early, the shadows completely transform the ruined architecture, they make it seem hopeful one moment, tragic another.*

A wall is a barrier, and light stands for knowledge and happiness; and so juxtaposing them transforms the solid wall into a wall *of* light. Far older than the church façades painted by Claude Monet, these walls, which Scully found a rich source of images, or what he calls "a visual supermarket," display the destructive power of time and the fragility of culture.

Even stone walls, so seemingly permanent, decay and slowly disappear. Any coloring long since washed away, all that remains are stones transformed by light. As the sun moved, Scully found that these walls in Mexico seemed hopeful at one moment, and tragic at the next. Like Guston, with these paintings he tells stories – he was interested in the changing light on these stones. His titles refer to colors, *Wall of Light Red* (1998) and *Wall of Light White* (1998); to times of year, such as *Wall of Light April* (2000); and to places, like the various Chelsea "Walls of Light" and *Wall of Light Peru* (2000).

Scully's color photographs of house façades in the rougher parts of London and Santo Domingo were downstairs at Knoedler. Showing walls and doors, these images reinforced the suggestion that we might see the paintings upstairs as being about real places. Scully had only recently started to show photographs. In 1991, he asked me:

*Do you think I should exhibit my photographs? I know for sure that I will get some fantastic ones back from this trip. I'm really taking formal portraits of ramshackle distressed and very humble structures. I find it incredibly moving and human.*

Later on the Island of Lewis in the Outer Hebrides, Scotland, he wrote:

*I was looking at and photographing ramshackle sheds, and old houses that were about to fall over.*

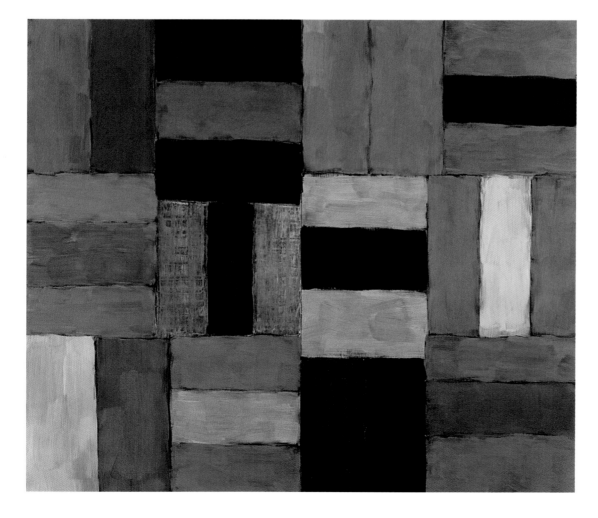

*Wall of Light White*
1998
Oil on linen
96 x 108 in.
243.8 x 274.3 cm

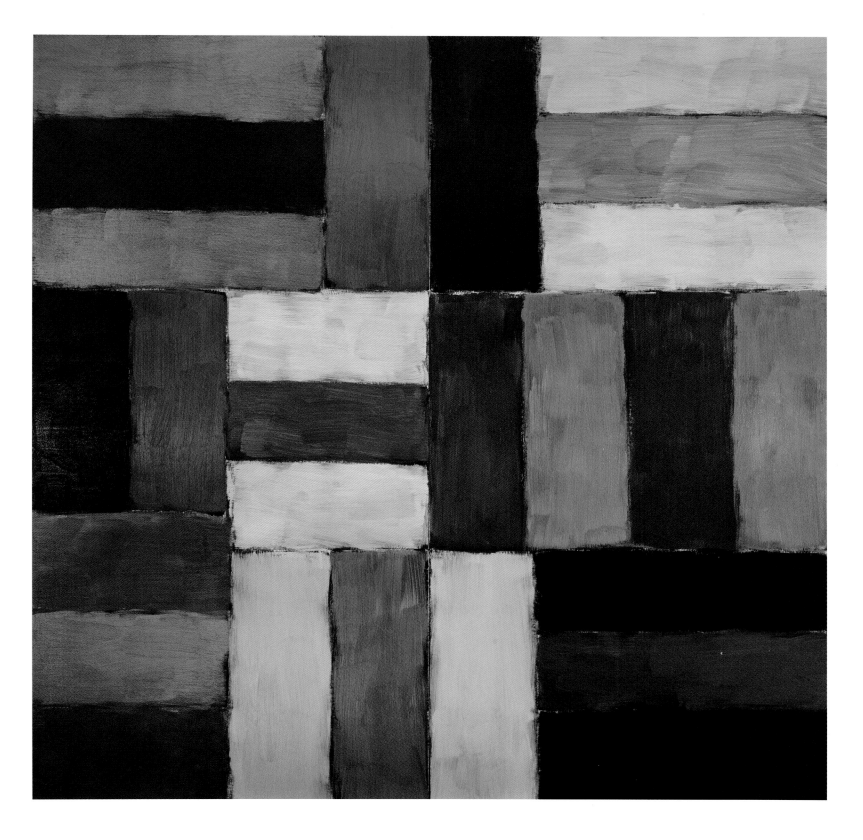

*Wall of Light Red*
1998
Oil on linen
96 x 96 in.
243.8 x 243.8 cm

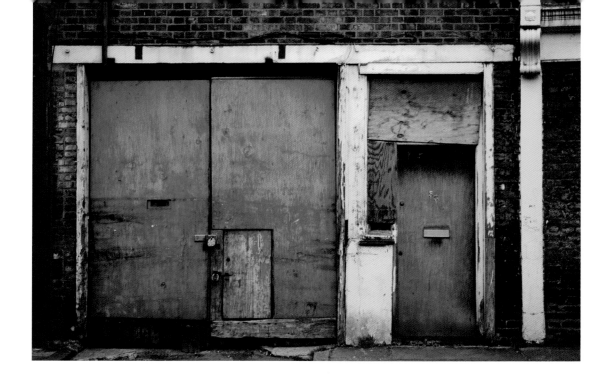

*They were so beautiful, so expressive of the personalities who made them – that they were driving me crazy as we drove by them. I had to keep stopping the car and running out to look at them.*

Is it surprising that he decided to exhibit these exquisite images? Like Scully's 1980s paintings, the Knoedler photographs of battered London doors and the colored Santo Domingo shacks pit one field of stripes against another. But the "Walls of Light" transcend such composition by opposition.

Let us go back twenty-two years, to November 1979. His gray, black, and white gouache on paper, *Untitled* (1976), was on the cover of *Artforum*. Inside was an essay by Sam Hunter, "Sean Scully's Absolute Paintings." Relating Scully's art to the austere black-on-black paintings of Ad Reinhardt, Frank Stella's early pictures, and Brice Marden's opaque encaustics, Hunter noted the artist's love of darkness, limitations, and preordained rules. And then Scully is quoted:

*The power of abstract painting today lies in a constant exchange and perpetual transformation of a physical state into a visual, emotional, and mental state, and back again. It is closely aligned to the human situation.*

This statement is a little vague – it's not really clear how Scully's narrow stripes transform physical into emotional states nor why that transformation is constant and perpetual. Had he spoken of the "human condition," his remark would better suit the dramatic personality described by Hunter. Earlier, it is true, Scully made more dramatic statements. When he was twenty-seven, for example, he said: "For me, painting is about presenting an extreme state of one kind or another." But in Hunter's quotation the significance of Scully's words, "human situation," is unclear. Whose situation is he talking about: his, the viewer's, or both? There certainly is an enormous gulf between the burning intensity of the person Hunter describes and the extraordinary restraint of Scully's late-1970s art and ways of talking.

*Untitled* (1976) is a diptych, the opposite sides linked by horizontal gray stripes running across the two canvases. Take away the gray, and you have two monochromatic panels; view only the stripes, and you have a handsome minimalist painting. But tension arises because these very different elements are superimposed. Almost life-size on the cover of *Artforum*, this twelve-inch-square gouache is somber, controlled, and very restrained. The later "Walls of Light" would present various times of day, but in 1976 Scully was making night paintings.

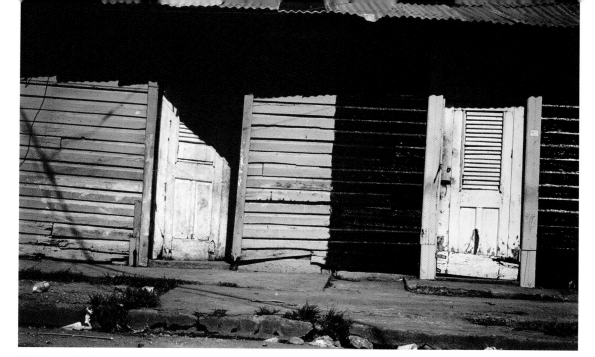

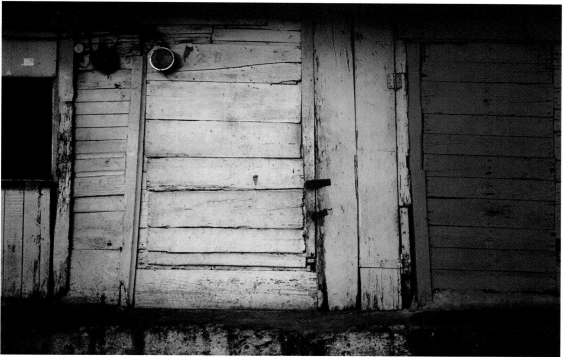

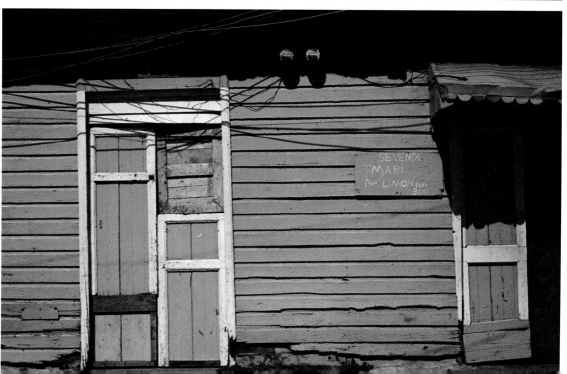

*Santo Domingo 1, 2 and 3*
1999
Cibachrome prints
37 x 49 in.
94 x 124.5 cm

*I would love to go out at night. I find the colours at night incredibly mysterious and beautiful ... those dark colours ... come from the air of night.... And the night for me is a time of great tranquility and mystery and in a way equilibrium.*

These very austere night paintings have a narrow range of subdued colors, and so Scully had to go through some drastic changes before making his "Walls of Light," which employ a wide range of intense colors, dark and light, to express an extraordinary variety of emotions. In the mid-1990s, he said:

*I think that painters must turn to painting because they are dumbstruck by the tragedy and splendor of life – and to paint is all that is left as a response. And to paint abstractly is to paint pure feeling and to try and set the spirit free in a totally direct way.*

Here we *do* find a direct relationship between his art and his aesthetic.

In 1979, Scully's art was in fact just on the brink of a dramatic transformation. Two years later, his painting would be completely different. Perhaps Hunter sensed this when he noted how much four years of life in America had already changed his art. In 1982, Scully wrote:

*I gain in strength, I think, with the painting. And it does seem to get stronger and stronger. But I wonder if I will ever be able to paint what a powerful privilege it is to be alive. That's an awful big thing to try and paint. The paintings get stronger, there's no doubt about that. But how good do they have to get in order to paint the intensity of that feeling. If I manage to find out I'll be satisfied.*

Immediately after his breakthrough, he speaks like the intense Romantic personality that we naturally associate with his broad striped, color-filled abstractions of the early 1980s.

In the 1980s, one of Scully's favorite words was "extreme," which he used to praise seriously extraordinary art and writing. Looking back, his 1979 art may perhaps appear extreme partly because it prepared for radical transition. The exquisite 1970s paintings exclude the viewer: their perfection means that all we can do is contemplate. But in the 1980s, Scully let us into his art. Before 1981, he was a gifted, original, and, at times, well-recognized painter. Soon after 1981, he

*London Door White*
2000
Cibachrome print
28 1/2 x 40 in.
72.4 x 101.6 cm

*Untitled*
1976
Gouache on paper
12 x 12 in.
30.5 x 30.5 cm

*Yellow Seal*
1995
Oil on linen
42 x 38 in.
106.7 x 96.5 cm

*Reef*
1995
Oil on canvas
96 x 144 in.
243.8 x 365.8 cm

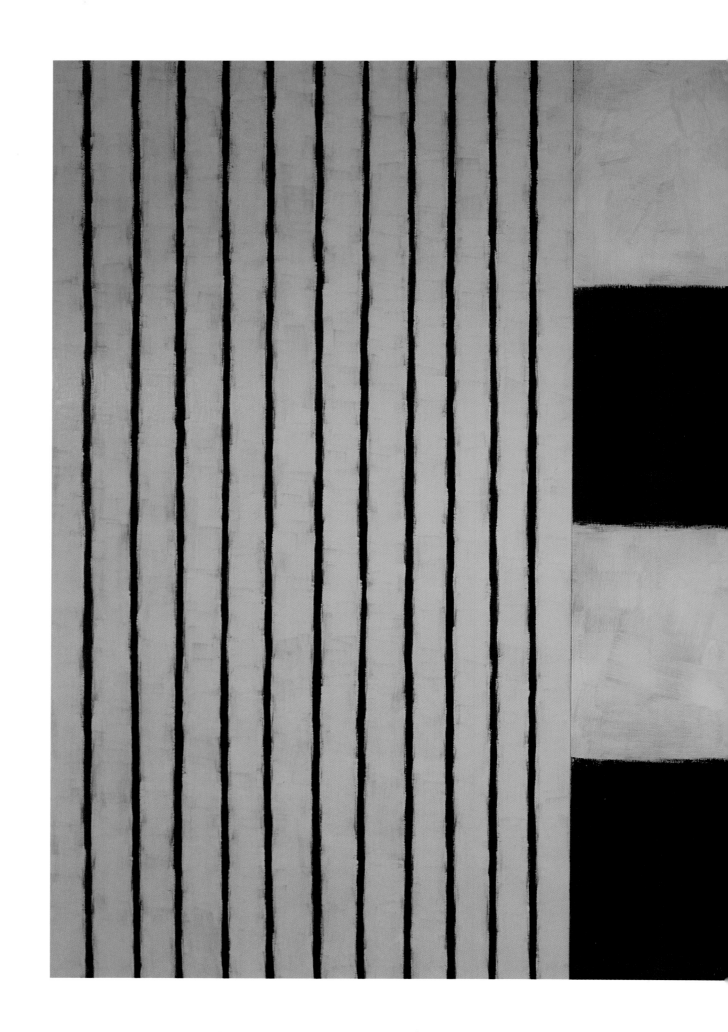

*To Be With*
1996
Oil on canvas
108 x 180 in.
274.3 x 457.2 cm

34

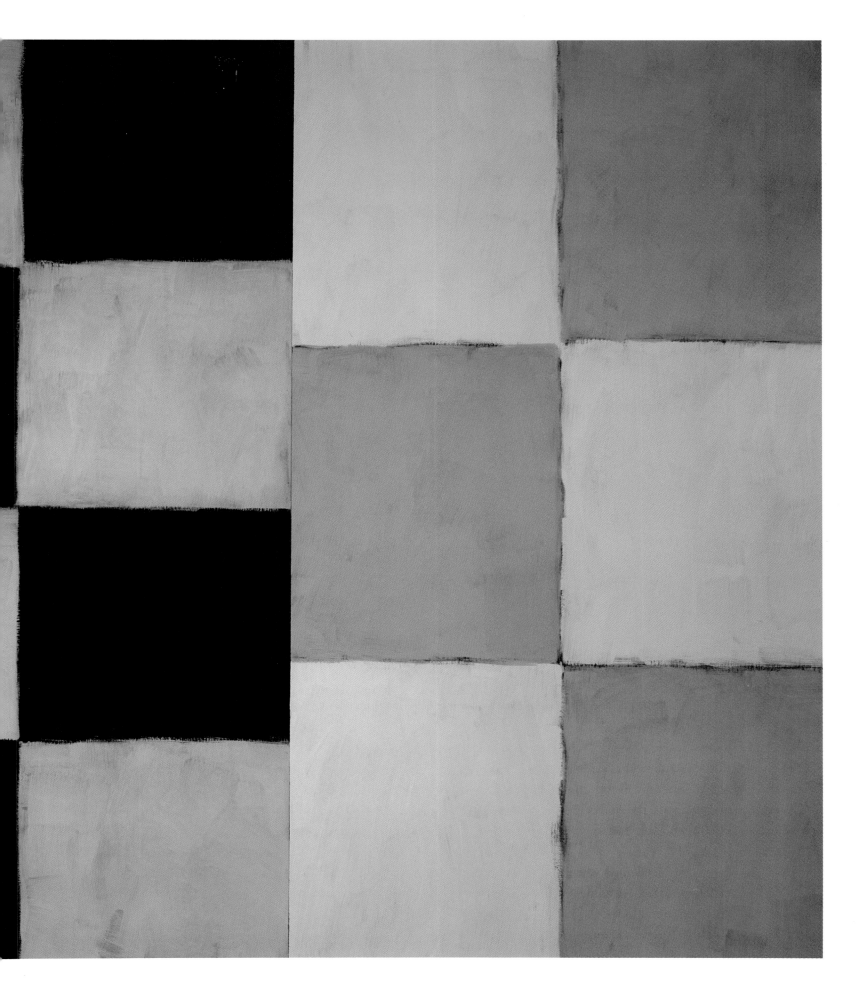

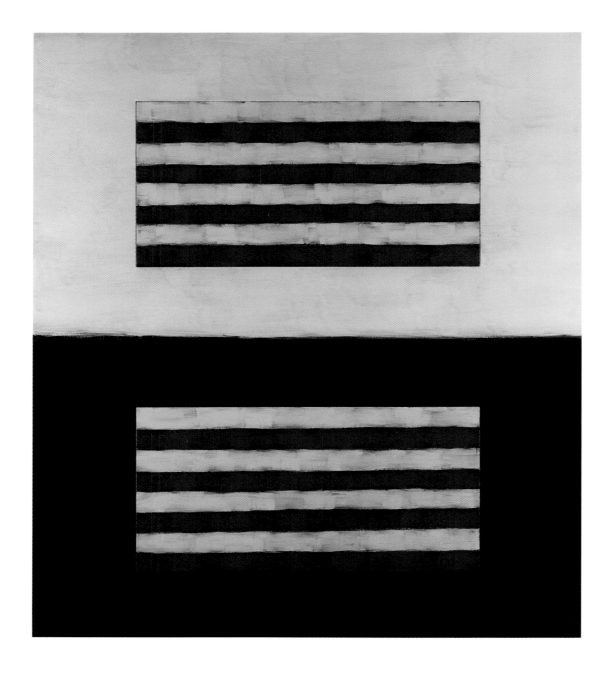

became famous. Photography, film, and travels taught him how to extend and dramatically transform *his* style. In moving from *Untitled* (1976) to the Knoedler show, Scully traveled an immense distance. In 1979, he was one of many promising newcomers struggling in New York City. By 2001, he had outdistanced all near-contemporary American abstract painters. No one else who started showing in America only in 1975 displayed so radical a capacity for self-transformation. But in these twenty-two years, the American art world has moved even further. And Scully's stylistic transformation depended in part, so we will see, upon critically responding to these changes on his own terms.

Scully became an abstract painter when abstraction was beleaguered. Painting itself and the idea of "style" were marginalized. He used that difficult situation to his advantage. For him, using a style ultimately involves moral issues.

*The issue of intensity is very crucial here because naturally one wants to make something that is intense and moving. But intensity is usually in bed with high focus and specificity. How to get all*

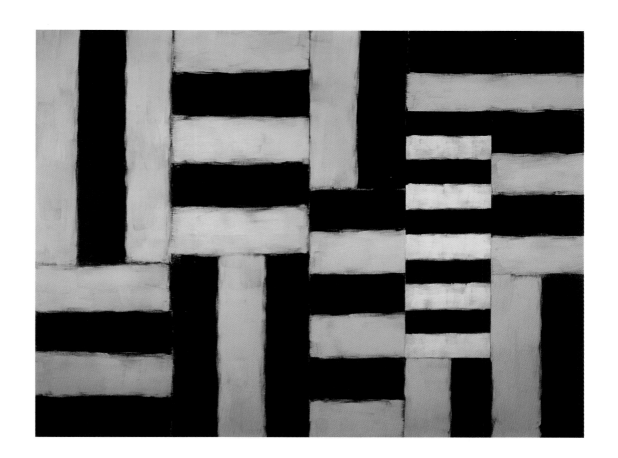

*Michael*
1997
Oil on linen
100 x 130 in
254 x 330.2 cm

*Coyote*
2000
Oil on canvas
108 x 120 in.
274.3 x 304.8 cm

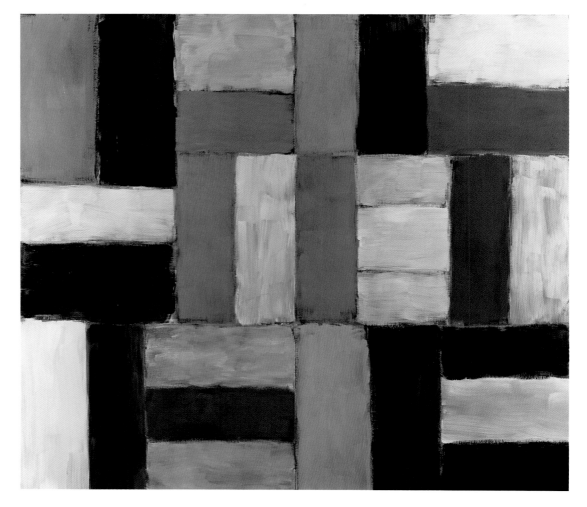

*that in the same place and at the same time while keeping it open and flexible enough to continue*
*to work and dream and develop is difficult.*

Unless very intense, your art will merely repeat the past. But "if you do this and develop," he adds, then "you have achieved something profound. Very few people have the stickability: it takes will and passion and discipline." Achieving a personal style requires both deep knowledge of history and willingness to break violently with tradition.

But even radical change such as Scully's development which we have charted between 1976 and 2001 grows out of the past.

*I'm seriously inclined to believe character (that is, potential and potential to be intense) is decided*
*more or less at the beginning. I believe if you get it right you will continue to get it right.*

The child *is* father to the man. "In talking about himself," Arthur Danto wrote of Robert Motherwell, "he was talking about his art, for his art really was himself." The same is true of Scully when he talks about *his* art.

*Unlike a figurative painter, I don't start out with something different each time and then make it*
*consistent with my attitude. I start out always with the same thing and then try to make it differ-*
*ent, out of myself…. Arthur [Danto] asked "why" do the stripes come together the way they do,*
*with such emotional complexity. That's the interesting question.*

They come together with such emotional complexity because we can relate each new painting to many earlier Scullys. As life changed, and his vision of art's history developed, so Scully's style evolved.

When he talks about how he works, Scully speaks like a Renaissance painter: "Being an artist is simply an attempt to imitate and if possible rival the natural world." Here we see his astonishingly deep link into old master ways of thinking. Like a figurative painter, he makes art mirroring and rivaling appearances. He depends, he adds, "on a curious combination of self-serving ability and humility." An artist with personal style is a double personality, arrogant in his faith in himself, humble in recognition of the depth of his roots in tradition. Scully's essential double identity appears both in the banal facts of his biography and in how he uses his sources. Irish born, English trained, an American citizen, he now lives much of the time in Spain and Germany. His big abstract paintings have the cultural resonance of popular music and film. Like the great African-American musicians, he wants to make genuinely popular art; like the most famous film-makers, he seeks a mass audience.

Style as Scully understands it unifies your personal history with your aspirations. This close connection between style in art and life explains why it took him so very long to find his style.

*In painting the medium is so powerful because it is so inert. And it is so inert because it is so*
*burdened by history. So in order to make it move now the painter and the paint have to become*
*one thing…. Since it's such a strong extension of the body, you are in the end like a dancer or like*
*a swimmer who goes up and down and round and round without end. Until there is simply no*
*difference between what you paint and your inner nature. They call this style.*

Scully's personal history is complicated, full of conflicts, and his aspirations are very lofty. That is why unifying his life and art has proven to be extremely difficult.

*Window Figure*
2002
Oil on canvas
60 x 52 1/2 in.
152.4 x 133.4 cm

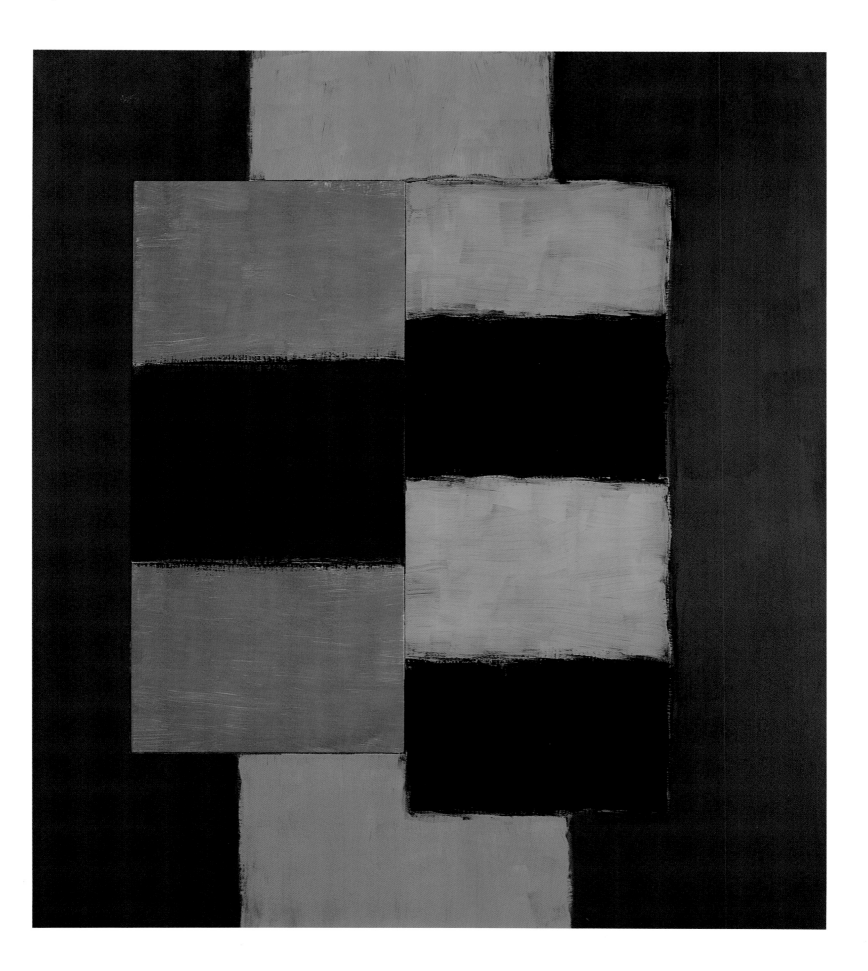

30 TP    à 6,70 F    +    = 201    FRANCS

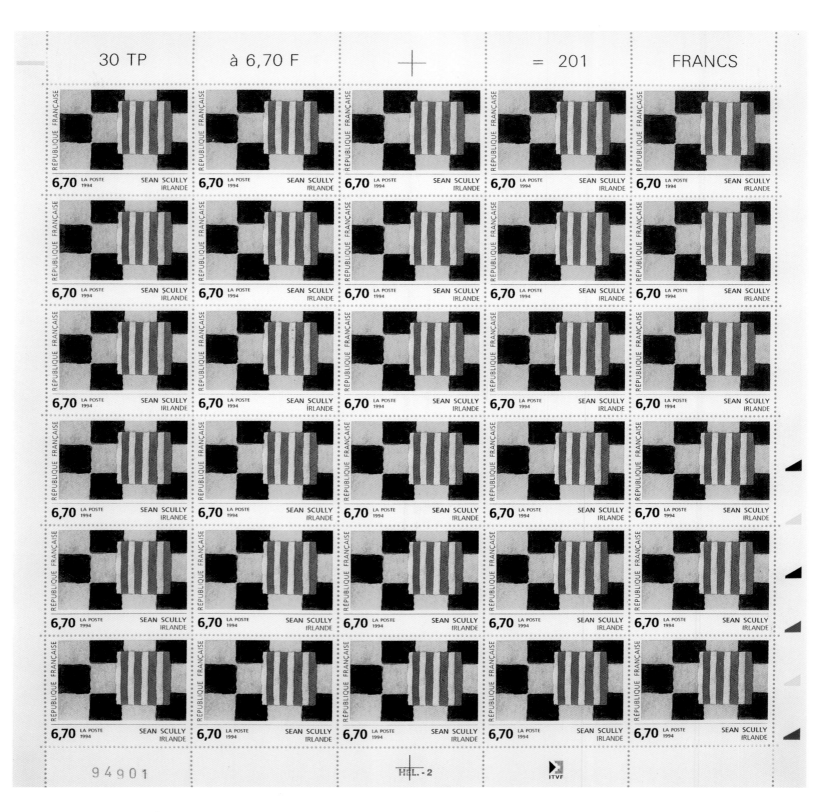

94901    HEL. - 2    ITVF

# PART 1  SEARCHING FOR A STYLE

## Chapter 1    A London childhood

*I think, or I suspect, I believe, although I can't prove it, that
the future is decided early on. For one thing, childhood decides
many things about your character, good and bad; it's all given.*

*Irelande*
1994
Artist-designed
postage stamp

Sean Scully was born in Dublin on 30 June 1945. Before he was four, his family had to cross the Irish Sea and move to England in search of work. In this difficult sea voyage, their boat was lost for eight hours in dangerous waters filled with floating mines left from wartime. In his painting *Precious* (1985), he gives thanks to his loving parents for their courage during the journey. His life has often come apart in this way; he has repeatedly had to work very hard to maintain continuity. And so he feels anxious when the panels are temporarily taken apart to transport his paintings. Scully's "very romantic relationship with Ireland," as he describes it, is not, so he well knows, based upon realism. He didn't have much contact with his country until after becoming an adult. Scully's childhood memories are less of Ireland than of being Irish in London. England is where he learned his craft, but he looks to Ireland for his heritage. When in 1999 I had dinner in New York with the Irish television crew making *Sean Scully: American Beauty*, I better understood this. They asked where he was born in Dublin, wanting to know not just what on street his parents lived, but on what side of that street. Scully's Ireland, I realized then, was a small, close-knit community.

Like all immigrants, Scully has been forced to learn to see the world from a number of different viewpoints. The scale of his paintings is American, but their paint and texture are European.

> *We live in a world of competing truths.... You can't just know one point of view any more.... My work is concerned with making something "classical" or "permanent" out of such a non-myopic attitude that doesn't work out of a simple point of view.*

What gives us reason to be optimistic, he suggests, is that "we are able to see things in more than one way. And that hopefully results in a kind of understanding." Experience of living between cultures is incorporated into his art and his artistic tastes. Scully greatly prefers James Joyce to Marcel Proust, for example, not because Joyce is Irish, but because Proust's "backtracking and refinement and subterfuge and indirectness" is not his favorite style of literature.

Living in impoverished south London communities, Scully was under a completely Irish cultural umbrella. The family was poor – life was hard. "I would describe childhood for me as a kind of purgatory: I couldn't wait for it to be over. It was very difficult. My ideas come out of the fact that I lived in the slums in London." The family had great respect for books and literature, but little contact with visual art. They loved music. His mother became a professional singer and when late in life his parents retired to Spain, they became champion tango dancers. Robert

Gardner's 1997 film *Sean in Malaga* shows them dancing, watched by their son, at an installation of his art. Irish literature matters to Scully. Much affected in the late 1960s by seeing Samuel Beckett's *Waiting for Godot*, he read Beckett's very austere novels; and in 1993 he etched illustrations for James Joyce's *Pomes Penyeach*. In 1994 Scully designed *Irelande*, the French stamp celebrating Irish membership of the European Union. His window of reds and pinks in a plaid sea is an image of his country.

Housed, at times with his extended family, in a tough, cold environment, Scully first learned about art in a small local Catholic church. He loved the crucifix, the Stations of the Cross, and the representation of the Virgin Mary.

> *They weren't probably any good … but they were paintings, and when you're a kid you don't really care so much what they're about. The fact that they're paintings is what's fascinating and that they tell stories and they make you have feelings.*

But he also had bad experiences with the Church. A priest who warned him of the devils under the beds of bad boys gave Scully a lasting fear of darkness. His father had to work on Sundays to support his family. When a priest complained, the family rejected Catholicism. Scully associates the expressive power of his abstractions with old master sacred art, but these incidents inspired deep ambivalence about organized religion. He would love, still, to do art for a church – his paintings could make wonderful Stations of the Cross.

Walking to school, Scully passed St Philip's Catholic Church. Fascinated by the beautiful big candles, he took some and buried them in his garden. Kleptomania is a form of love – and he especially loved these "metaphysical vessels that make light." One day a priest informed him that God, very forgiving, would favor anyone who returned things mistakenly taken from Him.

> *This was the argument that convinced me. I could make an advantageous agreement with God. I dug up the candles and handed them over. The priest walked up the street with a big smile on his face.*

How respectful was this tough rebellious boy of the priest's authority. Scully read in Ambroise Vollard's *Cézanne* that the French artist's "parents were humble artisans, profoundly attached to their religious beliefs, and deeply respectful of ancient tradition." This book meant a lot to him.

> *What's so interesting about Cézanne for me personally is that his work is almost mechanical, like mine, but it is also obsessive and monumentally emotional. The search for emotion in structure is deeply interesting.*

Identifying with the hero of Vollard's book, he wanted to emulate Paul Cézanne.

When his parents left the Church, Scully had to move from a convent classroom to the local state school. Leaving his Irish neighborhood to enter "a world that was gray, hard, spiritually empty and very violent" was a shock. Scully made scenery and puppets for school plays, and he was popular with the teachers. But the violence of the state school was very frightening. He had to fight to survive. Many friends ended up in institutions of correction. But he also found a way out of this tough environment, for he was inspired by a reproduction of Pablo Picasso's *Child with a Dove* (1901).

> *It was a tender painting in a rough school. I looked at that reproduction a lot. In fact, it was as important to me as the Church in pointing to art as an escape from a harsh, working-class environment.*

And experiences outside of school also taught him the importance of tenderness. When he was twelve, Scully met an English lady who cared for sick animals. Inspired by her, with the aid of his parents, he set up an animal hospital.

*I would take in a sparrow, I'd feed it a little crushed aspirin, I'd push it down to the end of a woollen sock, then hang it on the nail in the room, black and quiet, under the stairs: just like she showed me. The next day I would take it out, fix its wing and feed it: and wait for it to get better.*

When, at the age of fifteen, having learned about the power of art and the importance of compassion, Scully left this harsh school, he discovered the saving value of work. By the time he was seventeen, Scully had worked as a messenger, in a graphic design studio and as a plasterer's laborer. Because his father wanted him to have a secure job, he became a typesetter.

*You would make up something called a chase. The rows of type, and the photographic image on a metal half-tone plate were all locked together. They are so similar to the way I make my paintings, where I am bolting things together and pushing things together, and enclosing an inset, which is like the way one encloses a photograph.*

How much we learn about an artist by knowing his childhood. John Ruskin's "The Two Boyhoods" compares Giorgione and Turner. Giorgione grew up in Venice, "a city of marble … nay, rather a golden city, paved with emerald." Ruskin contrasts that splendid place with Turner's home, Covent Garden, then a very drab part of London with "dead brick walls, blank square windows, old clothes … black barges, patched sails, and every possible condition of fog." Turner loved decay, and so "devoted picture after picture to the illustration of effects of dinginess, smoke, soot, dust and dusty texture." Scully's childhood was similar to Turner's. As he tells: "You have to cross incredible social barriers to get into higher education in a way that puts you in any way in contention with being in any way an artist, let alone being a successful artist." Both artists, barber's sons, learned from poverty how to make decay and impoverished urban environments their subjects. "My work is political, yet of course I don't believe in an urban utopia. I love urban mess and filth – it expresses human nature so poignantly."

*Black Garden*
1990
Oil on canvas
102 x 136 in.
259 x 345.4 cm

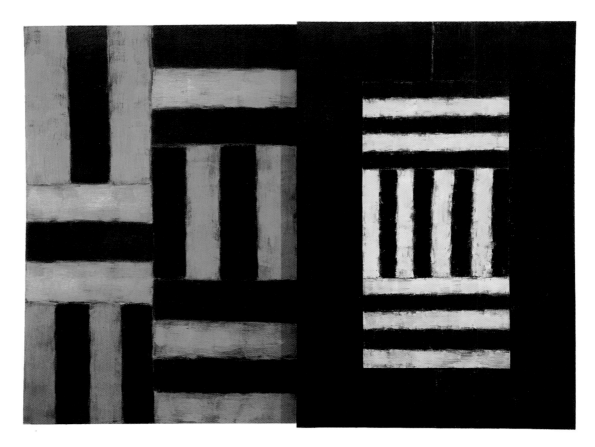

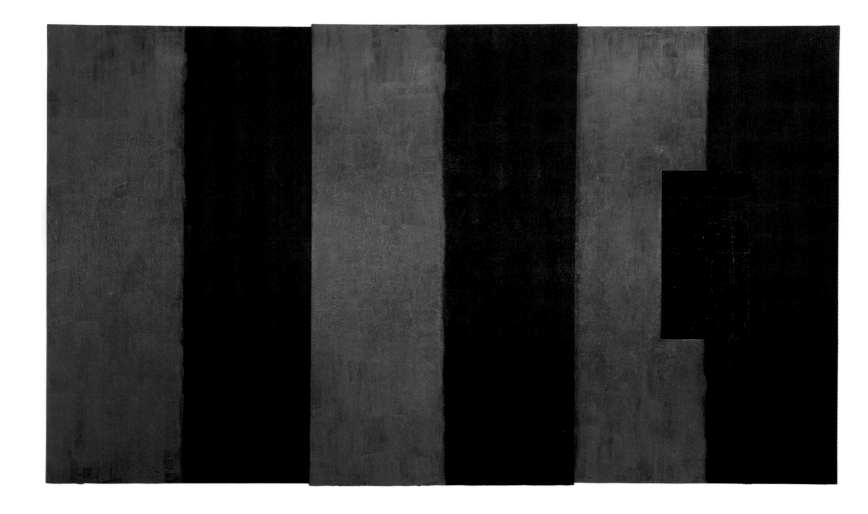

*Red Star*
1990
Oil on canvas
108 x 180 in.
274.3 x 457.2 cm

In some ways, Turner's London wasn't so unlike his. When Scully was growing up, the poorer parts of London still had "warm and very primitive" gas lighting, which he associates with his love of oil paint. Most contemporary paintings, done in acrylic, look brand new; Scully's pictures appear old, like old master paintings, even before being finished. Covent Garden has now been gentrified, but as recently as the 1970s, opera-goers walked through a vegetable market not unlike the rough place Ruskin describes. Scully's ways of making art are deeply rooted in his childhood experience of London but he believes that anyone open to visual excitement will respond to his pictures.

> *If I am moved and engaged by something, I find it beautiful. For me the term beautiful is not pejorative, it is always affirmative. If I say I find it very convincing, even though it is ugly, the fact it is done with such authenticity and conviction and it is finally persuasive, it becomes beautiful. In other words, I don't think beauty is simply a question of appearances.*

Impressive as they are, Turner's beautiful pictures of ugly places do cover up the brutal reality of everyday life. Scully's way of using urban experience in art now feels more authentic, truer to our sense of things.

Scully wanted to go to art school, but he had a tough time convincing his father that this was practical. And so he looked to painting for inspiration. At the Tate Gallery, most of the art didn't seem accessible. But then he found *Van Gogh's Chair* (1888). During the thirty-minute lunch break, Scully rode his scooter to the museum, looked at this painting for twenty minutes, and then ate lunch while driving back to work. He repeated this journey every day for weeks. It is

unsurprising that early on a Vincent van Gogh painting deeply impressed Scully, for the Dutch painter too had a passionate loving attachment to things that most people find ugly.

Roughly put together, *Van Gogh's Chair* has unexpected refinement. Van Gogh's pipe and tobacco are on a chair, set at an oblique angle on a checkerboard in front of a door, flattened gray wall, and a floor that resembles Scully's 1990s diptychs and triptychs. Like Renaissance artists who present a saint's attributes, Van Gogh uses objects to stand for himself. *Van Gogh's Chair*, Scully recalls, is

> a very, very simple thing ... it was so direct and physical, and ... it was so profound ... The object is *the painting, and I find it really powerful – the idea of accepting the fact that it's just stuff, that's all it is, it's just paint.*

This secular picture is thus associated with the traditions of sacred art. The sturdy and unassuming chair, worn from long, hard, everyday use, is just like one in Scully's Barcelona studio. This image of peasant furniture, as Arthur Danto describes it – for the artist as much a Christian symbol as the crucifix – is signed simply "Vincent," evidence of the painter's humility.

Scully hopes that someone just learning about painting can respond to his art the way he first naively responded to *Van Gogh's Chair*.

> I don't want my paintings to be about how clever I can be. I want to be an artist in the same way that Van Gogh was an artist. His paintings were all about empathy. What matters to me is to make something so empathetic that it is able to travel through time with us.

Like Van Gogh, he is a Romantic who aspires to the timelessness of classicism. "Vincent van Gogh's paintings, which are profoundly personal, and emotive and self-indulgent are the most democratic paintings." Scully loved *Van Gogh's Chair* because it is completely accessible to anyone. In 1989, he looked back on this formative experience with a new perspective.

> Our reactions to his works have changed enormously with time. I remember when I first became interested in art and came across some of (Van Gogh's) paintings, I thought he was regarded marginally. Now we've conquered their intrinsic ugliness, we can see clearly how beautiful his vision was.

Now, when Van Gogh's reputation is more secure and this painting has been moved from the Tate to the National Gallery, *Van Gogh's Chair*'s place in art history is perhaps more obvious.

At eighteen, Scully ran a London discotheque and sang in a band with his brother Tony and two friends. "I was incredibly badly behaved. I was brawling, committing burglary, gang-fighting. It was rough – seriously rough." He got into trouble with the police for fighting with bouncers from a rival club, and his discotheque was closed for being too crowded and noisy. Scully loved such songs as Etta James's "I'd rather go blind," Maxine Brown's "Oh no, not my baby," Martha and the Vandelas' "Dancing in the Street," and Mary Wells's ardent "My Guy." And he passionately admired the blues of John Lee Hooker, Slim Harpo, Muddy Waters, Sonny Boy Williams, and Howlin Wolf, and an English group heavily influenced by these Americans, The Animals. Commentators have often stressed the importance of this music for Scully's painting. So, too, has the artist himself. After explaining that he's no longer interested in organized religion, he adds:

> But I'm very interested in the issue of spirituality. And soul in art. And R&B is soul music. I mean it hits you in your soul – and that's music. Also it comes out of a sense of loss. But it has a life-affirming driving beat that runs all the way through it. And my paintings have the same thing.... The lines are almost like guitar strings in a room. And they're vibrative.

But this suggestive analogy between visual structures of paintings and temporal rhythms in music needs to be used with care. Does knowing that Mondrian danced the foxtrot and loved jazz really

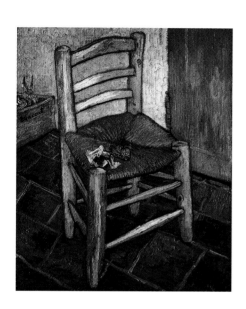

*Van Gogh's Chair*
VINCENT VAN GOGH
1888
Oil on canvas
36 1/8 x 28 3/4 in.
91.8 x 73 cm

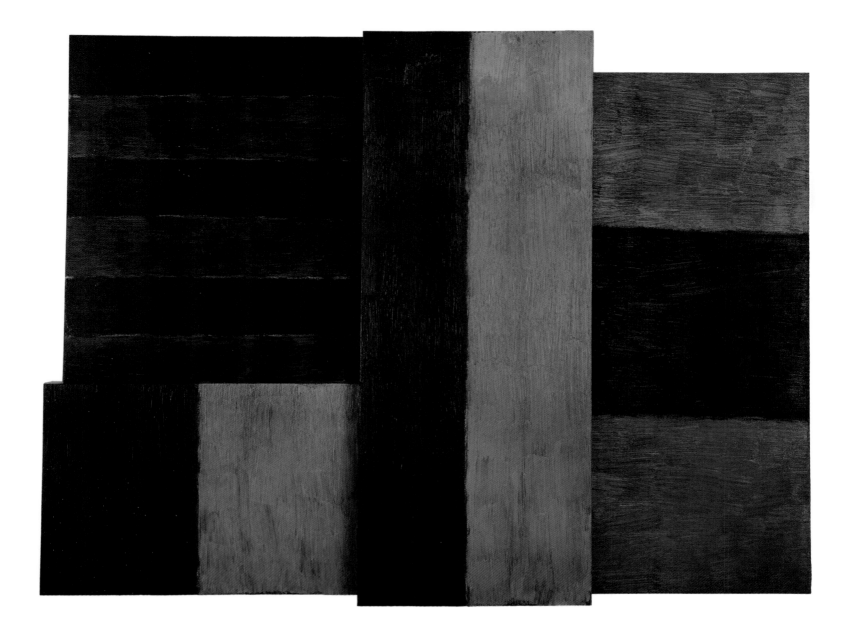

teach one about his paintings? For Scully, admiring James's voice and Waters' guitar blues didn't show him how to make abstractions. Although he heard their music in the 1960s, it was only in the early 1980s that he started to make paintings with comparable rhythms.

In the 1960s, Scully was very attracted both by African-American music and by the social role of these musicians. He thought of himself as an outsider, like them. Bored by everyday English life, he wanted to be taken out of himself. So too did many young Londoners – the creators of British rock and roll learned everything at the start from this music. But only later did the relevance of American blues to Scully's painting become entirely clear. Pop music has changed a lot, and so now it's as hard to hear these musicians as Scully did in the 1960s as it is to see Van Gogh's paintings as naively as he did. More recently, Scully has been enchanted by classical music, especially by Bach's cello music and Zoltan Kodaly's sonata for unaccompanied cello, which

> is enormously powerful and, yet, for most people it is too much, and the reason for this is that it is unknown, although it happens to be one of the best works ever written for violoncello… The work's pathos signals the medium's incapacity to fully express the artist's intent.

*Rock Me*
1986
Oil on canvas
96 x 126 in.
243.8 x 320 cm

But however suggestive he found this extreme composition, there is only a vague analogy between expression in cello sonatas and his paintings.

The arrival of African-American music in England was part of a larger cultural and social revolution, what Scully calls "an explosion of romantic idealism and hipness." He demonstrated in Trafalgar Square against apartheid, nuclear weapons and the war in Vietnam. Set against this exciting scene, his first painting *Cactus* (1964) may seem tame. But in fact this wonderful small oil is surprisingly revealing. Scully chose to depict neither some typically English theme nor pure fantasy, but a real imported plant.

> *I had a big collection when I was a kid. I always loved them. They flower when they feel like it, so they are independent and mysterious. You can never figure them out and they stay silent and mysterious.*

The vertical stripes behind this cactus inserted in an all-over field anticipate his panels of stripes.

*Cactus*
1964
Oil on canvas
13 x 11 in.
33 x 27.9 cm

*Untitled*
1967
Oil pastel on paper
10⅞ x 14¾ in.
27.5 x 37.5 cm

In 1965, after going to night school, Scully entered Croydon College, London. Neither precocious nor especially gifted, but with "very unusual empathy, passion, and sincerity," he had been turned down by eleven other art schools. Scully was used to being rejected. He spent four years at this remedial art school which took unqualified people like him. "I had nothing to lose. I had a very difficult childhood. And went to work. I had to fight to get back into art school." American abstract painting was frequently exhibited in London – the minor Abstract Expressionist Mark Tobey worked there. But this foreign art did not especially interest Scully until in 1967 he found the catalogue of Mark Rothko's 1961 exhibition at the Museum of Modern Art, New York. After that revelation, he didn't need to see Rothko's paintings to abandon figuration completely. Scully takes abstraction for granted, for it is the language he grew up with. In 1985 he spoke of figurative art as "worn out ... It's hard to give the human figure, or landscape, the profundity of form you need." And yet, although he thinks it inevitable that the greatest late twentieth-century art be abstract, the ghost of figuration haunts his paintings.

In his essay "Bodies of Light," Scully compares Rothko to Matisse:

*Matisse was essentially a French bourgeois who spent his entire life in comfortable surroundings. ... Rothko, on the other hand, was a poor immigrant.... His existence was always embattled. His work is less various than that of Matisse, but it has a moral, emotional force permeated with a sensual pathos, that is unique in the history of painting.*

Scully's experience certainly is more like Rothko's than Matisse's. But for all of the physical comfort of his later life, Matisse too had to struggle when young. And when Scully describes Rothko's paintings as "severe and geometric ... but ... inhabited by a sensual despair," he identifies only one side of his own art. There is despair in Scully's paintings, but also often exhilaration. There is too much realism in the weight and touch of his surfaces, and too many pleasures, for Scully's paintings to be consistently dark in mood.

*Even though I use the discarded vocabulary of the city and of art, I don't, won't accept the full force of the tragic. My work is about intervention. I try to offer something that gives us possibility.*

His paintings too have different personalities. Indeed, many individual paintings have multiple personalities. Scully, too aware of conflict to seek Matisse's luxury, calm, and voluptuousness, often is a highly sensual painter.

At Croydon College, Scully admired Ron Howard, an art history teacher who asked students to focus on the surfaces of paintings, not the picture spaces. For Scully, unlike the American formalists, making an illusionistic pictorial space has never been important. Interested in "a kind of reality, or in realities, or personalities," he makes panels with the real physical presence of architecture. He also recalls with pleasure the classes of his painting teacher, Barry Hirst, who emphasized the importance of color. Scully admired Hirst because when he was unable to make art that matched his standards, he temporarily quit painting, later returning as a figurative painter. Thanks in part to Hirst, Scully looked closely at the Fauve paintings of André Derain and Henri Matisse and at the expressionist art of Karl Schmidt-Rottluff, early Oskar Kokoschka, and Emil Nolde.

In 1968, Scully enrolled in the art school of the University of Newcastle, where he was a student for three years and a teaching assistant for the fourth. Newcastle, an industrial city located on the River Tyne, is fifty miles south of the border with Scotland. The visual patterns of its many train tracks and bridges fascinated Scully. Writing his thesis on Matisse's *La Danse 1*, he became fascinated by the rhythm of design and the relationship of dance to musical rhythms. Richard Hamilton, who taught at Newcastle before Scully arrived, was an important champion of Marcel Duchamp and Kurt Schwitters, whose masterpiece, the *Merzbau*, was installed at the school. Hamilton's image appropriations and playful treatment of ordinary objects as works of art were entirely alien to Scully. But the painter Ian Stephenson was a supporter and became a friend. Later they taught together at the Chelsea School of Art. Stephenson's romantic abstractions appeared in Antonioni's *Blow Up*, a film much admired by Scully and his contemporaries.

*It was Ian Stephenson, coming out of Georges Seurat and Jackson Pollock, who taught me how to conceptualize beauty. His paintings, made with tiny dots, were romantically and obsessively ritualistic.*

In Newcastle, Scully was therefore not isolated as he had been earlier in his life. He remembers this period fondly. "There were and still are many interesting abstract painters in England, though they receive scant support for their efforts." John Hoyland, Mark Lancaster, Tess Jaray, and Mick Moon are figures he respects. And in Newcastle he met his first important champion, the London critic and writer Ian Bennett, who came to his studio, asked the price of a huge painting, purchased it, and then moved when his apartment wasn't large enough to hang the picture. An authority on carpets, Bennett wrote repeatedly about Scully, asking in the *Evening Standard* why the Tate Gallery hadn't purchased one of his paintings. The obvious parallel between Scully's early all-over compositions and such features of Persian carpets as the "endlessly repeating medallion" Bennett describes in his book on rugs may help explain why the critic was so easily attuned to these paintings. Through Bennett, Scully discovered Japanese ceramics, which remain one of his great enthusiasms.

In 1968 and early 1969 Scully gathered his resources, as if in unconscious anticipation of his travels in the summer of 1969. In 1968 he did six *Untitled (Seated Figure)* oil pastels on paper. The next year he painted a group of mostly abstract works on paper. Scully's small, deeply romantic figurative images owe much to Derain, Matisse, and Nolde, but little to contemporary English

*Large Screen*
IAN STEPHENSON
1966–67
Oil and enamel on four canvases
120 x 120 in.
304.8 x 304.8 cm

*Untitled (Seated Figure)*
1968
Oil pastel on paper
11³/₄ x 13¹/₂ in.
29.8 x 34.3 cm

*Untitled (Seated Figure)*
1968
Oil pastel on paper
11³/₄ x 13¹/₂ in.
29.8 x 34.3 cm

*Untitled (Seated Figure)*
1968
Oil pastel on paper
13¹/₂ x 11³/₄ in.
34.3 x 29.8 cm

figurative art; the abstractions display his interest in Tobey and Jackson Pollock. Indeed, looking back, these figurative and abstract pictures appear unexpectedly similar. In the figure studies, with pigment painted wet into wet, the colors, apart from the flesh, are unnatural and the shapes mostly abstract. Scully uses the space behind his figures to create a wall of color. The models, whose faces are not shown, are treated abstractly, functioning as forms structuring the picture space. As in *Cactus*, the abrupt jump from figure to ground, which presses the figures into the field of color, anticipates the sudden transitions between successive panels in his abstractions.

In Scully's figure studies the light is intense. Make these pictures larger, take out the figures, enlarge the background stripes, and you have his 1980s paintings. Abstraction used his gifts as colorist without being limited by the associations of these figurative subjects. The ballpoint pen on paper drawings display his virtuosity at composing space-filling lines and the gouache on paper drawings show the influence of Paul Klee's intense color. The ballpoint pen on paper drawings,

*Untitled*
1969
Ballpoint pen on paper
8¹/₂ x 11³/₄ in.
21.6 x 29.8 cm

*Untitled*
1969
Ballpoint pen on paper
8¹/₂ x 11³/₄ in.
21.6 x 29.8 cm

*Untitled*
1969
Oil pastel on paper
11 x 19¹/₄ in.
27.9 x 48.9 cm

*Bend 2*
1969
Oil pastel on paper
11 x 19¹/₄ in.
27.9 x 48.9 cm

*Untitled*
1969
Oil pastel on paper
10 x 14¹/₂ in.
25.4 x 36.8 cm

a very tight all-over design, are as extreme as Jackson Pollock's early 1950s paintings. The oil pastels on paper present beautiful patterns of undulating circles and very narrow stripes. And *Double Landscape* (graphite pencil on paper) creates an image from closely spaced lines. In *Red Blue Yellow Green* (1969), Scully's first fully accomplished abstraction, stacked blocks of blue and red appear behind a surface drawing composed of short strokes of acrylic paint. This all-over painting, derived from the ballpoint pen on paper drawings, shows early versions of his signature stripes, hidden behind floating calligraphy, waiting to be brought forward. Like Seurat, Scully uses banal contemporary materials to poetic effect.

In the summer of 1969, Scully went to Morocco, a country whose sunny beaches and hippy culture made it a common student destination. Colorful, irregular repetitive structures, with

*Double Landscape*
1969
Graphite pencil on paper
16 x 12 in.
40.6 x 30.5 cm

rhythms more like those of blues music than the impersonal grids of European cities, were every-where. Strips of dyed wool were hung out to dry on the street, and on enormous beach tents he saw canvas bands of different colors. When the Moroccans ran out of one color of stripe, they used another. Striped, dyed fabrics were used to make the robes called *galabeyas*. With carpets piled up and partially covering each other, "outrageous formal relationships" were being con-stantly produced and destroyed in the markets. The trip had an enormous influence on Scully.

Before he left England, he had been building up the surfaces of his pictures. Directly upon returning, he made his first true stripe painting, *Morocco* (1969). He partially glued down blue, black, and yellow stripes of dyed cloth, cutting them to hang down on the white background wall. Many abstract artists were painting stripes at this time; *Morocco*, a physical portrait of Morocco, used stripes as real objects, not pictorial elements. The empty center – it looks as if student protesters have vandalized the stripes – is an early version of the inserted panels Scully calls "windows." This improvised breakthrough, a big sketch quickly worked and destroyed, made direct reference to the way that Moroccans dry materials by hanging them over a bar. The blue refers to the ocean and the yellow, Scully's favorite color, may suggest erotic adventure –

*Red Blue Yellow Green*
1969
Acrylic on canvas
72 x 84 in.
182.9 x 213.4 cm

54

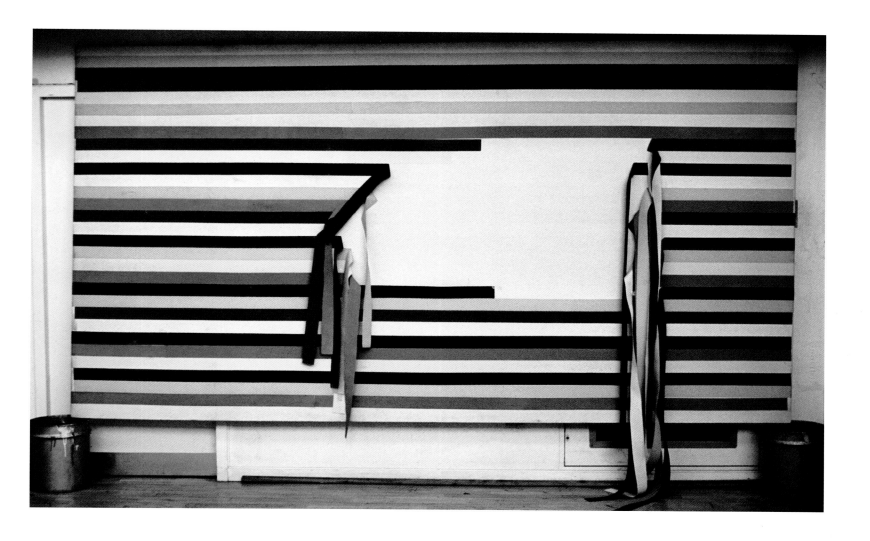

*Morocco*
1969
Canvas
72 x 144 in.
182.9 x 365.8 cm

"I always go to yellow, to fight death." But the black stands for slightly menacing night. What you find when you travel to an exotic place depends, in large part, upon your goals.

*Soft Ending* (1969), a lattice of blurred interwoven verticals and horizontals, uses some lessons of *Morocco*. Utilizing masking tape, revolving his large square canvas, this first supergrid, as Scully identifies his tight heavily fortified grids, has cage-like narrow verticals and horizontals, as if a piercing red fence has fallen through the horizontal stripes of *Morocco*. Scully employed the style of *Soft Ending* in other works, too. In *Backcloth* (1970), he tightened his grid, narrowing the stripes, showing a horizontal rectangular cut from an apparently infinitely deep, well-fortified field. He put down tape, painted, then stripped off the tape. This tight three-dimensional grid is closely woven, as if holding a shallow space under tremendous pressure. The highly animated *Red Light*, from 1971, uses complex layering creating a space whose depth is difficult to determine, and bottom impossible to find. Compared with *Morocco*, *Red Light* is claustrophobic.

Contemporary English art didn't offer much to Scully. The most influential local painting was the figurative "School of London" art. He admired the early twentieth-century abstractions of David Bomberg and valued the seriousness of Bridget Riley. But Scully the colorist owes more

*Soft Ending*
1969
Acrylic on canvas
89 x 89 in.
226 x 226 cm

56

*Backcloth*
1970
Acrylic on canvas
78 x 120 in.
198.1 x 304.8 cm

to Velázquez and El Greco, and to African masks, than to English art. He was fascinated by the French-based abstract artists François Morellet and Victor Vasarely. And he was very impressed by the walk-through installations of Jesús-Rafael Soto, displayed in Paris in summer 1969, which reminded him of the carpet arrangements he had just seen in Morocco. Other shows from this period played a formative role, too. Scully viewed a major Mondrian exhibition at the Tate, and the huge 1970 Matisse show in Paris. And he saw many Post-Impressionist paintings: Derain, Braque, Van Gogh, Seurat. French painting in general, going back to Courbet, was very important to him. Monet's pale gray colors had an enormous effect. He was also impressed by a large Barnett Newman retrospective at the Tate; "Art of the Real: 1948–1968," curated by E. C. Goossens, which traced the history of American art from Abstract Expressionism to Carl Andre, Ellsworth Kelly, and Tony Smith, excited him.

But for Scully, a strong artist working in isolation, London felt provincial. Decisively influenced by Rothko's art, he wanted to move to America. When he got there, Scully found that abstraction had developed in ways that mostly didn't deeply engage his concerns. Robert

Motherwell made a few magnificent stripes, but he did not develop this motif. The most influential heirs to Abstract Expressionism, Clement Greenberg's color field painters – Kenneth Noland and Jules Olitski – were minor artists, in his opinion. Such other abstractionists as Gene Davis and Frank Stella painted impersonal stripes, Stella making symmetrical, non-relational paintings. Scully juxtaposed horizontals and verticals, like Mondrian but employing intensely expressive color. Unlike Stella, Scully wasn't interested in emptying painting of meaning; on the contrary, he wanted to use stripes "as a kind of thing, giving paintings the solidity of architecture."

American modernism was an essential resource for Scully, but he had to figure out for himself how to use it.

> Abstract Expressionism is the production of a wonderfully productive collision of European angst and density with a uniquely American sense of freedom and honesty and frankness.

Only after he found his style in 1981 did he properly understand this situation. That Scully, the last great painter working directly within the American Abstract Expressionist tradition was trained in England may seem surprising. That he was Irish makes his role a little more understandable. As an outsider, he looked very critically upon the local visual culture in London – and he imagined that he would be more at home in the New York art world. Scully always thought of himself, then and now, as an outsider in England. But when he moved to America, he discovered that he was still an outsider.

*Red Light*
1971
Acrylic on canvas
108 x 72 in.
274.3 x 183 cm

## Chapter 2  Early visits to America

*If you have Mondrian, if you have Matisse, Mondrian,*
*Rothko, then you've got my work.*

*Overlay 1*
1973
Acrylic on canvas
84 x 100 in.
213.4 x 254 cm

*Van Gogh's Chair* was Scully's perfect starting point – like Vincent van Gogh, he wants to make art that everyone can understand. He does that by grounding his abstract painting in shared urban experience. The bridges and industrial grids in Newcastle, a city he thinks of as a "failed ship building town," are strikingly similar to the grids in Scully's early paintings. These regular rhythms, so very different from those in blues music, were more immediately accessible to a painter.

Repetition is complex. How varied are the most familiar visual and auditory rhythms.

*People who talk about repetition always seem to think that there is only one kind. You know the thing that happens over and over again on a regular beat. As if that describes its nature and its function in our lives.*

If you stand in the subway, you see everything repeated. When you drive across a bridge or walk through an airport and past skyscrapers you find stripes. Modern cities are filled with architectural repetitions because that is how our urban world is put together nowadays. And when you enter buildings you often hear popular music which

*isn't repetitious in order to be ordered, but in order to be emotional, that's been pioneered by Beckett, but it comes really from Africa, from Morocco, and it comes from Irish culture. Irish music, African music, and contemporary music are deeply intertwined. Irish music leads to folk, African to Rhythm and Blues. Popular music is a fusion of the two.*

Carpets in Moroccan markets and houses of the poor in Ireland and Mexico have irregular stripe-like patterns. Absolutely regular repetitions are deadening, but uneven stripes and rhythms are alive, and so can express individuality. "What I'm trying to do is something about modern life, something that carries with it a very powerful connection to the past. So, it has eternal truth in it, as well as modern truth." His art thus bridges the gap between Newcastle and Morocco, between the contemporary city and the developing world.

Echoing these urban structures that express human nature, Scully's stripes give abstraction the body and reality of traditional figuration. Resisting the depersonalizing tendencies of modern cities, his paintings respond to our world.

*I use rows of stacked stripes and lines to make my paintings because that is the visual urban language that surrounds me every hour in the city. To my mind it is absolutely vital to make art that is urban, since it is always in the most extreme urban situations that human nature collides with its own consequences.*

Human beings make their presence so strongly felt because they create the structures mirrored in his paintings. Canaletto showed eighteenth-century Venice and London, and Bellotto presented Verona and Dresden. And in the late nineteenth century, the Impressionists demonstrated that Paris and its suburbs could be viewed as works of art. Rarely today does ambitious high art depict the city in the manner of a realist painter – that task is mostly left to photographers and to film-makers. But Scully does abstractly for modern cities what Canaletto and other figurative cityscape painters did for pre-industrial urban culture.

Scully is not a realist – realists show things as they are. But neither does he merely invent, for he starts with what he sees. Informed by his art, we can view everything in the way that he sees and listens. In the street, we usually rush forward, rarely stopping to look closely. Within museums, we focus at leisure. Scully's art connects these usually distinct experiences, bringing street structures into museums. Making the intimate monumental, by reconciling us to our environment, he helps us be at home in cities.

Scully asks us to see the world in the terms defined by his stripes, which come directly from the visible world. Matisse and Rothko, he suggests, allowed the audience to be "active in relation to the completion of the painting. It is like an audience participation." His own paintings also do this.

> The more active art is, the more intense will be its relationship with the world. Since any work is engaged in a dialogue with the city it has a political dynamic to it, since the city is the result of our own social reality. But in my work, which is abstract, this relationship is not displayed as information.

Abstraction too often tends to be non-specific and remote, but his paintings are anchored in reality.

> I see a sort of urban romance in the makeshifts people use to keep a place like Manhattan together, though of course that is the point – it doesn't exactly hold together. It's not self-contained.

Scully's art, in short, is a metaphorical presentation of our social reality. Without directly depicting the city, his stripes suggest urban architecture and blues music.

The windows in Scully's paintings are like real windows – and his large door-like panels metaphorically suggest real doors. Calling "life a journey" or saying that "oil is black gold" relates different things, displaying their similarities, revealing unexpected connections. As writers use such verbal metaphors, so painters employ visual metaphors. In Morocco, for example, Scully observed that

> the idea of the door has such power, and people celebrate this power. They try to enlarge its mythic quality. You know, when you get married you carry your wife over the threshold. You could walk side by side but this act, bearing her over, implies that it's a crossing, like it's a river, bearing her across a river.… I find it very touching.

Scully uses doors as architectural metaphors to capture this mythical power. His windows and doors are closely enough related to real windows and doors to make comparisons suggestive, and in his interviews, titles, and catalogue essays he encourages us to see them in these terms. He suggests how to understand his art, but ultimately only we as viewers make these metaphors come alive. "I don't think anybody can do anything in this world on their own. As an artist or a writer, what you do is not defined by you – it's defined by others. Some of these things are not within our control."

In suggesting these metaphors, Scully only makes visible what he calls "the viewer's desire." He inherited this way of thinking from Mondrian, whose late paintings exemplify the city grids of Manhattan. Mondrian abstracts from the city an ideal geometry. Scully, displaying imperfections that make urban reality human, focuses on untidy walls and streets. Mondrian looked ahead to utopia; Scully learned from the poorest parts of Mexico and Morocco.

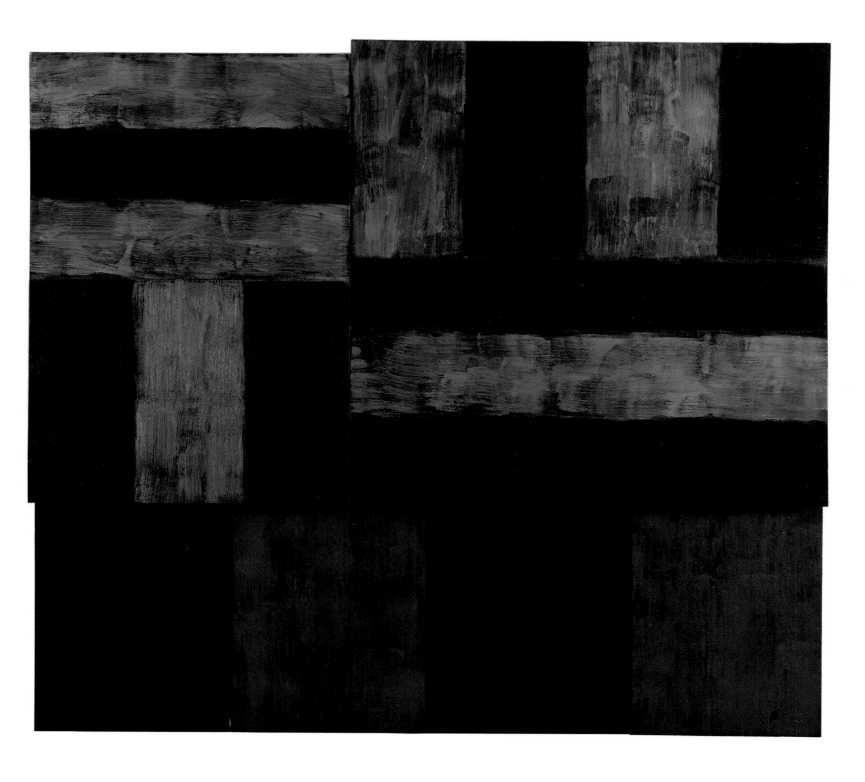

*Dakar*
1989
Oil on canvas
108 x 120 in.
274.3 x 304.8 cm

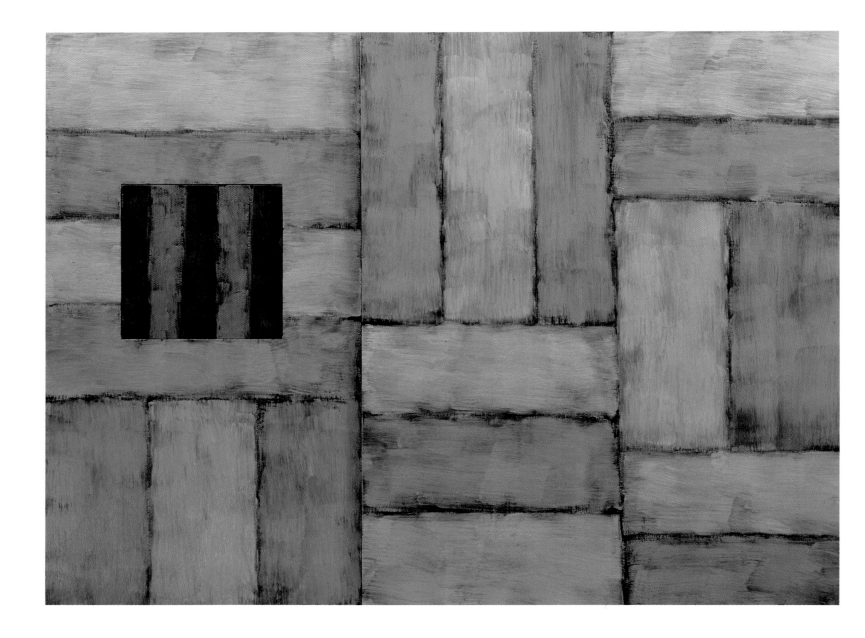

If by abstract art we mean painting that is abstracted from reality, then Scully's paintings are not abstract. "I don't think of my paintings as abstract, since they are not an abstraction of something that already exists. I think of them as real. I am always working towards a reality." Abstract painting depicts nothing, but metaphorical expressiveness permits it to be as richly significant as older art. Denying that their paintings had metaphorical meanings, some minimalists said that black stripes were just black paint. By contrast, when Scully calls his inserts "windows," as when Rothko associated his art with tragic themes, abstract works of art are described metaphorically. Merely seeing their paintings in a literal way, as exquisite decorative color displays, would totally trivialize them.

Speaking at the Albuquerque Museum in New Mexico in 1989, Scully provided an important statement about how he had understood modernism in 1972, just before he first visited America.

*I was powerfully impressed with the work of Mondrian. For me, he represented the old world – the aspiration of an artist trying to make work that is spiritual and profound through the use of*

*Palace*
1992
Oil on canvas
90 x 120 in.
228.6 x 304.8 cm

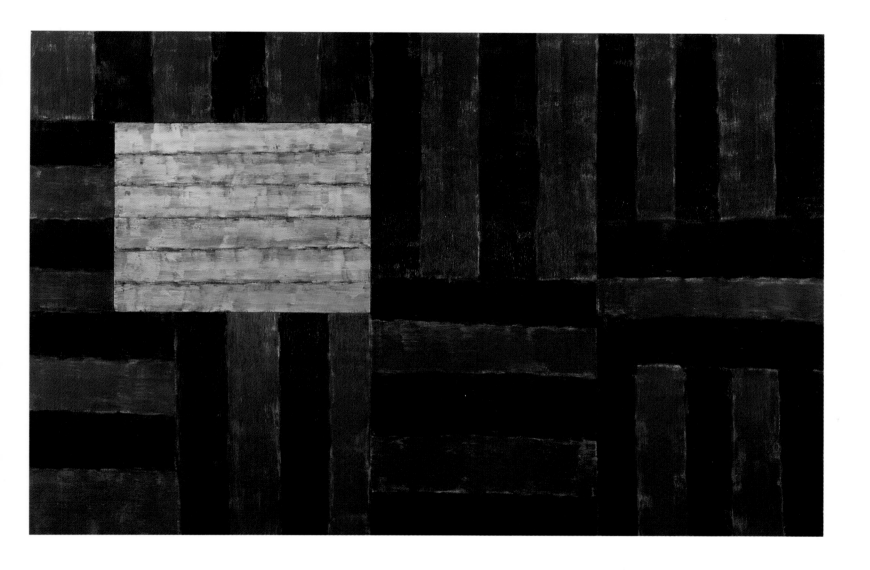

*White Window*
1988
Oil on canvas
96 x 146 in.
243.8 x 370.8 cm

*the horizontal and vertical. Pollock represented for me the new world. He represented a kind of freedom. All the cowboy movies that I had ever seen and everything I had up to that point found out about art intersected in the art of Jackson Pollock.*

The connection with Mondrian is easy to understand, for both men use horizontals and verticals and mostly avoid diagonals. What is more surprising is how Scully then describes Pollock.

*The contradiction, however, in these two artists was that Mondrian appeared to be compositional, but when one looked at his relentless façades, there was no possibility for spatial hierarchy. So, the composition in his work was leveled out by power of surface. Pollock, on the other hand, represented all-overness, and all-overness really was about a kind of anarchy, or a leveling of order.... But then the contradiction in his work is that it resolves into a kind of even harmony. They're very calm works in a sense; even though the chaos is very apparent in the method, the overall effect at the end was one of sublime harmony.*

These contradictions were resolved in Scully's 1980s paintings, which use expansive horizontal and vertical stripes, but avoid sublime harmony.

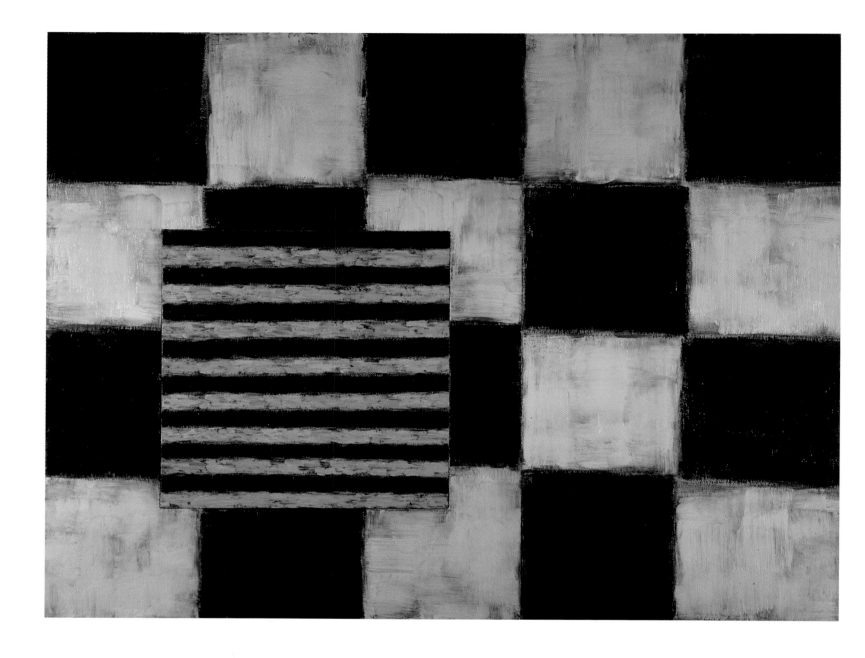

*Matamata*
1991
Oil on canvas
84 x 110 in.
213.4 x 279.4 cm

In June 1995, the morning after the opening of "Sean Scully: Twenty Years, 1976–1995" at the Hirshhorn Museum, in Washington, D.C., I walked across the Mall to the National Gallery of Art. By happy coincidence, the large, just-opened Mondrian retrospective made it possible to compare Scully's paintings with those of one of his great early influences. In a slide lecture, it might seem plausible to relate Mondrian's pictures to Scully's early paintings. But what struck me in Washington were the enormous differences in scale and their use of color. Mondrian's pictures are relatively small – and his abstractions use primary colors and black. In truth, then, alluding to "Matisse, Mondrian, Rothko" does not explain much about Scully's creativity. His paintings do not look very much like theirs – and he does not think in their terms.

In an invitation announcement for an exhibition pairing contemporary paintings with Pre-Columbian, African and Indonesian textiles, Scully wrote: "Even if we tried to do the same thing – in a different time – we cannot. Everything we do, no matter how universal, has its feet planted on its own time and its own place." He is rightly skeptical about attempts to compare visually

similar art from different cultures. Matisse, Mondrian, and Rothko certainly provided him with inspiration, but Scully's art-making has more to do with Pollock's frank acknowledgment of process and chance than with Mondrian's mysticism. Pollock's paintings are all rhythm – he didn't need color. Scully's paintings – even his all-over paintings – are linear and have body, and so demand color, even if occasionally his colors are mostly black and white. Mondrian's classical pictures are closed. *Backcloth* and *Red Light*, by contrast, seem to extend endlessly beyond their physical boundaries.

\* \* \*

*Mariana*
1991
Oil on canvas
96 x 84 in.
243.8 x 213.4 cm

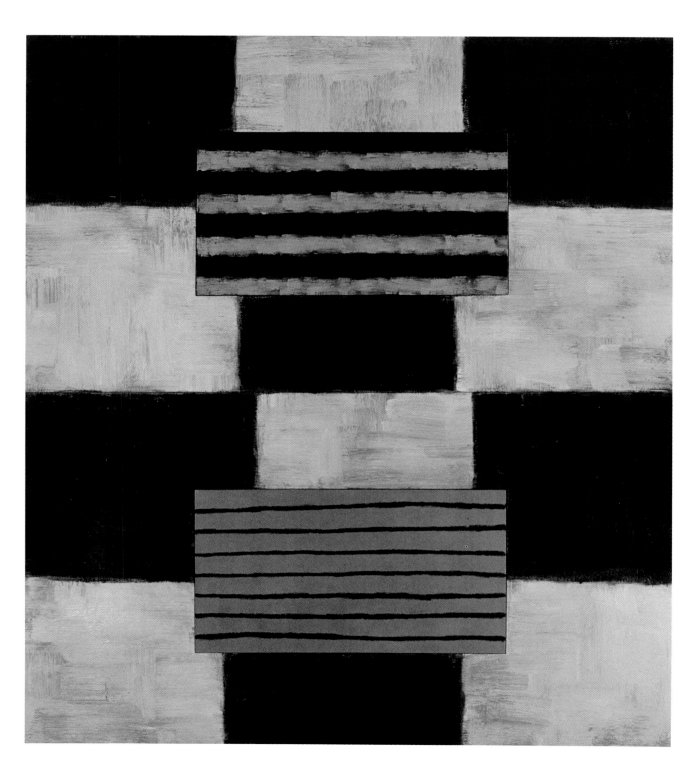

In 1973 Scully was awarded a Knox Fellowship which supported him for one academic year at Harvard University. It would be his first visit to America. As a graduate student associated with the Carpenter Center for the Arts, he was given half of the top floor of Hunt Hall, a nearby nineteenth-century revival building, for a studio. Asked to one faculty meeting, he promptly fell sound asleep, and so was not invited again. The Harvard faculty did not befriend him, but Scully's paintings were much admired outside the art world. His best friend at Harvard, the cleaning man, discussed painting with him every night, and some lawyers who lived in the suburbs bought his art. "I was ecstatically happy to be in America. I just made my own energy." Coming from London, the scale of life, and the generosity and diversity of the country impressed him. "The roads were wide, the light gorgeous," and some collectors were highly ambitious. And Scully began visiting Manhattan art galleries.

*Wrapped Piece (Harvard)*, 1973, made from acrylic painted fabric wrapped around a wood frame, looks like a rough Moroccan carpet left unfinished on the loom. Constructed from scraps of strips and protruding rods, with areas left free by Scully's primitive weaving, this improvised picture leans against the wall. At Harvard, Scully made open wrapped grids from strips of colored felt purchased very cheaply from factories in South Boston. In Newcastle he had painted illusionistic structures, but now, treating stripes like sculpted things, he redid the fabric paintings he had made in England by wrapping grids with colored felt. Moving quickly, short of funds, he made many such openly experimental paintings. His slightly earlier pictures have a shallow depth, but *Wrapped Piece* is all on the surface.

A great deal of modernist visual art and popular culture uses grids. Alfred Hitchcock's *North by Northwest* (1959) begins by showing the credits set on a grid, which then, as we watch, turns into a skyscraper. This very elemental structure, the basis for radically materialist art, also provides the natural pathway towards Mondrian's spiritual painting. The grid has been called what art looks like when it turns its back on nature, but it may be seen as a window on a landscape. The passing of time defines a grid in which our lives take place but the grid sometimes is an atemporal structure. We find grids, implicit already in Cubism, explicit in Mondrian's abstractions and in much minimalist art, including some of Scully's paintings.

Scully's early grids are as tight as bridge supports and subway rails. *Pink-Blue Grid* (1973), looks like *Red Light* turned in dramatic close up. Scully's earlier supergrids transformed the stripes of *Morocco* into highly refined paintings – here the fabrics of *Wrapped Piece (Harvard)* become the basis for a large, very intense abstraction. Painted diagonals dominate the background field, with various shades of red and orange interwoven, as in an Islamic carpet. The ambiguous pattern can be seen as going down either from right top to left bottom or from left top to right bottom. Scully's life was changing – and so these highly personal paintings offer two points of view.

Scully is rotating, tightening and fine-tuning grids. *Inset 2* (1973), inserts in the lower right hand corner of its grid a panel, a window, of plaid stripes. The top layer with thin verticals and horizontals, too thin to dominate the layers below, and an insert at the right quadrant, which has no visual connection to the rest of the picture, interrupt the field of stripes. Anticipating the arbitrary composition of Scully's 1980s paintings and his 1990s "Plaids," *Inset 2* is built from tightly compressed narrow diagonal stripes whose spatial ambiguity is undercut by the frontally placed panel at the bottom right. *East Coast Light 2* (1973) accentuates the spatial ambiguity of *Pink-Blue Grid*. Stripes appear to converge to the bottom left or right, as if we were looking up at a grid running towards the implied horizon. Shaped like a necktie, it also looks like Moroccan tents or spaghetti junctions in Boston, where roads go over each other. Scully was making paintings in

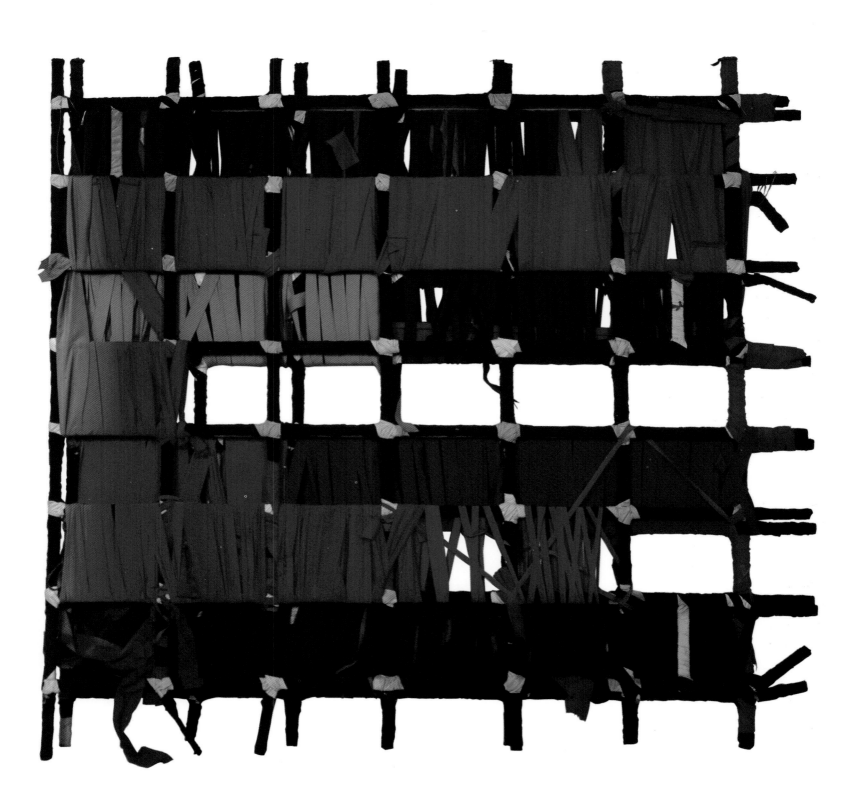

*Wrapped Piece (Harvard)*
1973
Acrylic, fabric and wood
82 x 82 in.
208.3 x 208.3 cm

*Pink-Blue Grid*
1973
Acrylic on canvas
96 x 96 in.
243.8 x 243.8 cm

*Inset 2*
1973
Acrylic on canvas
96 x 96 in.
243.8 x 243.8 cm

which you are not able to see everything. The title refers to the winter light on the Charles River in Cambridge as seen "when snow is coming down." *Overlay 1*, also from 1973, extends this style, adding the blue and yellow of *Morocco*. With diagonals of light colors, floating layer upon layer of stripes, *Overlay 1* is weightier but more open than *East Coast Light*.

In *Crossover Painting 1* (1974), we come much closer to the grid, which is turned to form horizontals and verticals. The yellows and blues are solid bands of color, similar to Scully's later stripes. Earlier supergrids display bottomless space; *Crossover Painting 1* stops the eye, the red stripes on the surface firmly fixed to a wall of orange and blue. Because the frame is not exactly square, and the colors on the boundaries do not quite match those of the opposite edge, *Crossover Painting 1* appears ready to expand upward, giving this almost static painting great energy.

*Overlay 3* and *Overlay 5* (both 1974) appear as solid as walls. These exquisite pinstripes, demonstrating Scully's admiration for the great emotional richness of Agnes Martin's ordinary looking art, return to a frankly self-protective style. The dark colors of *Overlay 3* anticipate Scully's late-1970s night paintings. In *Overlay 5*, very narrow horizontal and vertical stripes create an elegant pinstripe. Scully often finds and then very quickly destroys some too aesthetically perfect structure that inhibits advance. With the ground stripes and those at the top appearing simultaneously, his paintings from the late 1970s eliminated the Cubist grid. Painted in layers, one set of stripes is on a solid ground, while the other set obscures half of the rows, establishing a figure-ground relationship between stripes and background. Other painters usually laid stripes side by side. Scully set his in depth, forcing viewers of horizontal paintings to look at two things

*East Coast Light 2*
1973
Acrylic on canvas
84 x 96 in.
213.4 x 243.8 cm

*Crossover Painting 1*
1974
Acrylic on canvas
102 x 108 in.
259 x 274.3 cm

*Overlay 3*
1974
Acrylic on canvas
96 x 96 in.
243.8 x 243.8 cm

*Overlay 5*
1974
Acrylic on canvas
96 x 96 in.
243.8 x 243.8 cm

*Hidden Drawing 2*
1975
Acrylic on canvas
84 x 84 in.
213.4 x 213.4 cm

*Change Drawing 24*
1975
Acrylic on canvas
22 x 30 in.
55.9 x 76.2 cm

at the same time. After painting tight grids, Scully took this structure apart into its components, horizontal and vertical stripes.

*Hidden Drawing 2* (1975), a collage, has many buried secrets. Scully removed portions of the tape and painted the remaining parts, or left tape and painted over it. This checkerboard of nine grids, anticipating his 1990s "Walls of Light," creates a visual buzz not unlike *Red Blue Yellow Green* (see p. 54). Focusing first on the tight details and then looking at the background structure, we move backwards and forwards, as when viewing Scully's 1980s windows. *Change Drawing 24*, also 1975, a prison-like triptych even darker than Scully's large late 1970s black paintings, prepares for those narrow striped pictures. Tightening his supergrids until they seemed capable of containing explosions, using shaped canvases, and painting very narrow stripes, experimenting swiftly, unable as yet to make art satisfying his demands, Scully kept moving. When he returned to London after his year at Harvard, his first solo show sold out soon after the opening. But when he then began to make more ambitious paintings back in England, his second London show, in 1975, failed to sell. He had to go back to the States.

*For me to leave the old world was vital; that's also absolutely consistent with giving up figure painting. Coming to America and giving up figure painting are the same thing; one goes with the other.*

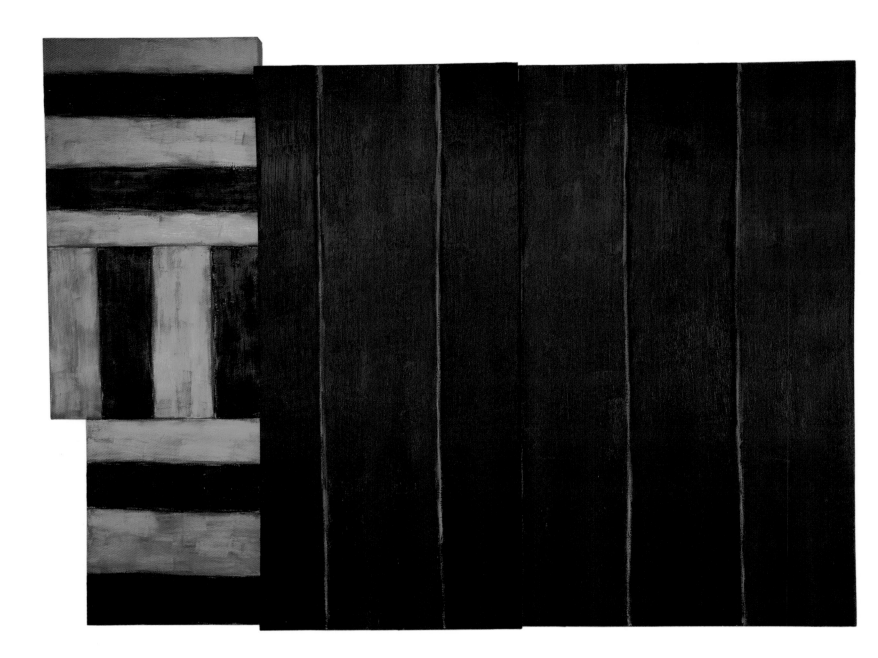

# Chapter 3    Becoming established in New York

*I took into consideration minimalism, but eventually rejected it as being empty, elegant and remote. I reconnected myself to the point in abstraction before it went into formulaic decline, which is Abstract Expressionism. Instead of adding to the story of abstract painting, I wanted to reroute it since I believed it had taken a wrong turn, and that it was close to exhausted.*

*Catherine*
1984
Oil on linen
102 x 134 in.
259 x 340.4 cm

By the time he was thirty, Scully had come an enormous distance in just a few years. A man from an impoverished background who had had difficulty getting into art school had turned himself into a major artist. Important critics were now writing about him and his paintings were sometimes selling. His reputation in England was growing steadily. In 1970 he had been awarded the Stuyvesant Foundation Prize, which involved the purchase of a painting, and in 1972 he was a prizewinner in the "John Moore's Liverpool Exhibition 8." He was in numerous group exhibitions and, by 1975, had been the subject of two one-man shows in a well-known London gallery. When he left England, he gave all that up. In New York, he was relatively unknown and had to work for years before establishing himself and a market for his art.

> *America is the place where the spirituality of the twenty-first century is being worked out more intensely than anywhere else. That's why there are so many crackpot groups: people are experimenting in a way that doesn't exist elsewhere. America is a place about defining the future. That's what I'm part of – this search for spiritual truth, the next wave of humanity.*

In 1975 Scully was ready to join this search. His year-long visit to America had convinced him that he needed to live in New York. But his Knox Fellowship required that he return to England at the end of that academic year. And so from 1973 through 1975 he taught at the Chelsea School of Art and Goldsmiths' College, University of London. Then he won a Harkness Fellowship, which allowed him to emigrate in July 1975. You have to be prepared to lose, he has said, for only then can you make something truly new. Scully knows that rarely has great art been produced in non-competitive environments. But in New York, he had to struggle very hard for many years to achieve recognition.

In 1975 Scully met Catherine Lee, the artist who became his wife. They nurtured and supported each other. Lee, who became a celebrated monumental sculptor, "a woman of great physical substance, provided extremely important input and accompaniment." Starting in 1979, through 1996, each year they selected his best painting and called it the "Catherine Painting." Initially Scully and Lee chose the most beautiful paintings. Then in the mid-1980s, they picked the most expressionist pictures. But the last three "Catherine Paintings" were classical. "It's so difficult usually to know what's going on … in a relationship…. But there is no question that the paintings are paintings for her – or with her in mind." The "Catherine Paintings" thus are not a series in the ordinary sense, but the story of their ongoing partnership. "The idea of the cycle of 'Catherine Paintings' is … absolutely and irrevocably and intrinsically connected to real time."

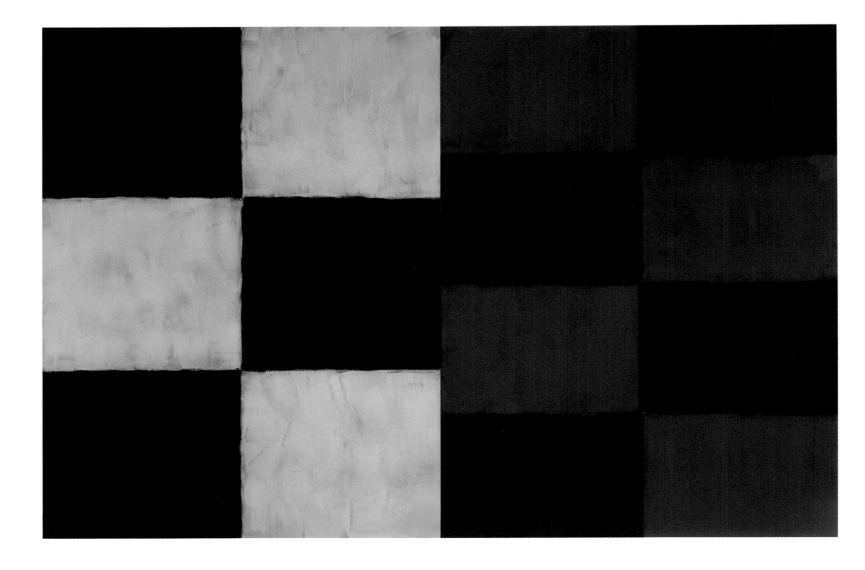

The architecture of New York provided the structure for Scully's paintings – and his human relationships animated the space provided by that setting. The ghost of figuration, as I have identified it earlier, thus is the ultimate source for these narratives.

> *I want emotional and contextual information to enter the work all the time. This is the pasture on which it grows. That's why I'm extremely selective about who my friends are. People say, "You're a very private person." I'm very private to the people who are not my friends. I've made a decision: I'm extremely selective. Those people who are friends of mine are affecting, infecting my work. That's how my work is made, through the vitality of these relations.*

The idea for the "Catherine Paintings" came from one such friend, Charles Choset. An aspiring playwright and composer who supported himself as a proofreader, Choset lived in Greenwich Village in a tiny three-room walk-up apartment so filled with art and books that he couldn't get in and out. Hard-up but extravagant, he supported Lee and Scully generously, ultimately owning twenty-six drawings and eight paintings. His emotional, psychological, and financial support was absolutely essential. The three of them were close like a family: Lee and Scully were devastated when Choset died of AIDS in 1986.

Finding Manhattan congenial but challenging, Scully took a long time to come to terms with what he describes as a "gridded jungle of stone whose deeply radiant color is so dark." Going

*Catherine*
1994
Oil on canvas
108 x 162 in.
274.3 x 411.5 cm

*Catherine*
1979
Oil on canvas
84 x 84 in.
213.4 x 213.4 cm

Sean Scully
1977

out late, loving dark colors, he found night a time of great tranquility and mystery. From 1977 until 1983, Scully taught part-time in the studio art department of Princeton University. At Harvard, he had been a graduate student. Now he was a teacher, and so had some economic and intellectual security. And the sympathetic Princeton art historian Sam Hunter understood his paintings immediately. Scully still was heavily involved with minimalism, but Hunter noted his concern with highly expressive art. Forced to leave New York City for one day each week, Scully started to see America. Before visiting Princeton, he had been making very rigorous contemplative black-and-gray paintings. Now he felt secure enough to again work with color.

Scully's first one-man New York exhibition, in the winter of 1977, was at Duffy-Gibbs, a gallery that lasted only four months. Almost totally unknown in America, he attracted a rave review from John Russell of the *New York Times*.

> *The basic motif of Mr Scully's paintings is a long narrow bar of pigment less than half an inch broad. Now alive in the light, now resolutely matte, Mr Scully's bars play off one variant of a given color against another in such a way that the whole room vibrates softly and yet briskly. Sometimes a single panel holds these vibrations in check; sometimes two panels are set side by side, with a subtle pairing that puts us in mind of other forms of making.... This is a very distinguished show.*

Not yet selling paintings, Scully did achieve recognition. After 1978, he had at least one solo exhibition every year. In 1976 Scully met Per Jensen, a young curator who soon became a great friend. When Jensen visited the studio, he was, so he recalls, "constantly impressed by how far Sean was able to push his ideas within such a narrow formula." Perhaps he sensed that very soon Scully would expand his style. In 1979 Jensen curated a show of twenty black-and-gray horizontally striped paintings at the Clocktower, Soho, Scully's first museum-scale exhibition in New York. The next year, Arthur Danto's discovery of a Scully painting in a Tribeca group show initiated their extremely productive relationship. And when in 1984 the Museum of Modern Art, New York, reopened after renovation, Scully was in Kynaston McShine's "An International Survey of Recent Painting and Sculpture." Neo-expressionist painting was very fashionable; there were only a handful of abstract artists in this show. Scully's painting fascinated and baffled people because "it looked like a Jasper Johns, but it wasn't a flag."

Scully supported himself from 1975 until 1978 as a pool shark, by working on construction, and by sales to Choset. He had played pool as a kid: that "was a sign of a misspent youth."

> *I think when you're a painter you have to be very good at scrounging in order to get through if you happen to land in the world without any money.... I've personally gone from one fellowship to the next and each time it's always been a kind of cliff-hanging experience. Now it all looks so much more peaceful than it was at the time.*

Doing labor on lofts, he radically changed living and working spaces in a way that wasn't possible in England. The existing interior supporting walls must be preserved in houses, but you can freely subdivide lofts. This construction work taught him how to build his 1980s paintings. And having learned how to divide walls, covering the wooden frame and leaving little windows, Scully designed all of his own New York lofts.

At Harvard acrylic paint had permitted Scully to experiment very rapidly. In New York, the rhythms of his painting slowed somewhat, for he had clearer goals. Henceforth he employed oil paint exclusively. This difficult, volatile medium can be put down in any order and any combination to make it dry fast or slow, shining or matte, opaque or transparent. Finding oil paint attractive in part because it easily gets out of control, he associates it with the mysteries of alchemy; it resists the "deadening ambition of the modern world to control everything absolutely." The rougher his paintings, the less patience Scully had with very thin lines. Because he paints in layers, wet on wet, often repainting repeatedly, you glimpse layers of color beneath his surfaces.

The title of *Fort 3* (1979), four squares of different colors, all with the same tonal range, refers to the classical form of Roman forts, which had four sections. This dark tightly controlled fortress banishes bright color and open spaces. As at Harvard, Scully protected himself at a moment of transition by restricting the expressive range of his art. Viewing the dark but not grim *Fort 3* is like

*Fort 3*
1979
Oil on canvas
48 x 48 in.
121.9 x 121.9 cm

*Upright Horizontals Red-Black*
1979
Oil on canvas
108 x 36 in.
274.3 x 91.4 cm

*Diptych*
1976
Acrylic on canvas
68 x 72 in.
172.7 x 182.9 cm

coming from sunlight into a dark room where, once your eyes adjust, you make very fine discrim-
inations. The ground is painted with horizontal strokes. He laid the tape over the ground without
using a ruler – these stripes (painted in minute vertical strokes) seem to undulate, creating a flat
light-catching surface.

Scully then dissembled his grids, creating fields of parallel repetitive elements – the vertical
and horizontal stripes which define his personal style. Seen from a distance, his late-1970s paint-
ings glisten. *Upright Horizontals Red-Black* (1979), taller than a person, is a narrow cut from an
expansive field. *Diptych* (1976), crisp and elegant, a one-piece canvas painted crème, uses black
tape running across horizontally to create thin lines. Scully built up gray paint, then cut the tape
down the middle and pulled it off on the right, leaving gray lines and bare canvas on that side. On
the left half, tape was buried. The ground allows the other half to be visible and enter into
"a democratic visual relationship." More exactly, Scully doesn't paint relationships: he paints
stripes on panels and then creates relations amongst those panels. *Upright Horizontals* stands to
*Diptych* as a tall, narrow single portrait does to a double-portrait. The grays in *Diptych* run across
and at the very bottom gray links the panels even as the dark green on the left and the greenish
yellow on the right separate them.

In 1979 the English emigrant artist Peter Nadin, who did construction work with Scully,
invited him to create a temporary work for one corner of his lower Manhattan exhibition space.
*Painting for one place* (1979) had stripes like those of Scully's earlier compositions bent at ninety

*Painting for one place*
1979
Acrylic on wall
120 x 240 in.
304.8 x 609.6 cm

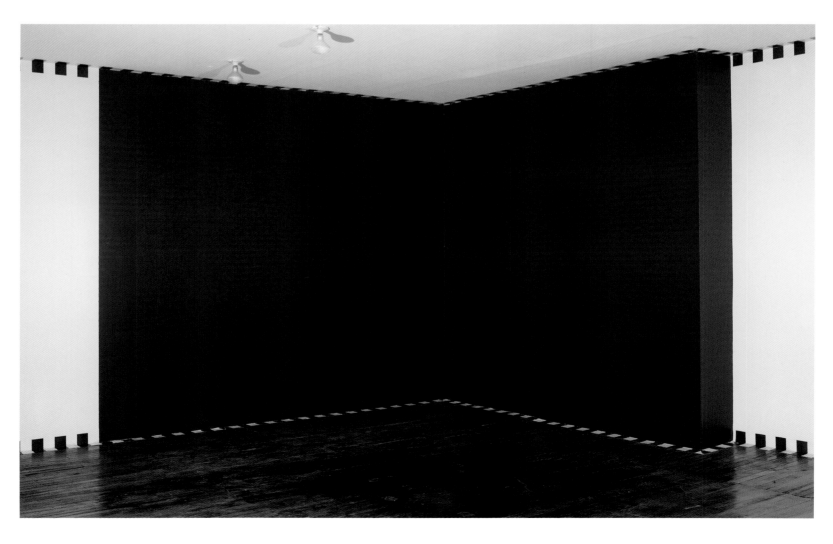

*Quintana Roo*
1980
Oil on canvas
84 x 42 in.
213.4 x 106.7 cm

*Catherine*
1980
Oil on canvas
84 x 36 in.
213.4 x 91.4 cm

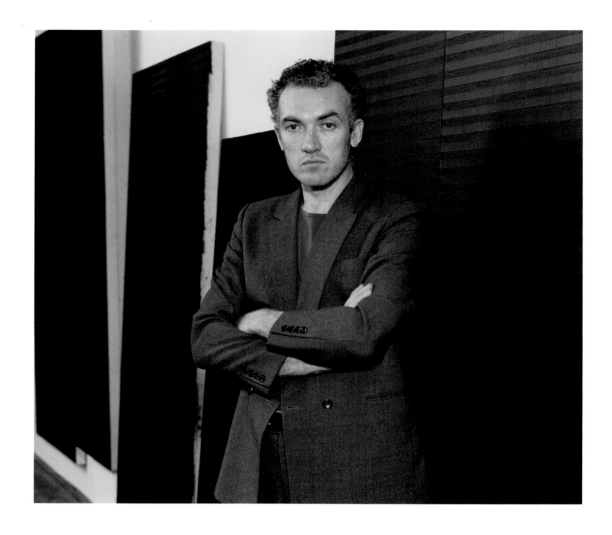

Sean Scully
1980

degrees right in the middle on the corner of the wall. "It … looked like a big bear in the corner.…
It was so optical, you couldn't even see there was a corner there." His first picture running around
a corner, *Painting for one place* had a surface painted in Scully's 1970s style, but a structure antici-
pating his 1980s art. Like *Morocco* (see p. 55), this big transitional painting, quickly made and
soon destroyed, allowed swift advance. Traditionally, artists experimented with sketches; Scully,
usually doing large pictures, is willing to let his paintings fend for themselves. He once said that
installing art on a rough stone wall just inside the Carnegie Museum, Pittsburgh, not a place
intended for a painting, would pose an interesting challenge. Rothko's sublime abstractions
require isolation. Because Scully's paintings originate in the tough visual environment of the
streets, they have less need for shelter.

    *Quintana Roo* (1980), named after a state of Mexico, has lines running across which don't
meet, the light red on the left jumping up to meet the darker red on the right. When brown meets
red, and orange intersects the deep red, there is a visual speed bump. Although brighter than the
immediately proceeding pictures, this too is a night painting. *Catherine* (1980), much darker, sets
verticals on the left against the horizontals on the right, two shades of blue against a black back-
ground. *Quintana Roo* moves the eyes straight across the picture; *Catherine* links the rightmost
black vertical to the horizontals on the right. On the left, the very dark blue is hard to distinguish
from the black. Darkness dominates. Setting verticals next to horizontals, Scully partially under-
cuts the color harmony. Opposition yields to unity in quiet repetition, as in Philip Glass's music.

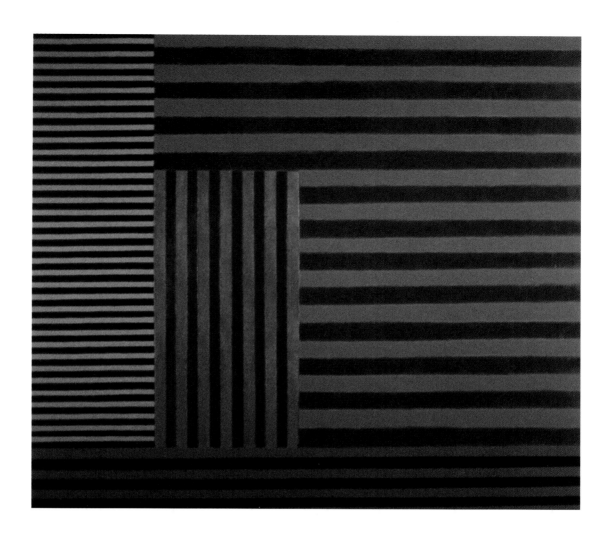

*Come and Go*
1981
Oil on canvas
84 x 97 in.
213.4 x 246.4 cm

Soon enough he was making paintings with rougher rhythms, analogous to the music of The Velvet Underground. The sense of mystery created by covering or layering runs through his art, especially these quiet, dark pictures.

Just before Scully's breakthrough work *Backs and Fronts* from 1981, his experimentation slowed momentarily, as if he were conserving energy for his coming jump. And his range of colors brightened. Compare the very dark hues of *Fort 3* (1979) or *Upright Horizontals Red-Black* of the same year with the fully saturated blues and reds of *Come and Go* (1981), which has broader bands and brighter colors than the late-1970s paintings. The horizontals at the bottom define a plane, as if the three groups of stripes above were a landscape. The dark brooding of Scully's late-1970s paintings left behind, *Come and Go* divides into four discrete areas, with stripes that need only be wider and more painterly to reappear in his art from the 1980s. When making overlaid grids and minimal pinstripe paintings, Scully gave up drawing. But now he was ready to draw again.

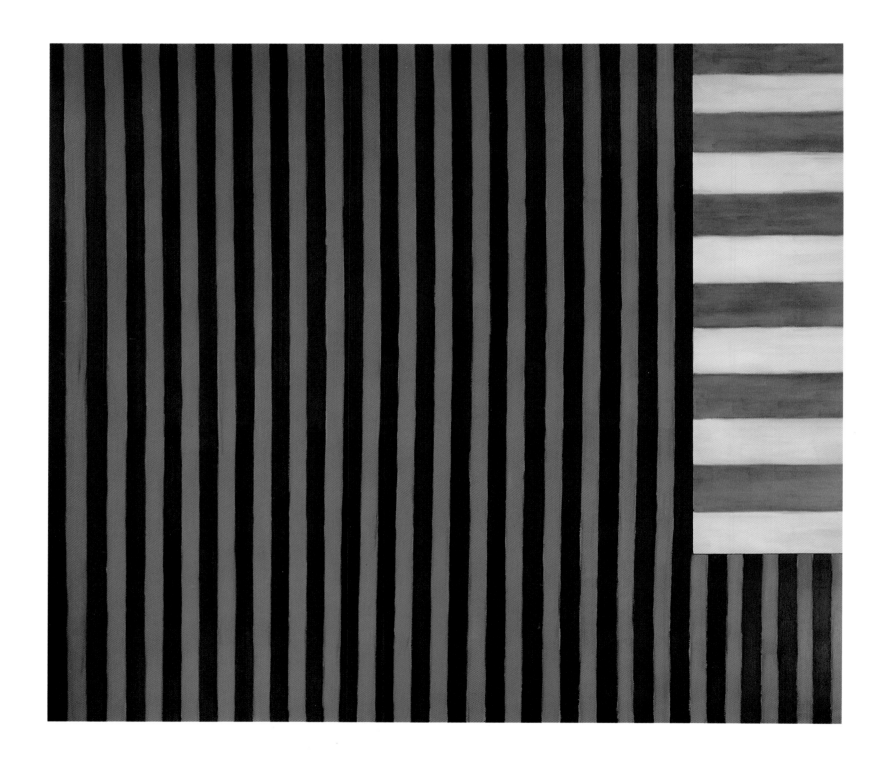

# PART 2   DISCOVERING A STYLE

## Chapter 4   *Backs and Fronts*

*My work is an attempt to release the spirit through
formal strength and very direct painting.*

*Catherine*
1981
Oil on linen
96 x 108 in.
243.8 x 274.3 cm

Why is abstract art significant? Why care about pictures that represent nothing? These are crucial questions for Scully. Figurative painting has value because we enjoy its subjects and admire the artist's skill in representing them. According to some theorists, pure abstract art is significant because, coming after figuration, it eliminates unnecessary reference to appearances. Clement Greenberg's extremely influential analysis arguing that abstraction has intrinsic value links that value to development out of figurative tradition. After the demise of formalism, no rival account proved widely acceptable. And once the messianic faith of Mondrian and Rothko in non-figurative painting had disappeared, the belief that art could be pure, not linked to the world, was no longer plausible.

Some contemporary painters give art value by associating it with film or electronic media. But doing that, Scully has argued, is an essentially unsatisfactory procedure. When painters borrow from other arts, they give up the inherent strengths of their own medium. Many artists want painting to comment on historical or political issues. That tends to make their art esoteric. Scully, by contrast, links painting to direct everyday visual awareness. Abstraction became esoteric, he strongly feels, when it was isolated from experience. Formalists cut the contact of art with external reality, separating painting from everything but its own self-sufficient history. So too, in a different way, do post-formalists appropriating media images. In the 1980s, anti-aesthetic art was fashionable – and denunciations of beauty commonplace. But where traditional aesthetic art seeks to be ideally harmonious, Scully, by contrast, views the world as visually attractive, even while recognizing that it is not always harmonious.

To understand Scully's view of these issues, we need to go back some twenty years. In January 1982, "Critical Perspectives," a group of exhibitions organized by critics with diverse perspectives showed at P.S.1, a major outpost for contemporary art in Queens, New York, just two subway stops from Manhattan. At this moment when the situation was unclear, critics wanted to pick out what was happening next. The room curated by Joseph Masheck, a champion of abstraction, contained *Backs and Fronts* (1981). Here I first encountered Scully's art. I'd never seen anything like it. Neither had anyone else, for it was entirely different from either minimalist painting of the 1970s or the newly fashionable figurative neo-expressionism. I don't remember the other rooms, nor most of the rest of Masheck's, which mostly showed younger abstract painters who have not survived the test of time. But I was immediately taken with Scully's painting, the biggest in the

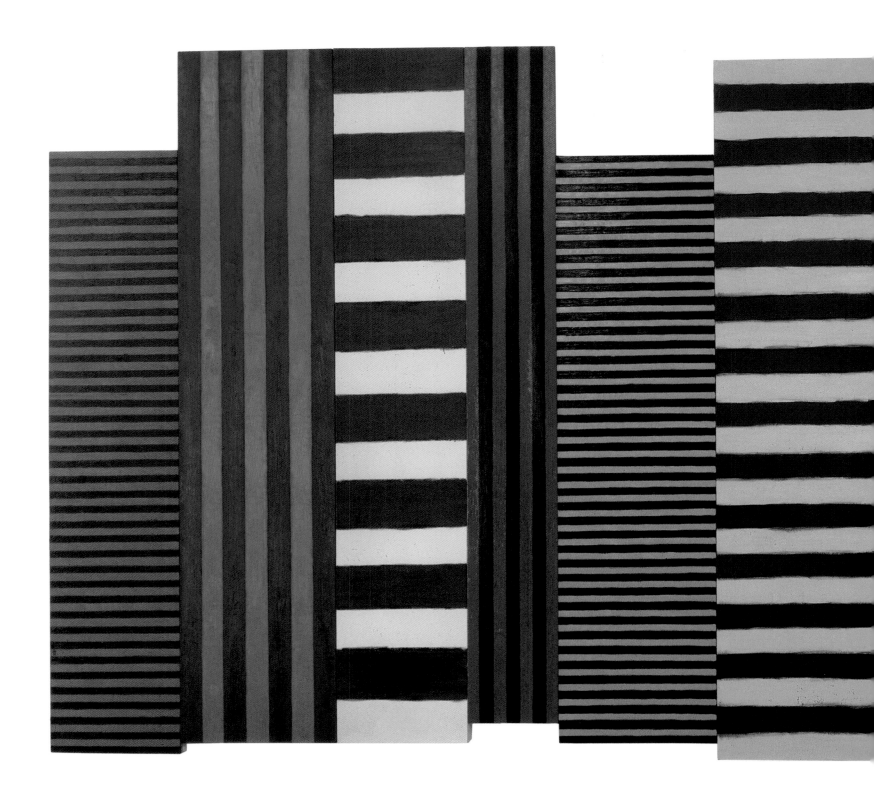

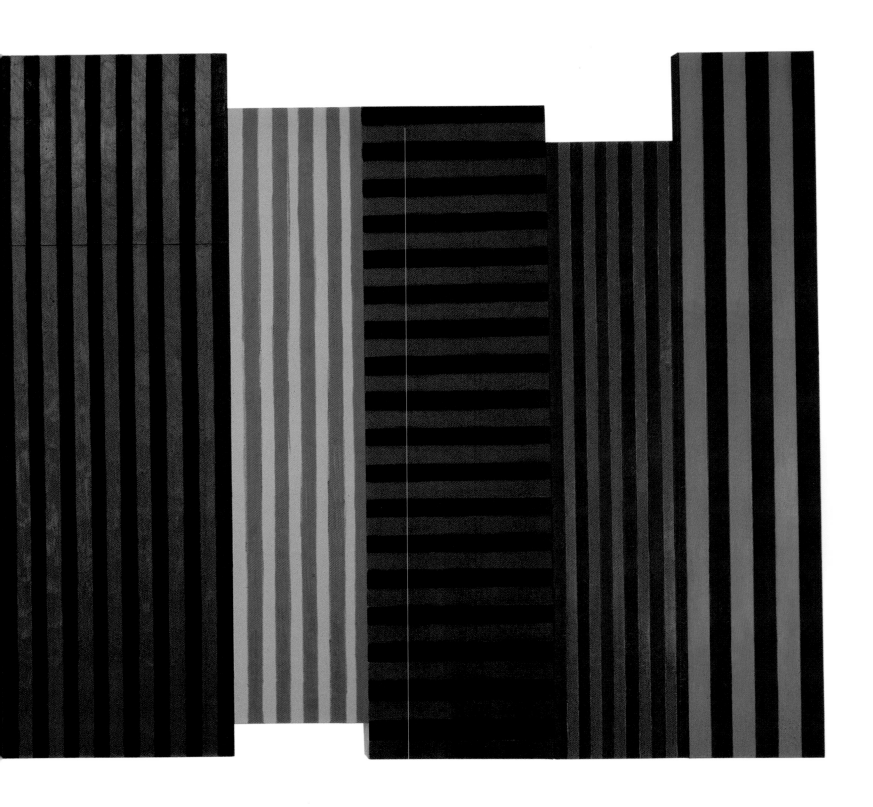

*Backs and Fronts*
1981
Oil on canvas
96 x 240 in.
243.8 x 609.6 cm

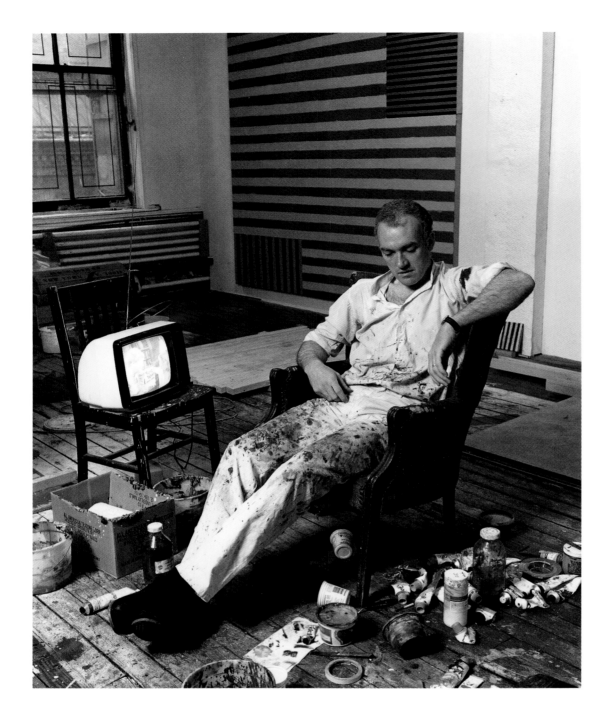

Sean Scully, Duane Street
1982

room. Because it's so awkwardly large, *Backs and Fronts* has not been exhibited again. Here everything came together. Scully's artistic life changed completely.

> *If you think about minimalism and all this rarefaction … and then you look at* Backs and Fronts, *there is real opposition there. It's absolutely the contradiction of what I was doing just a year before. It really flipped.*

Rather suddenly, after a decade and a half, Scully had found his fully achieved personal style. Here, then, we arrive at the key moment in our narrative. Up to this point we have told of Scully's childhood, adolescence, travels, and settling in America. He studied modernist art, achieved some success, and moved to New York. Thus far we have described an enormously talented young man who made some excellent art. Now in this one painting Scully's passionate love for African-American music, the urban rhythms of Newcastle, and the high modernist grid all come

together to yield an essentially unpredictable, extraordinarily original synthesis. Up to this point we have said much about Scully's life. From here our story is the tale of his artistic career.

Why did this great transition take place? Perhaps Scully's extreme gesture, painting a twenty-foot-long painting in a wholly unfamiliar style when his smaller, more visually accessible pictures were not selling, was driven in part by despair. When in 1981 he asked that *Backs and Fronts* be insured for $15,000, people thought that he was joking. At one dark, mercifully brief moment, Scully considered teaching in a provincial art school. He had some reason to feel depressed. After a good start in England, he had failed in six years to establish a market for his art in America. But his youth had also been very difficult. He was accustomed to struggling. And four people provided essential support: Choset, Lee, Masheck, and the art dealer Ted Bonin. "To make that painting in a period when I had no gallery, and almost no market, that's quite a statement. I just need to be in correspondence with those I trust and love to keep moving forward."

> *I'm not an empty bucket. I'm editing who gets to pour in water. There's a sense of collaboration in my life. I'm very exclusionary: it's the access that my friends have to me, in relation to my judgment. That dynamic is extremely important.*

That dynamic carried him through this hard period well into the mid-1990s.

Even now, twenty years later, Scully's astonishing moment of transformation is difficult to fully comprehend. I doubt that any account of mere external events could explain *Backs and Fronts*. His slightly earlier black-and-gray paintings were about acclimatizing himself to New York City. Comfortable in his new country, impatient with the indirectness of minimalism, he turned up the volume, using paint more directly, making more expressive art. Some panels are painted freehand; others are taped. Scully worked without thinking about the ultimate result. "The relationships express collision and fracture, issues of beauty and harmony being relegated to the periphery." Moving from left to right, you go from tight horizontals to comparatively wide verticals. His title identifies a line of figures whose backs and fronts we see waiting for something to happen. The Dadaesque composition of this "punk" painting makes no sense. "I wasn't trying to make a unity. In fact, I wanted something that didn't have a unity but had a kind of urban spread." Scully fantasized about leaving a panel in the studio, knowing that after six months he wouldn't be painting quite the same way, then inserting it into another painting.

Like the old masters, Mondrian and Matisse made fully resolved paintings. Scully believes that such art is not authentic today.

> *I reacted against the idea of perfection and of the holistic masterpiece. I wanted to make realities that were much more humanistic, where the problematic relationships between things could make a new kind of spirit and beauty. I am not trying to make masterpieces that are resolved. I want my paintings to express the pathos of relationships.*

The individual units of *Backs and Fronts* are not so different from those in his slightly earlier diptychs, but the combination of so many diverse panels in one picture is absolutely unprecedented. *Backs and Fronts*, almost too richly condensed to be fully satisfying, was made after a period of great hermetic intensity. Like *Morocco, Wrapped Piece (Harvard)*, and *Painting for one place* — other experimental works relatively few people have seen – *Backs and Fronts* prepared the way for sudden stylistic change.

Scully's constrained late-1970s paintings were too narrow vessels for the emotions he wanted art to contain. Minimalist painting suited Robert Mangold and Robert Ryman, but when a style does not correspond to an artist's personal needs, then it appears merely borrowed. Abstraction was being pushed aside because it moved away from extreme engagement. Scully looked back to

his *Untitled (Seated Figures)* of 1968 (see p. 50) to learn how to paint stripes in the way that he painted models in art school. In the 1970s, he waited for each layer of color to dry before repainting. Now he worked wet into wet, his wide brushes leaving visible marks. After *Backs and Fronts*, Scully wanted one surface in his pictures to "smash into another surface … I don't like to paint the divisions because I don't want to think about how I'm going to paint the edge, and if I take it out and I paint it, I can paint the thing right off, so I don't lose any velocity." His art now full of naked feeling, great emotion, and unabashed passion, he never turned back.

Scully was thirty-six in 1981 – his had been a long apprenticeship. Not surprisingly, Japanese collectors have an especial interest in his delicate, mutely colored late-1970s compositions, which can be associated with Zen Buddhism. But had Scully continued to work in this manner, he would not have achieved great international recognition. Other modernists made similarly dramatic transitions. Van Gogh, for example, had to move to Paris to find his style. But by 1981, Scully had spent some years in America and so was very familiar with High Modernism. Frank Stella became a famous painter just after graduating from Princeton University; Scully, by contrast, took much longer to find himself. Motherwell, Pollock, and Rothko only found their styles when they painted abstractions. But they had to discover how to paint abstractly *ex nihilo*, while Scully's mature style initially depended upon developing relatively accessible techniques.

In some ways, Scully's early career was similar to that of Morris Louis, born in 1912, who in the 1940s was a very minor contemporary of the first generation Abstract Expressionists. Louis only become deeply original in the late 1950s, and then died too soon to develop. But following *Backs and Fronts*, Scully underwent major changes. After this breakthrough, his development was somewhat like that of Willem de Kooning who also, after a long apprenticeship, found his style and then repeatedly reinvented himself. But where De Kooning could be thought of as belonging to the New York School, Scully has remained more isolated. Certainly Scully's stylistic transition was very abrupt. Compare *Catherine*, 1980 (see p. 87), a diptych with the narrow, somber stripes typical of his late-1970s paintings, with *Catherine*, 1981 (see p. 90), where broad horizontals on the insert decisively break the vertical field as if another world were intruding into an otherwise self-sufficient space. None of his paintings before *Backs and Fronts* has broadly painted stripes. After *Backs and Fronts*, he never made entire pictures with tight, highly compressed stripes. Scully wanted to get back to the grid dynamic without giving up flatness. He did that by in effect painting horizontals and verticals on separate panels, pulling apart grids to get their component stripes.

In 1982 Scully had a one-person exhibition at the William Beadleston Gallery, New York. An old friend and influential, semi-private dealer in modern art, Beadleston normally did not show contemporary artists, but he wanted Scully to get into a major commercial gallery. John Russell helped make that possible when he reviewed this show in *The New York Times*.

> *Sean Scully has made a whole new set of moves in his new pictures. They are rough, that is to say, where formerly they were smoother than smooth. Often they come in two very separate pieces that don't quite fit (and are not meant to). The formats are often irregular, and the participating sections talk back to one another. The basic unit is still the stripe, but this time each stripe has its own developed personality, whereas formerly they often came across as stripes with inhibitions. The paint quality is different, too – richer, fatter, stronger.*

Russell had witnessed Scully's key transition. The next year Scully was taken on by David McKee, whose midtown Manhattan gallery showed him frequently during the next ten years. Scully had a powerful creative relationship with this passionate supporter of Philip Guston, a painter who also was "an outsider who wanted success on his own terms."

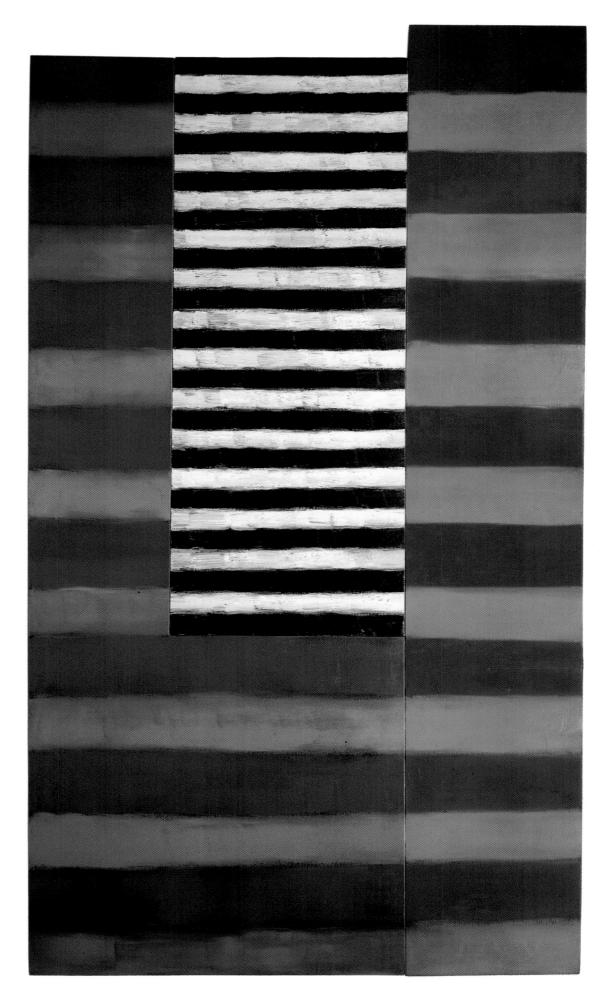

*The Moroccan*
1982
Oil on canvas
112 x 63 in.
284.5 x 160 cm

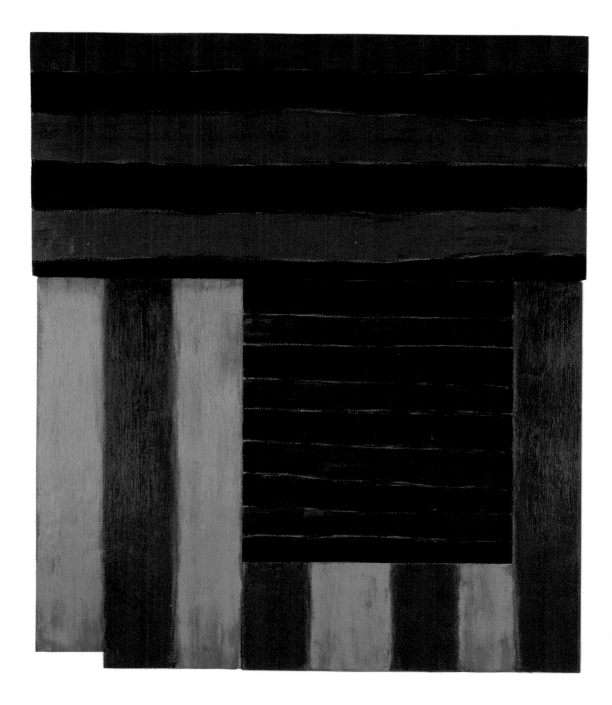

*The Fall*
1983
Oil on canvas
42 1/2 x 37 3/4 in.
108 x 96 cm

A great burden lifted, it was as if Scully had come out of a cave into bright daylight. Finally he felt free to open up his art.

*I use the discarded incidental details that lie around virtually unnoticed all over the city, reflecting its decay and arbitrariness. These relationships that I see in the street in doorways, in windows between buildings, and the traces of structures that were once full of life, I take for my work. I use these colors and forms and put them together in a way that perhaps reminds you of something, though you're not sure what.*

Once he emulated construction workers who nail plywood or use metal sheets on sidewalks, restraining politeness went out the window. Changing his painted panels at will, no longer using tape, he "deconstructed and re-constructed abstraction."

Now Scully's art tells stories. *The Moroccan* (1982) redoes *Morocco* of 1969, roughing up the cleanly painted neat stripes. *Morocco* opens the picture center with cut stripes; *The Moroccan*

looks like a man dropped into a sunlit landscape. *The Fall* (1983), *The Moroccan* inverted, inserts a dark striped panel in a field of intense oranges and red. The story comes from Albert Camus' novel of the same name. The fallen panel of verticals is held down by the massive horizontals above. Physically manipulating very small paintings gave Scully the idea of constructing large pictures with such built-in steps. *The Moroccan* sets one vertical panel in stripes; in *The Fall* a panel of horizontals falls into the stripes below, its weight pressing the vertical panel down.

At first, Scully and Lee rented a 4,000-square-foot loft with twelve-foot ceilings on Eighteenth Street for $400 a month. But evicted from this first home, they then had to struggle. Feeling vulnerable, Scully spent the next five years making fortress-like paintings. Moving to Duane Street, near the World Trade Center in what became fashionable Tribeca, Scully and Lee paid $700 a month for a loft of the same size with eleven-foot ceilings. This former textile warehouse was filled with thirty-year-old pinewood shelves. Ripping them down, Scully found that those straight and dry horizontal boards "looked so beautiful, like a rough minimal sculpture, full of possibilities when stacked up against the wall, that it was only a question of time before they found their way into paintings." Once all of these old shelves had been used, making deep stretchers became less interesting. The connection to the nostalgic mystery of the loft's former life had been lost.

Scully very quickly found formalism unsatisfying in the late 1960s because it yielded merely decorative paintings. But he rejected minimalism only after borrowing this style for an extended period, roughly from 1975 to 1980.

> *The idea of spirituality being tied to denial, austerity, and ritual repetition seems outdated to me. That seems to be connected with notions of spirituality that are implicated with orthodox religion on some level. So the assumption that minimalism carries with it an inherent spiritual aspect because it is empty and rigorously unsensual is misguided.*

He wanted profound, not simply disciplined art. Mere elegance no longer interested him. In the late 1970s, Scully found much of value in Agnes Martin, Barnett Newman, and Ad Reinhardt. "They represented a severe and spiritually elevated example." He was interested in Newman's talk about his extremely simple compositions and Reinhardt's lists of what artists should not do. But in the 1980s Scully argued that Rothko was more much important than Newman and that Reinhardt was a relatively limited painter. Newman, Scully then suggested, was moving towards the end of painting, unlike Rothko. Ryman's very extreme art served as an essential role model when painting was under assault from conceptual art in the 1970s. After painting made a huge recovery, for Scully Ryman was no longer so crucial.

Scully came to America to establish a relationship between his art and the grand American tradition of abstraction. But by 1981 the situation in New York had changed dramatically. In the 1970s, painting was beleaguered. And in the 1980s neo-expressionist art attracted much attention. Finding life in New York confining, in 1982 Scully re-established a studio in London. In 1995, after frequent visits to Mexico between 1984 and 1990 inspired him to learn Spanish, he found a Barcelona studio. He also frequently stayed in Munich, and enrolled in German classes. His earlier move to New York had an enormous effect, but the more recent frequent journeys between Barcelona, London, and New York do not affect his painting. In the 1980s and 1990s, Scully had many museum exhibitions in Europe. In July 1995, an enormous fiftieth birthday party was given for him at the Lenbachhaus in Munich. And recently he has been appointed Professor of Painting at the Munich Art Academy. By helping Scully to see how deeply his painting is rooted in European culture, these travels gave him a critical perspective on New York and its ways of thinking about art.

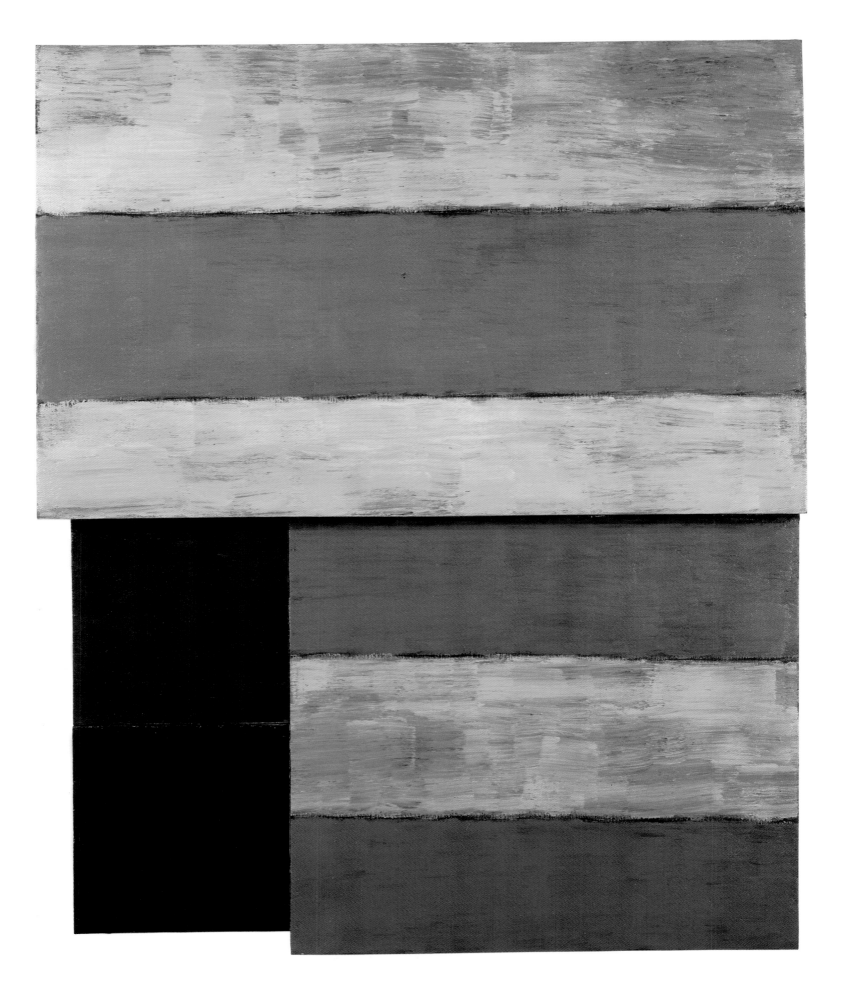

# PART 3    USING A STYLE

## Chapter 5    Staging abstract narratives

*Certain artists are unable to develop because they are disconnected from history. To me development is paramount. I think that development and humility go hand in hand.*

*All There Is*
1986
Oil on canvas
106 x 84 in.
269 x 213.4 cm

My choice of epigraph here links development and humility. Do we expect, rather, that successful development demands arrogant self-certainty? On reflection perhaps not, for arrogance implies that an artist knows dogmatically how to proceed, while humility involves productive acknowledgment of deep uncertainty. A merely arrogant artist repeats, never advancing: only a humble painter can radically develop. Making stripes certainly involves obsessive repetition, but finding and extending Scully's style demanded that he abandon the comforts of merely mechanical reiteration. Humility requires giving up control, trusting in one's ability to move forward. He's constantly trying, Scully says, to correct "the tyranny of my own obsessiveness." After a style is achieved, self-confidence is needed to productively use this constraining framework.

Scully is a great storyteller. In casual conversation often he is initially terse, especially when with people he doesn't know, but once he gets going amongst friends or in lectures, he is unstoppable. When we were in Morocco, more so than in New York, that side of his personality came out. Reading his stories is not remotely like hearing them, but you perhaps can imagine him speaking if you follow this tale he told me in a Marrakesh hotel bar:

*When I was a kid, I was fantastic at saving money. I was always a good little businessman even if I was just working with pocket money. And I used to love my mother so much, I saved up pocket money to buy her presents. Isn't that amazing? I would save my money to buy presents for her, not to keep it for myself. Except when it came to firework night, November 5, Guy Fawkes night, when you buy the fireworks and let them all off. Then I would systematically save up and I had a huge cardboard box full of fireworks, of the most spectacular collection, really expensive ones, the ones that go in the air and explode all over the place, and Catherine Wheels that go in circles, the ones that go "whrrrrr" and other things go on, and we had the bonfire and the guy, that's Guy Fawkes, and the spark from the fire went into the box, before I knew what the hell was happening, one went off, which set off another one, and another one which set off another one, set off another one. And the box was walking around the garden; it was like a person, literally turning over, going in a walkabout with things flying out occasionally, going bonk, and fluttering around. I was absolutely heartbroken. Isn't it awful? It took me three months to save up the money and in two minutes it was gone. It was actually beautiful; I can remember it like it was yesterday. There was the light from the fire and you had this crazy card box literally walking around, like a living being. It wouldn't just turn, it would turn and rock. And then turn the other way, because the*

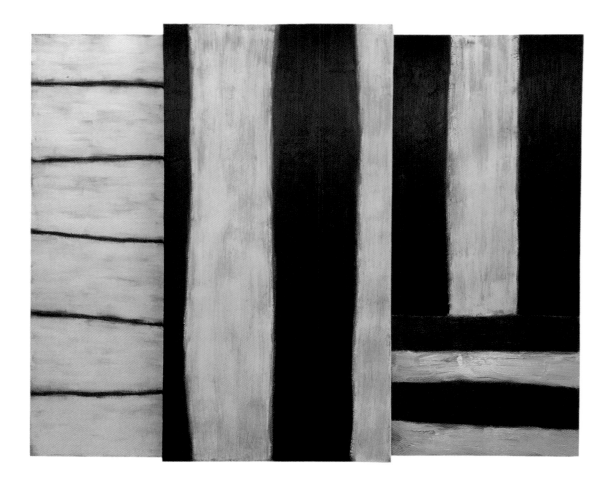

*No Neo*
1984
Oil on canvas
96 x 120 in.
243.8 x 304.8 cm

*things were exploding like crazy, smashing it to pieces. And eventually it just burnt. And then I
had to go around to the shops again, with what meager resources I had. The guy had two fire-
works left; I bought them both. And that was it.*

I was spellbound. But then on reflection, I wondered: What use could an abstract painter make of
such stories? Abstractions cannot literally tell stories, but their colors and compositions can suggest
relationships and therefore narrative. You can read Scully's paintings from left to right, or right to
left as you choose. "I try not to present something that is conclusive. I try to present something that
can be interpreted." Like three successive episodes in a movie whose connecting scenes provide the
plot line, *No Neo* (1984), is a triptych built upon violent contrasts. The title alludes to Scully's rejec-
tion of fashionable neo-expressionism. He placed diverse panels next to one another without
smoothing over transitions. The picture tells of the tension between seeking unity and flying apart.

*One might call my work an abstract narrative of thought and emotion…. I'm not going to say
"OK, my paintings are to be read, and here's the map." They are much more subtle, supple, and
complex than that.*

Were Scully not a painter, he would be a film-maker. In an editing room, the director can cut out
what he doesn't want and put the film together again. Scully attaches panels with clashing colors.
Reading left to right, his calm horizontals are suddenly invaded by brutal verticals, whose massive
presence is undercut by the delicate stripes at the bottom. *No Neo* suggests narrative that the
movie-lover can fill in.

*Once* (1986), which looks like three separate paintings, one behind another, also applies film
techniques. The two parts behind the front are slid far enough to the left to show the edge of these

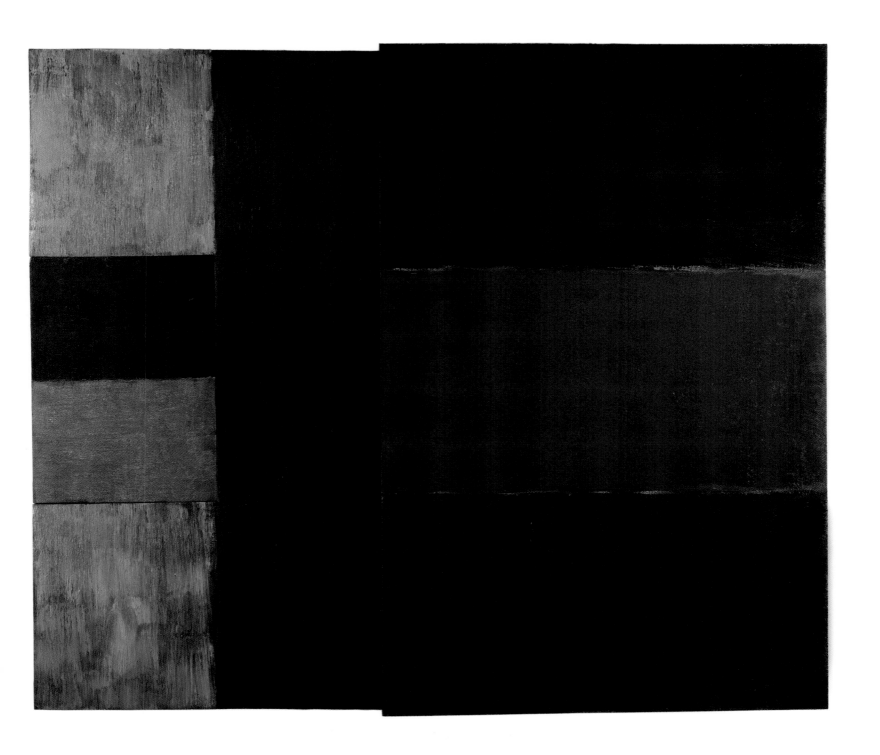

*Once*
1986
Oil on canvas
96 x 112 in.
243.8 x 284.5 cm

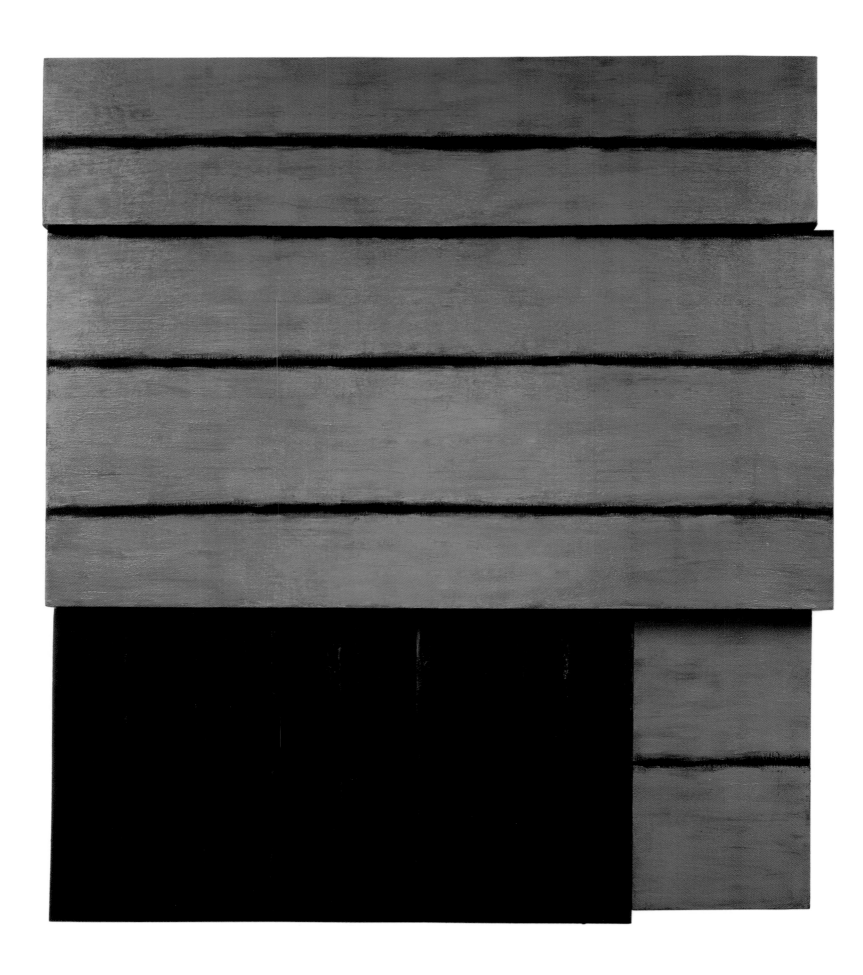

opposite
*This That*
1986
Oil on canvas
114 x 96 in.
289.6 x 243.8 cm

*West of West*
1995
Oil on linen
108 x 180 in.
274.3 x 457.2 cm

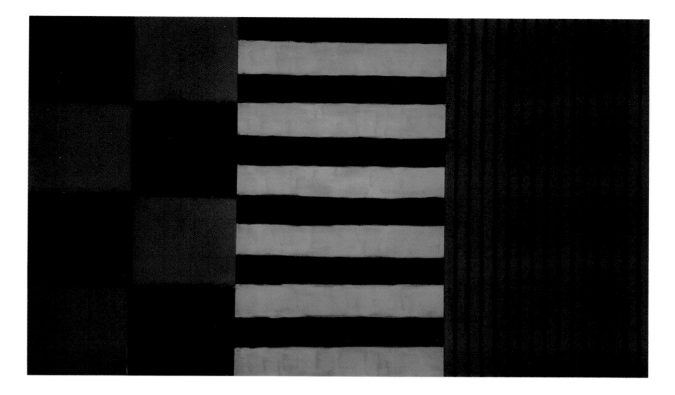

*Catherine*
1987
Oil on canvas
96 x 120 in.
243.8 x 304.8 cm

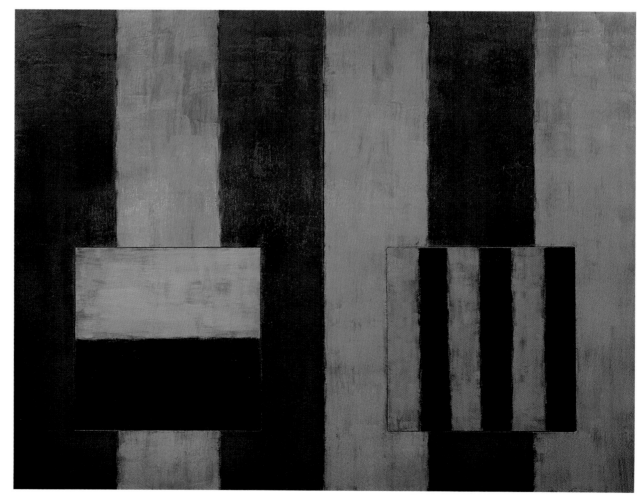

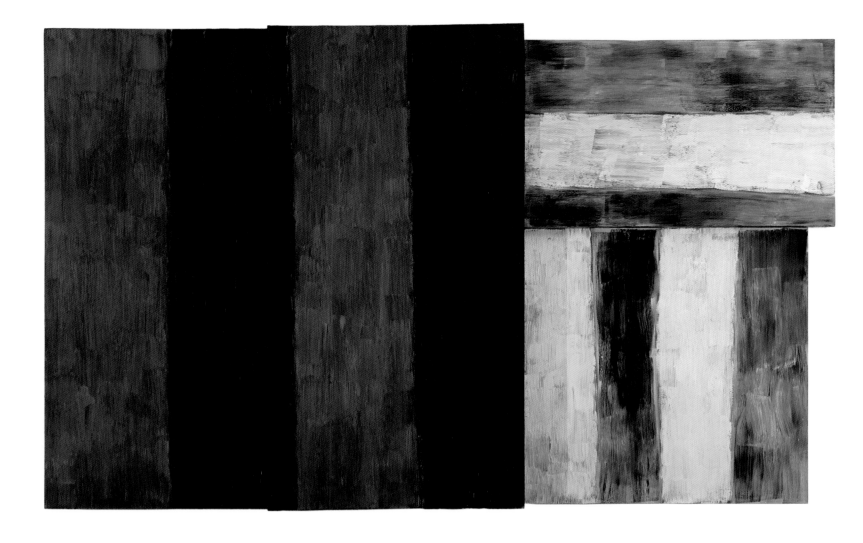

large panels, as if something were in the back of the solidly resolved right panel's horizontal stripes. The panels thus are like successive frames from a movie, one in front, with the second and third ready to appear. In *West of West* (1995), any one of the three handsome panels could stand alone, but together they exhibit no principle of unity. Nothing holds this extreme composition together except the equal insistence of the participating components. And the radiant *Catherine* (1987) uses two windows as pictures. Like zoom-in shots, they move us backward away from the ground of stripes by changing the implied scale. Were the stripes in the windows as wide as those behind, we would have to step back to focus. The storyline in *Backs and Fronts*, one event then the next in linear order, was relatively simple. Now Scully constructs more complex visual narratives.

Sometimes, it is true, Scully uses techniques not available to film. In *Darkness a Dream* (1985), for example, contrast the color of the right panels with the darker earth tones on the left. Scully aims not to picture, but to visually present a dream of darkness, this impossible goal inspiring brilliant painting. And in *Crossing* (1989), the potential harmony of the subdued colors, fading out as if at twilight, is undercut by the opposition of the reds and oranges of the windows to the black and blue verticals. Often Scully shows light that holds fast, but here his tonality suggests change. A film can display real change, but Scully, like an Impressionist painter, can only use one fixed picture to suggest how light changes. This crossing from daytime to evening is tranquil, fading from blue into solid black.

*Darkness a Dream*
1985
Oil on canvas
96 x 144 in.
243.8 x 365.8 cm

Titles play an essential role in communicating Scully's stories. His pictures, he says, *have individual personalities and that's why I sometimes give them the names of people or places. They anchor themselves to things outside of mere art. I'm not making mere paintings. I want them to be more than that. I want them to be humanistically expressive. So it's very important to me that they have titles.*

Abandoning neutral minimalist titles such as *Horizontals: Thin Grays* (1976) in favor of evocative names was a major change. "When you title your paintings, you have to think about a subject matter outside of the painting. You're thinking about something beyond the narrow confines of painting. You're thinking figuratively." African-American blues engage worldwide audiences because almost anyone experiencing everyday trials and tribulations can respond to this music. So, too, Scully's paintings also have immediate popular appeal because they deal with universal shared experiences. "I'm not trying to say anything different from what you can say. I want to say the same thing."

Scully often uses literary titles: Samuel Beckett's *How It Is* and *Murphy*; William Faulkner's *Light in August*; Brian Moore's *Black Robe*; and Vladimir Nabokov's *Pale Fire.* The etchings *Burnt*

*Crossing*
1989
Oil on canvas
90 x 120 in.
228.6 x 304.8 cm

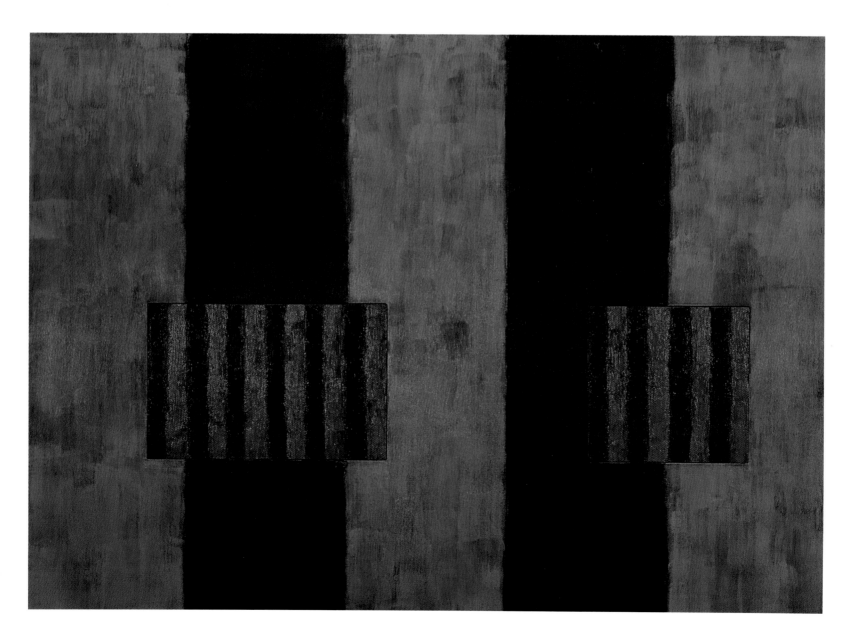

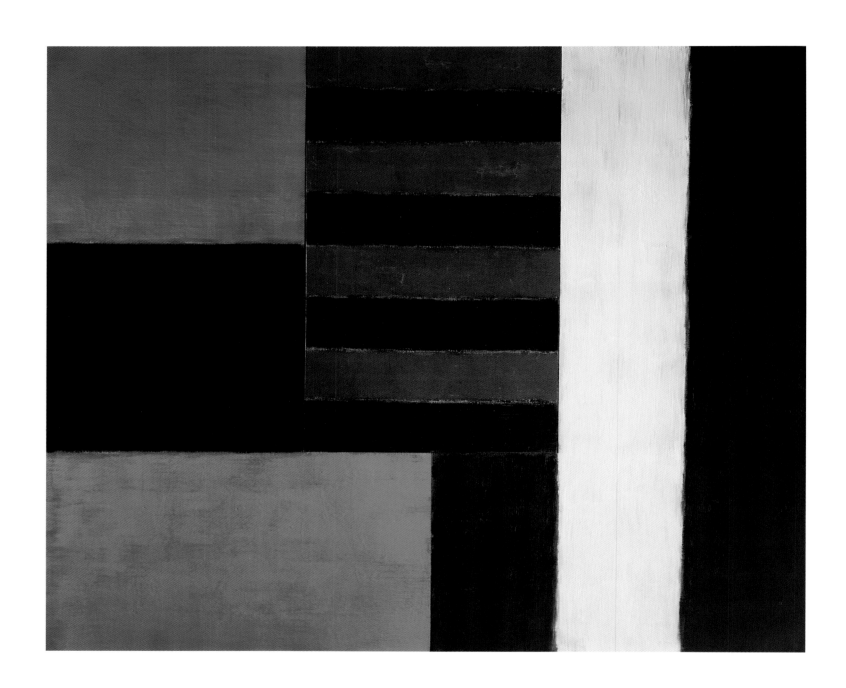

*Marius*
1987
Oil on canvas
90 x 108 in.
228.6 x 274.3 cm

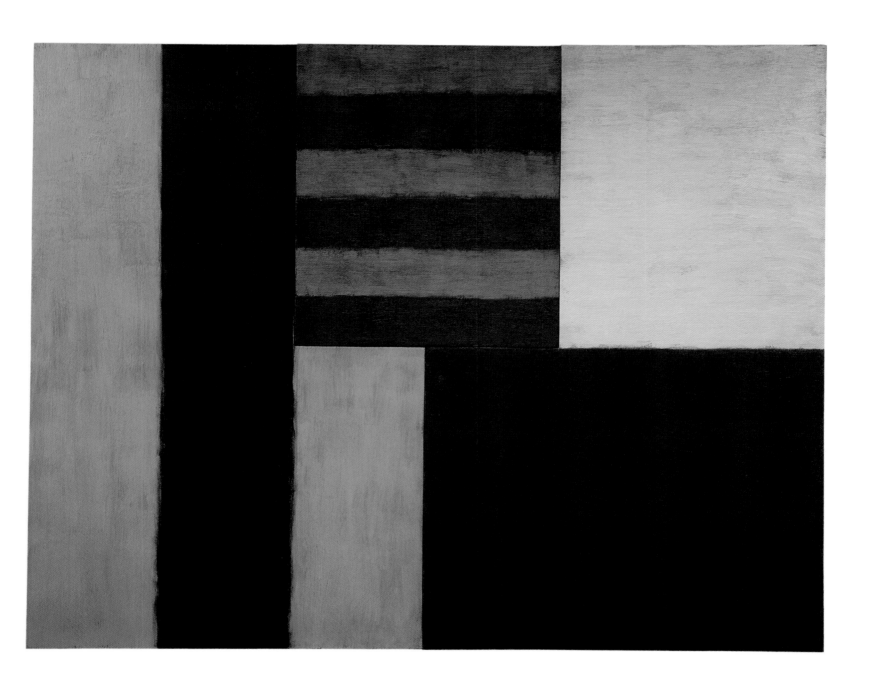

*Umbria*
1988
Oil on canvas
90 x 114 in.
228.6 x 289.6 cm

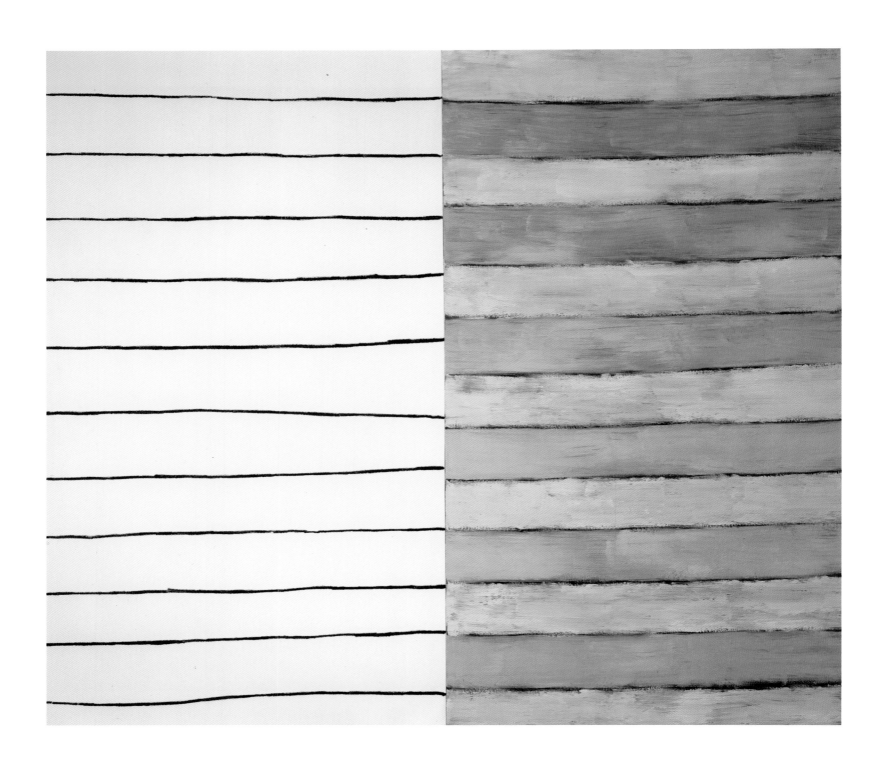

*Angel*
1983
Oil on canvas
96 x 108 in.
243.8 x 274.3 cm

*Angelica*
1982
Oil on canvas
96 x 84 in.
243.8 x 213.4 cm

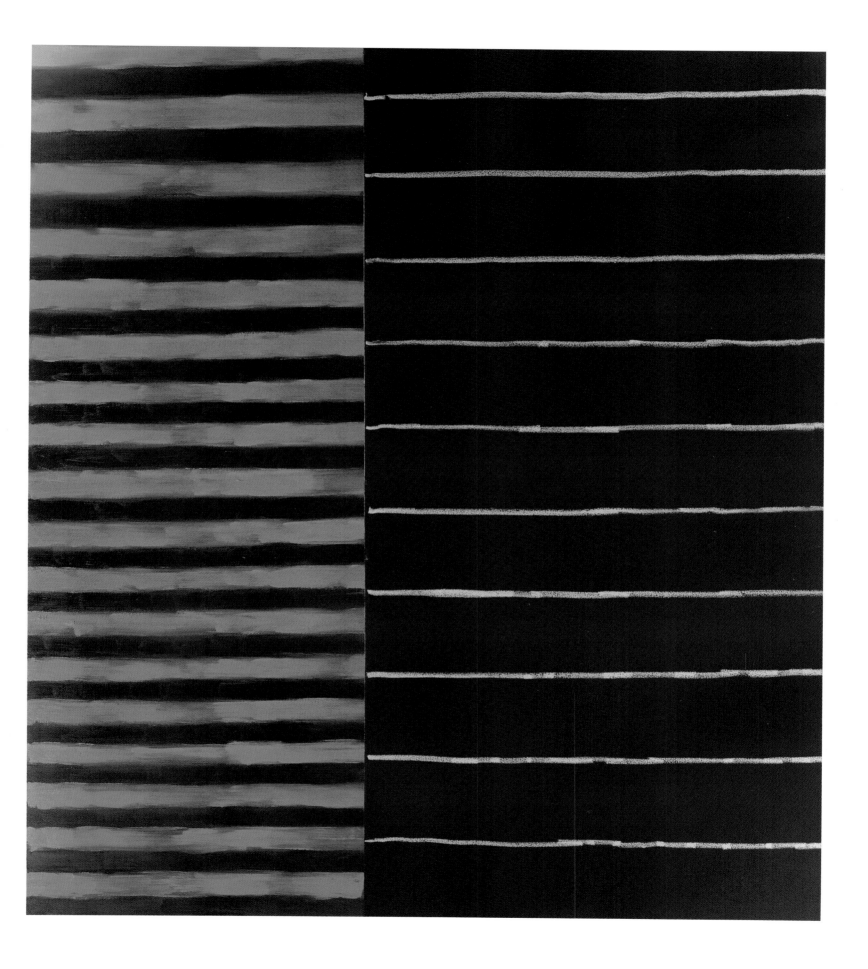

*Norton 1–3* are named after T. S. Eliot's poem of that title; and *Tyger Tyger* and *Upright Tiger* allude to the William Blake poem "The Tyger." Some Scully titles refer to women he admires, like *Helena*, named after his grandmother Helen, using the archaic form of her name. Some titles evoke religious themes – *Angel*, *Angelica*, and *Gabriel*, and also *Flesh*, *Spirit*, and *Empty Heart*. Pastels and watercolors are named by the date of their creation – paintings are usually named after completion.

Place names are important sources for many of Scully's titles. When in summer 1982, Scully lived and worked at Edward Albee's artists' colony in Montauk, Long Island, he named his small paintings after nearby islands: Block, Fire, Shelter Island. These very dense pictures look like islands surrounded by the ocean. *Shelter Island* was modeled on the big door in Albee's barn. In the painting, as in this studio, there is "a lot of white, a lot of black, and a lot of low sun and deep shadow." Some other larger Scullys are also named after places. *Africa* (1989) and *Dakar* (1989) refer back to the mood of *Heart of Darkness*, but using Scully's late-1980s tighter visual unity. Paintings with African themes usually are very dark; triptychs tend to have three-word titles. The Australian National Gallery was the perfect destination for *Bigland* (1988), a picture abstractly presenting that big land. And *Reef* (1995) shows a red reef, with a light horizontal strip suggesting the foam caused by the sea breaking on rocks. *Durango* (1990) is built of unbroken fields of large, interlocked striped forms, all the same scale. Durango is a barren, colorless state in Mexico – and that's just how *Durango* looks. The drawing and paint-handling try to unify the picture, which remains stubbornly divided. The panel in the middle sticks forward – this triptych is almost an all-over painting. Some other Scully titles refer to the seasons. *October* (1990), for example, is a

opposite
*Bigland*
1988
Oil on canvas
96 x 160 in.
243.8 x 406.4 cm

*Durango*
1990
Oil on linen
114 x 180 in.
289.6 x 457.2 cm

*Africa*
1989
Oil on canvas
90 x 144 in.
228.6 x 365.8 cm

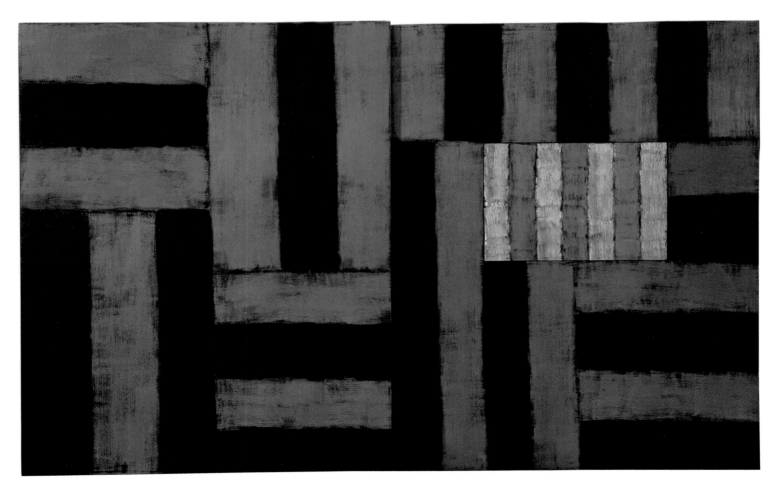

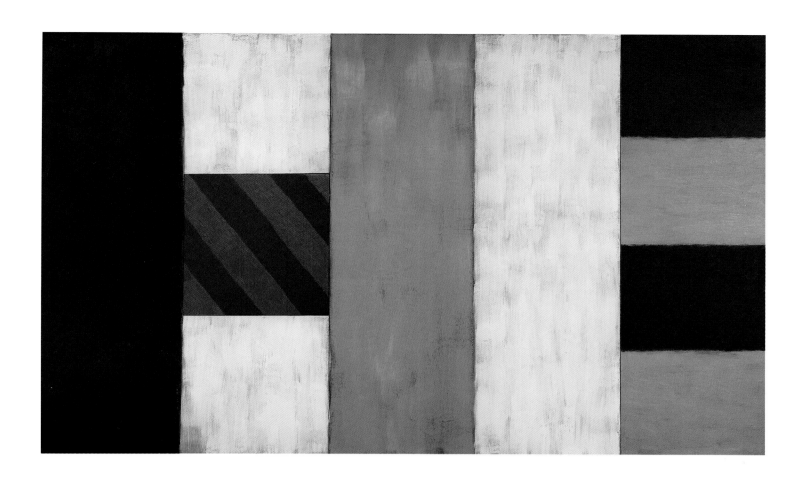

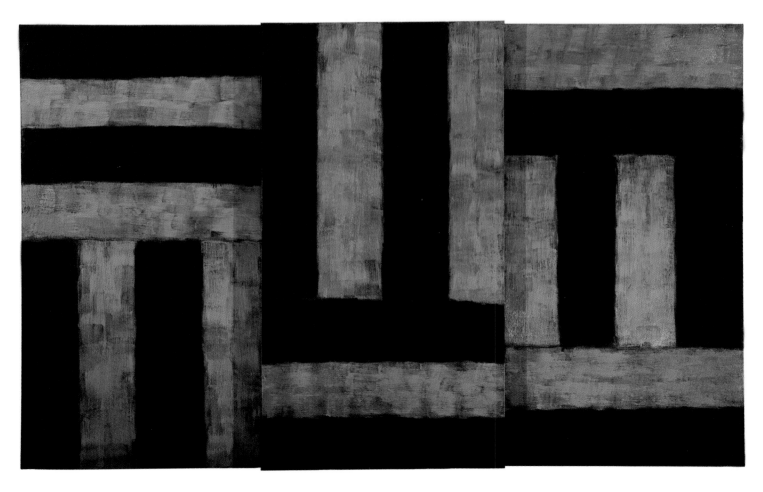

*October*
1990
Oil on canvas
78 x 129 in.
198.1 x 327.7 cm

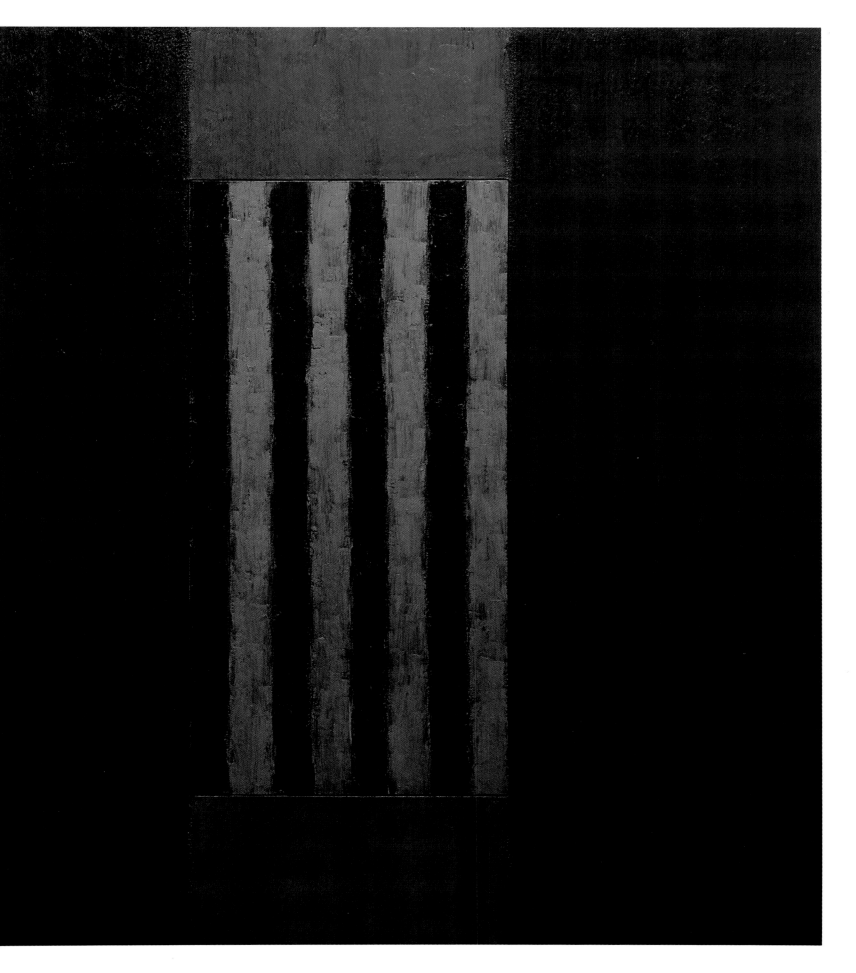

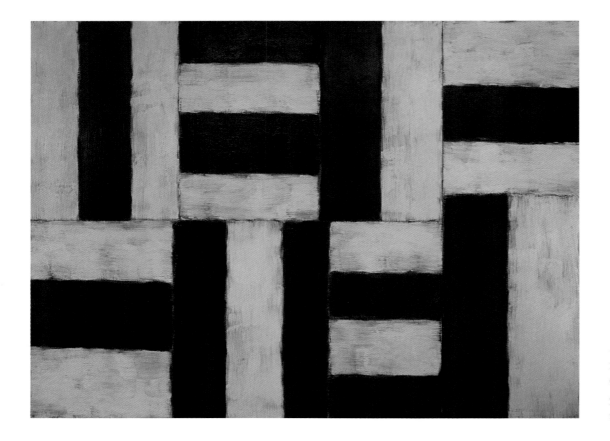

*Light in August*
1991
Oil on canvas
90 x 120 in.
228.6 x 304.8 cm

very broad painting with wide stripes of dark and light red, and one window on the right with fleshy orange and black verticals. All of the colors except for the black verticals are reddish. *October* has tight unity. Usually Scully's stripes open up pictures, but those in *October*'s narrow rectangular window are highly constrained, compressed between two vertical stripes. *Durango* and most other all-over Scullys are expansive. But *October* comes inward; summer has long since ended by October. As a student, Scully was struck by Paul Gauguin's idea that you can make color that is the equivalent of nature. *October* and also *Light in August* (1991) show that he has not forgotten that insight. *Light in August* is a painting about people with light and dark skins. The title, from Faulkner's novel, refers also to the beautiful light of August. All Scully's paintings have skin-like surfaces, but here he actually *paints* skin. In paintings, the body is reduced to a skin stretched out, with virtually no mass, except for the weight of the paint put on canvas by the painter's hand. Still, vulnerable, stretched out, and defenseless, *Light in August* is, so Scully suggests, "waiting, like nothing else in the world." Without depicting a landscape, he captures the delicious sunlight of late summer. Most of his paintings show struggle between light and darkness, or between happiness and sadness. *Light in August* is exceptional in its presentation of singleminded fleshy happiness. This very harmonious picture shows divisions but no conflicts.

Usually you need to know the sense of his titles and look attentively to understand Scully's stories. *Paul* (1984) memorializes his son, an eighteen-year-old boy he had not seen for many years, who had been recently killed in a car accident. The very broad stripes on the left panel are brutally stopped by two groupings of three verticals. The reds stand for the body's desire to live; the heavy horizontals negate that life force. *Paul* shows a figure in an idealized landscape. Were it

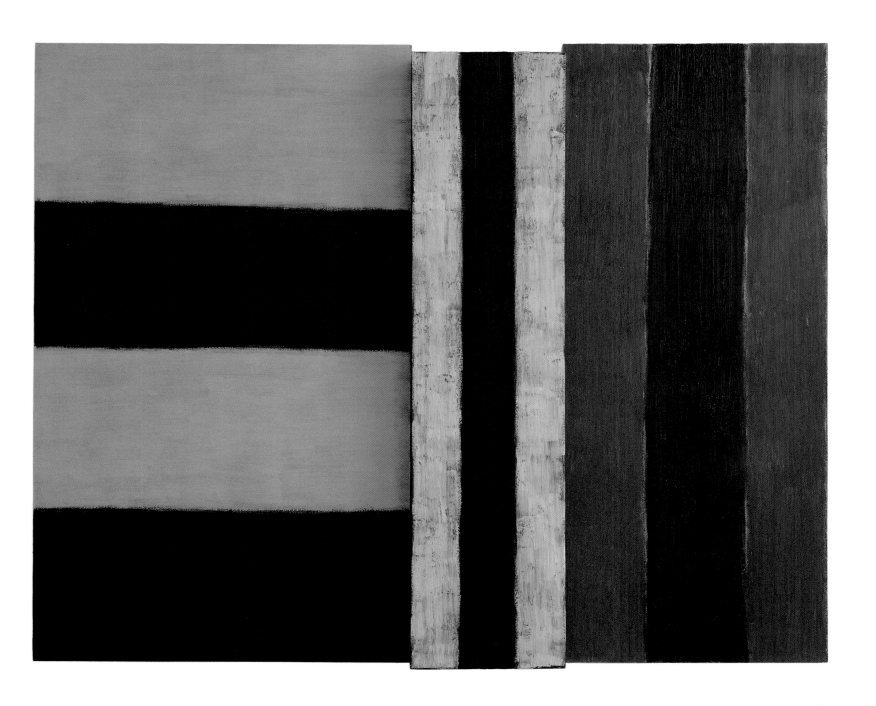

*Paul*
1984
Oil on canvas
102 x 126 in.
259 x 320 cm

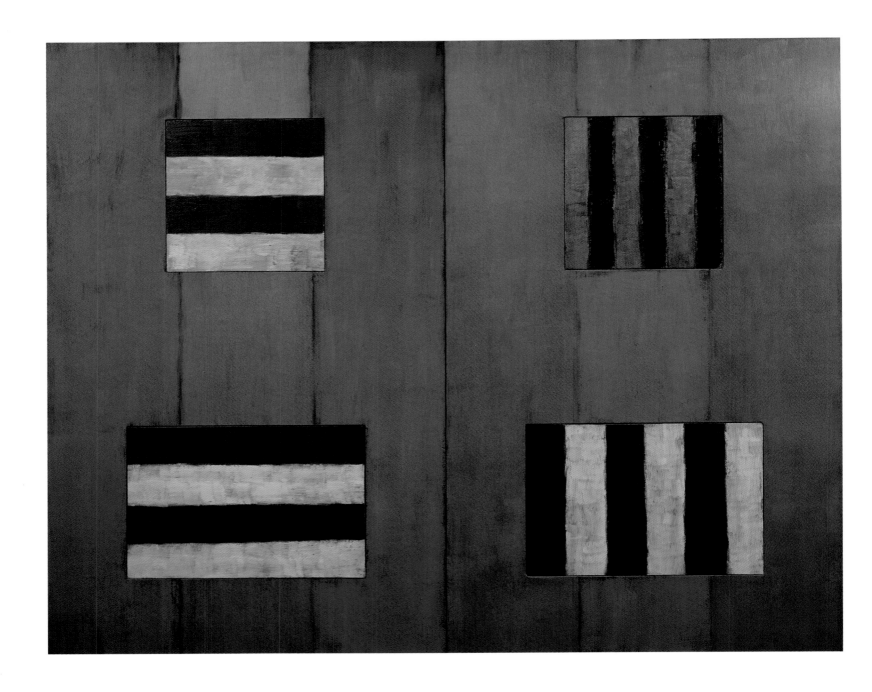

doubled around its right edge, it would be an abstract altarpiece like *Maesta* (see p. 147). As it is, *Paul*'s tightly compressed center tells the story of a young man's premature death. A life of a mere eighteen years is presented in this painting with incomplete unity.

Many other Scullys tell happy stories. *Us* (1988), for example, sets four windows in an all-over field of broad stripes. There is something inherently soothing about all-over wide vertical stripes in pale twilight colors. Perhaps things don't quite come together, but with its windows submerged in a background, this picture shows togetherness. And *A Bedroom in Venice* (1988), named after a Turner watercolor, displays erotic bliss. Turner left out the windows – Scully inserts two blanks. In this abstract image of a congenial couple, the window on the right breaks up the

*Us*
1988
Oil on linen
96 x 120 in.
243.8 x 304.8 cm

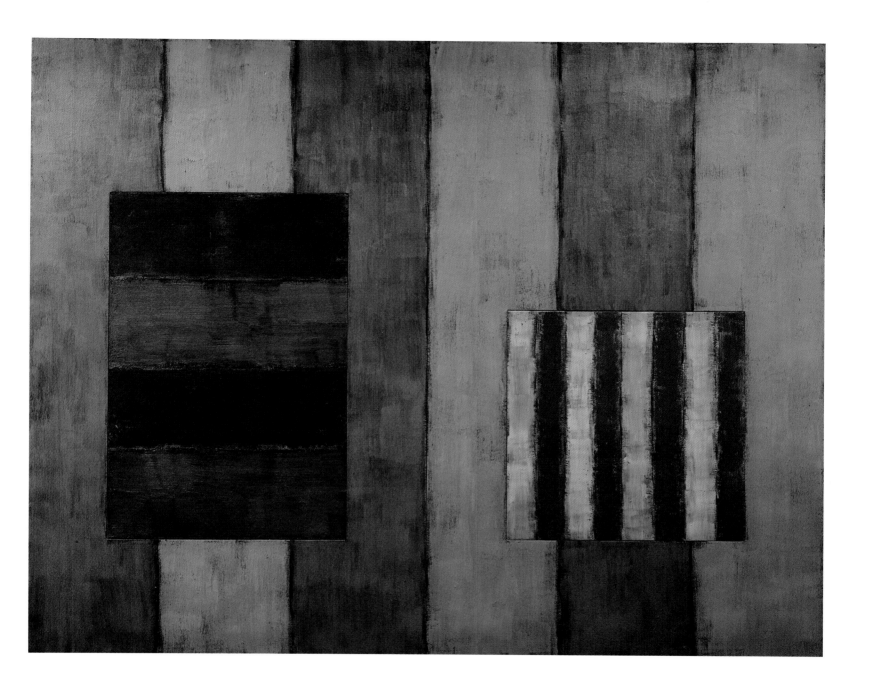

*A Bedroom in Venice*
1988
Oil on canvas
96 x 120 in.
243.8 x 304.8 cm

background field. Part of the field is missing, completed with an intrusion. The blue background of solid verticals harmonizes with the two windows.

Often Scully's titles are relatively straightforward descriptions. *Song* (1985) sets passionate stripes in unyielding juxtaposition to the darkness of the left, the verticals at the right arbitrarily juxtaposed to the wide horizontals on the left, broken up by the insert. Like a good song, this painting is lyrical. Set it next to *Flesh* and see how dramatically Scully opens up this picture, using three areas of stripes to display a sequence of moods. *Song* starts out severe on the left, but to the right we find strongly colored verticals. But occasionally Scully's titles do require verbal explanation. In *Pale Fire* (1988), a highly resolved painting, the single insert is at rest in a seemingly

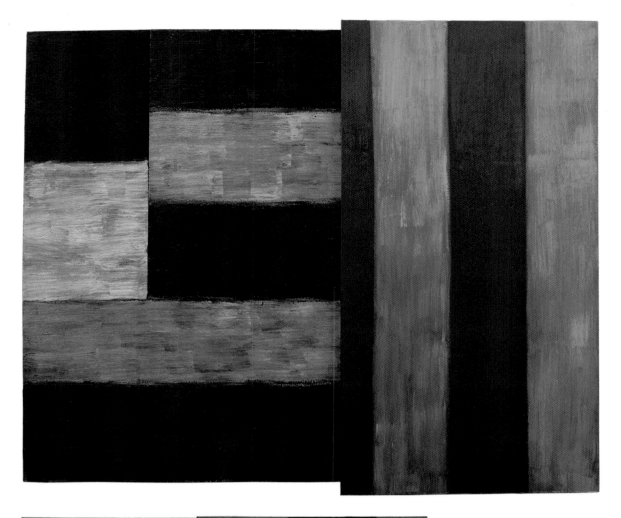

*Song*
1985
Oil on canvas
90 x 110 in.
228.6 x 279.4 cm

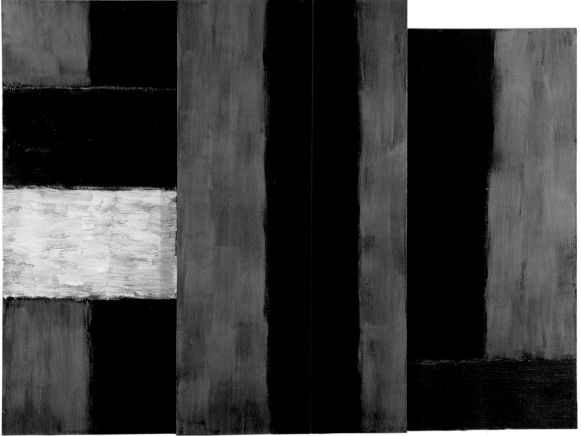

*Flesh*
1985
Oil on canvas
96 x 124 in.
243.8 x 315 cm

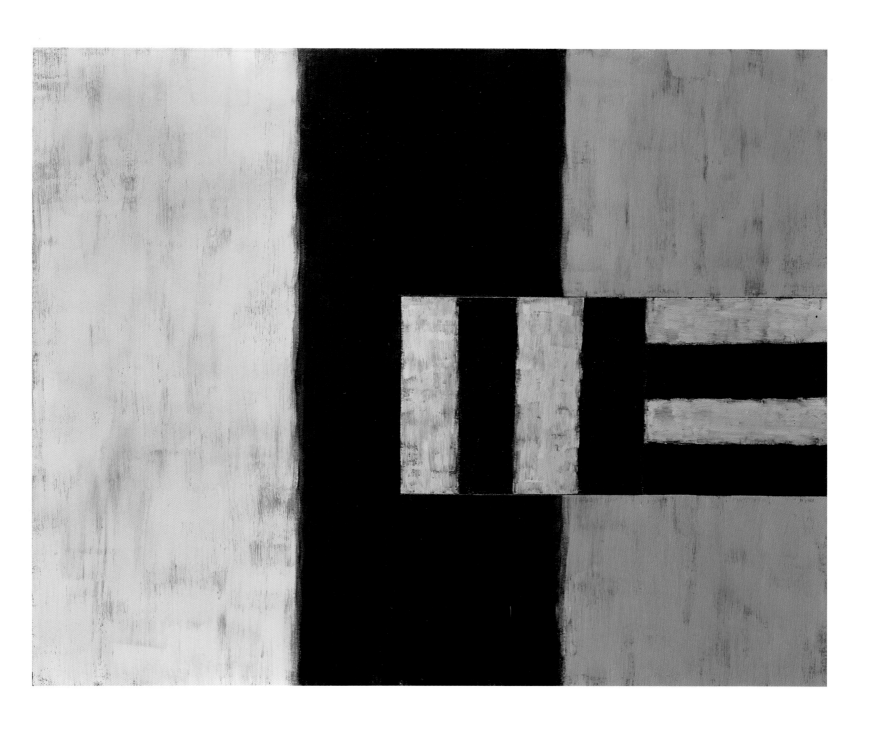

*Counting*
1988
Oil on canvas
65 x 78 in.
165.1 x 198.1 cm

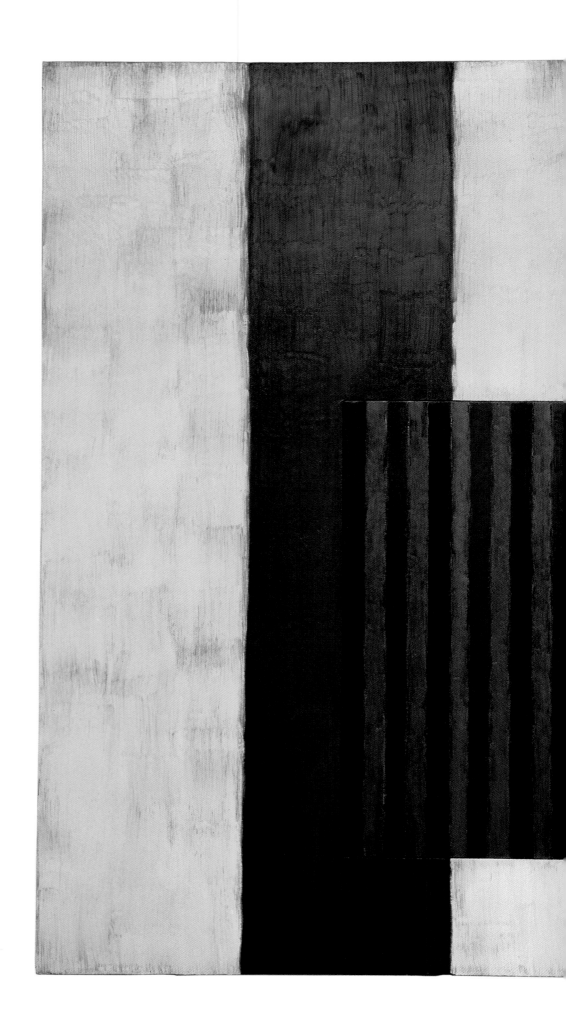

*Pale Fire*
1988
Oil on linen
96 x 147 in.
243.8 x 373.4 cm

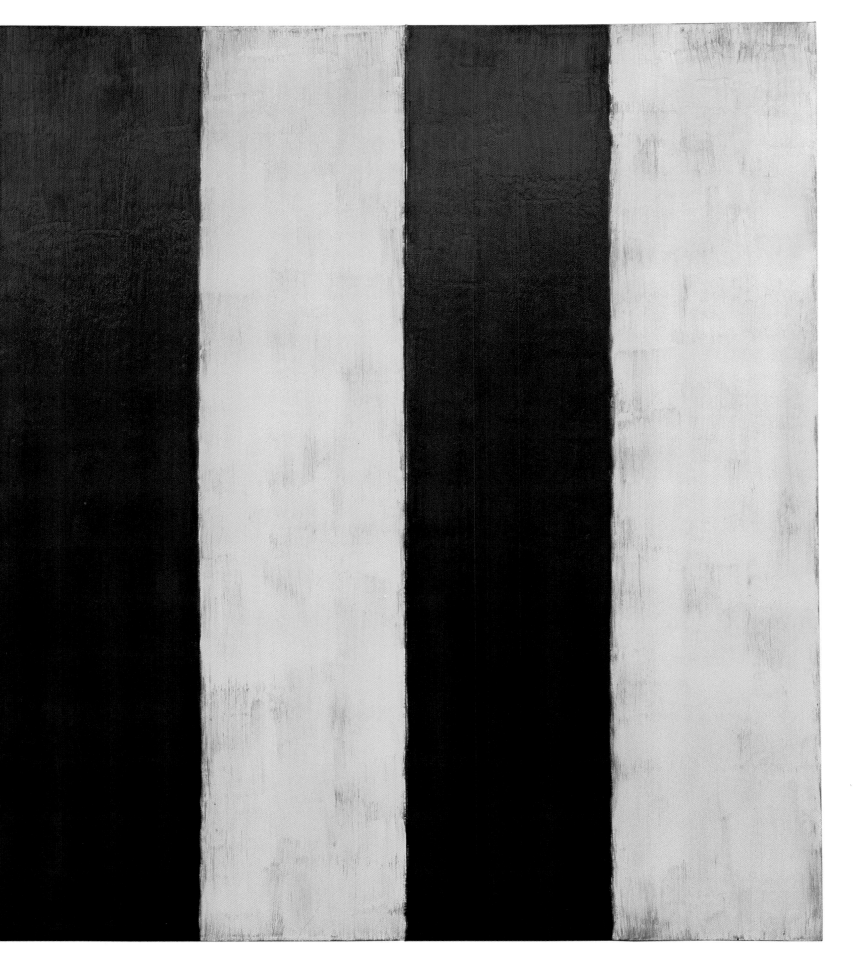

stable field of broad stripes. Scully, always in love with white as a way of making light with body, took the title, but nothing else, from Vladimir Nabokov's novel. And *High and Low* (1989), made before the famous art exhibition with that title, is about states of happiness and depression, emotional highs and lows.

Frequently, Scully's stories derive from older paintings whose titles he borrows. *Conversation* (1986), for example, pays homage to Matisse's *Conversation* (1908–12), which portrays Matisse and his wife, separated by a window opening onto their suburban garden. Matisse immerses his figures in the expansive blue, their conflicts submerged in a great soothing field of color. Scully's *Conversation* shows not conflict but radical disagreement. The three sections are totally unconnected, the color and scale of the blacks on the far left having nothing to do with the insert at the bottom right. Unlike Matisse, Scully leaves stark differences unresolved. For him, disharmony is as real as unity – conversation need not achieve agreement.

The *Narcissus* attributed to Caravaggio shows a boy directly above his reflection. In Scully's *Narcissus* (1984), very dark green-blues and blacks push against the small panel on the right like a pile driver pressing columns into the ground. Originally painted in 1982 as part of another work of art, the insert opens up the dark verticals in this high-pressure setting. *Tonio* (1984) comes from a different emotional world. *Narcissus* is about how one small panel can resist domination. *Tonio* shows three distinctly different stripes cohabiting without giving up their identities.

*Conversation*
HENRI MATISSE
1908–12
Oil on canvas
69⅝ x 85½ in.
177 x 217 cm

*Narcissus* (detail)
CARAVAGGIO
1598–99
Oil on canvas
45 x 37 in.
114.3 x 94 cm

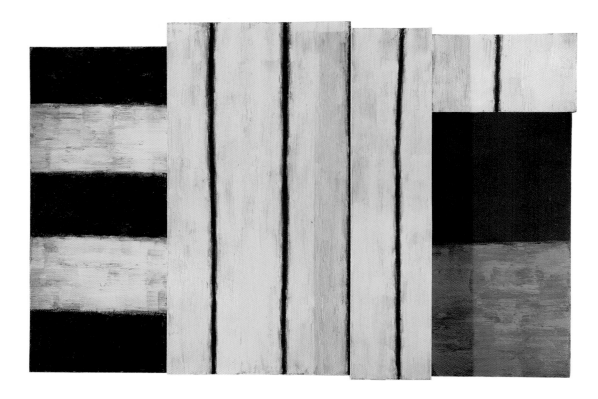

*Conversation*
1986
Oil on canvas
96 x 144 in.
243.8 x 365.8 cm

Opposite
*Narcissus*
1984
Oil on canvas
108 x 96 in.
274.3 x 243.8 cm

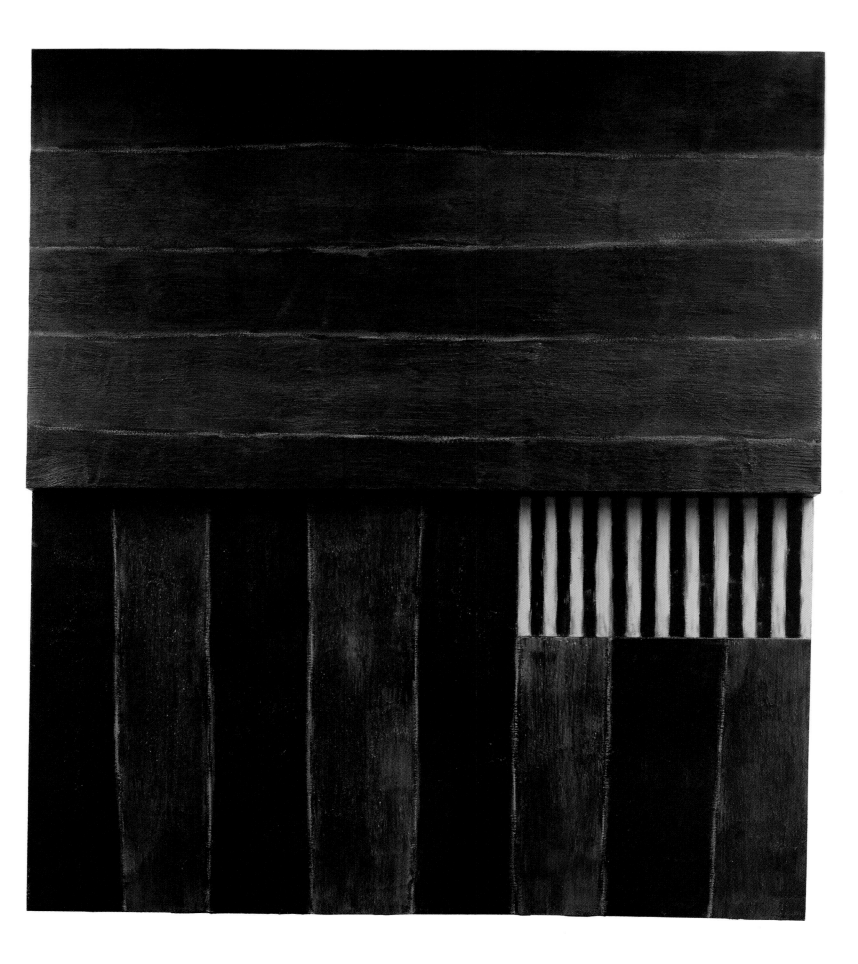

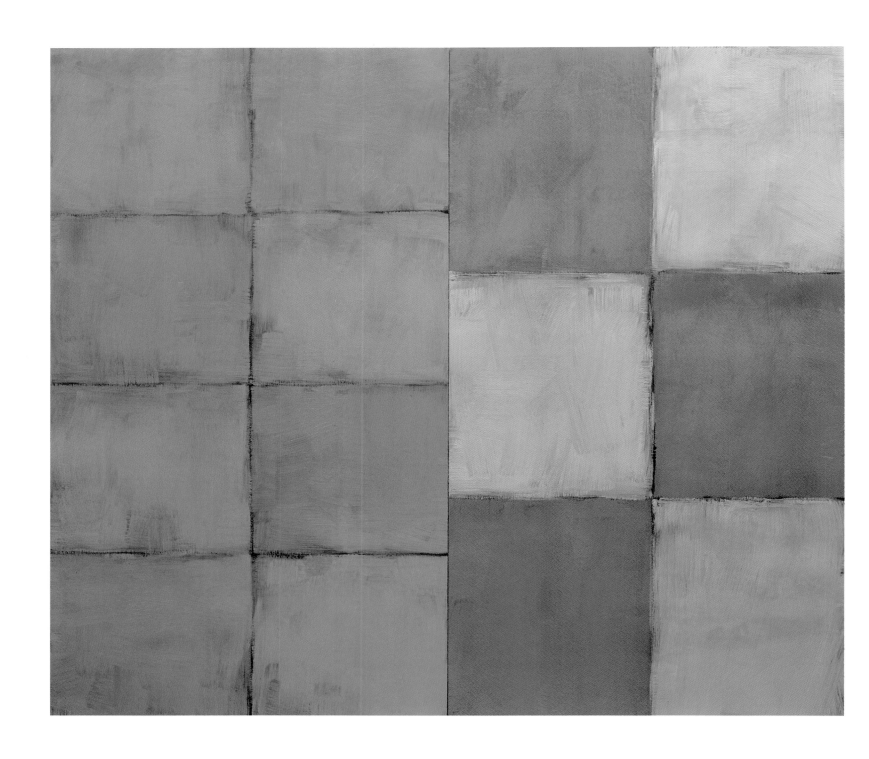

*Union Yellow*
1994
Oil on canvas
84 x 96 in.
213.4 x 243.8 cm

*Still Life with Oranges (11)*
HENRI MATISSE
1899
Oil on canvas
18³/₈ x 21³/₄ in.
46.7 x 55.2 cm

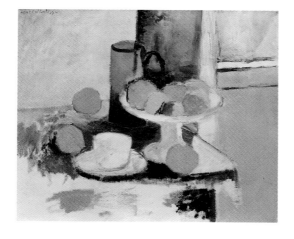

*Tonio*
1984
Oil on canvas
72 x 98 in.
182.9 x 248.9 cm

Were *Tonio* a movie with two stars and a strong supporting actor, it would describe the difficult relationships of three people. *Union Yellow* derives from Matisse's *Still Life with Oranges (11)*, 1899. *Still Life with Oranges* shows something natural and full of life suspended and protected, simplifying the round oranges, which become patches of color. *Union Yellow* rotates these oranges ninety degrees clockwise, the yellow of life held in the atmospheric embrace of three grays. "Union" refers to joining together, and in *Union Yellow,* the pale pink and whites on the left, smaller than the intense orange and whites on the right, establish two scales within one painting. Narrow stripes set in a background of broad stripes invite us to move forward, or step back, inducing dynamism into an otherwise overly frontal image.

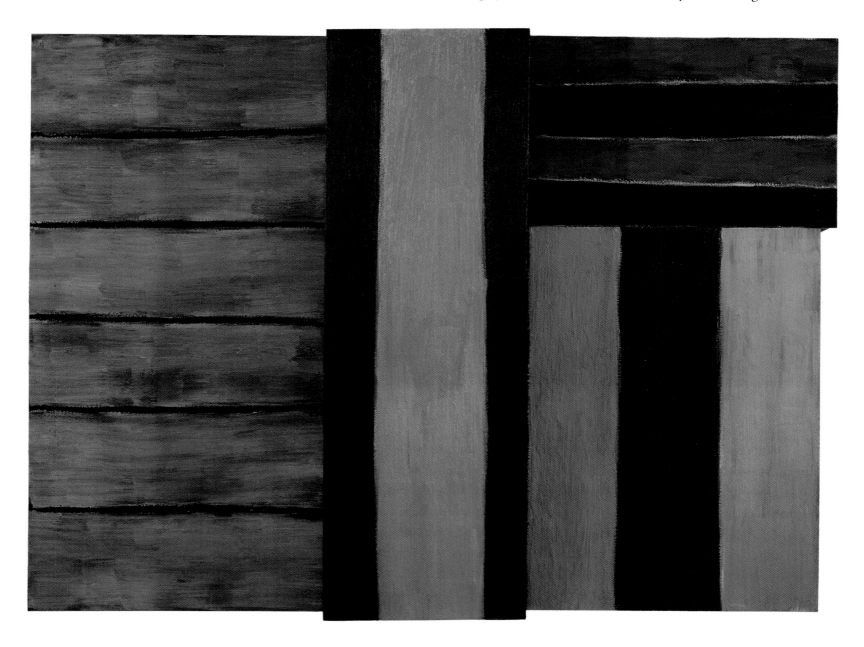

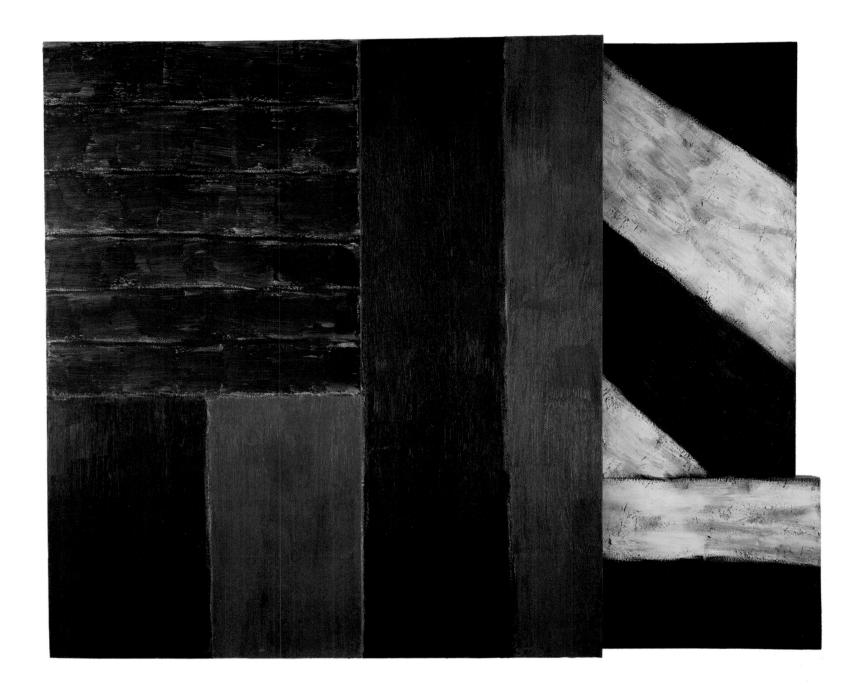

Once a few such examples have been presented, you are prepared to understand Scully's other paintings. His very direct visual language is usually straightforward. *All About* (1985), for example, one of his favorite works of art, a crazy picture, looks like three distinct paintings slammed together. The composition is off – the title refers to something that is all over the place. Scully was thinking of a very disheveled, off-balance personality. Nothing holds *All About* together, not composition, not color, not shape. In *Africa* (see p. 112) a claustrophobic plus-minus system shows the humid oppressive earth in colors made out of dirt; the insert stands for hope, a window in a traditional sense. Remembering driving through red and yellow dust in Morocco, Scully created dark stripes closing upon themselves. And *Secret Sharer* (1989), its title taken from

*All About*
1985
Oil on canvas
84 x 103 in.
213.4 x 261.6 cm

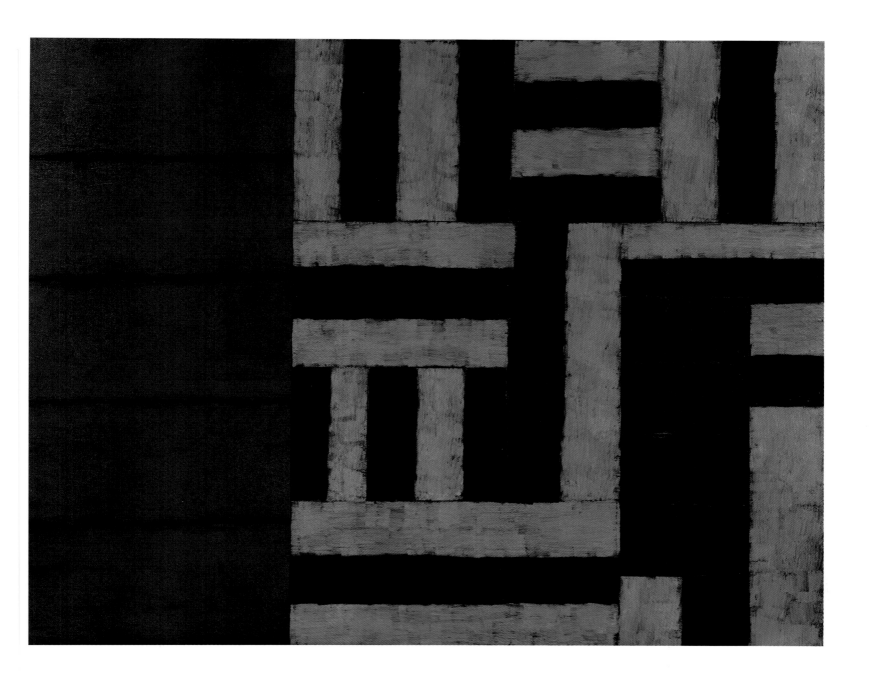

*Secret Sharer*
1989
Oil on canvas
100 x 126 in.
254 x 320 cm

Conrad's novel, has the classical "T" motif in the very center destabilized by the blacks at the lower right, which seem to lead off the edge of the canvas. The secret is in plain sight – there is no relationship between the horizontal stripes on the left and the intricate pattern of flesh and blacks on the right. As our eyes move across, the black at the bottom right points upward.

*John Anthony* (2000) is Scully's memorial to his father, who died in November the previous year. The colors are mostly dull, as in Fall after the leaves are down, and the spare composition is divided, except at the left and right bottom corners, into two dark elements. Compare *Empty Heart* (1987), which also displays devastation, the "T" at its center almost submerged in a background field of the same color. With color on the inside, this ragged minimalist picture turns on itself, going

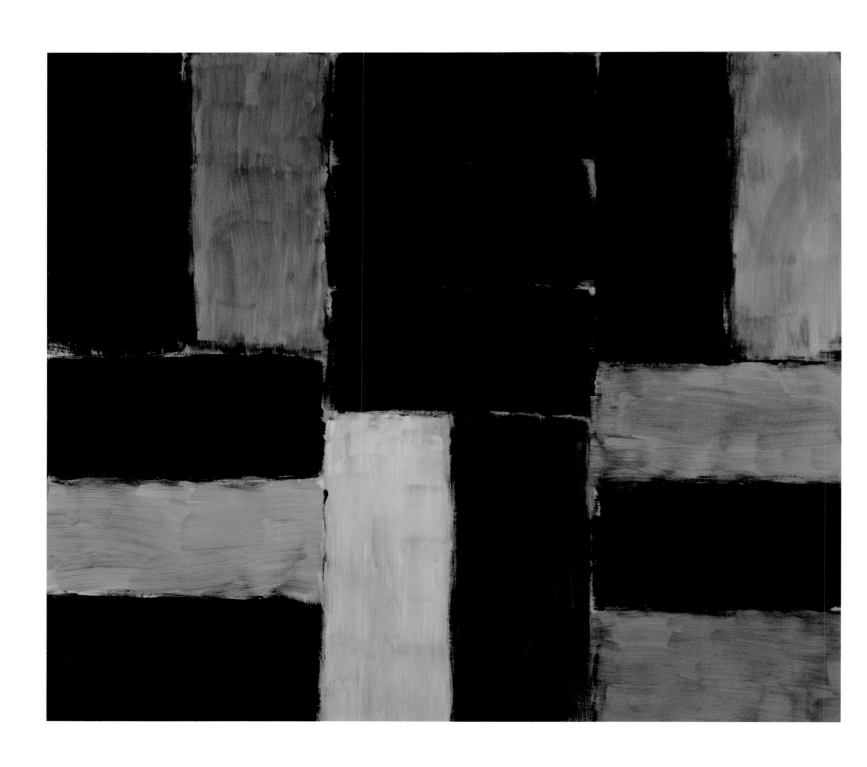

*John Anthony*
2000
Oil on linen
84 x 96 in.
213.4 x 243.8 cm

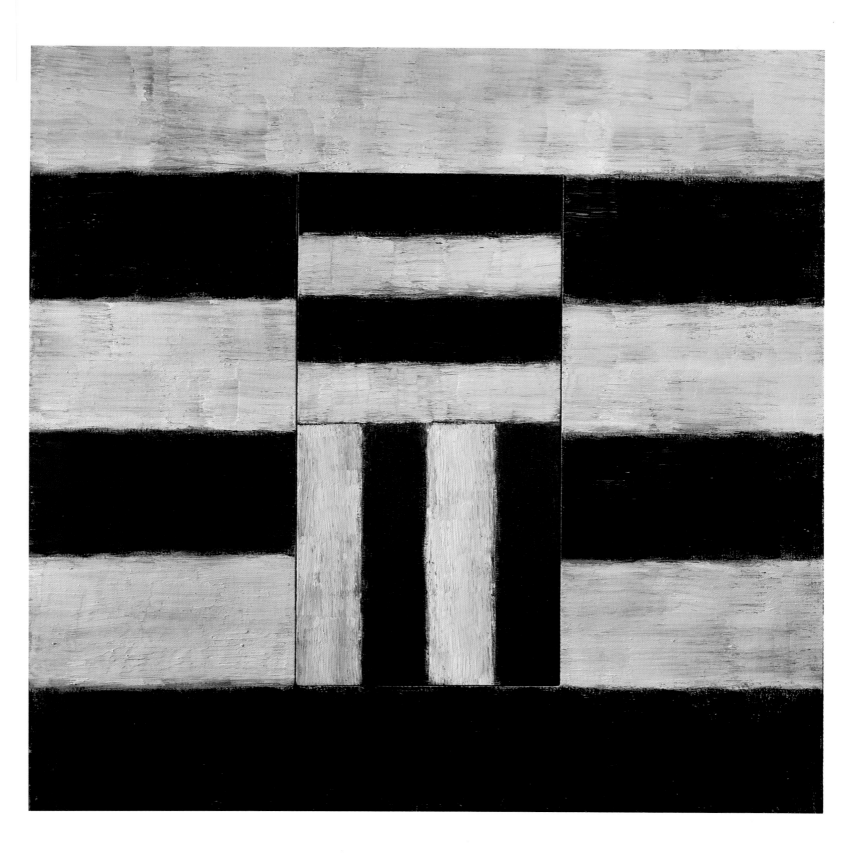

*Empty Heart*
1987
Oil on canvas
72 x 72 in.
182.9 x 182.9 cm

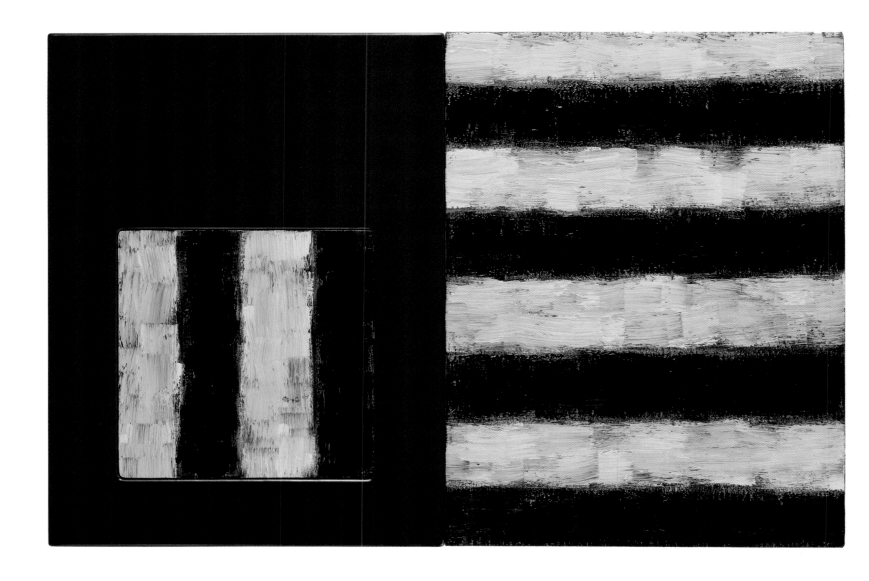

nowhere because it contradicts itself. At first it looks harmonious, but here appearances are deceptive. And now contrast *Flesh*, 1985 (see p. 120), with a flesh-color panel inserted into a triptych anchored by the horizontal panel at the bottom right. Strong sensuality is bounded by, and so controlled with, sober blacks and grays. Two isolated panels, left center and bottom right, stand out in this ominous painting, whose strong verticals display the power of desire. Here we are in a different world.

Scully's deviations from stylistic norms usually have expressive significance and so tell stories. Verticals and horizontals dominate his art.

> *I don't use the diagonals much … because the diagonal is everything that is in-between the horizontal and the vertical stated, whereas I've come to believe that in my work, the best way for me to represent everything in between is* not *to state it, to capture it by stating the two ends, and somehow imply everything in between.*

*Coll*
1993
Oil on linen and metal
23$^5/_8$ x 35$^1/_2$ in.
60 x 90 cm

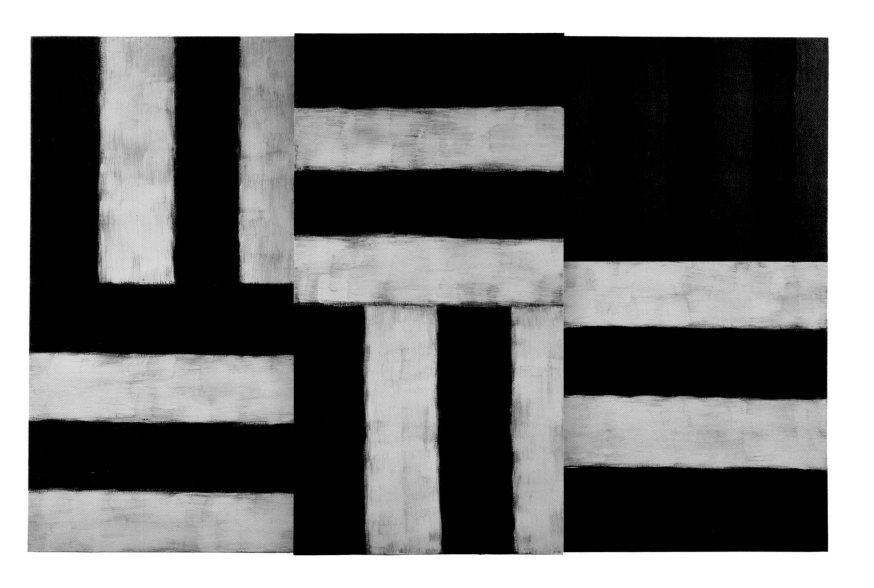

*Stone Light*
1992
Oil on canvas
110 x 165 in.
279.4 x 419.1 cm

But *Without* (1988) is split into two very different zones, the color stranded in the left-hand side which has diagonals. This very big picture without unity is "elegant and dislocated, all at once." *Charles (For Charles Choset)*, 1988, another picture with diagonals, hung just beyond the entrance of Scully's 1989 exhibition at the Whitechapel Art Gallery, London. The rising lines mirrored the stairs and the verticals on the right echoed the windows on those stairs. As soon as I walked into that show, the placement of this painting oriented me. And when I saw its title, I understood Scully's dedication of the retrospective to Choset in the catalogue. *Charles* expressed hope; the more recent woodcut *Planes of Light* (1991), with similar diagonals, functions similarly.

Scully's 1980s panels do not quite form rectangles – their unity is provisional. Kenneth Noland's and Frank Stella's 1960s shaped canvases play predetermined compositions against the outer frame. By contrast, the structure of Scully's multi-panel pictures is inseparable from the frame's shape.

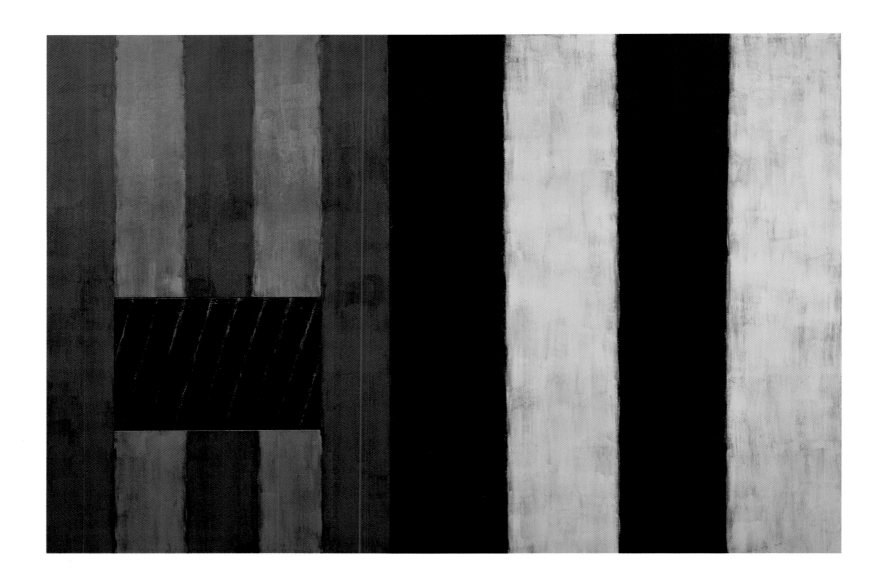

*The 1980s paintings found their shape from the inside out. This is the source of their power. Other shaped paintings had been made by doing a drawing, and then making the painting from the outside in. Mine were made by free improvisation, adding and subtracting.*

Valuing each pictorial element, Scully is unwilling to subordinate these parts to the whole picture. In the 1970s, extremely interested in process art, he made black-and-gray paintings with surfaces testifying to the processes used to create them. And in the mid-1980s, he turned to process composition.

Avoiding any central focus, *One One One* (1984) makes each of the three joined canvases equally important. The black and white stripes in the center are so wide as to be almost panels. Everything is equal to everything else, as in a relationship where three egocentric parties retain their character perfectly intact. Neither color nor connections between units nor all-over tonality hold *One One One* together.

*Without*
1988
Oil on linen
96 x 144 in.
243.8 x 365.8 cm

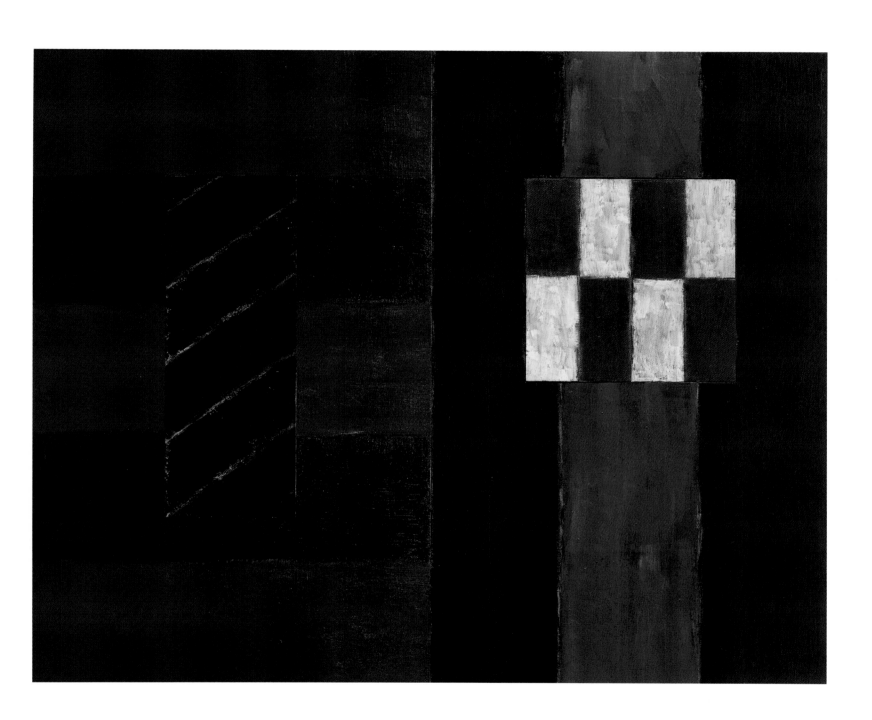

*Charles (For Charles Choset)*
1988
Oil on canvas
75 x 90 in.
190.5 x 228.6 cm

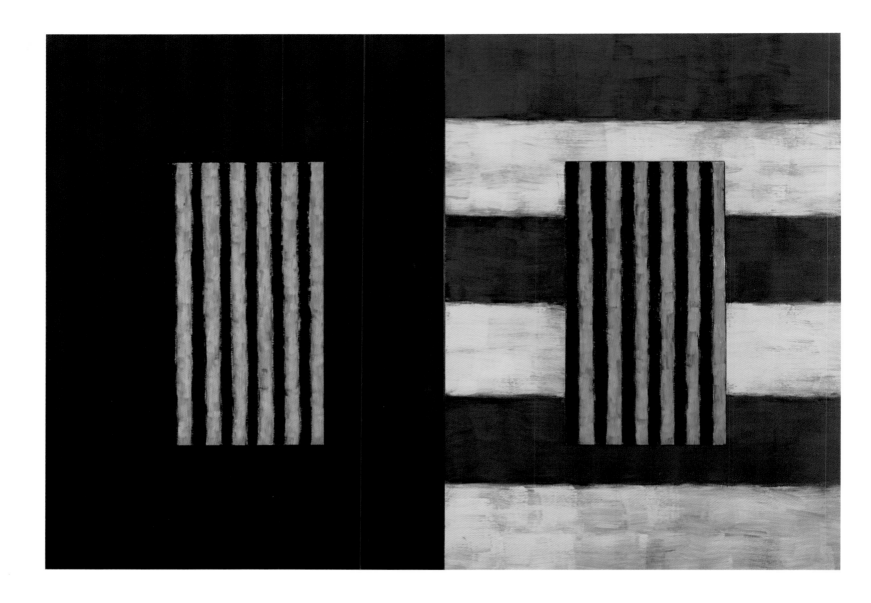

*Let's say we make a table, just for argument's sake. And this bottle is placed here. Then it creates perhaps a curiosity as to whether the bottle might be placed somewhere else. Now the question for me, that's a permutation, is whether it's a necessity to make another one. And that could be turned into a very difficult argument – I can see how it could be.*

Such a relationship, possible in art, would be a nightmare in life. For Scully a picture need not be in equilibrium, but may display obvious disharmony, as when *Molloy* (see pp. 148–49) sets the second panel from the left with jarring colors against the red and black stripes of the three other panels.

According to traditional aesthetics, works of art express beliefs, emotions or ideas of the artist. Poussin's paintings show his favorite pagan fables, and Matisse's pictures display his sense of female erotic power. Reversing that way of thinking, mass art – rock music, popular films, and also comic strips – expresses the audience's fears and hopes. Scully is acutely sensitive to this important change in the nature of art.

*As Was*
1993
Oil on canvas and steel
84 x 120 in.
213.4 x 304.8 cm

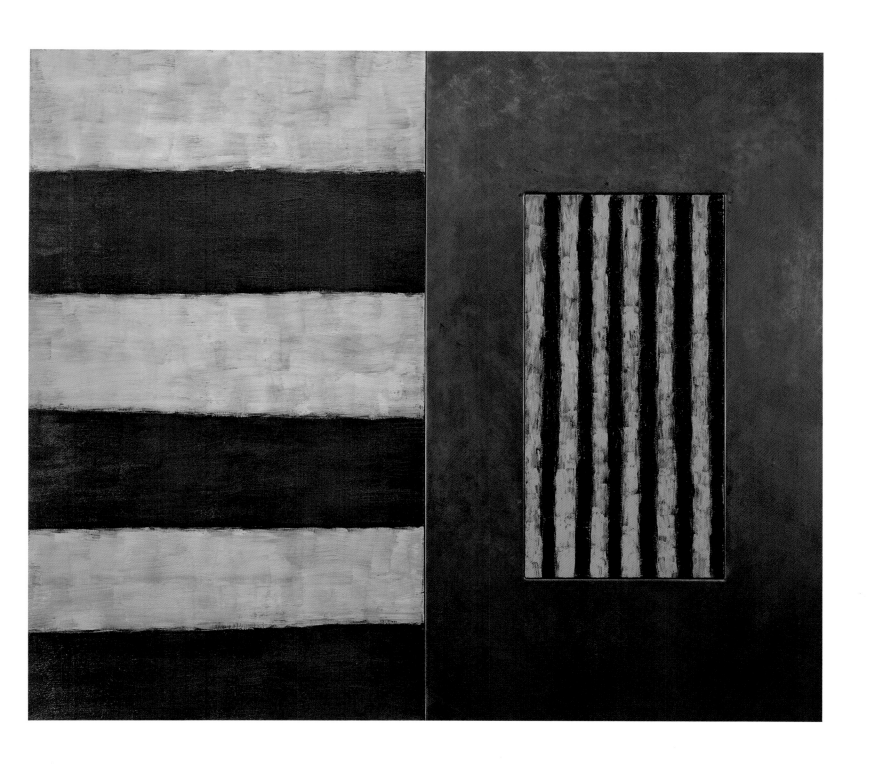

*Yellow Junction*
1992
Oil on canvas and steel
84 x 96 in.
213.4 x 243.8 cm

*The history of art has been in the direction of ... taking major themes and pulling them down.... If you trace it from Giotto, it gets more and more pulled down to the street level, or the level of the bizarre – the market-place. And these big themes are poked fun at and then they're pulled to pieces, presented in a way that makes them more and more disenfranchised, to use Arthur [Danto]'s term.*

The private desires of the musicians, directors, and artists making mass art become almost irrelevant. You don't need to know much about Martha and the Vandelas to hear the joy in their music. The films of Alfred Hitchcock, a very strange man, were enormously popular because they touched upon widely shared worries. And George Herriman's great comic strip *Krazy Kat* charmed many readers who knew nothing about its creator. Mass art provides a mirror in which we can see ourselves, and so learn about our collective desires.

Like Martha and the Vandelas, Hitchcock, and Herriman, Scully tells stories which matter to many people. His experiences of erotic passion and of deaths of loved ones, his dreams, fantasies, and fears are very different from mine and, most probably, also from yours. But when you or I look at his art, we can find stories speaking to us. Certainly Scully makes high art. As he says: "My position is that art cannot be popularized without robbing it of its central 'difficulty'; its mystery and morality is crucial to its survival." But in making him sound like a very tradition-minded painter, that statement does not tell the whole story. And indeed he continues:

*As I impact with the paintings, and I hope as others impact with the paintings, so the divisions within the paintings impact and form relations with each other. This moment of us coming together with the painting, as the painting remakes its own relationships, within its own borders, is meant to be a moment of emotion.*

Scully uses the resources of modernism as the source for his popular high art. In the 1980s and early 1990s, the expressiveness of his individual paintings depended upon the range of choices available within his style. When he chooses intense red rather than flesh color; jarring rather than harmonious composition; or windows which sit easily within a background field rather than disruptive arrangements – then we know the expressive significance of his resulting paintings.

For some, this significance verges on the spiritual. Scully's sense of the sacred, encompassing more than traditional religion, includes everyone without reference to dogmas. As he says: "Our spirituality is too elastic, and too important to be left simply to a narrative that was invented 4,000 years ago and then again 2,000 years ago." In 1994, Scully discussed the question of sacred contemporary art at length.

*There is a certain static characteristic to what we have called spirituality. Certain aspects of it cannot change since it will always refer to what we cannot see, but only feel through the power of imagination. This process will always be the same.*

Much of his statement sounds very traditional. The sacred, he is saying, has an unchanging essence. In contrast, he then adds a very different idea: "Our concept of spirituality is being modified in a way that amounts to a revolution, since what it is tied to, connected to, represented by is in an endless process of change." Here he is thinking about the role of his own abstract painting. Offering an historical perspective, Scully then synthesizes these claims.

*Two hundred years ago it was close to impossible to contemplate spirituality without referring to religion. However, since the development of the human ego has become self-referential, self-obsessed, and disconnected from notions of external authority in spiritual and emotional matters, because of the discovery of self-analysis (a celebration of the unconscious) our ideas of spirituality have become anachronistic.*

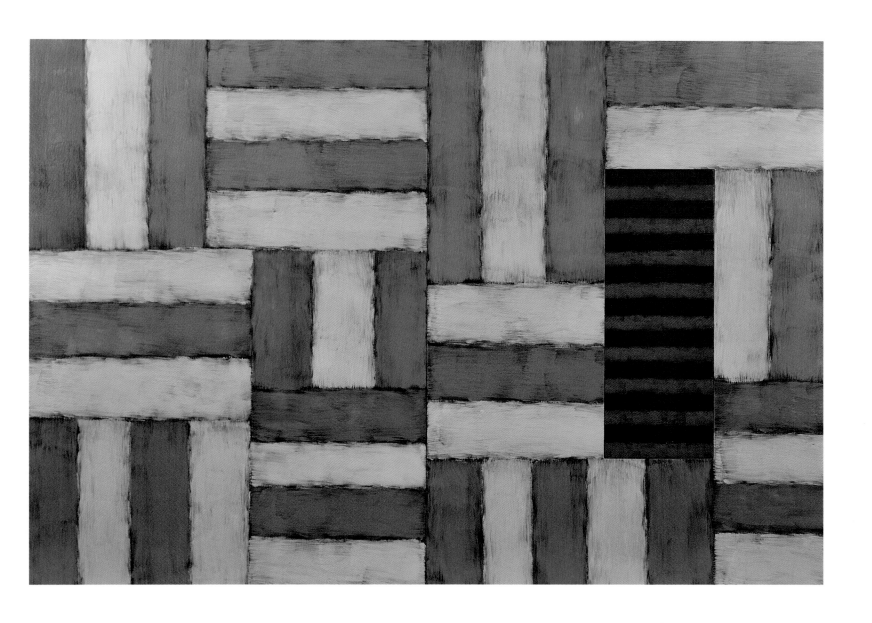

*Gabriel*
1993
Oil on linen
102 x 144 in.
259 x 365.8 cm

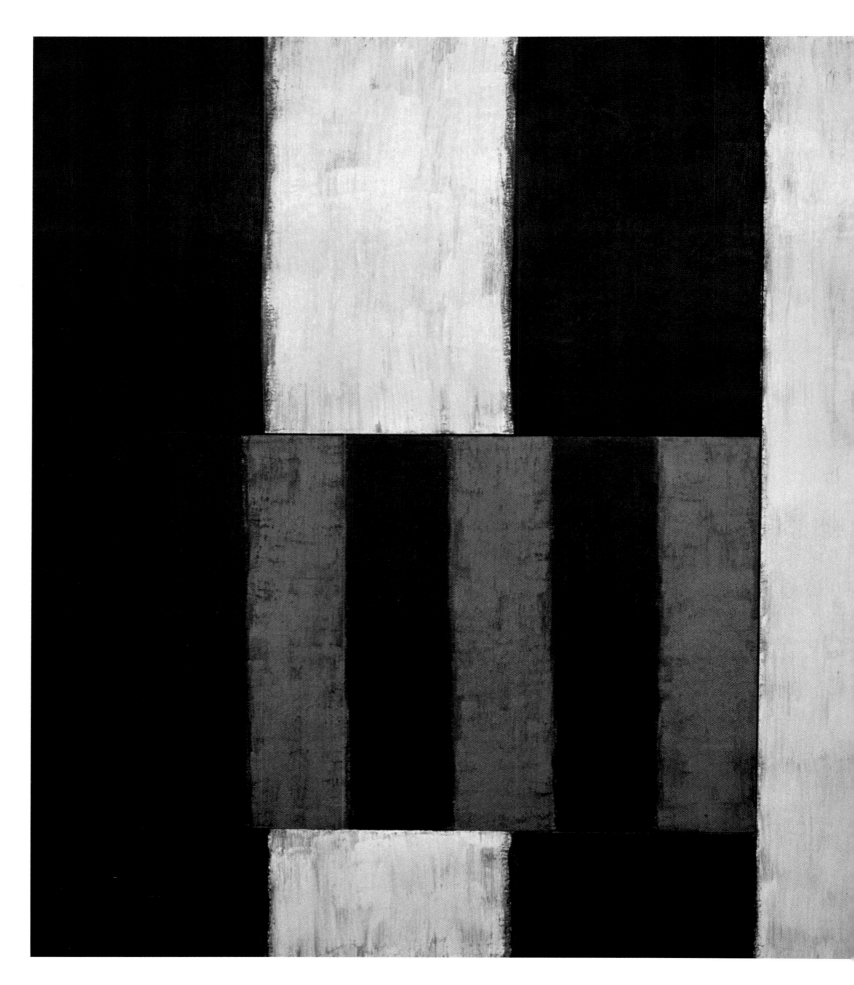

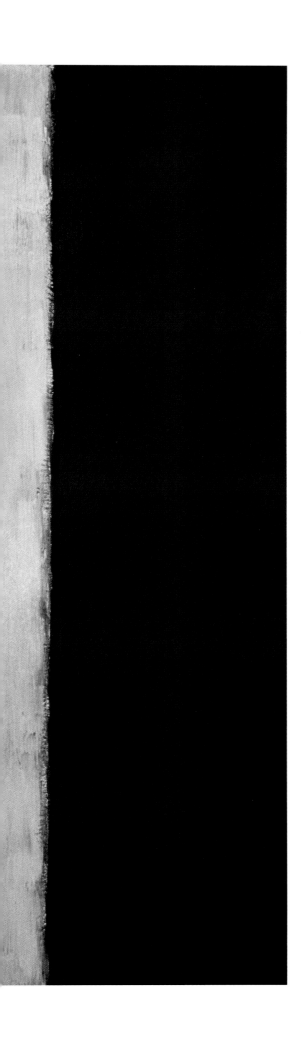

*Cathedral*
1989
Oil on canvas
98 x 126 in.
248.9 x 320 cm

*Boris and Gleb*
1980
Oil on canvas
96 x 35 in.
243.8 x 89 cm

*Saints Boris and Gleb*
14th-century icon
76 x 37³/₈ in.
193 x 95 cm

Having left behind his Catholic childhood world, he still retains some of its values.

In Scully's painting, which invokes the sacred without using traditional Christian imagery, spirituality is part and parcel of a multicultural world.

*We are in a time when it would be difficult to find two belief systems concerning spirituality, belonging to two different people, to match perfectly. In a time of intellectual and spiritual anarchy the most we can aim for are degrees of similarity. Our sense of certainty is gone.*

Each person has equal value – differences therefore should be valued and celebrated. To better understand the significance of that claim, look briefly at *Cathedral* (1989), a very literal painting showing the essence of a cathedral, massive vertical ambition headed straight up. All of the stripes are vertical and the very simple colors were changed many times – "it has a lot of dirt and, also, a lot of light in it." You look at something big that pushes you back, while a smaller element pulls you in and so there's a certain ruggedness in trying to deal with it as a physical thing. A magnificent cathedral feels a little oppressive to a working-class Irishman.

Scully *is* fascinated by the mysteries of the obvious, which he finds in all successful art, even that which does not speak to his concerns.

*[Barnett] Newman, in his time, what could be most obvious? Put a big stripe in the field. That was unpretentious and elemental. Warhol's technique seems obvious. Take a picture of Marilyn, print it like an industrial Matisse. You take something that exists in the world and you repeat it.*

In finding what seems ordinary deeply mysterious, Scully invokes a very traditional religious way of thinking. What he himself does, equally obvious, is repeat the simplest unit, the stripe, in varied colors and widths. This stripe thus is his subject, as Cézanne's apples, Morandi's bottles, and Matisse's odalisques were theirs. His art is deeply expressive in an essentially democratic way for, as Scully says, "there's nothing more special about me as a human being than any other human being."

Scully's verticals and horizontals are not physical vehicles reaching towards the transcendental, for he rejects that early modernist view of spirituality.

*Mondrian and Kandinsky and Reinhardt, they were concerned with solving planar problems. I'm much more concerned with giving my work a kind of content. A kind of stand-in for a figurative content, a traditional content.*

In the late 1970s, Joseph Masheck linked medieval and contemporary sacred art. "We were both interested in the same issues," Scully recalls, and so it was natural for Masheck to champion his friend. But Masheck's aesthetic, too paradoxical to inspire emulation, did not catch on. And Scully has never relied upon abstruse theorizing. "I don't really have ideas. I don't like ideas." His aesthetic has always developed directly from immediate practice.

When an old master shows the annunciation or crucifixion, then whatever his personal beliefs, his paintings deal with religious themes. But how can Scully's stripes convey sacred meanings? *Boris and Gleb* (1980) is named after a fourteenth-century icon. The Russian picture shows the two martyred saints holding their swords, standing next to each other. How can Scully's very willful minimalist painting, with two fields of stripes forcing light to emerge from darkness, also be *about* Boris and Gleb? Merely borrowing the title is not enough to convey that meaning.

Consider *Adoration* (1982), whose title refers to the adoration of the Magi. We see standing figures, three on the right, two on the left, around a center core, the Holy Family. Then Scully did a very different picture when a crude hand-painted sign outside a lower Manhattan post office inspired *Heart of Darkness* (1982). He was looking at African sculpture and reading Joseph Conrad's novel at the time. When making the work, he was:

*Adoration*
1982
Oil on canvas
108 x 156 in.
274.3 x 396.2 cm

*reacting against … a certain tendency in American abstraction to make a tautology which is something, to my mind, that is a rather tight argument, but it's also airless. It doesn't really open itself to the world and, to me, that is an enormous problem for the abstract painter.*

The black of darkness is everywhere, even intermingled with the stripes on the right. *Adoration*, presenting the life-giving qualities of light, which make the colors throughout that painting come alive, metaphorically presents Christ's union of spirit and flesh. *Heart of Darkness*, about the savagery of European civilization in colonial Africa, ominously shows darkness on all three panels. This contrast helps identify the sacred concerns of *Adoration*. *Boris and Gleb* conveys sacred concerns, I would suggest, because its colors and format are austere, because it has a striking physical resemblance to an icon, and because its title contrasts it with Scully's more secular pictures of this period.

Just as old masters painted religious subjects one day and pagan mythologies the next, so in 1982 Scully's style was elastic enough to yield first *Adoration*, then *Heart of Darkness*. The next year he made another painting with a religious theme, *Maesta* (1983), named after Duccio's *Maestà*. *Maesta*'s side panels evoke the spirit, and the central panel, the body. Renaissance painters set their most important figures in the center, which for Scully, who does not paint hierarchical triptychs, often is the transitional panel. Placing the Madonna on a side panel would create "a truly democratic anarchistic triptych," like his *Maesta*. As irresistible as a train, his massive horizontals push into the intense reds and blacks and the frail stripes at the right. Color establishes a close relationship between the three panels, linking the horizontal stripes on the left to the narrow

*Heart of Darkness*
1982
Oil on canvas
96 x 144 in.
243.8 x 365.8 cm

*Maestà* (central panel)
DUCCIO
1308–11
Tempera on wood panel
84 1/4 x 162 in.
214 x 411.5 cm

verticals on the right. Scully quickly secularized this sacred painting in *Molloy* (1984), turning *Maesta* inside out. Verticals surround the insert painted the colors of fields and flesh; Beckett's novel provided the title.

Painting both sacred and secular pictures, Scully excludes no subject, neither sexual desire nor death nor just the felt pleasures of a beautiful day, from his art. He has made only a few paintings with explicitly religious themes, but until the late 1990s all of his work deals with what he calls doubleness.

> *I want my paintings to express the sentiment that things are more than one way. It's not a question of making something perfect, it's a question of making something true. Something that can reflect the dimensionality of the human spirit within the grid of our world. We have more than one soul.*

We are physical, but we want to be both physical and spiritual. We believe many contradictory things at the same time – art should reflect our lives.

In *Vita Duplex* (1993), for example, the all-over background is interrupted, without apparent provocation, by a vertical panel with four rectangles. "In the twentieth century there has been a schism between the concept and the physical manifestation of that concept." Scully associates this dualism with Mondrian "who as a painter sitting solidly on the cusp between the more emotional indulgent painters and the cerebral conceptualists exemplifies this schism physically. The crisis of our age." *Homo Duplex*, also 1993, a related picture, sets a window in a "Plaid." The title, describing any stretched-out alien state of mind, comes from Conrad, who called himself a Homo Duplex. And *Body* (1993), a very physical painting, heavy and passionate, was reworked, painting wet into wet, to get the shimmering quality. The window interrupts that field, set close within but apart, just as, according to classic Cartesian philosophy, the mind relates to the body. Setting his window with fleshy orange within the field of cerebral gray stripes, Scully offers a strikingly anti-Cartesian vision of the self, showing the body held or imprisoned within a gray all-over background.

As in these paintings from the early 1990s, Scully often employs old master devices to abstractly present sacred themes.

> *We've invented the window as a way of being in one situation and experiencing another situation, which is a fantastic human invention. That's really part of our brilliance that we've managed to create something architecturally that allows us to have a double experience.*

*Maesta*
1983
Oil on canvas
96 x 120 in.
243.8 x 304.8 cm

*Molloy*
1984
Oil on canvas
96 x 122 in.
243.8 x 309.9 cm

148

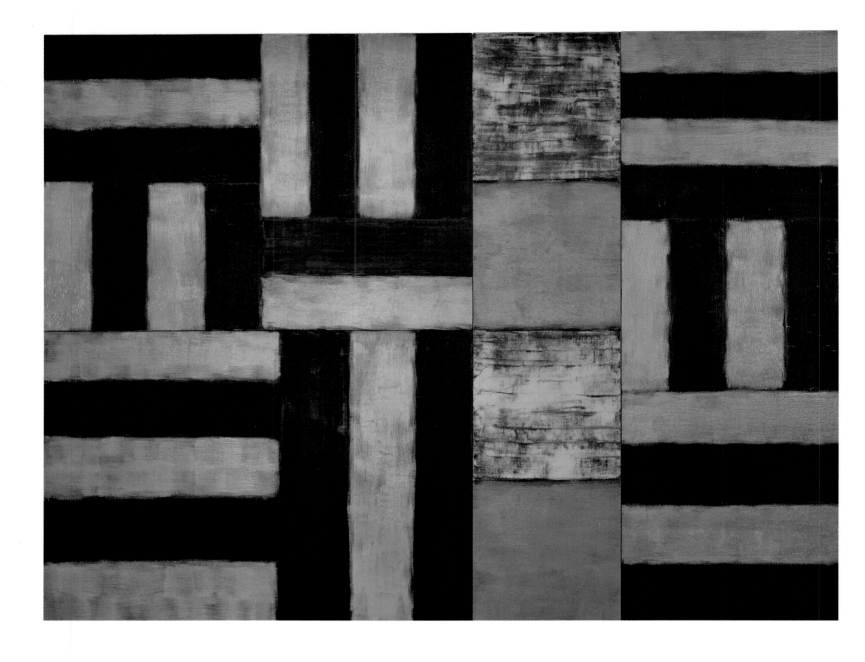

For Matisse, by creating a figure-ground relationship, a window opens a view and so "is not simply an architectural device, it's about two realities." Matisse's windows are about the place of the sacred in modern life; Scully's, metaphors for hope, insert another reality in an otherwise obsessive field of stripes. "By closing the space down, by destroying the space and bringing everything onto the same surface I try to empower the persons looking at the painting, to be involved in a way empathetically where they complete the painting themselves." Matisse often depicted beautiful women in golden rooms, his inherently harmonious models filling the space with light, transferring the charm of their bodies onto the otherwise banal room. Scully's subjects mostly are not harmonious. Matisse's stimulus was the sensuality of the model – the beauty of his images the objective correlate of his pleasure in her beauty. Scully's pictures are abstract – that option is not open to him.

In thinking about sacred painting, Scully aligns himself with Rothko. The austere seriousness and emotional intensity of his art "allow him to stand alongside Cimabue and Titian: two

*Vita Duplex*
1993
Oil on canvas
100 x 130 in.
254 x 330.2 cm

opposite
*Homo Duplex*
1993
Oil on linen
100 x 90 in.
254 x 228.6 cm

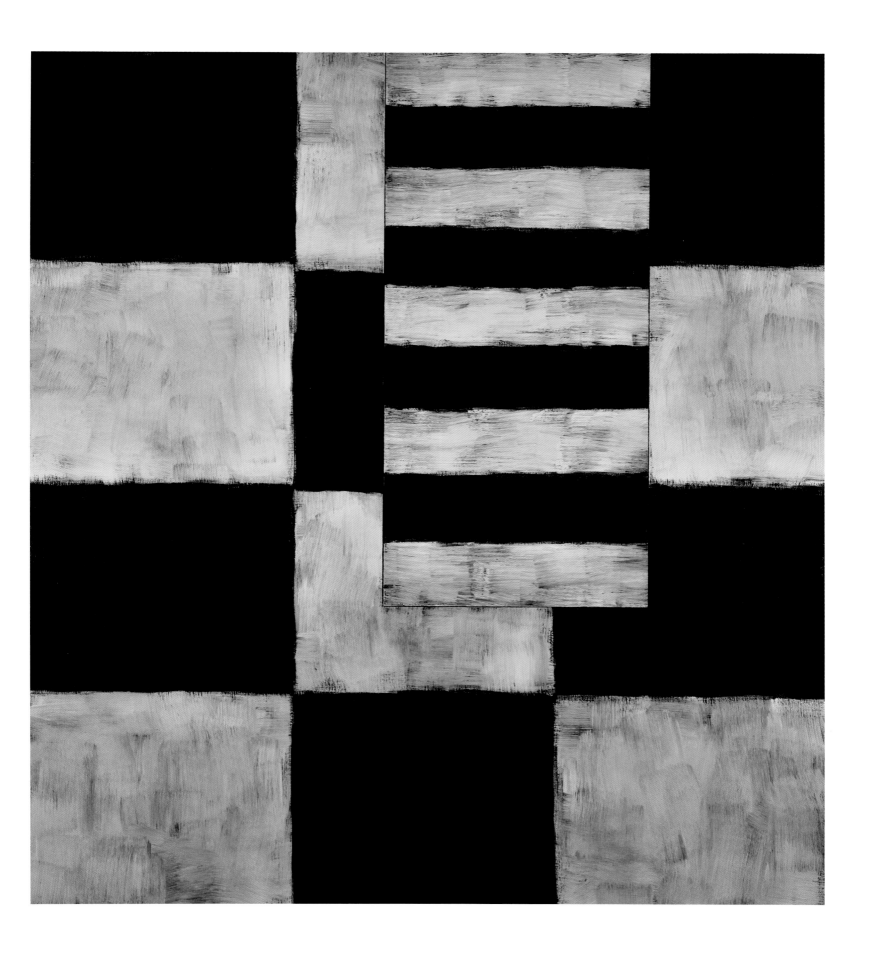

other great transcendentalists. I am committed to the perpetuation of this heroic line." This, I am sure, is why the Romantic landscapes of Caspar David Friedrich spoke to Scully when

*I had an experience in the snow. I stood by the side of the road in France, and it was really the same experience literally as standing inside one of these paintings. Everything was so still, so frozen – the air was clean, bright, pure, the moon was whole. I hadn't had that experience before, I hadn't related that experience to his paintings.*

Friedrich's combinations of realism and physicality also excite Scully because they anticipate Rothko. And he greatly admires Morandi, "the ultimate reverential artist," while recognizing that his own relationship with the world is more "lustful." Unlike a formalist, Scully seeks emotional experience – and all of his art is driven by sexual energy.

We can understand Scully's individual works of art because he has made many paintings. We compare his somber *Heart of Darkness*, for example, to the exuberant nearly contemporary *Angel*. If he had died right after painting *Backs and Fronts*, what would we have made of that painting? Creating his style required faith in his future. Now that he has made such a splendid variety of paintings, that faith is justified. In 1981, Scully found his style. In the late 1990s, he extended that style dramatically. *Backs and Fronts* rejected his earlier style. His equally extreme 1990s development involved a less radical break with the past. After 1981, he never again made tight stripes. In 1983, Scully, noting that he had been working with bands, lines and stripes for a long time, was thinking about the future of his art. "I try to make the paintings as extreme as I can.… My work is an attempt to release the spirit through formal strength and very direct painting." He wanted to extend dramatically the expressive and formal range of his art. In the 1990s he did just that.

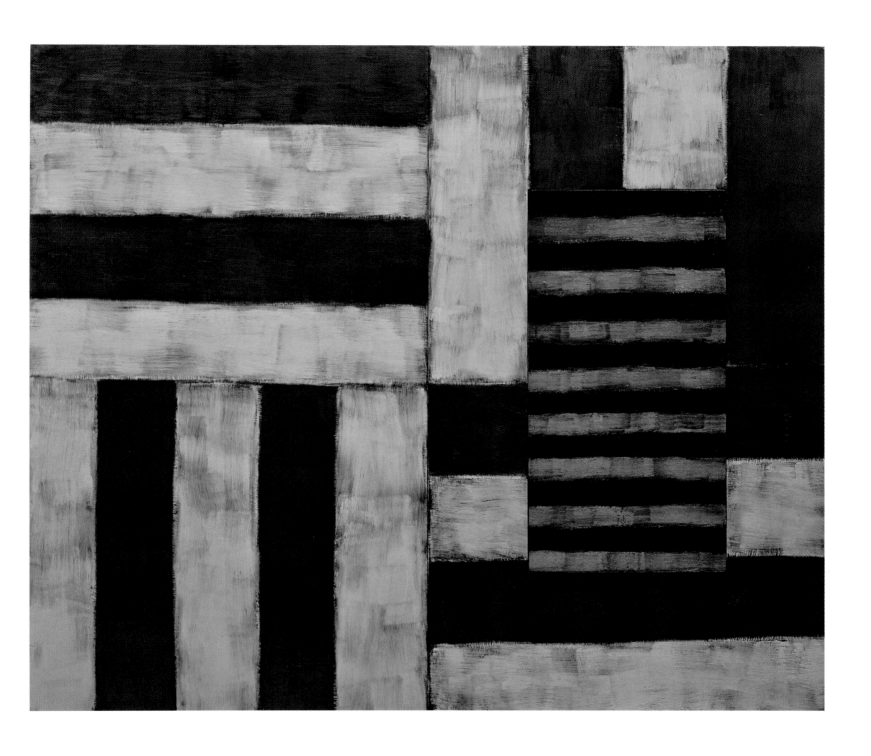

*Body*
1993
Oil on canvas
84 x 96 in.
213.4 x 243.8 cm

153

# Chapter 6    Art on paper

*A painting cannot look visionary because it already is what it
aspires to be. But a print in a sense may have a visionary aspect
because it implies something bigger. And that can be very affecting.*

*Untitled*
1969
Gouache on paper
12 x 9 in.
30.5 x 22.9 cm

Some painters are decisively influenced by artistic concerns extrinsic to their painting. Andy
Warhol, for example, devoted much attention to films and photography, to his journal and
books, and to The Velvet Underground. His development after the 1960s depended in large part
upon these activities. Through the time when he did *Backs and Fronts*, Scully was essentially a
painter. He made an etching in 1968, a series of gouache works in 1969, a silkscreen with water-
color in 1972, and another etching in 1982. But only in 1983 did he start to work intensively with
printers. He was inspired by a Jasper Johns print retrospective.

> *I then was convinced that it was possible to make something absolutely magnificent as a tandem
> body of work to another body of work. I decided to commit myself very deliberately to trying to
> make a good number of prints most years.*

In the early 1980s, Scully's paintings informed his art on paper, but by the end of that decade and
in the 1990s, the drawings and prints began to influence his paintings, which became less physi-
cal, more luminous, and more consistently lyrical. And in the late 1990s, doing photography had
an enormous effect on his painting.

As the epigraph for this chapter indicates, Scully dramatically contrasts his working tech-
niques in painting and art on paper. But he also describes these activities as having a similar
structure.

> *I draw where I am. I'm not doing a drawing and blowing it up, or transferring it. Everything I do
> is where I am now. If I'm making a line now, that's the line that I'm making right now. When I'm
> painting, I'm not thinking about something that's different from what I'm doing. I'm painting
> everything to be exactly what it is.*

Matisse worked from a model, showing her from where he was while drawing her. The difference
in scale between paintings and drawings mattered a great deal to him. But since Scully does not
use models, what does he mean by saying that he draws "where I am?" His stripes are literal picto-
rial elements – he is not representing the repetitions of the architecture he sees! And this puzzle
leads to another. Scully thinks drawing important because "it proves the work, it makes it more
or less believable. If an artist is no good at drawing, it always bothers me; that's why I've tried
to develop my drawings and my prints and my paintings, all major bodies of work ultimately."
The first part of that statement, too, seems surprising. How can drawing make his abstract paint-
ings believable?

In general, drawing matters more to figurative artists than to abstract painters. Drawing was not a major concern for either Mondrian or Rothko. But Scully wants his art in all media to be fully realized. And because he started his working life as a printer, he enjoys making art on paper. He wants to make huge paintings, medium-sized paintings, small paintings, etchings, line drawings, huge prints, small prints, watercolors – "which are the ultimate act of delicacy and intimacy" – and also pastels, which are big weighty works on paper. Articulating surfaces like a figurative painter, he makes abstractions with "the body and reality you see and feel in figurative painting." Working from "where I am" matters to Scully because he thinks of drawing more like a figurative artist than a typical abstract painter. "Sometimes with the paintings, I don't even do a little sketch, I don't even rehearse at all. I just make a painting because I conceive of it in that medium and on that scale." When Matisse paints stripes behind his model, he represents something that actually exists. And when he draws, he depicts her on a different scale, in another medium. But when Scully paints or draws a stripe, or makes a stripe in pastel, his stripes are purely abstract.

Constructing relationships in the act of painting, without knowing how his pictures will resolve, Scully often honestly shows conflict. Unity is achieved only after taking into account rupture, and the possibility of lasting deep internal discord. Imperfections, faults, and mistakes all have their parts to play.

> *Beauty is not beautiful, it is tragic. Beauty stands alone. It doesn't collaborate with the "what already is," the "status quo," as does the decorative and the ornamental whose purpose is to "lift" what already is. Beauty never collaborates: it separates itself. It stands in opposition. As an example of the difference between art and life. As an example of what is lost in life, and of our failure to make a beautiful world. This is the tragedy of beauty in art. It is exiled.*

For Scully, a quintessential Romantic always ready to struggle, beauty is not at home in this world.

Matisse breaks up his paintings into bits and pieces, which he then patches together, "pressing his model into his grids." Scully's procedure during the 1980s was similar. But where in much abstract painting, as also for Matisse, the stripe reinforces the picture edge, Scully uses stripes more aggressively. Viewing Matisse's paintings and drawings, we admire his skill in representing models. Looking at Morris Louis's stripes or Kenneth Noland's pictures, we appreciate their ability to float acrylic paint on unsized canvas. Scully, by contrast, works more like Matisse, drawing "where I am" because his small and large works on paper are self-sufficient, not mere images of paintings. A stripe in his pastels, etchings, monotypes or watercolors thus has its own validity. Because it is not a small version of a painted stripe, it reveals the distinctive properties of its medium.

Scully paints on canvas in a vertical posture using sweeping arm movements with a large brush. But his watercolors are made leaning over horizontal sheets, using brushes with fine hairs. Paul Klee's art is an important model for him because "the medium of watercolor … allows … what I would call a kind of geometric intuitive meandering impulse." Scully's paintings, delicate in their coloring, often are roughly assembled. Because his ethereal works on paper are on one continuous surface and (except for some prints) relatively small, they appear unified, even when their color contrasts are as dramatic as in his most extreme paintings. Scully thus adapts his scale and working technique to very diverse situations.

Drawing stripes is often how Scully communicates – it's how he expresses himself. In 1983, immediately after receiving his Guggenheim fellowship, he made a drawing on the list of Guggenheim fellows labeled *Desire*, showing two of his three panel paintings, with broad stripes, the bottom one crossed out. Often he illustrates faxes with a sketch. When I was writing this

*Untitled*
1969
Gouache on paper
9 x 12 in.
22.9 x 30.5 cm

*Untitled*
1969
Gouache on paper
9 x 12 in.
22.9 x 30.5 cm

*Untitled*
1969
Gouache on paper
9 x 12 in.
22.9 x 30.5 cm

Sean Scully at the
Garner Tullis workshop
1987

book, he sent a drawing of the animal hospital he established as a teenager. In the mid-1930s, Matisse drew the model very close up, sometimes showing infinite regress, his picture containing a picture of his hand making the drawing showing her; and around 1940, he experimented with Cubist techniques. The subjects of these drawings are different from, sometimes more radical than, his paintings. By contrast, Scully's works on paper mostly employ motifs already used in his paintings. As in paintings, he sometimes moves the inserted window from the edge, with two sides touching the larger body of stripes. Or he puts the corner, where three sides were touching, into the field of stripes, with four sides touching so that the window is a figure, the ground in front of his background stripes.

In the 1980s Scully did many pastels, woodcuts, and etchings. The woodcut *Standing I* (1986) juxtaposes two fields of stripes; in *Passage* (1991), windows are superimposed on the wide vertical stripes at the left and the diagonals on the right. The small woodblock *Narcissus* (1991) looks like the painting *Narcissus* (1984) reversed left to right, with dark background colors and a bright insert. But since on paper the top panel cannot extend forward from the wall, the verticals at the bottom, which in the painting press down against the bottom panels, become horizontals. And here, as often with his woodcuts, the stripes show the grain of the wood used in printing.

Scully's paintings bring in proximity things that don't necessarily belong together. His pastels, by contrast, are unified images. When he compares making them to putting on makeup, it's useful to recall his strong preference for the "feminine" Matisse over the "masculine" Picasso.

> There is this dust on the paper, which I rub in. I push it right into the paper with a piece of cloth or paper or my hand. Once it's embedded into the surface, I fix it. And then I work it up, adding another layer … until the pastel starts to stand up a little from the paper.

Unlike a painting, a pastel can be made in a single day. Some Scully pastels are given evocative titles, like paintings, but others are identified only by date. When Scully was an apprentice commercial printer, using red ink after many hours of work with black provided intense pleasure. "I like color because you can't control it the way you can form. … The only way I can work with it is

*Wall of Light 4.84*
1984
Watercolor on paper
9 x 12 in.
22.9 x 30.5 cm

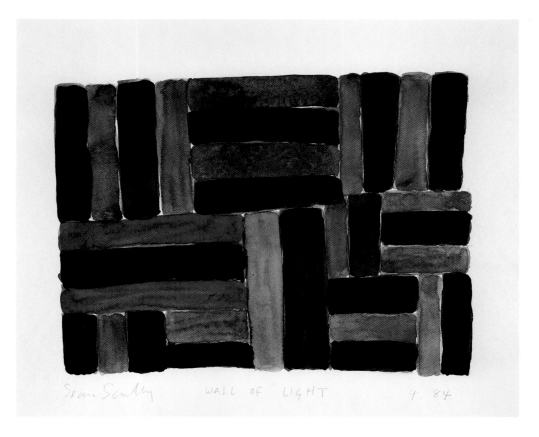

*Desire*
1985
Etching
22¹/₄ x 30 in.
56.5 x 76.2 cm

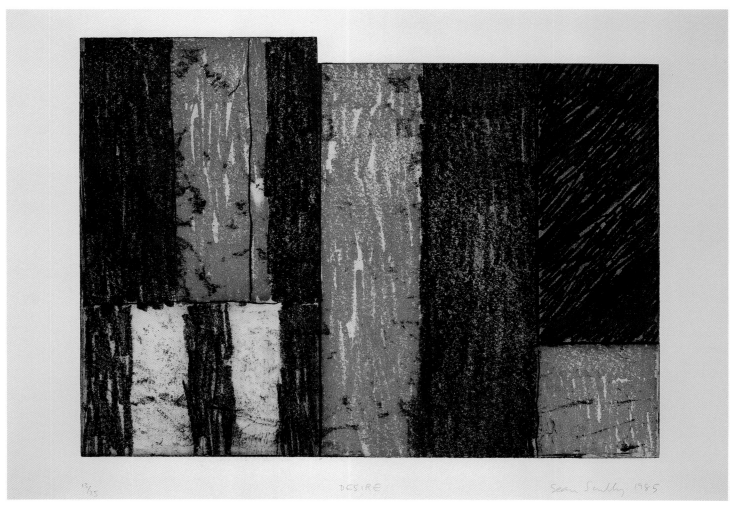

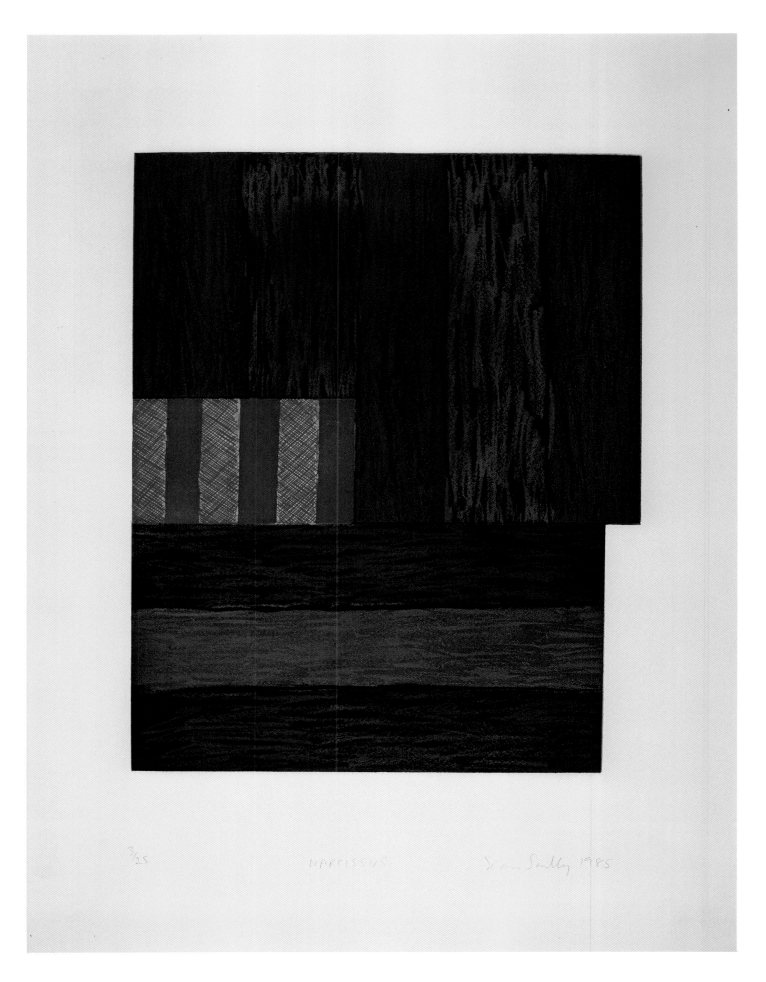

3/25                    NARCISSUS                    Sean Scully 1985

opposite
*Narcissus*
1985
Woodcut
15³/4 x 20 in.
40 x 51 cm

as a metaphor for spirit." Edges in paintings are drawn; the edges of pastels break down. Made by rubbing, not linear drawing, their soft stripes look out of focus. The colors are dark, mysterious, and layered; they don't have the surface aggression or directness of the oil paintings, or the effortless innocence of the watercolors.

> *I'm working with my hands, rubbing into the paper, flattening the material, pushing it in, so that it becomes embedded in the paper. You have no idea where they start and where they finish. In that sense, they're like the space in a cinema, whereas the painting always asserts itself as a painted surface that you can physically touch.*

Scully invests less physically in pastels than in paintings. His dry-looking monumental pastels don't have a skin, and so need to be displayed under protective glass. His paintings are shiny surfaces that often reveal layers of underpainting, visual evidence of the prolonged labor required to make them.

Making monotypes, so Scully discovered in the 1980s, involves yet other physical techniques.

> *The interesting thing … is that you don't have to force each piece to a conclusion. You can be very open ended. That's the key to using monotype. You can have many different versions of the same thing. With paintings, doing that would trivialize you. You paint out. You're striving for the ultimate version. With monotype just the opposite.*

*Backs Fronts Windows* (1991–93), more than three meters wide, like the related painting *Backs and Fronts*, juxtaposes a number of panels, but with window inserts. Painting requires adding, covering up information, but printing involves transference. "With printing, what you see is a lot more, generally a lot more activity coming through from the back." And Scully wants "to express that we live in a world with repetitive rhythms and that things are existing side by side that seem incongruous or difficult. Yet, out of that, is our truth. It expresses where we are."

The inherently repetitive rhythms of printing proved very well suited to his style. Scully shows things literally existing side by side with his multiple editions.

> *There is something very elemental about taking a plate, covering it with black material, hard ground, and then just scratching out a drawing; it's the equivalent of a line drawing. And when the acid bites into the metal and the ink sits in the metal and then it is transferred to the paper, it stands up on the paper and there is an indentation. And then what you have is the result of something that is quite mysterious as a process. Whereas with the painting, it is a direct result of putting down a brushstroke.*

*Backs Fronts Windows*
1991–93
Woodcut
42¹/2 x 125 in.
108 x 317.5 cm

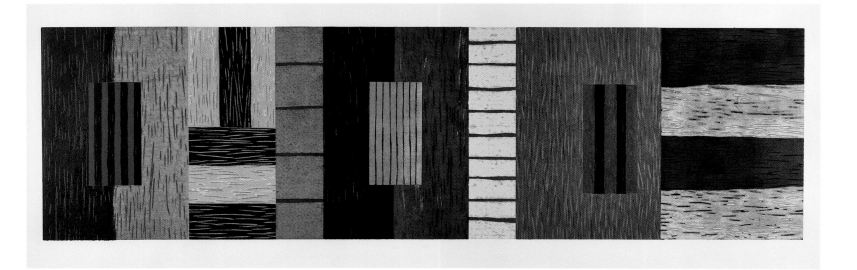

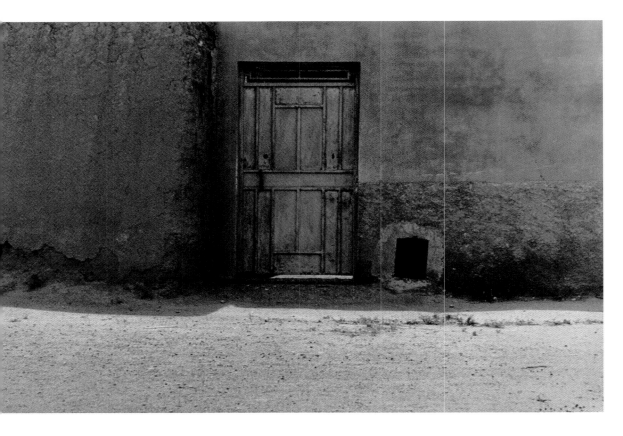
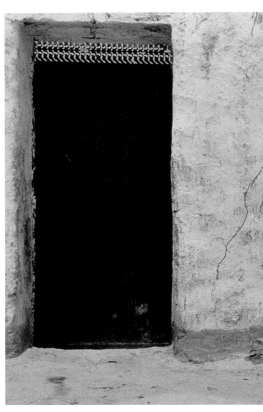

*Atlas Walls*
1996
Cibachrome prints
20 x 24 in.
50.8 x 61 cm

162

In the 1980s, as soon as Scully was intensely involved with working on paper, his prints and pastels quickly became important. By contrast, initially when he made photographs he did not think of this art on paper as especially significant for him.

While photographing his *Atlas Walls* in 1996, Scully enjoyed making art "where there wasn't any expectation or pressure." Photographs don't have the sensuality that binds him to painting. In showing (real!) architecture which looks similar to his paintings, Scully's photographs initially seemed to make his abstractions more accessible, making explicit the visual metaphors which in his paintings are merely implicit. That's why doing photography so quickly became so important for him. "I'm always after the same thing. I didn't need to experiment as a photographer." But then the very power of this obvious parallel led him to modify his painting style in the late 1990s.

Seeing that urban architecture in Scully's photographs looks like his paintings, it would have been possible to mistakenly think him a realist. In the Abstract Expressionist era, some photographers took pictures similar to those abstract paintings. But it is one thing for abstraction to draw meaning from the outside world, and quite another for non-figurative art to be implicitly representational. The photographer takes a picture of a thing already there, but when painting, Scully makes something that never before existed. Photographs always have a surface that's the

*A Corner of Barcelona*
1997
Cibachrome print
36 1/2 x 48 in. (image sheet)
92.7 x 121.9 cm

same – no two Scully paintings have the same surface. The camera creates mechanical surfaces; with painting, the surface, the color, and the way it's put down depend entirely upon the individual artist. Scully's artistic use of photography acknowledges these differences.

Matisse thought that photography threatened authentic aesthetic experience. Scully, by contrast, embraces our new technologies, for he believes that they ensure painting's survival in an era of mechanical techniques of image production.

*As the world has become more technological, a human need for mystery and the individually authentic experience has become desperate. And painting, because it is outside the technological evolutionary loop, can deal with that.*

Matisse dreamt of what he famously describes as "an art of balance, of purity and serenity, devoid of troubling or depressing subject matter." Scully, however, deals frankly with conflict and other difficult themes. When looking at his astonishing photographs, we momentarily see the real world as he does. Photography, Scully observes, has taken over the job done by Dutch painting in the seventeenth century.

*Those surfaces are machine polished, whereas in the painting we have now, the surface is the footprint, or handprint. The personality of the painting is really expressed by the way that the surface is built up. Each artist has a different idea of the surface: Barnett Newman's high-minded neutrality is very different from De Kooning's sensual intimacy.*

Scully made photographs as early as 1979, when he took pictures of the Siena doors, which were printed and exhibited only in 2001. Taking over the job of representing walls, windows, and doorways, these photographs freed his paintings to move in new directions. His photographic subjects are always banal:

*I have a perfectly normal bathroom, and I find all sorts of beauty in it. I want to take a series of photographs from this. What I do is take this very very humble subject matter, and I move it in the opposite direction – I move it into the domain of heroic ambitious art.*

His photographs could have been made a century ago. "The early photographs are my favorite photographs. I reduce it to something very primitive and I take photographs of very primitive structures." He usually presents architecture or walls absolutely straight on, never showing people. Scully's photographs depict roughly constructed buildings, often with vertical or horizontal stripes, structures like those in his paintings. When he takes photographs, he destroys their context. Without titles, it's hard to identify the locations of his scenes.

At some crucial points, my knowledge of Scully's development is limited. I can only speculate about his important early transitional works of art, *Morocco* and *Painting for one place*, for I never saw them. The one and only time I saw *Backs and Fronts*, I didn't yet know him. But, although I knew Scully well by 1996, and was driving the car when he made the *Atlas Walls* photographs in Morocco, initially I had no idea what he was doing. We had been in Marrakesh and then Essaouira, the seaside town where Bernd Klüser photographed Scully's sand drawings. We went over the Atlas mountains, a rough drive on steep narrow roads past the only Moroccan mosque foreigners can visit, Tin Mal, to lunch at a lavish, gated hotel from the world of the old regime. Scully didn't photograph any of these obviously picturesque places.

In mid-afternoon we were driving in a poor neighborhood with detached houses on both sides of the two-lane road. This area was not busy and so initially no one noticed when I slowed our big rented Peugeot, positioning it to frontally face these houses. Scully began photographing and within minutes, the Moroccan boys saw us, came out and asked for money. The camera put away, we went into a house to have tea with the men and boys, who knew some French. These

friendly Moroccans were hardly prepared to understand what Scully was doing. Tourists didn't come to this neighborhood – why did he photograph their modest houses? When I first looked at the *Atlas Walls*, I was struck by their uncanny resemblance to Scully's 1980s paintings. The photographs, too, are frontal, multicolored compositions mostly based upon a grid; unlike Scully's paintings, they include lots of picturesque painterly details. The Moroccans crudely painted their dilapidated dwellings. When they ran out of one color, they used another. They didn't take much aesthetic interest in their surroundings. Treating the Moroccan houses as found art, Scully transformed them into beautiful pictures.

Scully wasn't especially interested in everyday Moroccan life. But south of the Atlas Mountains, he found a visual culture like that presented in his paintings. The Muslims didn't see themselves in these, his terms; neither, initially, did I. In the 1990s, Scully photographed houses in Mexico, Ireland, and Scotland and, towards the end of that decade, also in poor neighborhoods of Barcelona and London. And he discovered that the bare stone walls of the Aran Islands in far west Ireland look like his stripes. These utilitarian markers, rough or smooth, coarse or elegant, heroic or sensual, as varied in their expressive qualities as Scully's paintings, surround farming and grazing lands. Once he looked, he found that the structures of his paintings existed in many cultures, waiting to be presented in his photographs.

Over and above the value of his individual paintings, Scully's *oeuvre* has a quite distinctive aesthetic value. The painting of many contemporary artists, including some justly renowned figures, is essentially predictable. Employing history in surprisingly simple ways, their art shows us the next logical step. What, by contrast, makes Scully's *body* of art unique is its radical unpredictability. Everyone knows that the development of politics and technology is entirely unpredictable. Scully reveals that the same is true of painting.

Of course the world would think it needs art that is at once cooperative and entertaining. But there's another persistent human need that is deeper and more desperately urgent – the need to know that a passionate individual can still make a difference.

Today when everyday life is ever more closely controlled, subject to the necessities of regimentation, the body of Scully's art, revealing a singular freedom, shows how much a gifted individual can accomplish.

incredibly moving and human.

It is this relationship with life that is giving me all the ideas in any work. Perhaps that is why my love affair with New York is over to a large degree. I need to streghthen my relationship with the unselfconcious and poor part of urban life. How things are before they get knocked over. These structures have a kind of nobility in the way they stand against all odds. They are not made to impress, like corporate buildings, but they have inspired decisions running through – since they are made out of bits and pieces.

So today I am working on a small checkerboard painting with a set of blue stripes put into it.

with very best wishes

Sean

Letter from Sean
1991

166

*Lost Door in Ireland*
1999
Cibachrome print
26 3/4 x 40 in.
68 x 101.6 cm

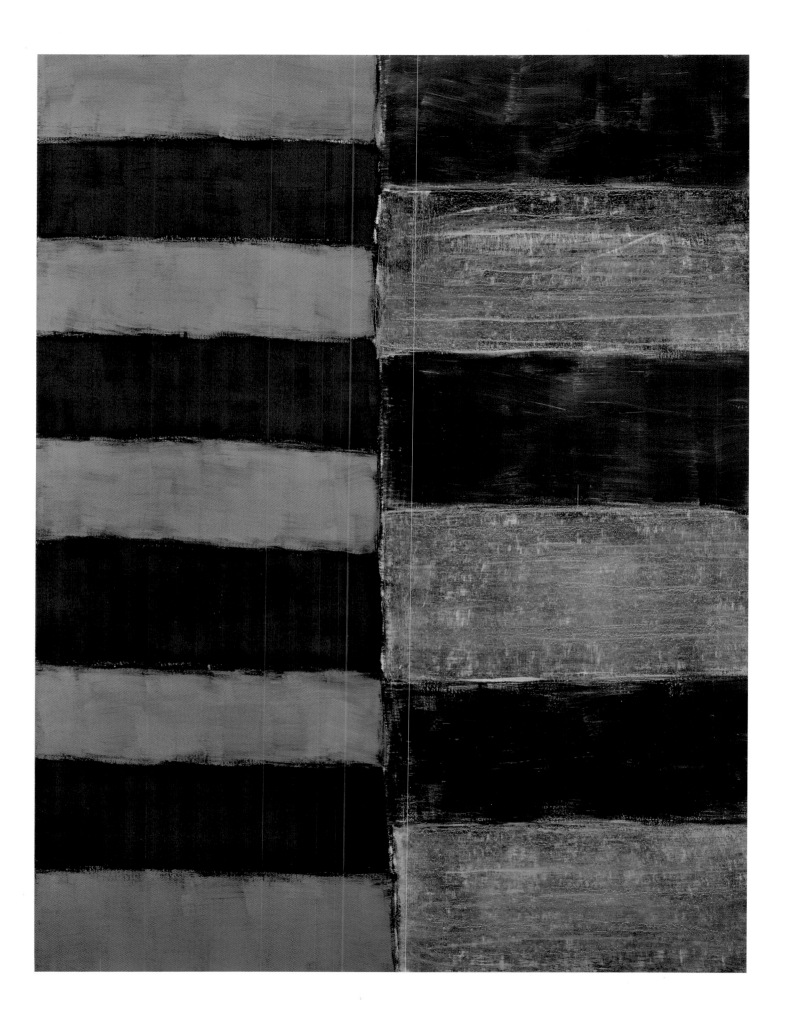

# Chapter 7  "Plaids," "Mirrors," "Floating Paintings"

*Painting is connected to the past but I really believe that my painting is all about the future. Nothing is more profound and moving and exciting [than] … to make a contribution [to] the possibility of empathetic communication. The relationship between things in the world is what we still need to discover.*

*Mirror Red Blue*
1997
Oil on linen
72 x 54 in.
182.9 x 137.2 cm

Seeing someone in a car, someone else on the street, and still other people in office buildings, you can watch diverse lives unfolding, everything happening to everyone everywhere all at once. Television viewers channel surf – we love to follow several narratives unfold simultaneously. In Scully's 1990s art, three or four distinct motifs were developed at the same time. Making art on paper in the 1980s taught him the importance of working on diverse scales at once, employing the physical qualities of different media. Applying that lesson to painting, he then radically extended the metaphorical expressiveness of his art. Very diverse musical and visual repetitions are juxtaposed in the city. "We believe many contradictory things at the same time" – we see and hear so many rhythms, all at the same time. And so now in the 1990s the variety of Scully's art reflects our real everyday experience.

When an artist is young, it is natural to understand his development by identifying his sources. But once he finds a style, that way of analysis is no longer productive. The philosopher Arthur Danto, Scully's great friend, has argued that we need narratives to make sense of our experience. Narratives are important to historians because they explain political and social change. And they are very important in art – narratives made by poets and painters provide intense aesthetic pleasure. Danto's account helps us to understand Scully's development. In the 1980s, Scully's paintings told stories. The richness of his art depended, so we have seen, upon its narrative engagement with everyday experience. In the 1990s, no longer trying to compose one body of art, Scully painted in several distinct styles simultaneously. "We can't make simple works of art anymore," he said, because "false clarity is repressive and artificial." He found how to make a more complex body of art.

By conjoining two or more distinct opposed elements, Scully's 1980s paintings naturally suggest anecdotes about relationships. Dividing fields of stripes with a window or juxtaposing two fields of varied colors and widths inevitably implies a narrative. Why does a massive panel crush a smaller one? How are opposed units visually linked? Where is a harmonious field of stripes interrupted by a window with disruptive colors? We tell stories to answer these questions. But in the early 1990s, Scully developed three motifs undercutting such visual storytelling. "Plaids," all-over patterns, deny narrative. "Mirrors," starkly juxtaposing self-sufficient panels of broad stripes, do not suggest stories. And "Floating Paintings," set at right angles to the wall, elide those oppositions that suggest anecdotes.

Scully's stripes derive, so we have seen, from the deconstruction of superimposed verticals and horizontals forming a grid. A "Plaid" is a grid, with successive squares in different colors, painted as if

two distinct stripes had been interwoven. A stripe has to follow the direction given but in a "Plaid", "the paint can go anywhere." A checkerboard is a game board where things happen. Scully's "Plaids" play on, and extend, that simple idea, for one beautifully painted "Plaid" is decorative and harmonious, but setting two with different colors and dimensions alongside one another creates strong visual tension. *Union Black* (1994), for example, brings together two "Plaids" with the same dimensions but different colors. The "Plaids" of each panel of *Catherine* (1993) and *Union Yellow* (see p. 126) are well behaved, indeed almost decorative, but set together they create conflict, which prevents the paintings from becoming static. Were the black, light black, and bright gray panels in *Union Black* the same size, then the picture would be decorative. But as it is, color gives enormous energy to this composition.

Scully's "Mirrors" conjoin two fields of horizontal stripes with different widths and colors. Ordinary mirrors are suggestive for figurative artists, whose representations are often said to mirror appearances. And mirrors fascinate philosophers, who argue that mental representations give us knowledge by mirroring the external world. Arthur Danto selected the etching *Large Mirror III* (1997) as the jacket illustration for his collected essays, "in part for its beauty, but also in part for the fact that it relates to the representational themes of these essays. The mirror is, after all, the ground analogy for the mind, and its failures and successes are slyly mapped in Scully's marvelous composition of thin and thick bars." Scully's "Mirrors," like such early diptychs as *Quintana Roo* (see p. 87) or *Boris and Gleb* (see p. 142), allude to this dualistic philosophical view

*Union Black*
1994
Oil on linen
86 x 128 in.
218.4 x 325.1 cm

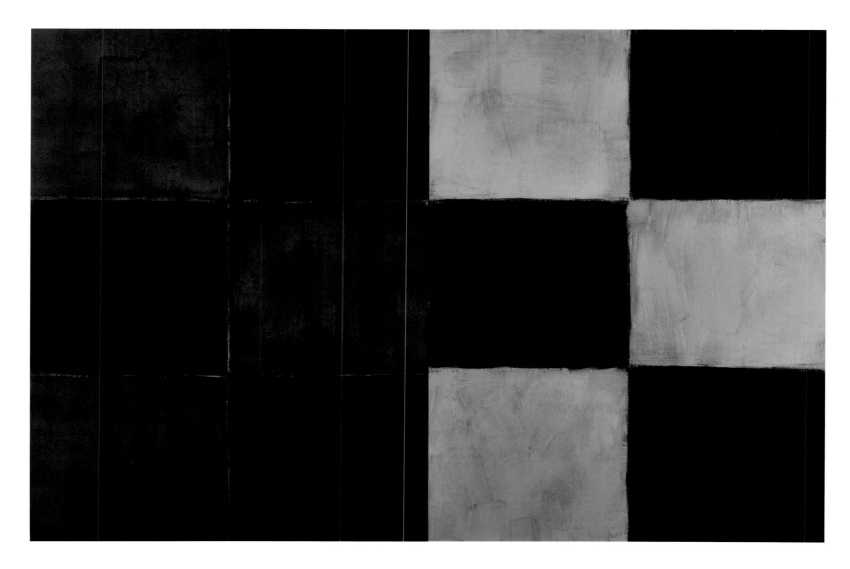

of the self in relation to the external world. When two panels of stripes are conjoined, we seek some visual relationship between them. In *Mirror Red Blue*, although the narrower reds and oranges on the left do not mirror the cooler broader blues and bluish white on the right, there are visual connections left to right. Which side is the original – and which is the mirror reflection? That question is unanswerable. In *Four Large Mirrors* (1999), varying the colors and widths of stripes creates a complex sequence of panels which fail to match, left and right. Using his own style, Scully responds to the concerns of the post-modernists. From where we stand, the "Mirrors" make the distinction between reality and appearance, between what is and what merely is reflected, impossible to establish. But even so, in themselves these pictures are aesthetically pleasing.

The stripes on Scully's "Floating Paintings" are always vertical. Unwrapped they would constitute an all-over field, as found in his 1970s paintings. As it is, this new format, boldly original and completely unexpected, may remind you of Donald Judd's minimalist boxy sculpture or the more humanistic painted sculptures of Catherine Lee. But the rhythms of Judd's groups of unpainted boxes are too regular to satisfy Scully, and the jagged, dagger-like shapes of Lee's sculptures too intimately bound up with life in her native American Southwest to suit him. *Floating Painting Grey White* and *Floating Painting Red White* (both 1995) set stripes on single box frames. *Floating Painting Munich Triptych* (1996) displays narrow greens and whites on frames set so close together that you can hardly walk between them.

*Catherine*
1993
Oil on linen
96 x 144 in.
243.8 x 365.8 cm

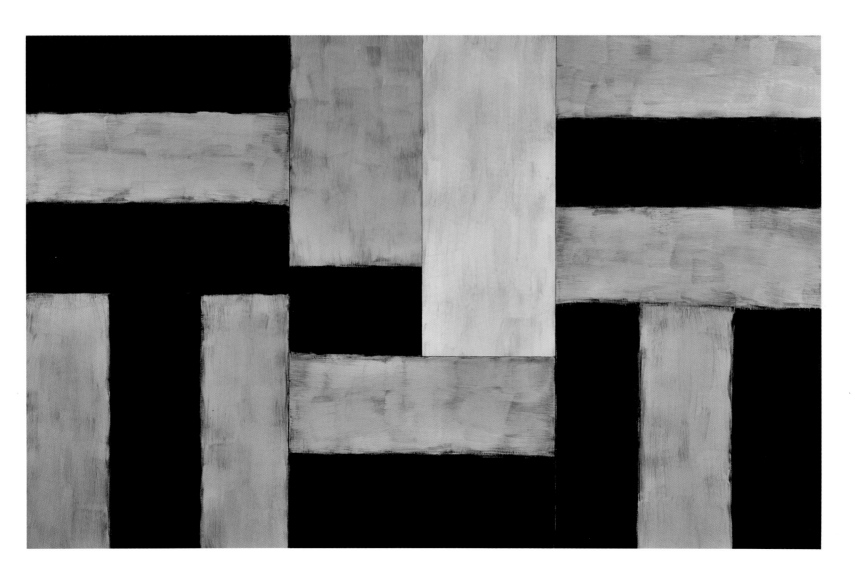

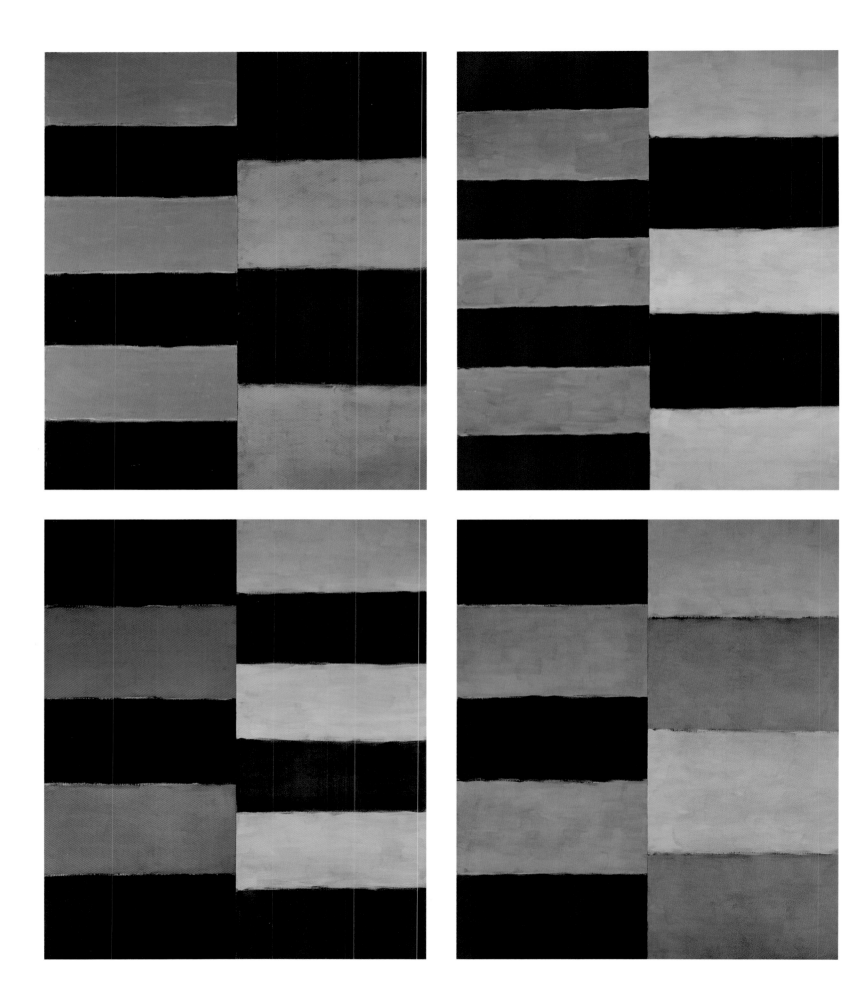

opposite
*Four Dark Mirrors*
2002
Oil on canvas
108 x 96 in.
274.3 x 243.8 cm

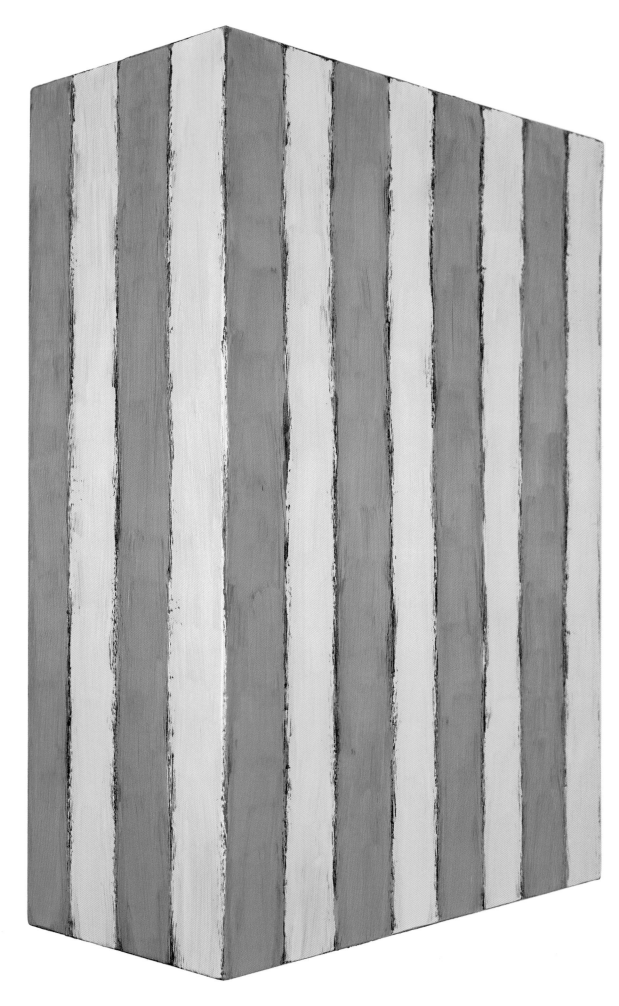

*Floating Painting Grey White*
1995
Oil on metal
24 x 16 x 8 in.
61 x 40.6 x 20.3 cm

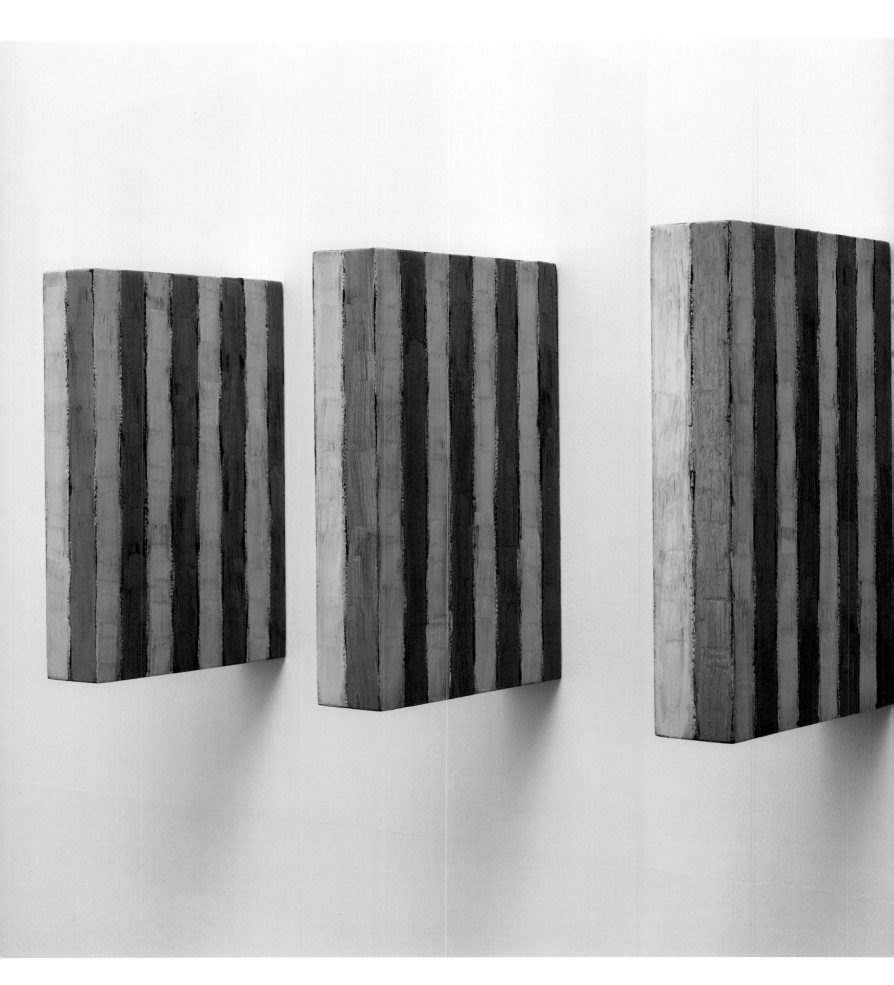

*Floating Painting
Munich Triptych*
1996
Oil on metal
15 x 10 x 2 1/2 in.
38.1 x 25.4 x 6.4 cm

*Hammering*
1990
Oil on linen
110 x 174 in.
279.4 x 442 cm

When making the "Floating Paintings," Scully was inspired by thinking about what was inside, as defined by the shape of the box; about the way that the shape was painted; and about how these shapes were wrapped around the box. He imagined a place that you could know or feel but not see, a secret space pressed against the wall.

*These painted metal boxes occupy space, but at the same time they vanish, they disappear. I think that's why you call them* Floating Paintings. *They can't hold themselves as sculptural objects.*
The "Floating Paintings" are exhibited like two-sided drawings, at ninety degrees to the wall, "like a shark fin in the water." Sculpture often is meant to be looked at from different points of view, but these are paintings with the frames functioning as the canvases. Scully's 1980s diptychs and triptychs, assembling panels on a wall, come forward like relief sculptures; these off-the-wall paintings are painted on three-dimensional box structures.

In the 1990s Scully began to use a fourth related motif, developed slightly earlier, an all-over classical composition, as we identified it earlier, using "T"s made out of single vertical and horizontal stripes. In *Hammering* (1990), a large field of black and whites, the repeated "T" motif, inverted in the left and center panels, set upright at the bottom right hand corner, seems to whirl, moving in the way that Pollock's drips run across *his* paintings. As your eyes seek some focus point, you are unsure when, if ever, they will come to rest. And yet *Hammering* is not quite an all-over painting, for the center panel bulges out. The title is the last word from the last line of Bob Dylan's "Chimes of Freedom." The song speaks of "mad mystical hammering," a phrase which

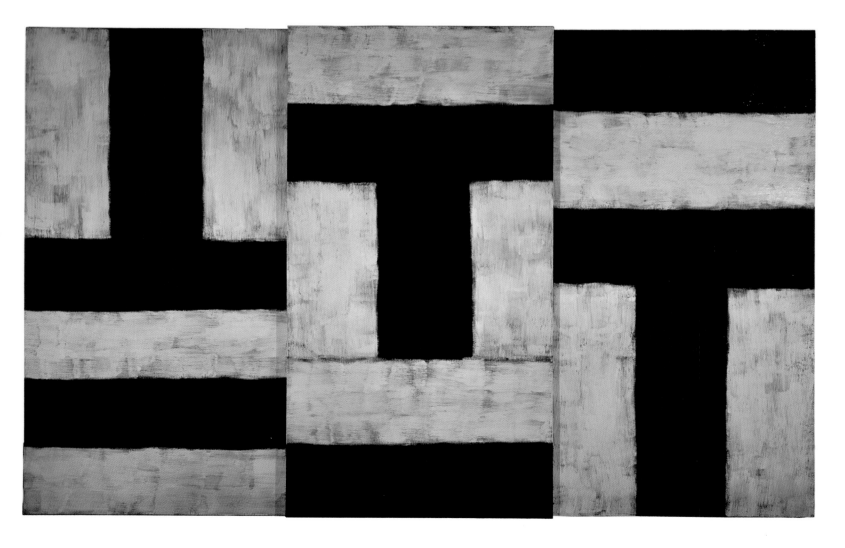

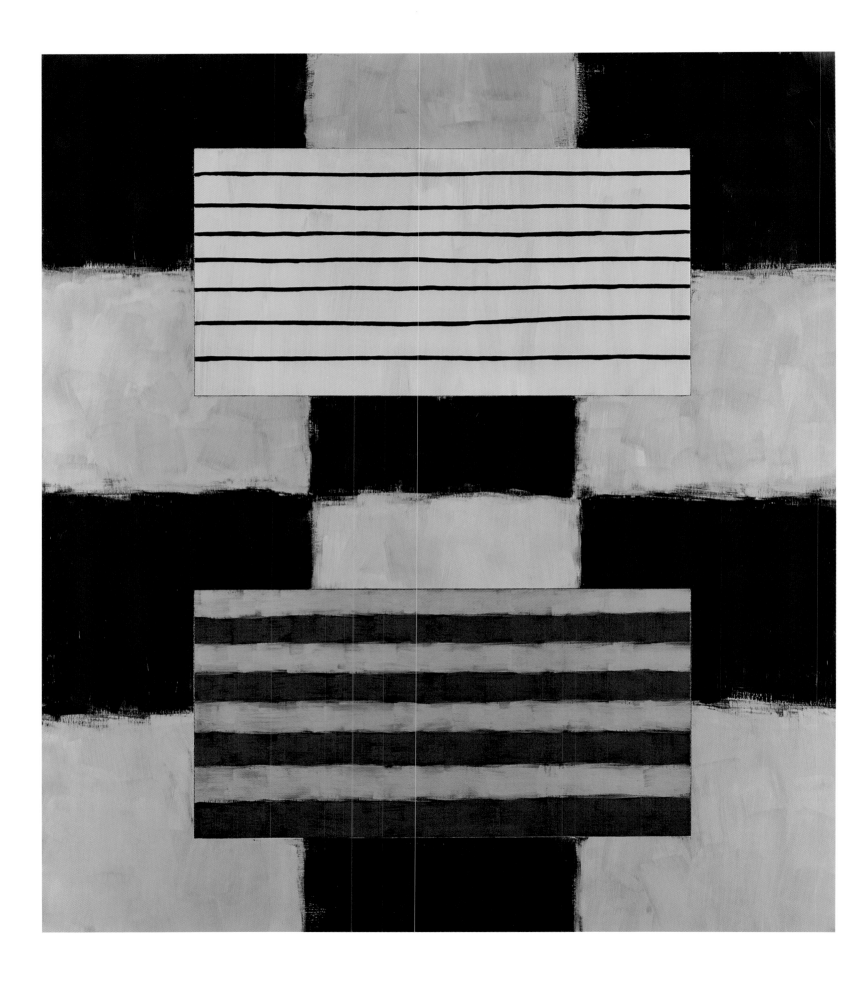

describes the sound and insistence of *Hammering*, though not its calm, even serene light. Soon Scully's "Walls of Light" will abolish the distinction between horizontals and verticals; this "T" motif, by contrast, strengthens that sense of direction, for here it is set in a normal, stable position, as at bottom right, but also inverted as on the upper left. "The paintings are never conclusions, and so they are never closed, and that's part of the reason that I never terminate something." Scully is, as he has often said, a dialectical painter.

In the mid-1990s, many of Scully's paintings have descriptive rather than narrative titles. "Plaids" like *Union Yellow* (1994) and *Union Blue Grey* (1998) are identified by a generic title "union" signifying bringing together – supplemented by an identification referring to their colors. "Mirrors," whether they be pastels like *Four Large Mirrors 10.20.00* (2000) or paintings like *Four Small Mirrors* (1999) and *Four Large Mirrors* (1999), are titled by reference to their size and, when on paper, by their date of making. And the titles of the "Floating Paintings" identify them by color – *Floating Painting Grey White* (1995) – or by place, such as *Floating Painting Munich Triptych* (1996). But Scully also made many paintings with descriptive titles such as *This This* (1994), plaid on the left but with stripes on the right, or *Planes of Light* (1999), made of two windows on a "Plaid."

Indeed, in the 1990s Scully sometimes combined these new motifs and his older devices, as in the various "Passengers," in which a window is set within a "Plaid." "The insert, or the inside, is a 'passenger' within a bigger structure that evokes a kind of mother-child association, something being protected or held by something bigger." And in *Petra* (1993), two horizontal windows inserted into broad horizontals radically disrupt the scale established by the background stripes, making us move forward and backward to get them in focus. *Seal*, also 1993, setting one relatively large window implying diagonal movement off center, takes us back to his shaped canvas, *East Coast Light 2* (see p. 72). Even if we regard the cross as a formal accident, who can deny that it expresses peace, serenity,

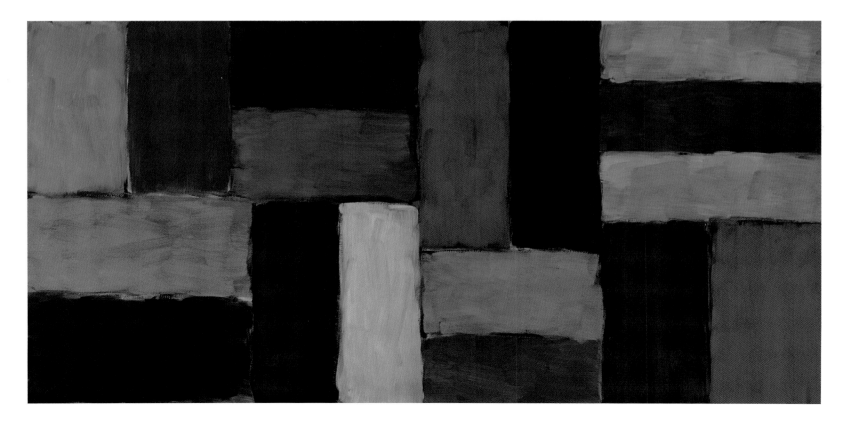

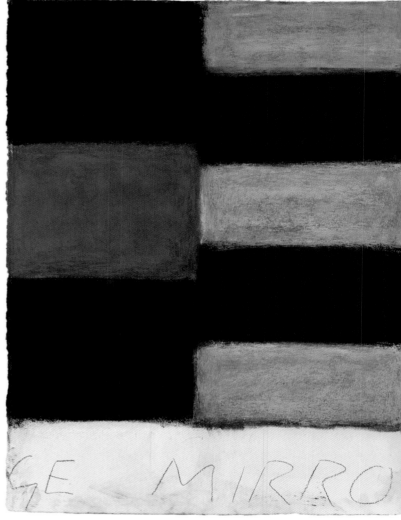

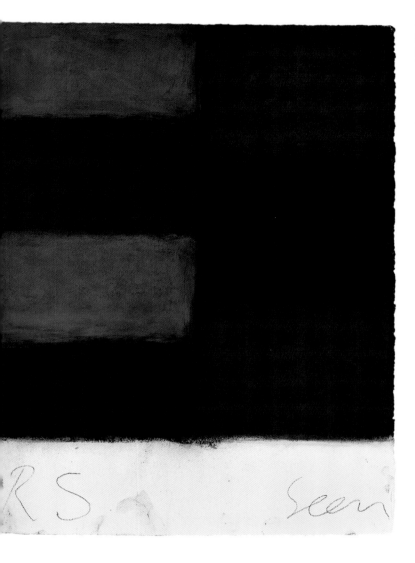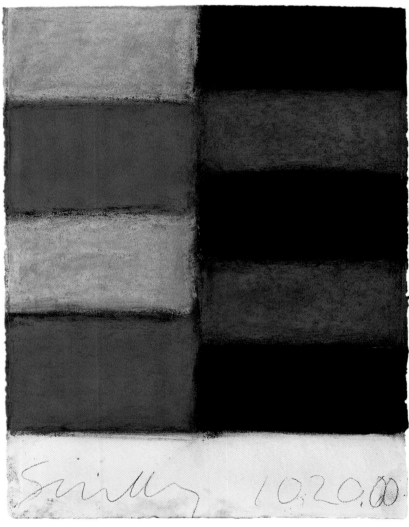

*Four Large Mirrors 10.20.00*
2000
Pastel on paper
30 x 23 in.
76.2 x 58.4 cm

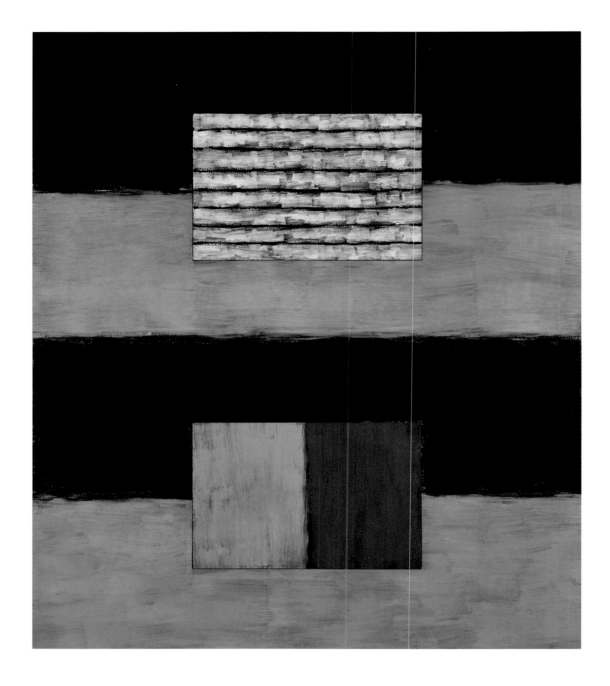

*Petra*
1993
Oil on canvas
84 x 72 in.
213.4 x 182.9 cm

and bliss? Both panels are symmetrical, but setting the window off center on top gives the sense that it is sliding down towards the bottom right-hand corner, creating unresolved tension.

When mixing motifs, Scully brings storytelling back into the picture. *Yellow Red Light* (1996), for example, shows ideal harmony, the bright stripes dramatically set before a dark background field. The "Plaids" are interrupted by a forcefully intrusive window. And it is hard to imagine a more elegantly beautiful picture than *Lucia* (1996). The windows open up the grid, as if allowing us to look into the distance. But our view is blocked, for these apertures are set in front of the pale-colored checkerboard. One window gives the illusion of being set in front of, and below the background, moving downwards towards us. Scully's paintings within paintings allude to traditional figurative pictures inside pictures, as by Velázquez and Matisse. Had he been interested merely in developing a brilliantly successful signature style, he would have repeated this composition. But Scully being Scully, he quickly moved on.

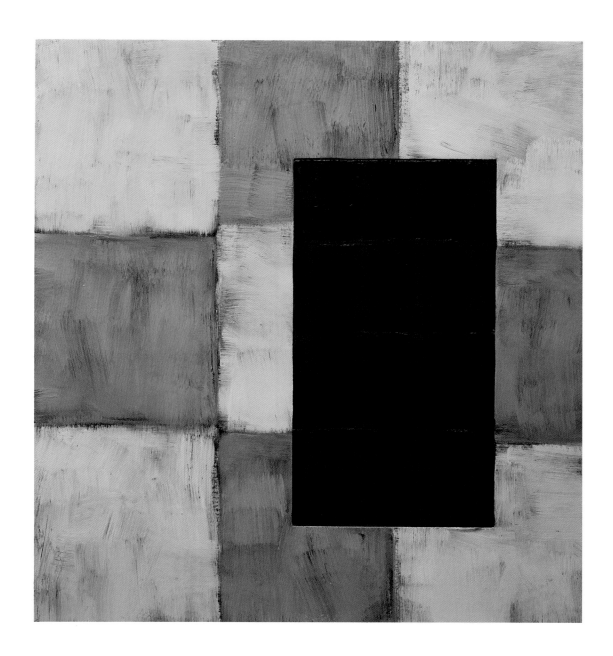

*Seal*
1993
Oil on canvas
42 x 38 in.
106.7 x 96.5 cm

Compared with the dramatic transition marked by *Backs and Fronts* (see pp. 92–93), the stylistic change we are chronicling is highly complex. In the 1990s Scully did not abandon story-telling. Indeed many of his paintings look back to narratives suggested by the *Untitled (Seated Figures)* of 1968 (see p. 50). But now he recognized that it was also possible to work in quite different styles which owed more to his ballpoint pen on paper drawings of 1969. Already in 1991, we find clear evidence of this developing transition in one published interview. Scully begins and concludes by speaking in the heroic terms of Abstract Expressionism:

> *Abstraction is the Art of our time. It represents the reality of human nature. It is not necessary to depict – but only to be…. If an abstract artist can achieve the specific emotional insight of the greatest figurative art of the past, abstraction will prevail for a long time.*

But in between, he says something surprising and more unexpected. Comparing abstraction to figurative art, he notes that:

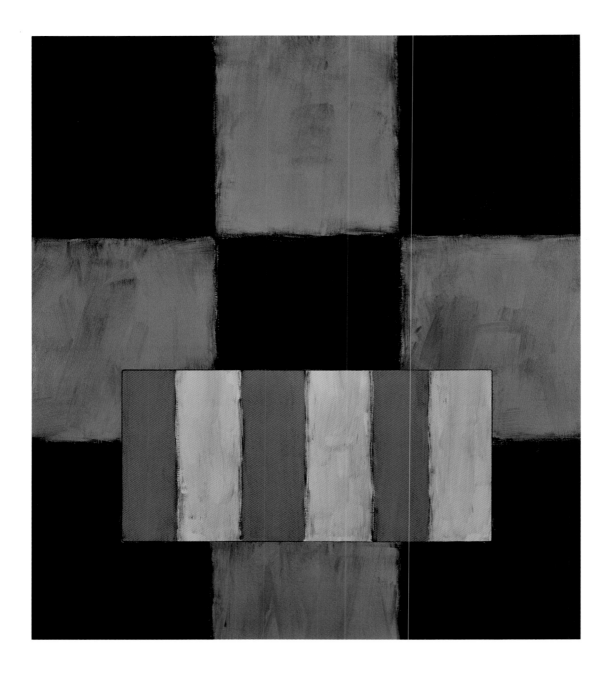

*Yellow Red Light*
1996
Oil on canvas
96 x 84 in.
243.8 x 213.4 cm

*with abstraction it is more difficult sometimes to reach a kind of intimate revelation. But since the forms are used "abstractly" we are free to make our own reality; it is the difficulty of this that makes it possible to achieve profound pleasure.*

When he makes his own reality, Scully's abstractions are most personal and satisfying. That happened when he discovered these new motifs.

Some American critics have complained of lack of development in Scully's recent art. That reproach is surely mistaken, but he has taken it very seriously.

*I suppose the criticism of my work might revolve around its seeming lack of invention. Which is bound up with lack of distance. If anything, the space between what I am, in all its strengths and limitations, and what I make is extremely compressed.... I start out always with the same thing and then try to make it different, out of myself.*

The first part of this statement is quite clear, but the last two sentences require some explanation. Here Scully again is discussing style. Because he feels so close to his own painting, it could seem

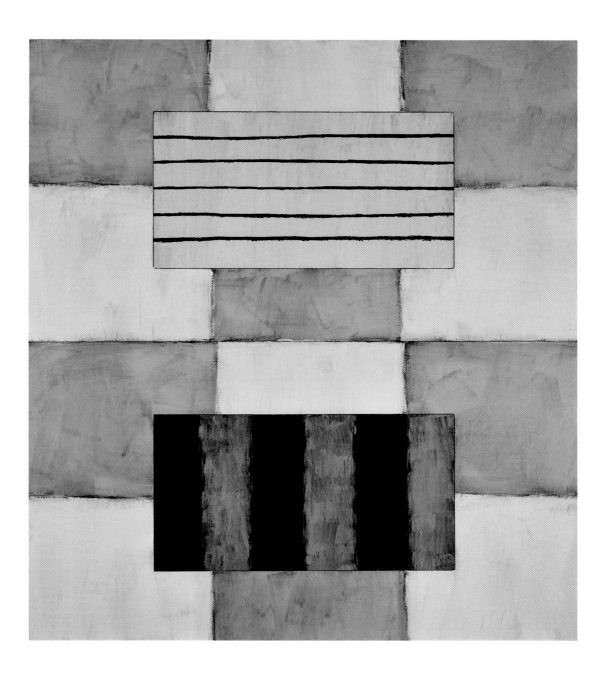

*Lucia*
1996
Oil on canvas
100 x 88 in.
254 x 223.5 cm

that his art is always the same, always based upon repetitive stripes. But in fact the opposite is true – because his body of art is so closely tied to his life, his painting changes when his life develops. And since his life changed dramatically in the 1990s, his painting then became very different.

That, at any rate, is how Scully sees his art, but for the viewer, who probably knows little of his life, these pictures seem highly compressed because they suggest a variety of meanings that need to be spelled out. As he has said: "An artist who can provoke empathy is the one who simply completes your thought or makes visible our desire (yours and mine). I'm not trying to say anything different from what you want to say. I want to say the same thing." In this way, he is like a Symbolist painter who makes seemingly simple pictures very richly suggestive. But unlike Symbolist art, Scully's is highly personal. We don't expect the products of a house painter or industrial laborer to reflect their inner life. On the contrary, productivity in modern industry requires suppressing individuality. Traditionally painting was valued because the artist, by expressing himself in his work, shows that he is not an alienated laborer. Abstract Expressionism continued that

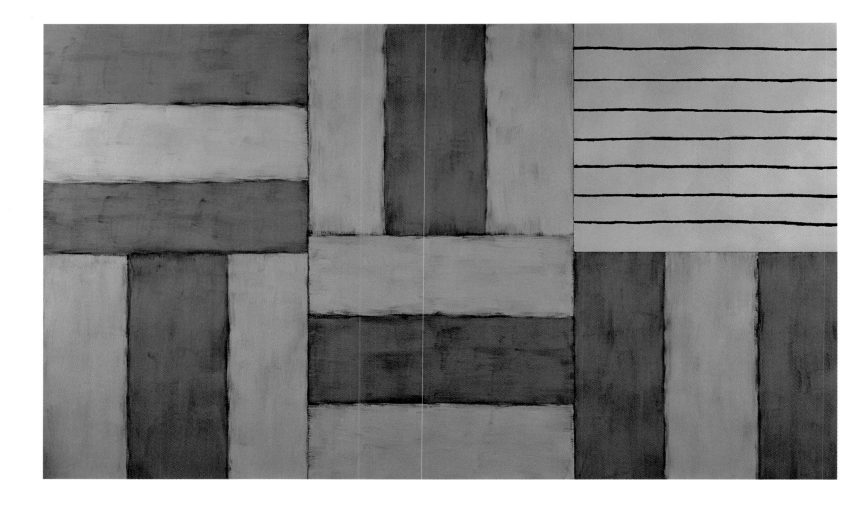

tradition, putting a premium on the personal touch of the painter. But in a great deal of recent art, there is no trace of the everyday life of the artist – Judd and the other minimalist sculptors, like the post-modernists, aimed to completely avoid self-expression.

Scully rejects that ideal of impersonality. Abstraction, he notes, traditionally "tends to be nonspecific and remote. So I've tried to make paintings that really are quite individual in their personalities." But, he then adds,

> *the paintings are quite figurative in a certain sense. They're not meant to be remote. They're meant to be about very particular feelings … the task that I've set myself is to somehow reconnect abstraction – to bring it out of a kind of isolation and make it possible for people to get a direct feeling about the real world in relation to an abstract painting that they're looking at.*

This he calls "the beauty of the real." His paintings and works of paper, so intimately linked to Scully's life, are meaningful to many people because they express feelings that matter to us. Do we find those feelings there or read them into the pictures? No doubt we do both, for as with mass art, it's hard to distinguish what emotions, fantasies and thoughts are *in* the paintings and what we project into them. His art encourages us to blur that distinction.

Acknowledging the complexity of this situation, in which misunderstandings are easily possible, Scully has a passionate interest in communication.

> *The real truth is ultimately what the public says. You can be nothing. If you take a big risk – if you make your work and your work is extreme in some way, and I think that my work is extreme in a number of very subtle ways, but it is quite extreme – then you can be rejected.*

*Angelo*
1994
Oil on canvas
108 x 180 in.
274.3 x 457.2 cm

Here again, the analogy between Scully and a film director or popular novelist is extremely suggestive. When asked about how his art could find an audience, he said:

> *It's a question of whether what you do intersects with their longing, that emotion that hangs out in the air, like an antenna, hoping to come into contact with something. And that's what art does; it's like floating through the space of debris. If someone's art touches that in many people, then you become incredibly famous, and if you don't, you won't: it's simple.*

In order for high art to be truly popular, it must engage our lives. In focusing on this concern Scully certainly distinguishes himself from almost all of his American contemporaries. "I've gone the opposite way of almost everybody of my generation. I've stood alone for a certain kind of painting." The "Plaids," "Mirrors," and "Floating Paintings" do this. And then his "Walls of Light" dramatically extend the search for a new kind of painting which responds in a deep way to the moral dilemmas of contemporary life.

*Passenger Line Red*
2000
Oil on canvas
18 7/8 x 15 in.
48 x 38.1 cm

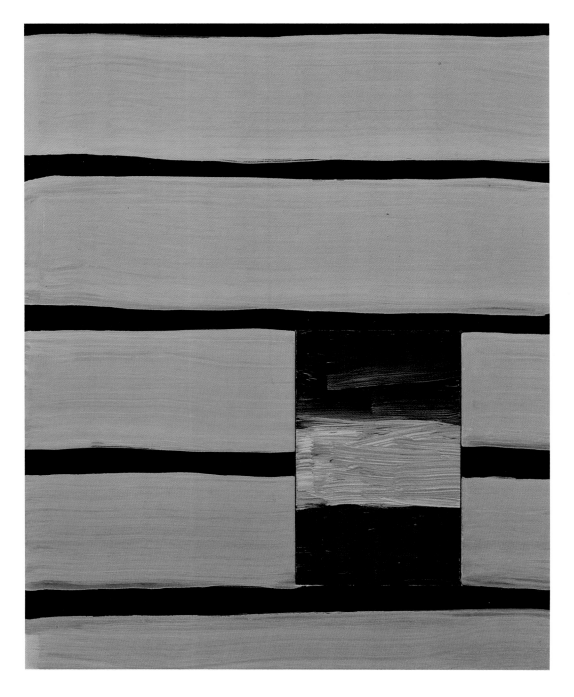

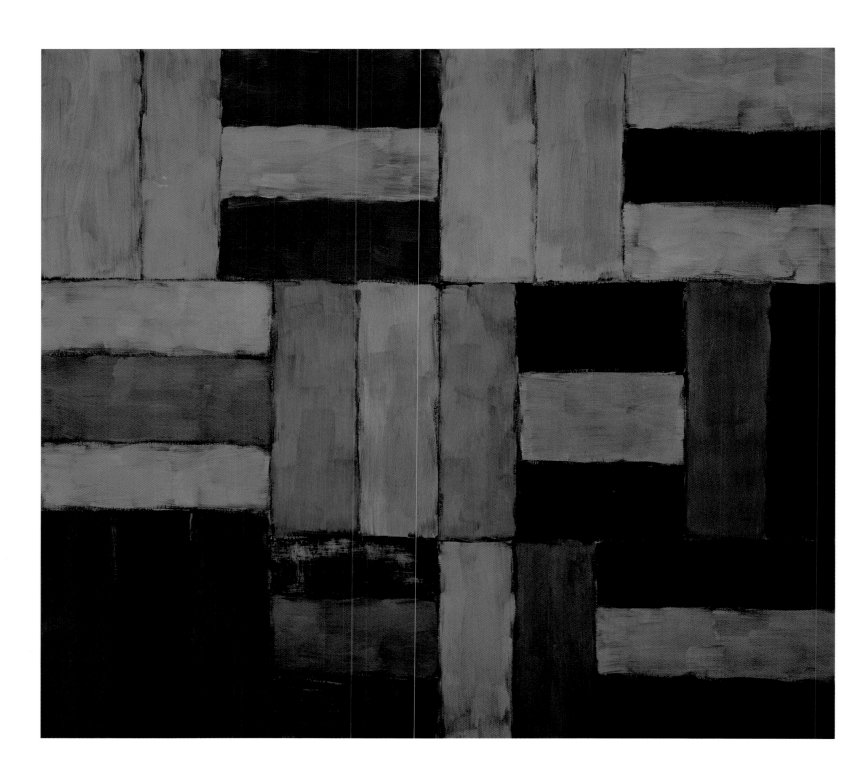

# Chapter 8 "Walls of Light:" Scully's utopian pictures

*I'm always trying to combine morality, which I see manifested in structure, with high emotion, manifested in beauty.*

*I've kept painting. Few painters have kept painting in the sense that when they paint they are learning about painting and inventing the painting they are making at the time of its making.… I'm learning all the time, I haven't stopped going to school.*

*Wall of Light Pink*
1998
Oil on linen
96 x 120 in.
243.8 x 304.8 cm

In 1993 I had the great pleasure of meeting the famous connoisseur Sydney Freedberg at the opening of the exhibition of Scully's "Catherine Paintings" at the Modern Art Museum, Fort Worth, Texas. For two decades, I had read and reread with absolute fascination his famous books devoted to the High Renaissance and the early Baroque. Since Freedberg doesn't discuss abstract painting, I didn't know what to expect. In the galleries he moved slowly, frequently pausing to lean on his cane, looking very closely. Freedberg didn't say much in the exhibition, but as soon as we sat down at the reception he said that he tremendously admired the show. He compared Scully's color to that in Venetian art. I was very struck by the intensity of his immediate response. For him, I realized, there was no distinction whatsoever between the concerns of Scully and the old masters he had written about.

The next day when I went with Scully to the nearby Kimbell Art Museum to look at the old master collection, I thought again about that conversation. Scully, I discovered, understood art history in exactly the same way as Freedberg did. Although his pictures look very unlike those by Duccio, Giovanni Bellini, and Cézanne in that museum, his concerns, so he feels, are essentially the same.

*Since ultimately all art is essentially figurative, the question has to be how to put the human beings into it. What I have tried to do is something close to the ambition of portraiture or still-life. I paint my abstract form as if it were a portrait.*

That statement helps explain how both Freedberg and Scully understand his abstractions. When he was younger, so we have seen, Scully was concerned to reconcile Pollock with Mondrian. But now in middle age he finds himself "in dialogue with Titian and Velázquez." His concern with "sensuality, mastering of paint, light effects, and beautiful colors" linking him directly with these old masters, Scully identifies his own art as a bridge between modernist tradition and the present.

Abstract Expressionism was invented in order that modernist painters could make spiritually ambitious art. Once they found their styles, most of the Abstract Expressionists (apart from Willem de Kooning) were not especially concerned with ongoing innovation. After that era ended, abstract painters felt beleaguered, for they were in a minority position. But nowadays, so Scully feels, abstractionists can build upon tradition in a less anxious way.

*It has been suggested to me that the 50s and 60s during the time of Abstract Expressionism were a "golden age," and our time, being less obviously concerned with spiritually ambitious art, is a "silver age." I don't believe this. I believe it's always a matter of urgency.*

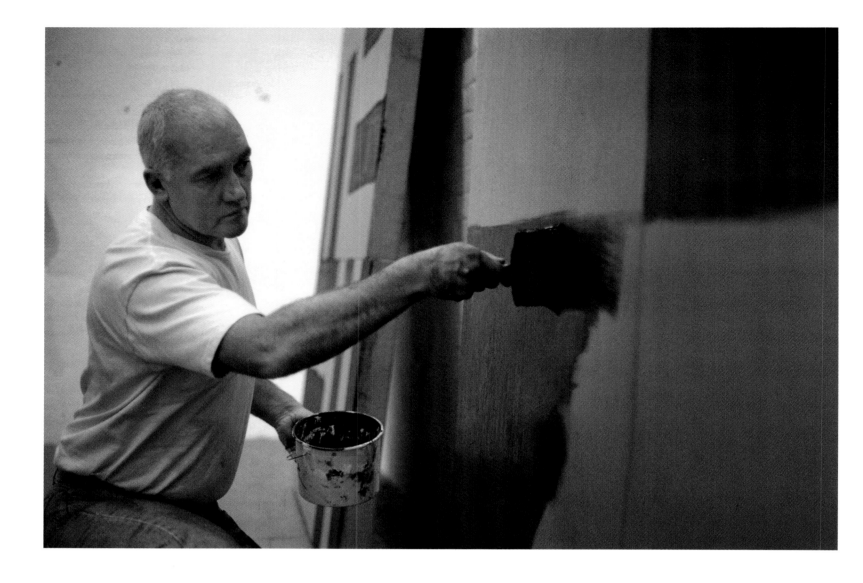

According to Clement Greenberg, Abstract Expressionism extends Cubism and Impressionism, building directly upon the heritage of old master art. He often said: Tradition is everything. After the demise of formalism, everyone rejected this view of history. Leo Steinberg and his many very influential followers said that post-modernist art broke decisively with the past. In the late twentieth century almost all younger critically acclaimed artists, whether they performed or made installations and videos, or even painted, thought of themselves as doing something quite different from the modernists. They emphatically rejected any belief in the importance of historical continuity.

What most dramatically separates Scully from most contemporary American artists is his belief that Clement Greenberg was right about the importance of tradition, though of course Scully rejects both formalism and Greenberg's personal reading of modernism. Scully also parts company with Matisse, who like him had a passionate belief in tradition. Late in life, Matisse became pessimistic, speaking of how "in an age like ours ... cinema posters and magazines present us every day with a flood of ready-made images which are to the eye what the prejudices are to the mind." He feared that the unbroken figurative tradition going back to Giotto, continued by his own painting, was threatened by photography. Scully has a very different view. Since "it is difficult," he says, "to pretend that the frescoes of Giotto are not figurative painting serving a religious theme," Matisse failed to acknowledge that, however strong his personal connection with Giotto's painting, his own

Sean Scully
1994

modernist art, which mostly deals with secular subjects, was really doing something new. Maintaining tradition, Scully concludes, is possible only if we rethink fundamental issues.

In the twentieth century, theorists and visual artists responded to mass culture in two ways. Some, like Greenberg and Matisse, thinking of popular culture as corrupting, isolated high art. The Abstract Expressionists and their heirs, the minimalists, turned away from mass culture. Other artists, in turn, responded by utilizing materials from popular culture. In the 1960s Andy Warhol and Richard Hamilton used advertising imagery, and in the 1980s very many artists recycled advertising, film images, and newspaper headlines. Worried that high art could not compete with popular culture on its own terms, they borrowed content from mass culture. Neither of these approaches satisfies Scully. He wants to extend the traditions of high art. But, as he recognized early on, effective paintings must also acknowledge the potent mass arts – photography, film, and pop music. Since we all are so much influenced by popular culture, it is neither possible nor desirable to isolate high art. But for Scully, incorporation of mass media imagery into painting is unsatisfactory because then this art has only a borrowed relationship with reality. Jasper John's flags, Roy Lichtenstein's images of comics and old master art, and Sigmar Polke's appropriations use second-hand imagery. Many very fashionable 1980s and 1990s theorists claimed that contemporary artists could only do pictures of pictures, never making contact with the world. Scully has too robust a sense of reality to take that view seriously.

Post-modernists demanded that art critique the bourgeois social order. Otherwise, so they feared, important works of art would merely become luxury goods, decorations for the homes of the wealthy. But since experience repeatedly shows that the most prestigious collectors and museums soon do purchase even the most radical seeming art, how is such politically critical art possible? As a young hot political activist, Scully made many posters. But already when he was nineteen or twenty, he realized that "the deepest and greatest art couldn't be political but had to be spiritual." Although passionately interested in politics, he recognized that he could not be an activist artist. "I don't think there is such a thing as effective political art. There is only art that is politicized. You either do politics or you do not." Always upholding strong progressive positions, he does not express these deeply felt concerns in his art. His abstract pictures contain no explicit political messages.

But recently Scully did make one political work of art, the Starr/McCarthy T-shirt (1998).

*I wanted to lay it out using the language of the crude political graphics from the early part of the twentieth century. I was thinking of Rodchenko. It's kind of Russian political typography. You have red, black: I wanted to link up the two names.*

Starr/McCarthy T-shirt
1998

When using these strong reds and blacks, he thought back to his early labors as a printer. He sent his T-shirt to every congressman and senator. Many Republicans sent it back, but he got supportive letters from a number of Democratic senators. Conjoining the names Kenneth Starr and Joseph McCarthy, calling them "Two Great Americans," Scully explains very clearly

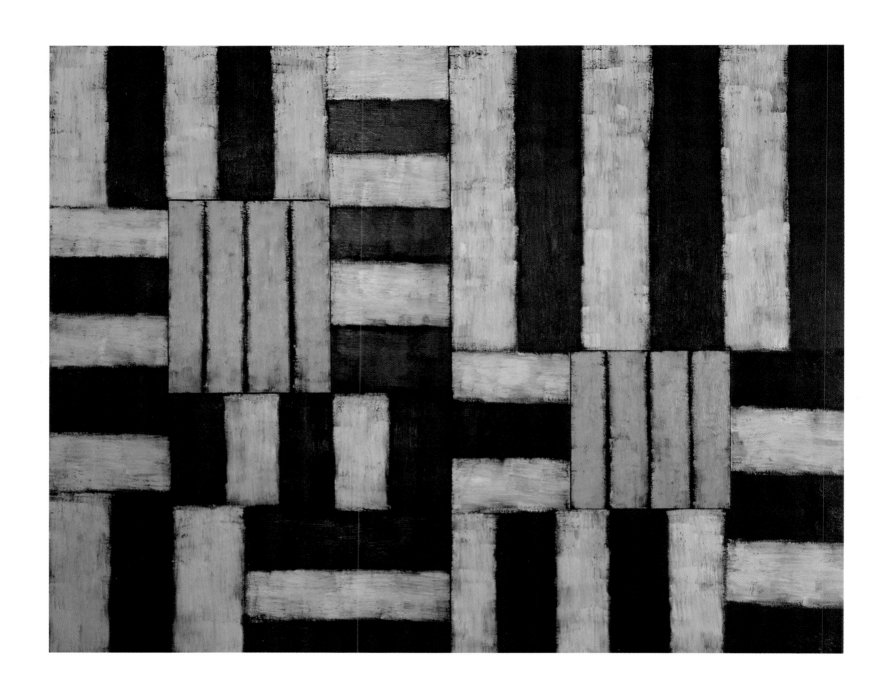

*White Robe*
1990
Oil on canvas
98 x 120 in.
248.9 x 304.8 cm

how he understands Starr – the Starr/McCarthy T-shirt is effective political art. Compare *White Robe* (1990), whose title refers to the painting material – to paint *as* material. Scully's paint is thick so that even though his picture is about light, the paint is about weight. The picture is about opposition and bringing what seems opposed into one picture – the relatively small windows resist the field of color in the background. *White Robe* is poetic and elusive. Any attempt to pin down its expressiveness would be heavy handed. By contrast, the meaning of the Starr/McCarthy T-shirt is precise and prosaic. This also means, of course, that like much art referring explicitly to contemporary events, it dates quickly.

Speaking as a Romantic, Scully describes the present marginal state of painting:

*You can make an argument for painting as a redundant art form… If you look at history and at the way we have moved in our society from the unique to the mass-produced and the technological, paint-ing is in stubborn and absurd opposition to this… As the world has become more technological, a human need for mystery and the individually authentic experience has become more desperate.*

But then, he often has thus resisted dominant cultural trends. In Newcastle, he defined his passion for abstraction by opposing Richard Hamilton's Pop art. And in the 1980s, again in opposition to fashion, Scully denied that video could replace painting or that painting could productively borrow from other arts.

*The whole point of painting is that it has the potential to be so humanistic, so expressive. To give that up is a tremendous mistake because then what you are doing is imitating forms of technological expression which can be manifested more directly, more efficiently, and frankly, more beautifully, in their original form.*

In Scully's art, as in 1960s radical politics, cultural resistance is of great importance. But in rebelling against clichéd ways of thinking about political art and the limitations of painting, he does not seek escape from the present.

Had Scully merely pursued his engagement with tradition without taking notice of contemporary art, he would at most have been a magnificent eccentric. But in rejecting the dominant cultural trends, he has taken notice of them on his own artistic terms.

*It's not necessary for you … to support the majority view because the majority view is already by definition oversubscribed. What's interesting is to go against it. That's what needs to be done.*

Indeed, this felt need to engage with contemporary thinking has driven his recent stylistic development. In Arthur Danto's 1995 A. W. Mellon Lectures in the Fine Arts, which warmly acknowledge Scully's friendship and reproduce *Homo Duplex* (1993), a vision of our post-formalist period is developed. Scully, in turn, has more recently responded actively to Danto's claims, writing extended notes on the manuscript of the forthcoming Carus Lectures, which are devoted to analyzing the contemporary role of beauty and the sublime.

In Greenberg's era, Danto notes, abstraction was taken to be the culmination of art's history, with the Abstract Expressionists identified as the inevitable end product of tradition. But once formalism was abandoned, it was natural to turn to pluralism. Indeed Danto himself has written admiringly about such diverse contemporary artists as Mel Bochner, Robert Mapplethorpe, Komar and Melamid, Cindy Sherman, Mark Tansey, and Scully. Writing as a philosopher, Danto offers a general characterization of our period, identifying the shared world view of artists who in his criticism are given attention as individuals. What then are the implications of this analysis for an abstract painter like Scully? If in fact the history of art now is closed, as Danto argues, then how does Scully's style allow him to respond to this situation? To answer these questions, we need to look back briefly to the beginning of Scully's career.

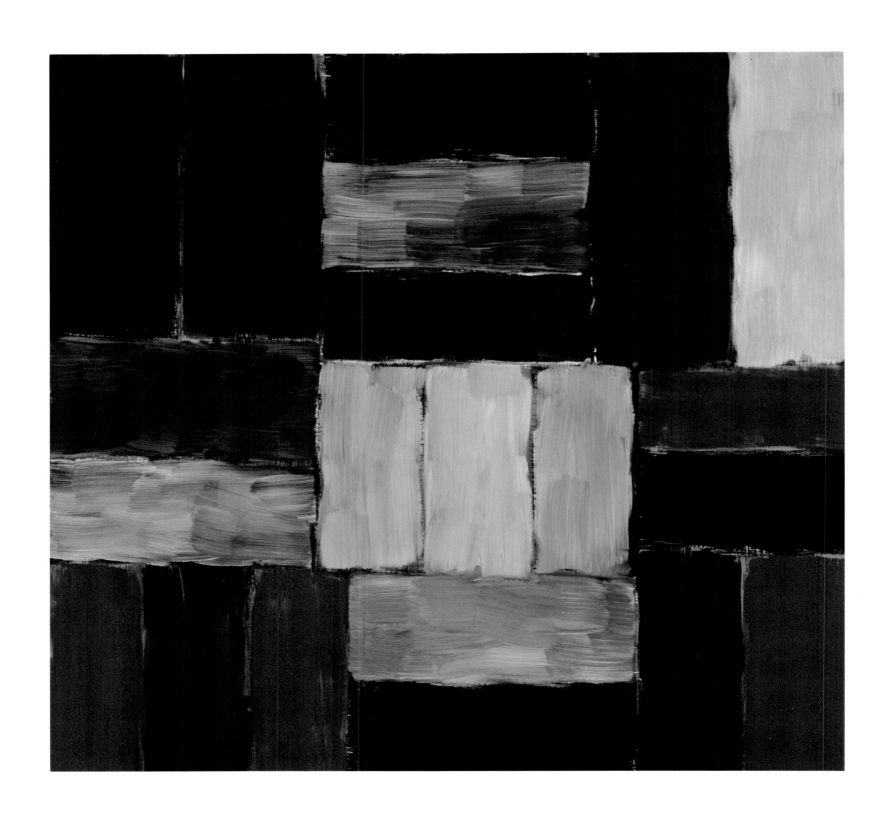

*Wall of Light Red*
1999
Oil on canvas
75 x 80 in.
190.5 x 203.2 cm

The 1960s student protest movements that engaged Scully were deeply fascinated with utopian thinking. This was, as Danto notes, the era when American feminism and the struggle against racism took hold. Inspired by nineteenth-century socialists and their intellectual descendants, many protesters imagined a brave new world transcending bourgeois conflicts. They thought that political struggles and divisions were merely man-made. In an ideal society, so these young radicals believed, aesthetic harmony would prevail. Analogies were drawn between utopian politics and avant-garde art – analogies with Matisse's use of saturated fields of color and the elimination of traditional pictorial relationships in extreme all-over minimalist painting. Just as student revolutionaries sought a new post-historical way of life, so these very extreme pictures were said to transcend traditional composition. Today, upon sober reflection, it is hard to reconstruct this analogy. And yet, so we will see, the "Walls of Light" demonstrate that this seemingly dated way of linking art and political speculation still remains of value.

From 1981 until the late 1990s, Scully's art mostly tells about love or failed relationships, about the pleasures of sensuality and the fear of death, about hope and despair – about an immense variety of expressive states. Scully's diptychs and triptychs metaphorically describe relationships, some harmonious, but many conflict-filled. Inserting windows in stripes, or setting panels in all-over fields creates visual relations. A window permits us to see two distinct distant spaces at once, and so imagine their connection. An insert breaks up the background field of stripes. And in triptychs with three-word titles, the painting is "constantly reconstructing itself, remaking its relationships." His abstract art thus never abandons its starting point in his student figurative paintings. The "Plaids," "Mirrors," and "Floating Paintings" modify but do not essentially reject those concerns.

But in Scully's "Walls of Light" there are no figures and no ground – nothing is set behind anything else. There is no visual hierarchy because every element is equal to every other. The "Walls of Light" thus replace the storytelling of his multi-panel pictures with monistic unity. Transcending the world of everyday conflicts, these visual utopias, so very different from his 1980s and mid-1990s paintings, return to that all-overness that interested him as a young man. I know of no recent precedents for Scully's latest development. Driving through Harlem, Jasper Johns saw a striking wall that he copied in his painting *Harlem Light* (1967). On the left he depicted the surface appearance of that wall, and on the right he imprinted a window and a painting. Johns' playful demonstration of the impossibility of certainty presents a central theme in all of his art. Scully's "Walls of Light," by contrast, both break with *his* established concerns and

*Harlem Light*
JASPER JOHNS
1967
Oil and collage on canvas
78 x 172 in.
198.1 x 436.8 cm

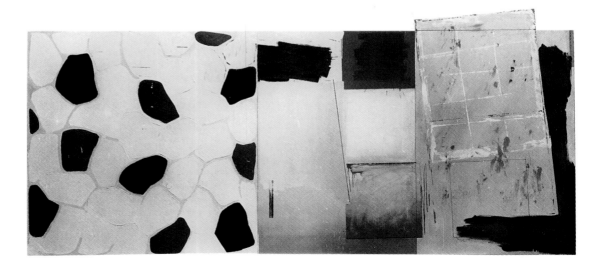

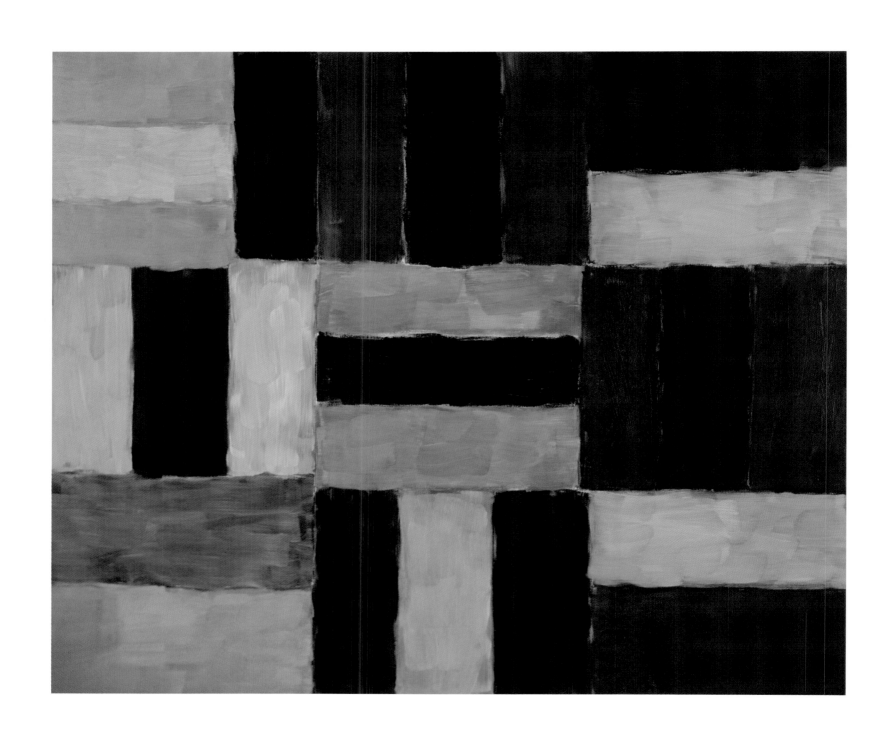

*Chelsea Wall 1*
1999
Oil on linen
110 x 132 in.
279.4 x 335.3 cm

reaffirm his relationship with tradition. When viewing these pictures we experience a stasis that is but another name for visual bliss.

Scully's earlier narrative paintings had titles identifying their stories. The "Walls of Light," by contrast, are harder to describe because they are *not* abstract narratives. *Wall of Light* (1999), for example, nearly square, sets its blacks at the top, to left and right of center, and at the bottom left-hand corner. One "wall of light" not given a color or place name, it has blacks and fleshy oranges, but also dark red, light gray, and, at the top left and middle edge at the right, white. The pink and cream blue come from a De Kooning painting, whose source was Picasso's *Les Demoiselles d'Avignon*. As their generic title indicates, usually the "Walls of Light" are about a wall as seen at different times of day or diverse seasons. (One exception is *John Anthony*, Scully's memorial to his father; see p. 130.) "What I'm trying to do [is] make a very emotional kind of classical art." Now the realm of storytelling has been transcended. As its title indicates, *Backs and Fronts* (see pp. 92–93) shows diverse elements – backs *and* fronts. By contrast, the monistic "Walls of Light" transcend such storytelling concerns. "Walls of Light" thus redo *Red Blue Yellow Green* (see p. 54), Scully's first large abstraction, dividing the canvas into panels drawn together by color, but now using stripes.

The "Walls of Light" are usually associated with very specific places and times in Scully's working life. *Chelsea Wall 1* (1999), for example, made in Scully's new Manhattan studio, only a few blocks from the site of his first New York loft, is *about* walls in Chelsea.

*Wall of Light Sky*
2000
Oil on linen
96 x 144 in.
243.8 x 365.8 cm

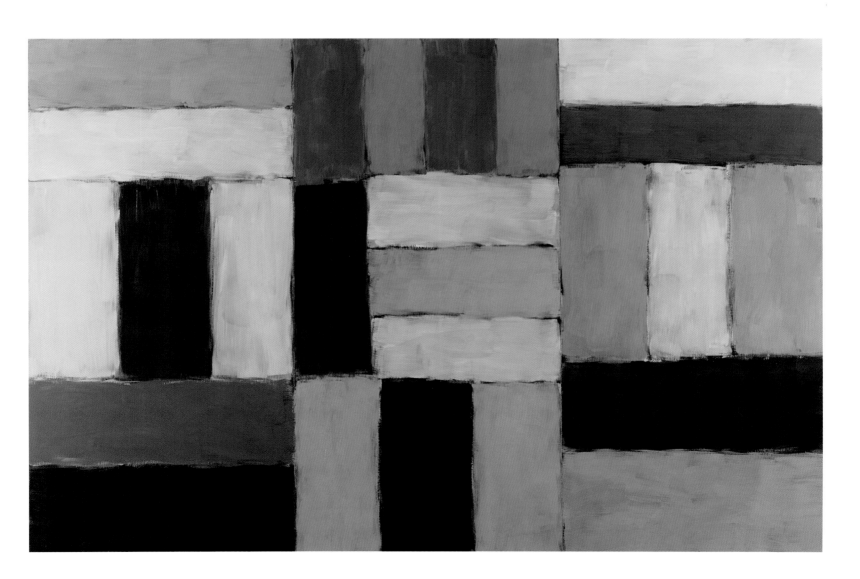

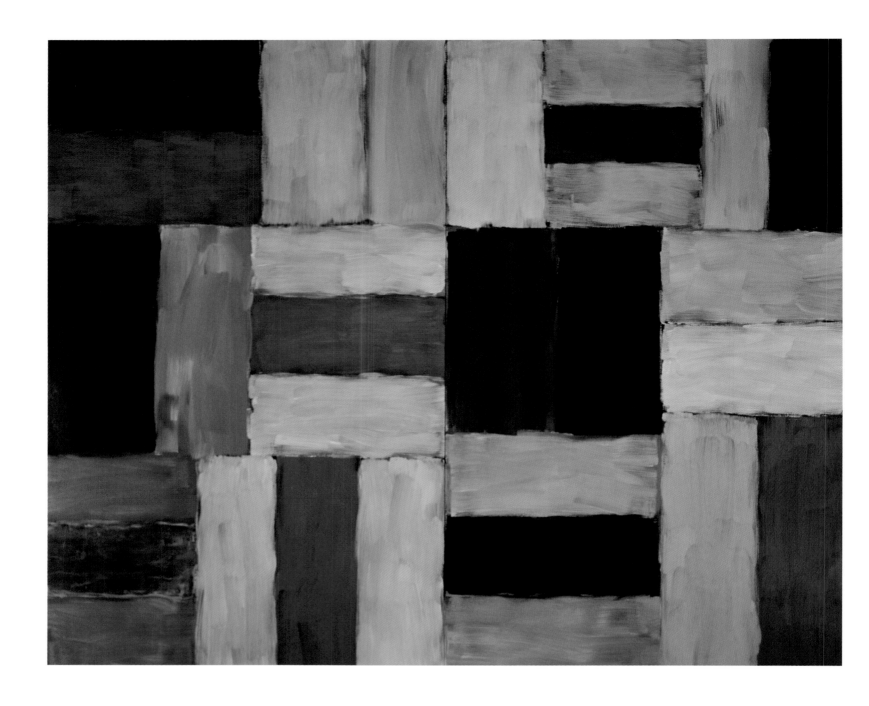

*I painted my first painting on Seventeenth Street, a real beauty with strong brush-strokes – it seems
full of light and air. Very interesting in relation to Monet, Bonnard, and Abstract Expressionism.*
Wall of Light Desert Night (1999) was inspired by a drive into the desert of Nevada.
    *There I saw extraordinary color. Every shadow cast down into the desert floor from the rocks was
made of sand and dust and light. It was like looking at a sculpture of my pastels. I held these colors
of blue, gray, pink, black, black-blue in my mind, as if they were being carried back to New York
in a perfectly preserved vessel. And there I painted them the day after we got back. The feeling of
the desert was so strong, the painting was making itself.*
And *Wall of Light Tara* (2000), originally made during the filming of Scully's Irish TV documen-
tary, was repainted with more melancholic colors when he returned to New York six months later,
"the color almost buried under a blanket of gray, leaving only the sour yellow to stand for the pos-
sibility of a colored world."

*Wall of Light Desert Night*
1999
Oil on linen
108 x 132 in.
274.3 x 335.3 cm

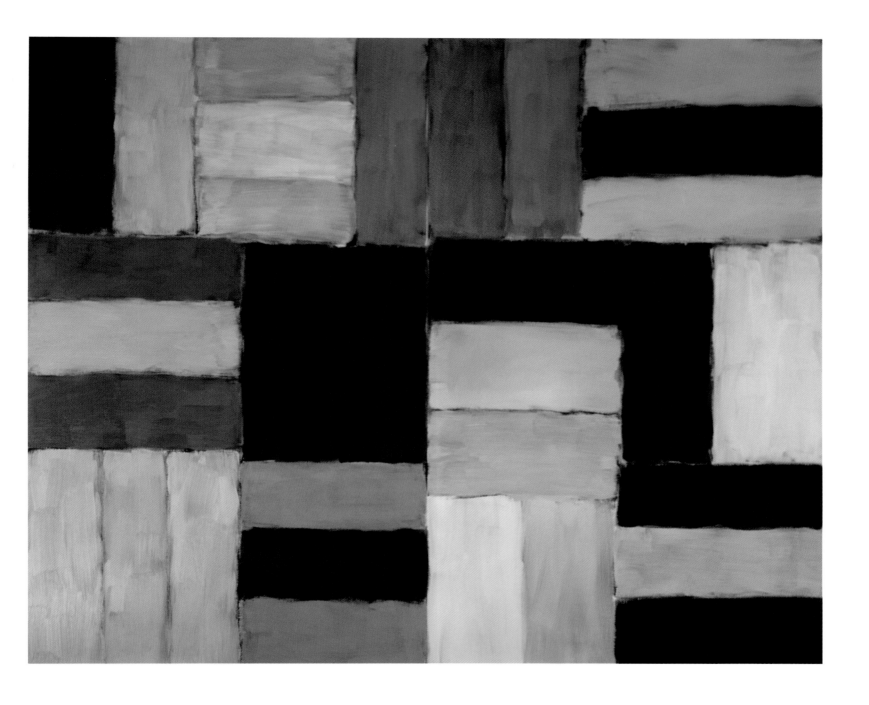

*Wall of Light Tara*
2000
Oil on canvas
110 x 132 in.
279.4 x 335.3 cm

Unlike the transition-yielding *Backs and Fronts*, the development of the "Walls of Light" was directly linked to Scully's personal life. In 1996, the last of the "Catherine Paintings" chosen, Lee and Scully separated, eventually divorcing, and Scully came to live with Lillian Tomasko, an artist with a very different personality.

> *The work reflects a lot the relationship I'm in. I want emotional and contextual information to enter the work all the time; this is the pasture on which it grows. The people who are friends are affecting my work; it's made through the vitality of these relations.*

Scully's life changed drastically, and so too did his art. The "Catherine Paintings," a kind of sequence, tell the story of Scully's development from 1979 onward. His 1980s paintings have a heroic combative quality, but now he was ready to throw off "that physical cargo" in favor of light and translucency. This change, he allows, "has something to do with the climate of my private life, there's no question of that." Other important changes also occurred. In 1999 Scully left

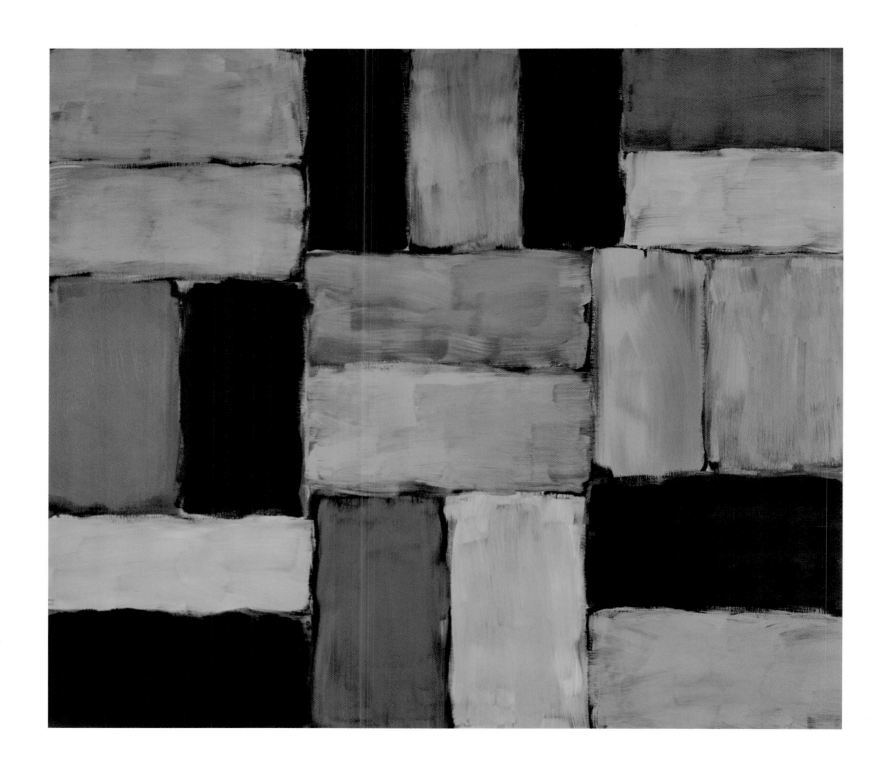

*Wall of Light Alba*
2001
Oil on canvas
75 x 85 in.
190.5 x 215.9 cm

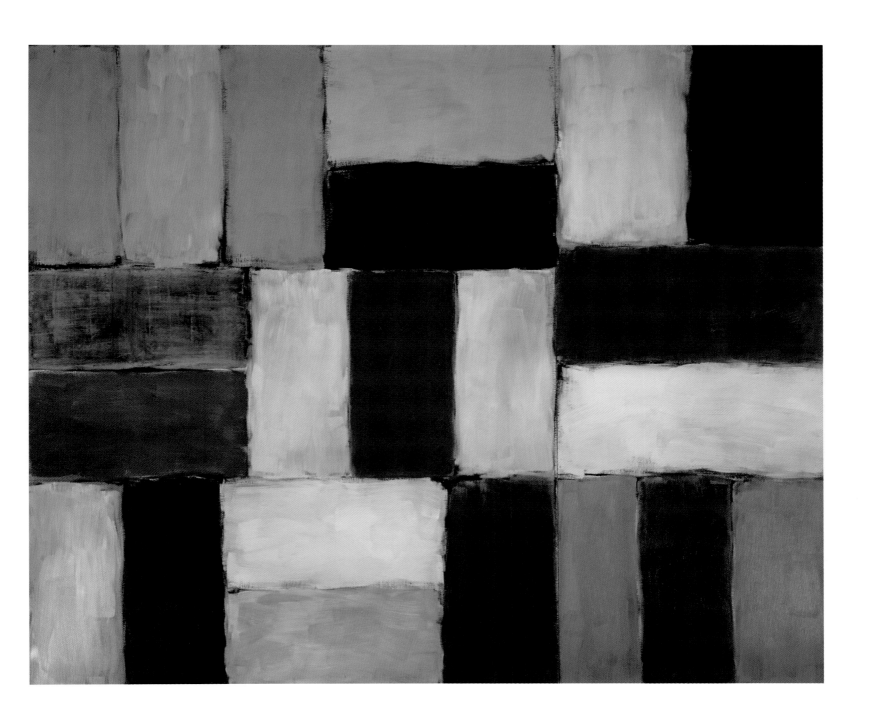

*Wall of Light Dark Orange*
2001
Oil on linen
110 x 132 in.
279.4 x 335.3 cm

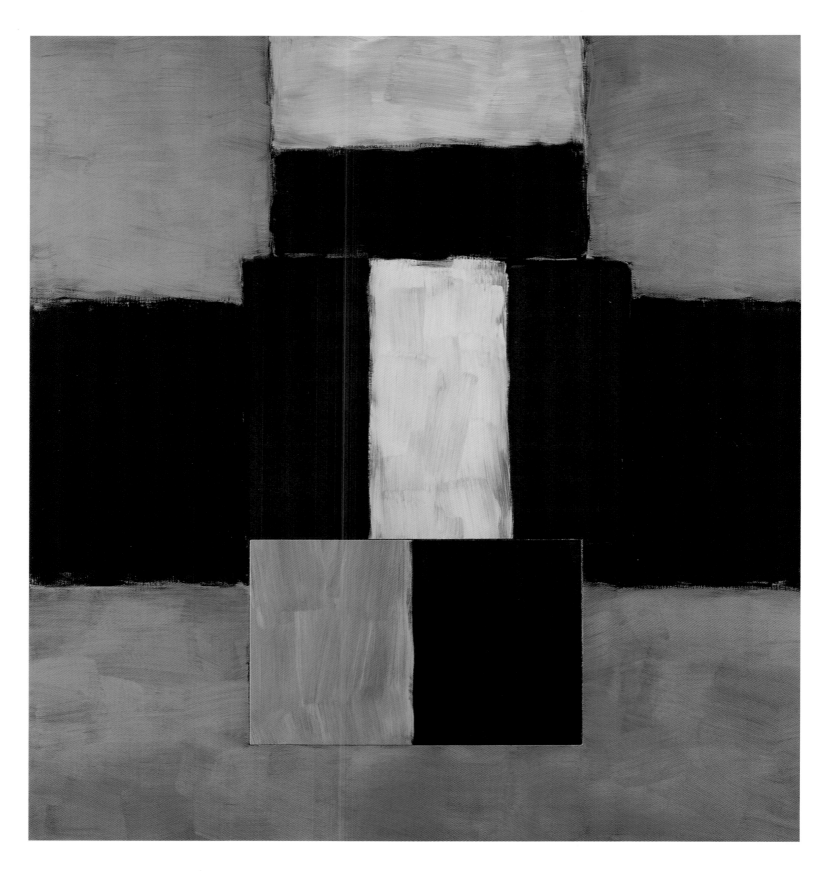

*Falling Figure*
2002
Oil on canvas
79 x 72 1/4 in.
200.7 x 183.5 cm

200

Duane Street and moved to Chelsea, changing his working situation dramatically. With great high wood ceilings and ample overhead natural lighting, his new 5,000-square-foot studio resembles the nearby upscale art galleries. And now his living and working spaces are separate.

Scully recently spoke of "the degree to which I've managed to combine a kind of deep emotion and the energy seen in Expressionist painting," which he studied in the 1960s, with the concerns of abstraction. He wants to preserve everything of his past and so his development moves in a spiral, circling as he sets his older concerns in newer contexts. "With my work … there's an endless process of cannibalization and recycling and reinterpretation and material being reused, over and over and over again." Integrating new experiences is a slow, entirely intuitive task. With the world "rubbing up against his art," as he describes this situation, Scully's recent stylistic development can plausibly be linked to Danto's theorizing. In a famous passage prominently cited in Danto's Mellon Lectures, Marx and Engels imagine a future communist utopia where someone might hunt, fish, rear cattle, and write criticism without being forced into the limiting roles of hunter, fisherman, herdsman, and critic. After modernism, Danto suggests, artists will have this kind of freedom. In evolving "into a painter who is able to make the painting freer, to do it with the way things are painted," as he describes himself, Scully has done exactly that. In Danto's analysis, the end of history means that the long period in which artists sought to extend some developmental narrative, as in Greenberg's formalist analysis, has concluded. And this, it would seem, is what we see in Scully's "Walls of Light."

The source of the "Walls of Light" was *Wall of Light 4.84* (1984), Scully's most important watercolor, made on the beach in Mexico. He was fascinated by the lonely abandoned architecture of the Yucatan. That he "forgot" to make the "Walls of Light" for fourteen years shows his powerful faith in his future. He must have known that sooner or later he would use this motif. According to a tradition dating back to the early Renaissance, a painting is a window on the world. Wanting to tear down the façade that separates the inside from the outside, Scully paints out the dead weight of the stone wall, replacing it with a "Wall of Light." As Jürgen Habermas has noted, in Scully's recent paintings:

> the creation of intimacy and closeness is due to an optical stimulus, which in turn provokes the hand's sense of closeness. These paintings help bring into focus the effect on the senses in such a way that we are reminded of the ambivalent meaning of "sensation" as stimulation of the *sense* and *feeling*.

Like Chardin's still lifes, Scully's paintings thus evoke imagined experiences of touch. But where Chardin's small pictures offer tactile experiences of china, dining silverware, and fruit, Scully's

How TO PAIN? YOURSELF
INTO A CORNER,
with abstraction people had
the idea that they would
paint everything, but as
time went by the worst
painters—made it more and
more and more elegantly
conceptually refined. So they
ended up painting nothing
i'm always trying to reconnect.
Sean NY - 1.15.01

Fax from Sean
2001

"Walls of Light" ask us to imagine touching a wall. Like a checkerboard composed of windows without any background stripes, these paintings consist entirely of inserts, without the physical solidity of a true wall.

Original as they are, Scully's "Plaids," "Mirrors," and "Floating Paintings" build directly upon his 1980s style. But the "Walls of Light," more dramatically rethinking his essential concerns, can best be understood by looking back to his very early art. In Rothko's paintings "all the experiences that the artist has lived and all the stories he would like to tell, are condensed into rectangles that have the solemnity of the stones of Stonehenge and the weightless drama of Turner's air-and-seascapes." Scully's stripes, similarly, tell experiences that he has lived and stories that matter to him. When Mondrian (in his late art) and Pollock (in his late 1940s paintings) moved beyond figure-ground relationships, they sought to transcend such narratives. Making every visual element equal to every other one, a true all-over picture cannot present a narrative. But perhaps there is something inhuman or deeply inaccessible about a picture telling no story. We love narratives in film, literature, and music because they make sense of life, linking together what would otherwise be disconnected events. And so it is difficult to understand art that transcends this condition. Or maybe we simply lack sufficient experience to fully comprehend such extraordinarily pleasurable pictures. As yet, it is unclear how to interpret these new paintings.

How paradoxical are Scully's "Walls of Light"! His art moved forward by looking backwards, turning from the rhythms of the modern city to pre-colonial Mexico. Fascinated by the changing light on the stone walls in the Yucatan, he created pictures whose light held fast. After Scully made *Backs and Fronts*, he had learned as much as he could from Matisse, Mondrian, and Rothko. But since his 1980s and early 1990s paintings were richly expressive, why move on again in the mid-1990s? Once Mondrian and Rothko made their way to abstraction, they found styles that satisfied them until almost the very end of their lives. Here Matisse is a better model, for he made several dramatic stylistic shifts after finding himself. From 1904 until 1917, he made compositions. After that he created total environments. His early manifestos, *Luxe, calme et volupté* and *Bonheur de vivre*, show utopias far from the present; in Nice, Matisse again depicts this ideal world, but now set in the immediate present. Like Matisse, Scully reinforced "his faith in painting as a source of undisturbed pleasure." But where Matisse was absorbed after 1918 in making staged images of his studio life, Scully now constructs environments based upon stone walls.

At the end of the High Renaissance, who could have predicted the sensuality and humanism of Titian's late paintings? Many thought that painting's development was finished, as in the 1980s so many American critics claimed that the story of art had ended. For Scully, however, the future of his art remains absolutely wide open.

> *Often I long to return to figuration. Maybe one day I'll be able to reconnect with the appearance of the world, and its examples. But right now my need to paint everything rather than something or one thing makes it impossible. I'm always trying to paint the whole thing, the whole world. But at the same time I long to be figurative.*

Now, as always, his career is a strange ongoing romance. Refusing to settle down into a signature style, he continues to innovate radically. When he became an abstract artist, he left something important behind, and so is, he reports, "still yearning for the union with life." That yearning makes his ongoing development essentially unpredictable. And that, I think, has to be a very exciting prospect.

*Big Grey Robe*
2002
Oil on canvas
90 x 72 in.
228.6 x 182.9 cm

overleaf
*Floating Grey Wall*
2002
Oil on linen
63 x 126 in.
160 x 320 cm

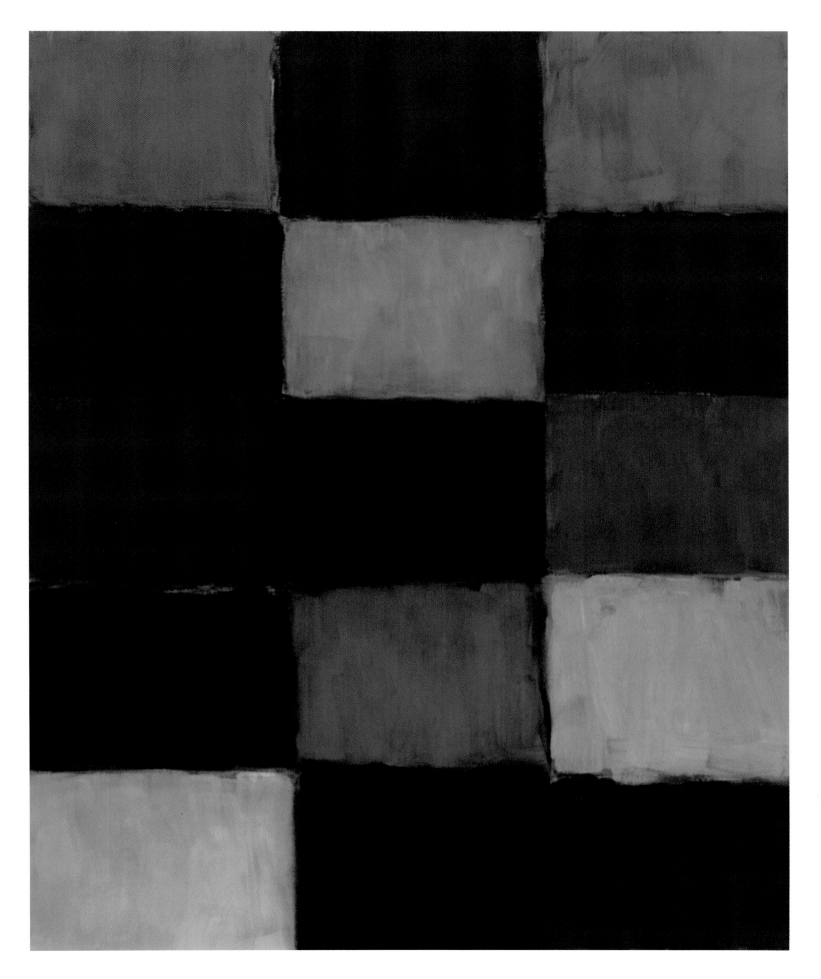

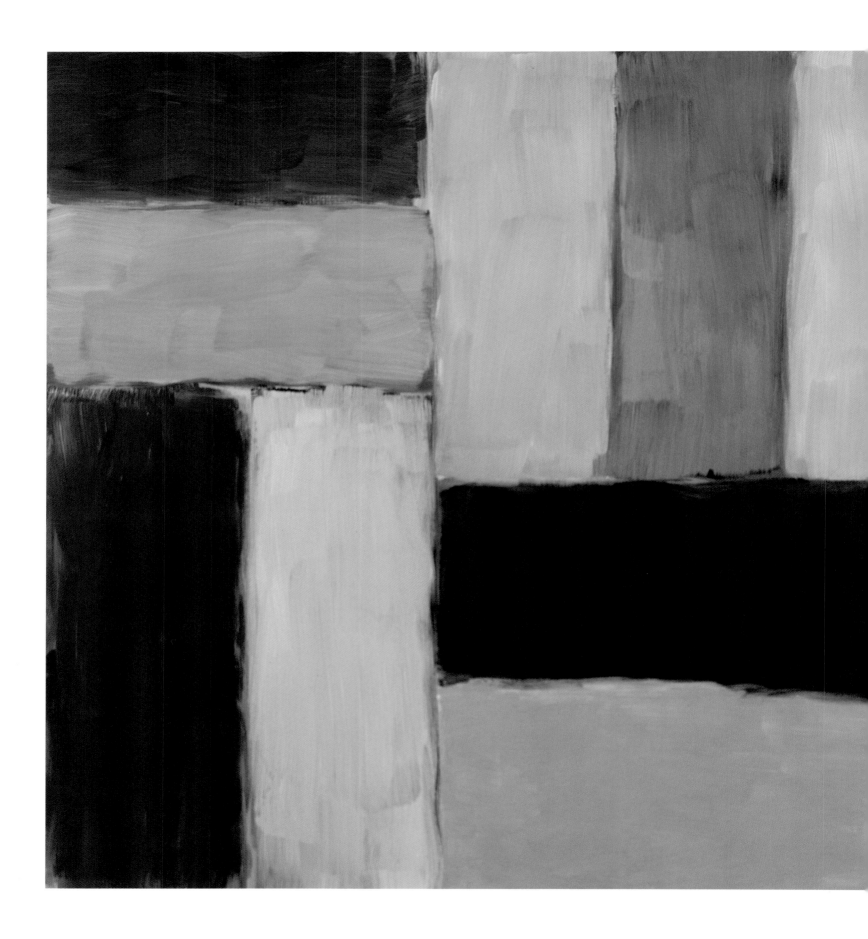

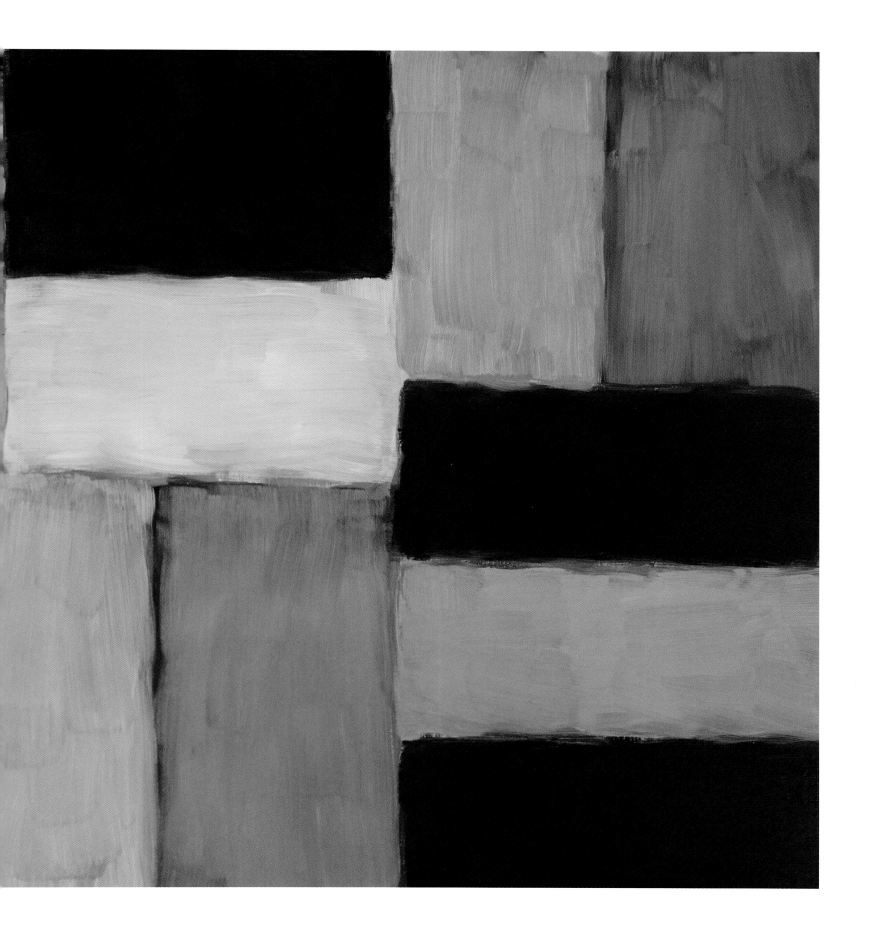

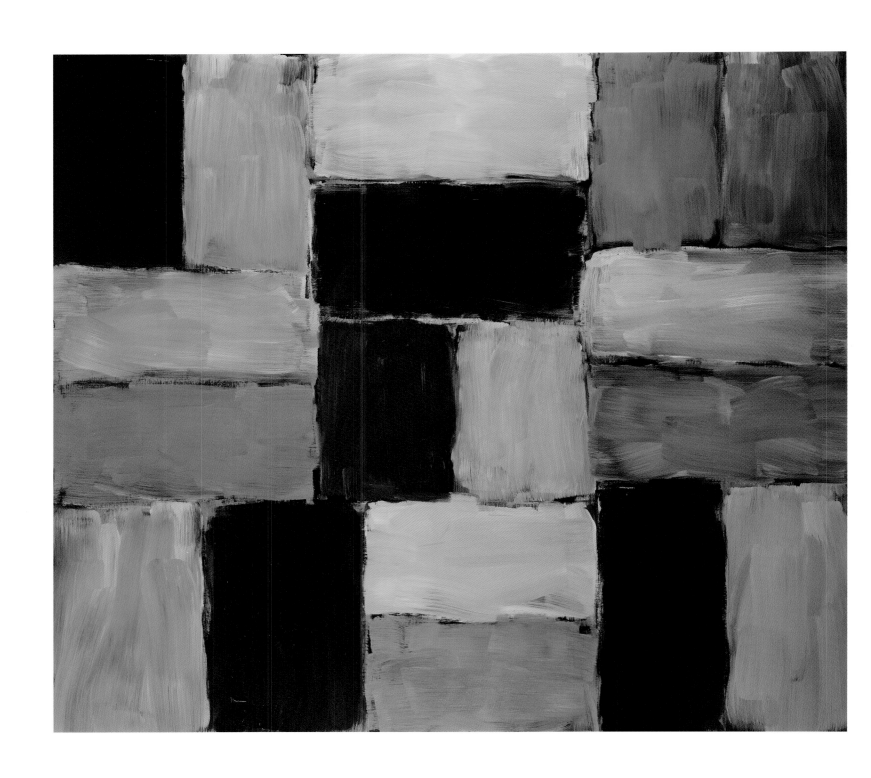

*Yellow Bar*
2002
Oil on linen
75 x 85 in.
190.5 x 215.9 cm

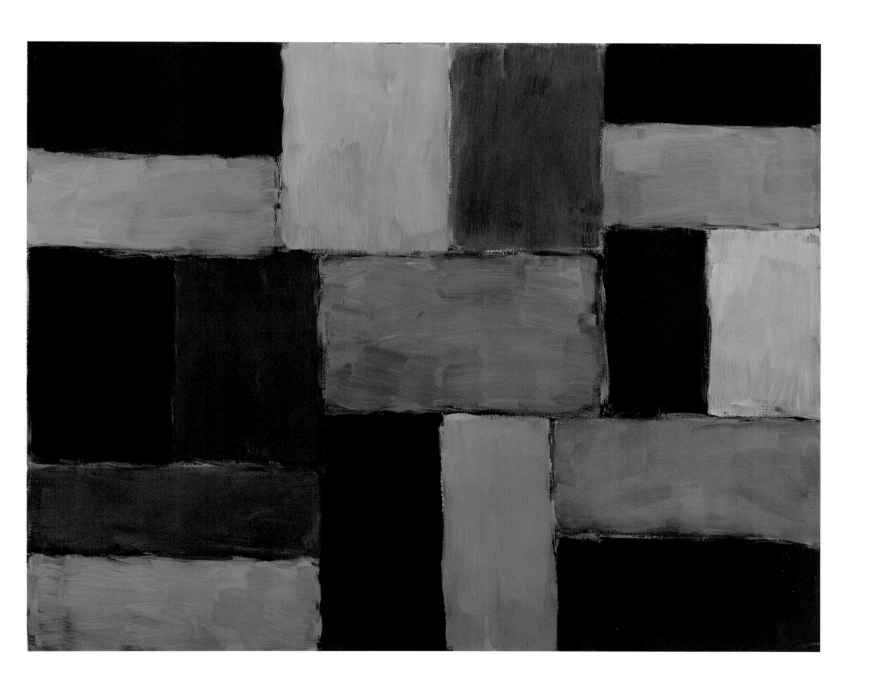

*Wall of Light, Pale Light*
2003
Oil on canvas
72 x 90 in.
182.9 x 228.6 cm

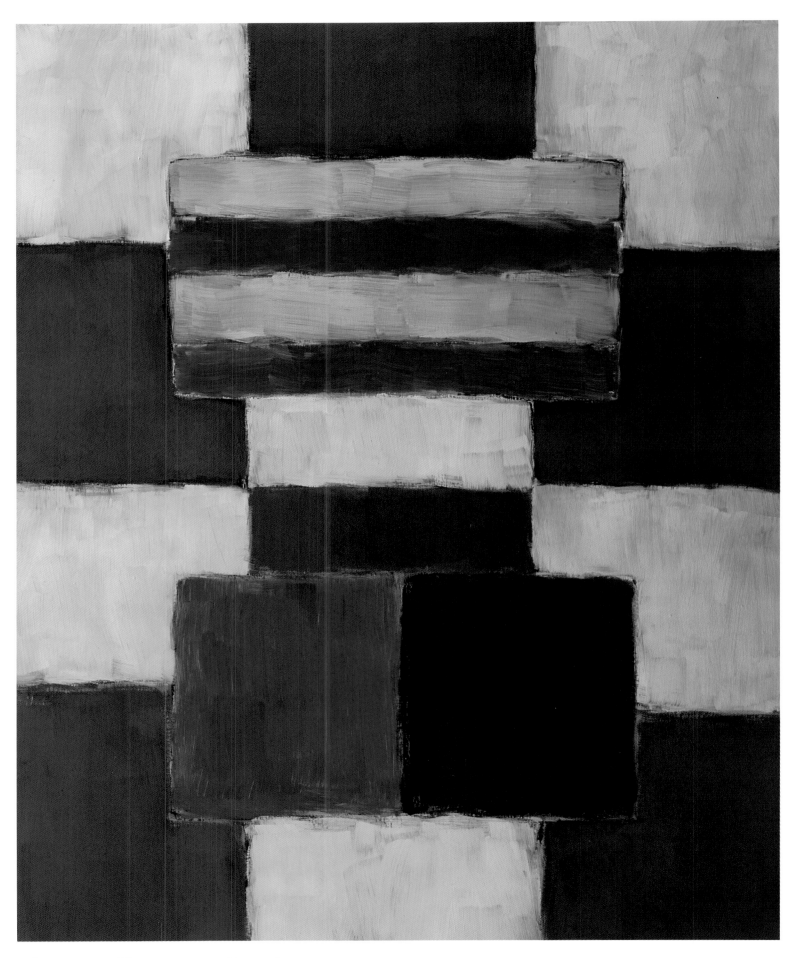

*Robe Figure*, 2003. Oil on canvas, 70 x 56 in., 177.8 x 142.2 cm

KP  You matured in the climate of the 1960s – an intensely active period both culturally and politically – politically with Civil Rights marches and race riots in the States, with the assassinations of the two Kennedy brothers and Malcolm X, Vietnam and the My Lai Massacre, the death of Che Guevara, the civil conflict in Ireland and May '68 in Paris, and culturally with Pop, Fluxus, Land Art, Happenings, Assemblage, Minimalism, and with Newman terminating his Stations of the Cross and Rothko the series of works for a chapel in Houston. What was it for you that now appear as key formative experiences and what were your significant encounters with contemporary art?

SS  *It has often been said that at certain points in the 1960s, London was the cultural centre of the world. And it certainly felt like it. My influences were everything; everything was coming in. The class system in London was falling, was in fact in free-fall. For me personally, it was the discovery of American Blues, and the shameless exploitation of it by British rock bands; cinema from Japan and France that was being shown regularly; and on top of that, Jean-Paul Sartre and Samuel Beckett. But more than that, after the Second World War, a certain kind of structured, class-ridden society in England was finished forever. I was living in a milieu of freedom and experimentation. Everything was philosophical, in the sense that, unlike today, an active and aggressive questioning of every possible value and mental structure was ongoing, in even the seemingly smallest of conversations. There was an intense romantic idealism in the air. It is a strain that has stayed with me and marked me deeply. We were very much marked by events. I was highly political. For example, when JFK was shot, I was painting huge theatre sets for a small-time theatre company. We all worked for nothing. The rest of the time I made anti-Vietnam posters. We fought in the streets with the police to bring down apartheid; and we did it. There was an attempt to make a new kind of spirituality. So when I finally devoted myself to Art, at the end of the 1960s, it had to embody the values that I manifested in other ways, in the mid-1960s. It's a very interesting question, in that people don't often ask me what the spirit of the 1960s did to my subsequent paintings, and what it continues to do.*

KP  1960s London would have included the London Group, English Pop, Rauschenberg; the huge 1954–64 show at the Tate provided for so many of us our first overall view of American work, etc. How did you negotiate all of this? Where did you see a context or point of departure for yourself?

SS  *London, by many, was regarded as the epicentre of the universe during the 1960s and more specifically in '67. My involvement with the culture of music and political change was total. As you know, I opened a blues club in '69 and I received, let's say, the occasional affectionate smack on the back of the head, in Trafalgar Square, when the police were trying to discourage our extremely enthusiastic attempts to bring down apartheid in South Africa. It was an extraordinary moment to be young and to this day I am deeply affected by it. That is to say, I am romantic and idealistic.*

*London recovered its extraordinary verve. All influences were pouring in and being absorbed, and very importantly I was beginning to understand the long-term differences between art and politics, what their limitations and possibilities were, and are to this day.*

KP  Both yourself and numerous critics of your work have discussed it in terms of its relationships to four major contemporary figures, Mondrian, Matisse, Rothko, and Pollock. Indeed, you have said that, "if you put Mondrian, Matisse, and Rothko together you have my work," meaning not so much that it is an amalgam, or a derivation, but that they constitute the figures with whom you consistently dialogue. These are the figures that create what Harold Bloom would call "the anxieties of influence." The fathers that a strong artist has to assassinate for his own work to fully emerge. Could you expand on the nature of your long and intimate argument with their work? And could you also say why Pollock – the existential wild card – was so quickly discarded and why your impulse should have been to tame him. I am thinking here of your remark that, "Mondrian taught me how to geometrize Pollock" – rather than, say, explode into the freedoms that his work appeared to offer?

SS  *I have always been deeply attracted to a sense of structure. In these terms another monumental influence for me would be Cézanne, whose work is heroic. He is a builder of paintings; he said that all he had was his little thrill. And this, in a sense, is all I have. I go to the mountain, as he did, again and again, and I am driven by love and feeling, though the need to make a kind of moral order is very deep in me. My work is not a rejection of influences, nor an assassination of artistic parents, but rather an incorporation of whatever is of use to me. I have eaten them, and now I am them. This is what I mean by spirituality. It's an absorption and complete identification into another way. I have not advanced merely through a sense of competition.*

*I have never particularly liked or admired Newman's criticism of Mondrian. I always thought that it was ungrateful and inappropriate. And ultimately I believe it to be a part of his limitation. Pollock is, of course, very interesting and important. He is, as I am, a linear artist. In addition, we are both obsessed by rhythm as, of course, was Mondrian. However, my deepest agenda was always to go deep into the soul of painting; to classicize it to a degree. And to make an emotion that was built and permanent. Pollock's energy takes painting to its very limit and, like other Abstract Expressionist artists, he made it extremely difficult to follow, except with further reduction. I am involved in the rebuilding of painting. It's a historically more complex agenda.*

KP  I mentioned Rothko in the terms that your forms also often bleed at the edges, have an understated aura, but could you tell me what it was that impacted you about Rothko's work, what it was that mattered, how much the work was the measure of the man?

SS  *The majority tendency in our age is to simplify the art problem. In other words, the visual and the serious have come apart, thus cancelling out the profound.*

*In the work of Rothko, and one or two others, the ideal of making high-minded visual art that's great to look at (like, for example, Veronese) is achieved.*

KP   In all events your opting for what might be seen as a transcendental wing of Abstraction goes somewhat against the climate of the times when Abstract Expressionism was beginning to be seen as a style, where Jasper Johns, whilst maintaining the visual seductiveness of the work, had clearly frozen or cooled things down so that the work appeared as a barrier rather than an invitation to emotional empathy, where Ryman was engaged in paring everything down to painting's simplest components, and where Minimalism was trying to reassert an edge of social criticism, even political dissent, in a kind of common-man poetics. What were your reactions or reserves to these new tendencies?

SS   *Quite clearly, I have been variously fascinated by them and yet critical of them. They are all important yet ultimately inadequate, in relation to what I want to do. So basically I have tried to use, or bring into my own domain, some of the aspects of the work you refer to, whilst, at the same time, rejecting its limitations. Peter Schjeldahl argued that Johns' flag paintings proved that you can't paint abstract anymore. I would argue the reverse. In other words, I would say that if you want to paint things that already exist, you have to paint them flat, like abstract paintings. Johns is very important to me because he values and paints beautifully the subjective surface, whilst embracing banal subject matter. It is transcendentalism cut off at the knees. I have kept this frontality, and I have made what might be called an emotional frontality which permits me to rescue from the wreck of the past, the color, the subjectivity, the touch, the sensuality and the sexuality of lost values in painting, while continuing to paint a contemporary rhythm, which doesn't submit to spatial narrative.*

*My subject matter (formally) is also quite banal since it's only stripes and blocks. However, it's freer than Johns. We do share very much in common, though, a kind of mastery of touch that looks back. One might even argue that Johns' paintings look like Cézanne's transformed into flags and numbers.*

*Am I out of fashion? I certainly hope so! The majority position is, by definition, oversubscribed, and therefore in no need of further representation.*

KP   You have shown a consistent wariness of the vaporous dangers of spirituality and an insistence on relating it to, or discovering it within, life itself. It amounts almost to a belief that it starts in the ordinary. I recall a series of photos of yours from the 1990s that centred on doors and windows where the tonalities and wear of the paint on the buildings was close to your own textures and colors. Do you always start from something outside in the world or do you also work directly off an emotion?

SS   *This feeling of course further aligns one with Johns, though our solution to this problem is very different. Particularly in the case of abstraction, where many artists hardly know how to draw, there is a great danger of achieving a kind of empty seductiveness that really ends up as sentimental decoration. I'm not questioning the artists' intentions which, I'm sure, are very sincere. It's simply that, when one enters too acceptingly into the seductive space and beauty of abstraction, it's possible that only pleasure will be achieved. And that's not art! This, incidentally, is happening with great frequency now, in other art forms, such as video, where the artists are simply too happy with their inherent technical possibilities. In other words, where everything is visually impressive for a couple of minutes and everyone goes home happy. This is the Biennale syndrome!*

*I believe that any kind of transcendence, spirituality or redemption, starts with the ordinary. I come from the ordinary. I grew up in the ordinary. And early on, I went to work like an ordinary person. A seriously dangerous problem for an artist working in an Academy or in New York or London is that you can build your arguments on too much received opinion and philosophy. This is comfortable, but fatal. And you are likely to end up, however unwittingly, as a sophist, building or extending arguments, too comfortably situated on the accepted point of view.*

*I have tried to connect my work with the world that exists outside painting, from subject matter inspired by the street.*

KP   Your work is intensely musical. It has the kind of intensity of listening to each other that one finds in a string quartet or in the Miles Davis albums of the 1960s. It is characterized by rhythms, modulations, intensely felt chords. It surges and affirms a highly nuanced presence and emotional range. It seems to hold time within it. In other words, do you still feel that Abstraction is the ideal language for deep emotion or what might be called the lyric valuables that allow contradictions to lie up against each other?

SS   *Yes, indeed, I do. I have talked recently of the relationship I have to music. And as you know, I had a blues club when I was eighteen. And I never work without music, unless I have to. It is sometimes said that all art aspires to the condition of music. I would like my art to aspire to something like the condition of music, but a condition that can be felt and experienced in a deep moment. I think with painting you can get rid of the problem of time. You can feel it abstracted in the rhythms, in the layers of the painting, but you are, for a moment, free.*

*I do believe abstraction is and was meant to embody deep emotion. I believe that's its job, in the history of art. The edges of the characters and forms in my paintings should lie against and with each other, with complexity and emotional depth. Naturally, one feels time in my work, because it is layered. It is repainted many times, in different colors and weights of paint, always by me. I do so until somehow everything lives, however gracefully or awkwardly, in its right place. So it's a façade, but it's a façade that submits to feeling or is overwhelmed by it, since nothing is perfect.*

KP   You have talked about yourself as a "romantic realist," a stance that given our present circumstances, is not easy to sustain, both on account of the geopolitical changes taking place in the world and because numerous philosophers seem to be questioning the gains of our Western humanist tradition to which such an attitude clearly belongs. How do you see the real as now penetrating the romantic frame through which you "feel" the world?

SS   *This is a very big question, a question about which one could write a book. I am very aware that the romantic is now seen to be of limited relevance. However, I have attempted to articulate my idealistic sense of romanticism in the world, as it is, with its problems now, without giving up on my true personal feeling. To say it simply, I think it's not only possible but important to offer a deeply felt example of a humanistic art form in a world that has become extremely cynical. I have lived through many changes, social and political, that have affected me and changed me. However, my art is trying to address something eternal and universal. So however difficult it may be for someone with my sense of connection (connectedness) to continue to offer an idealist/ humanistic view, I have to keep doing it. In fact, the worse it gets, the more crucial it is to offer it. I hope my work can stand as an example of another*

*possibility. I realized, when I moved out of the political arena in my radical days, that I would experience as an artist moments of guilt and impotence.*

KP You construct through what you term a daft plan of verticals and horizontals as a kind of loose inclusive form that allows you to feel at ease with yourself, but how do you understand these principles – as formal, as symbolic, as psychological?

SS *Of course I use horizontals and verticals, more or less exclusively. I use them as symbolic and psychological. Horizontals are the eternal horizon, where we see the edge of our own local world. Verticals are assertive, like us standing. There are a lot of references to figures and nature in my work, so naturally it has a psychological aspect to it, where the assertive and the affirmative human action comes into contact with the permanent.*

KP Ambiguity, the principle of uncertainty via Heisenberg, Negative capacity via Keats were very much contemporary figures of the 1960s. These are saturated existential and romantic stances towards reality. You seem to have constantly held to them, suffused them with some kind of poetic whisper or affirmative shout. Much contemporary work places language at the centre whereas you still hold to man, and above all to man as engagé, as committed in the Sartrian sense. The Sartrian affirmation was ideological and you remain deeply political. How do you see this entering the work?

SS *Yes, I hold to man in the face of the constant disconnection from and disembodiment of language and methods of the dissemination of language and information (such as war on television) from our emotional moral self. I have watched this tendency develop, definitely since the 1960s, and it disturbs me. I try always to reconstruct my language with emotional human force. I live in an age of deconstruction and sophism, where spirituality is circumvented in favour of socially and morally "separated" language games. I see that this can have a function, since it might serve some notion of clarity but I don't ultimately believe this. I don't believe that a separation of linguistic structure from morality and emotion clarifies anything of any use. I am therefore a reconstructivist. My work is affirmative. I want to affirm the expressive potential of the individual, to re-establish this in the face of world order.*

KP How do you see yourself in relation to Greenberg's statement that the superiority of abstract art is based in its historical justification, by which he means abstract art's ability to salvage something from the collapse of the bourgeois cultural order? In other words, in Greenberg's terms, that abstraction produced an avant-garde culture, a superior consciousness of history. By which at one more remove he undoubtedly meant a Marxist critique of society. There is a lot at stake here, and Greenberg also insists that there are higher values than aesthetic values and he even reminds us of Thomas Mann's argument that to take aesthetic values and introduce them into questions of morality is a barbarism. It is a useful reminder! Can art, in fact, affect the course of human affairs? Can you relate to this in any way?

SS *I think of Greenberg as probably a great man who I don't agree with. He may be right about the historical position of abstraction, if one considers the work of Malevich and Rosanova, etc. However, he is also the same person who said at a lecture I attended, "Dem Ruskies can't paint." I personally think that, like Napoleon, Greenberg lost his way. The historical vitality that he refers to is not exemplified by abstract painting that is made (or designed) according to canons of perfect arrangement or good taste or, let's say, high-minded taste.*

*The high-minded ambition that I refer to with Rothko has nothing to do with taste: the question of beauty is raised here. However, to my mind beauty in art has to be complex and complete as an experience and must therefore be prepared to take on pain and pathos.*

*I don't see abstraction as historically superior. But then it's true to say that Greenberg's historical references are very different to mine and I was born when the Second World War was over. I think abstraction in a sense could be considered as historically inferior. This might even be more interesting.*

*I am not interested in the obvious centres of power. The greatest Rococo painter, for example, was Jean-Antoine Watteau who painted the demise of his own artistic context. I would argue that "power" obscures truth or emotion. I find myself historically in the position of an individualist since the terrain that I look out on is occupied by other art forms. This allows me to make paintings that are "figurative," or put it another way, that are concerned with the memory of the human figure. I paint relationships. I don't paint abstractions. I think the "weakness" of abstraction is the very centre of its expressive potential.*

*Historically speaking one might say that my work has evolved in reverse. Greenberg is right to assert that abstraction came out of revolution, but at that point it was weighted with mysticism and symbolism. In America it was opened up and cleaned up so that it became visually and physically commanding and self-evident. I worked my way through Minimalism. Now I'm taking a simple syntax that has been identified with Suprematism and Minimalism and I'm filling it in. I'm giving it back to emotion and humanism, and since my own story begins in Europe, and since I have the whole history of European painting to draw on, I'm using it. It would be different and unavailable for an artist who started life in America. As information moves back and forth it's modified and transformed, and then it takes on a possible new meaning. Painting seems especially adapted to this process of reinterpretation since it has the ability to absorb small changes that give off different emotional realities. In the beginning of Italian art (13th century) painting was devotional, and almost entirely devoid of ego. It might have to return to that state in order to continue. That's one of its options.*

KP You have said that your works don't deal with clarity but with revelation. What is it that you mean by that? Consuming clarity surely constitutes a form of revelation?

SS *I understand what you mean. And certainly one form of revelation (which is to see and understand) is bound up with clarity. What I meant by my seemingly contradictory remark is that I don't necessarily associate revelation with focus and clarity. I associate it with harmony and a sense of belonging, whilst accepting that the world and being human in it is complex and inscrutable. Perhaps one could say that to have an insight into your own self doesn't necessarily have to clear everything up. I may also have made this remark in the context of a discussion of perfection. My own view is that perfection (which involves clarity) is somehow false. My own sense of harmony includes mystery and imperfection.*

KP Your work is like a high energy construct, very much a charge of the emotions of the moment, of a knot of emotions. Are they specific, that is, anchored in a known circumstance or feeling, or are they more a general spiritual condition?

SS *The emotions that I'm working out of, or working under the influence of, must be specific since they have to be present in order to exert their influence. But I*

*am not attempting to "paint" them or "represent" them, though I am definitely directed by them. But feelings don't have names necessarily. When I'm painting in the countryside I might make a green painting. However my problems and possibilities get carried around with me. I think the big issue is to have a connection with the world so that this connection can be recognized in the work. Then it's affecting.*

KP  You said somewhere that beauty has more to do with the relationships we make than with the way we make things, in that we're not living in an age of crafts. How do you take that over into the work? I recall Olson arguing that our central task after Modernism was to undermine the egocentric position of man, of man as artist, as authority, and find a more ex-centric stance to reality. In terms of poetry this implies a new inclusiveness, both in terms of reducing the need for a dominant authorial language and in a new receptiveness to outside voices, to other narrations. How do you feel that this beauty, implicit in relations with an "other," can enter the work, i.e. so that the artist actually does listen to the other as equal?

SS  *We are not living predominantly in an age of crafts. This does not mean however that crafts do not exist, or that they are not important. They are very important, outside the militarily and economically dominant corner in which we live. But in a mass-produced culture, one of our shrinking possibilities lies in the arrangement of mass-produced objects as opposed to the objects themselves. If you go into your friend's house and he has the same telephone as yours, it may not be on the same table and even if it is, it may not be on the same carpet and even if it is, it can't be the same apartment unless you live together. Identical arrangements don't exist.*

*In my own work I am taking my painting into its own humanistic expressive history and away from the direction of the mass-produced world. One could argue that the mass-produced world is dehumanizing, though that depends on how we use it and where we create our areas of freedom. My work is relentlessly emotive and whenever I paint I surrender to emotion made by hand, so in that sense I am resistant. I'm making a romantic complement or opposition.*

KP  Are these loose formal structures metaphors, resistant structures that you subjectivize and humanize?

SS  *These formal structures like 2, 3, 4, 5, or even 6 are common and actually don't mean anything. I made a very simple little triptych last month in Barcelona. The painting came out very dark. It looked like a painting from the 19th or 17th century, pushed through the curtain of abstraction so that it arrived in the present remade wrong. It has the feeling of the past that is all shadow, and touch, but it's made out of the material that we have now.*

KP  How do you relate and choose color? I know that you have talked of yellow as conveying the tragic and the sexual but, I suspect, it is not your intention to allocate symbolic connotations to color. Your palette might be seen as relatively reductive in that there are clearly characteristic Scully colors, but the range of tones is immense.

SS  *I did recently paint a painting for someone who was dying, and I used yellow and black and white. I was immediately attracted to Van Gogh, in part because of yellow since it has such a strong sexual life-affirming charge. So many flowers and trees are yellow. I don't think of color symbolically when I work, although I am aware that often I fight for color in my work, to assert my connection to the natural world. I actually have no theory about color*

*whatsoever, and I have no idea really why I make my paintings the colors they are. Afterwards I can always interpret them as active, sad, resolved, awkward, etc., though not when I'm painting them. At that point I am working, wet into wet, in an emotionally charged state. So I am not looking for clarity; I am looking for emotion. Therefore I work and work, until it arrives. I am not, in a sense, making it, or forcing it, or controlling it: I am improvising and painting with feeling until it arrives. I feel as if I am making the painting, though I am not controlling its destiny.*

*There is, as you say, a wide tonal range in my work. And most of the colors are impure and then found again on the surface, since that's where they are given their body and shape and place, how they are situated and painted, and how the rhythm of the painting is affected by them. So it's extremely complex since a painting that was yellow and that then has turned black in its journey can never be a completely black painting. It will always be a black painting with a yellow history. This, of course, is the way our world is made. There's no such thing as a clean slate.*

KP  What is your intention with the floating pieces?

SS  *I wanted to make a double-sided environmentally active painting. That engaged memory, and walking around: the way sculpture does. I was also fascinated by the idea of a painting that was tentatively connected to the wall. It was also a way of activating painting since paintings are occasionally overlooked because they are always presented the same way. Flat to the wall. I wanted to turn them out into the space, put them into a floating relationship with architecture, and especially with the floor. I once saw a double-sided drawing installed this way: perpendicular to the wall. I couldn't stop walking around it.*

KP  In the 1980s many artists deconstructed Abstraction, insisting that it is essentially a language code, a known rhetorical figure that stands as one of the major contributions of Modernism. How would you answer that?

SS  *The painters who deconstructed abstraction are mostly, in fact, from my generation. I think of them as clerks or book-keepers. They have replaced a sense of creativity with a sense of inquiry. And most of them would, I suspect, have been nearly top of their class at school!*

KP  I am wondering how you react to that English tradition of portraiture that has accompanied you across these years – Bacon, Auerbach, Freud – that seems in a strange way to complement your own concerns in that it is deeply human, saturated in emotion, full of contradictions, clumsily moving forward, and overwhelming as presence?

SS  *This is a fascinating question, and one that I had to answer definitively when I was a student in England. I was giving a lecture once in Berkeley, California, and someone asked why I left England. I replied that I once had a dream, and in my dream I walked into a wet cobblestone cul-de-sac. At the end of the cul-de-sac, slumped against a damp brick wall, were Francis Bacon and Lucian Freud, dead drunk, sketching each other. I love everything about their enterprise, with the exception of its insularity and its hermetic investment in a certain branch of London society. This again is related to the question of the 1960s. They grew up in another age, during the war. I grew up in an age where we rejected the high-society bohemian values that preceded us in favour of a bigger, internationally minded idea.*

KP  Your work process seems to me to involve a minimal structuring agent that may have its origin in diverse sources, coming both from the world

outside and from the organizing tendency of the mind. I am referring once again to the horizontal/vertical structure or the pairing both as oppositional and as complementary forces. But my point is that when you are working these reference points become holds that in a very literal sense hold the physical activity together. Things are cancelled out, overwritten, without a second thought, and harmony in any classical sense is clearly not a central objective. What seems to matter is something more complex, like a glimpse of truth. That seems to be the drive behind the work and constitutes what is emotionally and intellectually at stake. You may well cancel out a color through what seems to me essentially an impulsive reaction and you may also cancel out a type of brushstroke without thinking specifically about what lies next to it. You seem rather to think or act in terms of a fluid whole that can finally, through a momentary recognition or intuition or through a more calculated mental process as to what works or does not work, come to some kind of resolution; although I suspect if one thing does not work it immediately upsets the whole apple-cart and things have to reposition themselves, find their place once again. I may, of course, be off the mark in what I have said, but I'd like you to comment on the process that is central to the works, as an enactment or re-enactment of something coming into being.

SS  *I am surprised by how well you intuit my working process since I have never explained it to you. Also to a degree you answer your own question. I paint and repaint to "get at" or "hold" a glimpse of some truth. That's why my work is not formalism or even a form of structuralism. I don't work towards a sense of obvious harmony, though I am concerned with beauty. Because it has a surface like no other art form, I believe that painting cannot only show pathos but is uniquely able, at rare moments, to embody it. The difference between an image and a painting is profound, like the difference between a photograph of a person and a person. The only visual form that can embody so much experiential structure and feeling in a single moment, a glimpse, is painting. And that's a question of skin.*

*I'm using extremely simple forms that I see running through the basic human ordering systems. I never allow it to become baroque or intricate. I keep it somehow fundamental so that it can be recognized from more or less any cultural point of view. I see these simple forms as what unites us and what runs beneath the cultural superstructures that have caused us to be estranged. That is why I keep it simple. Then I'm using my body and emotional condition to layer it with meaning, to give it the power to draw out light, touch, and feeling.*

*Every time I start a work, I am aware that I am picking up, once again, a simple way of ordering relationships. But the act of painting is highly nuanced, so after a while (I mean about thirty years) the color and the material and the emotion become unified, everything is inseparable from everything else. So the relationships between the shapes are constantly open to re-interpretation, everything becomes weighted and colored into place, and relationships are ongoing and flexible and nuanced; their meaning is not fixed or rigid, although what they paint into place is basic.*

KP  Related to the question I have just asked I'd also like you to specifically address the weights, implications, and meanings of the brushstroke since they often involve very different kinds of register, which presumably have to read as distinct emotional states or as the complexity of physical action,

as in the metaphor of the dance so present in the work of Matisse and Pollock, and, of course, so different in the ways in which they were understood. Do you work through a whole range of emotional states within the picture, as part of its essential tension, as fragmentary statements or impulses, or do you see the whole as an emotional statement with a coherence that can also embrace contradictions?

SS  *When I am working I'm not interested in simply arriving at something that looks good visually. I had a friend comment once, after watching a film of me working, that I had painted out three or four good paintings on my way to the final version. She was right in a sense, but a painting has to bring more, it has to embody meaning. It's not just a sign; it's a sign with a skin and a body.*

*If the spaces between the blocks in my paintings are opening up, that has meaning. It makes the relationships less secure or more flexible; it's not a simple question of visual effect.*

*When I'm working I'm moving around a lot in front of the paintings, so there is rhythm in the brushstroke: this is affecting the shape, how it is made, how it looks, how it meets, or not, the shapes next to it. The way I'm painting directly affects the weight of the paint and thus the color. Everything is painted into its place. As the title "wall" implies, I'm building a surface, but I'm building out of feeling directly, and this feeling has rhythm.*

*Cézanne paints the ordinary. He paints his apples and his apples are ordinary just like any others. So that cannot be the point. To paint the subject down, or to paint a subject that is banal, is to search for transcendence in the simple, to elevate the simple rather than to illustrate the important.*

*Artists who "want to get at something" to represent a profound moment with intimacy have to work with the simple. So obviously my work is relating to Mondrian and Newman, but my painting solution is very different. Mine includes sensuality and the body and I pursue a kind of pathos that is ever present in our attempts to capture these moments.*

*Cézanne said that all he had was his little thrill, and in a sense that is what he had. He was a picture-builder who wanted to give deep structure to feeling. I could say the same: all I have is my little thrill, supported by will.*

KP  This takes me to my own central problem with reading abstraction. I don't believe, of course, that it dies. I remember Pablo Palazuelo telling me that there was no way of going back to any prior condition once it had been linguistically stated: an unequivocal claim for its superiority as a language. But I do wonder, with the collapse of Marxism, with its dialectic ceasing, if there has been nothing left for abstract art but its own values, i.e. it talks about itself and thus matters only to very few of us. And possibly even more problematic is the fact that we now feel intellectually absolutely at ease within its discourse. I mean that the values it stands for are no longer in active interplay with other values to which they refuse to be subsumed. I believe that abstraction has certainly been revived through deconstruction, I mean through deconstructing how language systems work and what they have come to mean, and it has never lost its pertinence as a metaphor for science which produces images of the world, of ourselves that we have never seen and are abstract in essence (I expect you remember that book by Waddington, in the 1960s I think, that showed the intimate relationships between the abstract works of the Expressionists and biology). I also think, and it is here that I would inevitably situate your work, i.e. within a system of beliefs where that abstraction can still track the

complexity, inclusiveness, uncertainty, and contradictoriness of human nature and of contemporary experience – but I also wonder how it can do so! Does it need a structure? Could it be as flowing as life itself? The possibilities seem immense, but not all are opportune or touch a nerve within the time. The whole Eurocentric sense of the unquestionable superiority of Western civilization is being put into radical question and this inevitably means a collapse of many of our central myths.

SS  *Your problem with reading abstraction leads us into our zone of disagreement. Since I don't really care so much about the connection between abstraction and its obvious centre of cultural political power, it necessarily follows that I don't see its loss as anything other than a future possibility in the ongoing evolution of painting, abstraction being only one part.*

*If one looks, for example, at a fifty-year-old film, it looks as if it is fifty years old. Despite my love of film and my knowledge of it, I acknowledge that this is a problem. This will happen soon enough to video, too, because it depends so deeply on the seductive power of technology. It has "obvious appeal:" too obvious to be interesting.*

*I am personally not concerned with the development of abstraction. I am involved with the development and the relevance of painting. That is why my work is so different from abstract painting (like Newman) that it has formal similarities to. On reading your question again, I might revise my opinion that we disagree here, but I do believe we see it as something distinct culturally.*

*I also don't agree that abstraction was revived by deconstruction. Deconstruction in philosophy might have been an interesting moment, a little house-cleaning so to speak. But in painting I believe that it has achieved perfect mediocrity. Because painting is an art form and philosophy is not. Painting is made out of material and if it's used as a terrain of examination, it might sound clever, but finally, it lacks the quality that is crucial to all visual art: the power to affect us.*

*As I previously mentioned, I'm a reconstructivist. It's one thing to take a bus apart, and as I've acknowledged, it might be argued that it has a function, but it requires an entirely distinct form of energy to put it back together again.*

*The philosopher Schelling in the 19th century thought that art had reached the place that philosophy struggled to find. The power of painting lies in its ability to realign and redefine itself with evolving concerns without having to transform its physical character. It can also compress feeling and experience in a way that doesn't submit to over-explanation, into a simple flat surface. Philosophy is, in a sense, everything. So is painting, but it's a different kind of everything. Philosophy has to explain itself. If it doesn't it is in danger of becoming Art. When Art tries to explain itself it becomes weak, and the*

*abstract painters who were influenced by deconstructivist philosophy did just that. I can see that the conceptualists might like it, but that's not my problem: I'm making paintings.*

*I use abstract forms because they are fundamental shapes: this makes the rhythms of the relationships move in a free space. Nearly every form of communication in the world now submits to deconstruction. Painting has moved into a space where it can resist this juggernaut.*

KP  What new concerns, as emotional tensions or as images from the world outside, are now pushing themselves forwards as urgencies within your latest work?

SS  *Lately, my work has been moving towards more lyrical movement and swing within the work. The architecture that was so strong in the 1980s has given way to a more influential brushstroke. Instead of making my work more critical of the condition and possibility of painting, it is becoming more secure in its own simple and unique opportunity. The word "light" enters these days with great regularity into my titles.*

KP  I'd also like you to comment on your sense of the pair that runs throughout your work. Is it a metaphor for the basic human relationship and for the whole range of confused and contradictory emotions and ideas that come from that?

SS  *The pair and the whole idea of coupling is fundamental to my work. I've been working with diptychs for many years, which I believe represents an obsession with relations. I wanted to put back into painting (abstraction as it is called) relationship, and the first relationship is ourselves in the mirror or ourselves with another. It's an endless possibility and an endless problem. In fact it's the* problem *and the* possibility: *so I'm painting it, again and again as it happens.*

*In this sense, abstraction can be considered close to philosophy, the juxtaposition of bodies and thoughts, whose open-ended pairing and ordering and texture reveal deeper meaning.*

KP  And finally, I know that you are now teaching in an art school in Germany, a master class where painting stands as a central figure, but also as an open figure. What would you see as your central purpose in taking on this task, which at one level can only be a distraction from the work, even though it obviously supplies a continuing dialogue with the present through the interests and preoccupations of the students?

SS  *I am teaching in the Academy in Munich because, simply put, I want to give a place to young people who want to paint and who have, in art school, been bullied into not doing so.*

April 2003

# Chronology

| | |
|---|---|
| 1945 | Born 30 June in Dublin, Ireland. |
| 1949 | Family moves to London, England. |
| 1960–62 | Apprenticed at a commercial printing shop, London. Joins a graphic design studio. |
| 1962–65 | Evening classes at the Central School of Art, London. |
| 1965–68 | Croydon College of Art, London. |
| 1968–72 | BA in Fine Arts, 1st Class, Newcastle University, Newcastle-upon-Tyne, England. |
| 1969 | Travels to Morocco. |
| 1970 | Receives the Stuyvesant Foundation Prize. |
| 1971–72 | Lectures at Sunderland College of Art and Teaching Assistant at Newcastle University, Newcastle-upon-Tyne, England. |
| 1972 | Prizewinner in "John Moore's Liverpool Exhibition 8." |
| 1972–73 | Receives a John Knox Fellowship. Harvard University, Cambridge, Massachusetts. |
| 1973 | First exhibition, Rowan Gallery, London. |
| 1973–75 | Teaches at Chelsea School of Art and Goldsmith's College, University of London. |
| 1975 | Receives a Harkness Fellowship. Moves to the United States of America. |
| 1977 | First solo exhibition in London, at the Rowan Gallery. |
| 1977–83 | Visiting Art Professor at Princeton University, New Jersey. |
| 1981 | Ten-year retrospective exhibition at the Ikon Gallery, Birmingham, England. |
| 1981–84 | Professor at Parsons School of Art, New York. |
| 1982 | Works at Edward Albee's artists' colony in Montauk, Long Island, for part of the summer. |
| 1983 | Receives Guggenheim Fellowship. Becomes an American citizen. |
| 1984 | Receives Artist's Fellowship from the National Endowment for the Arts. Participates in "An International Survey of Recent Painting and Sculpture," The Museum of Modern Art, New York. |
| 1985 | First solo exhibition in an American museum, Museum of Art, Carnegie Institute, Pittsburgh, Pennsylvania. |
| 1989 | First solo exhibition in a European museum, Whitechapel Art Gallery, London. |
| 1990 | Monograph published by Hudson Hills Press, New York. |
| 1992 | Revisits Morocco in December to make a film on Matisse for the BBC. Joins Galerie Bernd Klüser, Munich, and the Waddington Galleries, London. |
| 1993 | First exhibition of the "Catherine" paintings in the Museum of Modern Art of Fort Worth, Fort Worth, Texas. |
| 1994 | First paintings in a new studio in Barcelona in the summer. Participates in the Joseph Beuys Lectures, Ruskin School of Drawing and Fine Art, University of Oxford, England. Participates in a colloquium held in conjunction with the exhibition "Richard Pousette-Dart (1916–1992)" at the Metropolitan Museum of Art, New York. |
| 1999 | Paints *Chelsea Wall 1*, 1999, the first painting in the new studio in Chelsea, New York City. |
| 2000 | Inducted as a Member into the London Institute of Art and Letters, London. |
| 2001 | Inducted into Aosdána, an association honouring artists of outstanding work and their contribution to the arts in Ireland. |
| 2002 | Professor for Painting at the Akademie der Bildenden Künste, Munich, Germany. |
| 2003 | Awarded Honorary Doctor of Fine Arts degree, Massachusetts College of Art, Boston, Massachusetts. Receives Honorary Doctor of Fine Arts degree from the National University of Ireland, Dublin. Dedicates a monumental sculpture for the University of Limerick, Ireland. |

# Solo Exhibitions

*(c) denotes a published catalogue*

1973 Rowan Gallery, London

1974 Rowan Gallery, London
Tortue Gallery, Santa Monica, California (c)

1976 Tortue Gallery, Santa Monica, California

1977 Duffy-Gibbs Gallery, New York, New York
Rowan Gallery, London

1979 *Painting for One Place* (installation), Nadin Gallery, New York, New York
Rowan Gallery, London
The Clocktower, New York, New York

1980 Susan Caldwell Gallery, New York, New York

1981 Rowan Gallery, London
Museum für (Sub)Kultur, Berlin
"Sean Scully: Paintings 1971–1981," Ikon Gallery, Birmingham, England
Traveled under the auspices of the Arts Council of Great Britain to Sunderland Arts Center, Sunderland; Douglas Hyde Gallery, Dublin; Arts Council of Northern Ireland, Belfast; Warwick Arts Trust, London (c)
McIntosh/Drysdale Gallery, Washington, D.C.

1982 William Beadleston Gallery, New York, New York

1983 David McKee Gallery, New York, New York

1984 Juda Rowan Gallery, London
Galery S65, Aalst, Belgium

1985 David McKee Gallery, New York, New York
Museum of Art, Carnegie Institute, Pittsburgh, Pennsylvania
Museum of Fine Arts, Boston, Massachusetts (c)
"Drawings," Barbara Krakow Gallery, Boston, Massachusetts
"Sean Scully: Neue Arbeiten," Galerie Schmela, Düsseldorf

1986 "Sean Scully: Paintings 1985–1986," David McKee Gallery, New York, New York (c)

1987 "Monotypes from the Garner Tullis Workshop," Pamela Auchincloss Gallery, Santa Barbara, California (c)
David McKee Gallery, New York, New York, Douglas Flanders Contemporary Art, Minneapolis, Minnesota (c)
Mayor Rowan Gallery, London (c)
Galerie Schmela, Düsseldorf (c)

1988 "Four Paintings," Art Institute of Chicago, Chicago, Illinois
Matrix/University Art Museum, University of California, Berkeley, California (c)
Fuji Television Gallery, Tokyo (c)
"Prints," Crown Point Press, New York, New York; San Francisco, California

1989 David McKee Gallery, New York, New York (c)
The Whitechapel Art Gallery, London. Traveled to Palacio de Velázquez, Madrid, Spain; Städtische

Galerie im Lenbachhaus, Munich (c)
"Pastel Drawings," Grob Gallery, London

1990 Karsten Greve Gallery, Cologne
Galerie de France, Paris (c)
McKee Gallery, New York, New York (c)

1991 "Paintings and Works on Paper," Jamileh Weber Gallery, Zurich (c)

1992 "Prints," Weinberger Gallery, Copenhagen
"Woodcuts," Pamela Auchincloss Gallery, New York, New York
"Prints and Related Work," Brooke Alexander Editions, New York, New York
"Sean Scully: Woodcuts," Bobbie Greenfield Gallery, Los Angeles, California
"Sean Scully: Woodcuts," Stephen Solovy Fine Art, Chicago, Illinois
Daniel Weinberg Gallery, Santa Monica, California
"Sean Scully: Paintings 1973–1992," Sert Gallery, Carpenter Center for the Visual Arts, Harvard University, Cambridge, Massachusetts

1993 Waddington Galleries, London (c)
Mary Boone Gallery, New York, New York
"Sean Scully: The Catherine Paintings," Modern Art Museum of Fort Worth, Fort Worth, Texas (c)
"Sean Scully: Paintings, Works on Paper," Galerie Bernd Klüser, Munich (c)

1994 "Sean Scully: The Light in the Darkness," Fuji Television Gallery, Tokyo (c)
"Sean Scully: Works on Paper," Knoedler & Co., New York, New York
Butler Gallery, Kilkenny Castle, Kilkenny, Ireland
Kerlin Gallery, Dublin
Galleria Gian Ferrari Arte Contemporanea, Milan (c)

1995 Galeria El Diario Vasco, San Sebastian, Spain (c)
Galerie de l'Ancien Collège, Châtellerault, France (c)
Waddington Galleries, London (c)
Mary Boone Gallery, New York, New York
Galerie Bernd Klüser, Munich (c)
"Sean Scully: Twenty Years," Hirshhorn Museum and Sculpture Garden, Washington, D.C. Traveled to High Museum of Art, Atlanta, Georgia; La Caixa des Pensiones, Barcelona; (1996) Irish Museum of Modern Art, Dublin; (1996) Schirn Kunsthalle, Frankfurt (c)
"Sean Scully: The Catherine Paintings," Kunsthalle Bielefeld, Bielefeld, Germany (c). Traveled to Palais des Beaux-Arts, Charleroi, Belgium

1996 "Sean Scully: The Catherine Paintings," Casino Luxembourg, Forum d'Art Contemporain, Luxembourg (c)
Edicions T, Barcelona (c)
"Sean Scully: Floating Paintings and Work on Paper," Galerie Nationale du Jeu de Paume, Paris. Traveled to Neue Galerie der Stadt Linz, Linz, Austria; (1997) Culturgest, Lisbon (c)

"Sean Scully: Paintings and Work on Paper," Galleria d'Arte Moderna, Villa delle Rose, Bologna (c)
Galeria Carles Taché, Barcelona (c)
"Sean Scully: Pastels," Galerie Lelong, New York, New York
"Sean Scully: Prints," Galerie Angelika Harthan, Stuttgart
"Sean Scully: Works on Paper 1975–1996," Graphische Sammlung, Munich
Traveled to Museum Folkwang, Essen; Henie Onstad Kunstsenter, Høvikodden, Norway; (1997) Whitworth Art Gallery, Manchester; Hugh Lane Municipal Gallery of Art, Dublin; (1998) Herning Kunstmuseum, Herning, Denmark; Milwaukee Art Museum, Milwaukee, Minnesota; Denver Art Museum, Denver, Colorado; Carpenter Center for the Visual Arts, Harvard University, Cambridge, Massachusetts; (2000) Albright-Knox Art Gallery, Buffalo, New York (c)

1997 "Sean Scully 1987–1997," Sala de Exposiciones Rekalde, Bilbao
Traveled to Salas del Palacio Episcopal, Plaza del Obispo, Malaga; Fundacio "La Caixa," Palma de Mallorca (c)
"Sean Scully 1982–1996," Manchester City Art Gallery, Manchester (c)
"Recent Paintings," Galerie Lelong, Paris (c)
Kerlin Gallery, Dublin
"Floating Paintings and Photographs," Galerie Lelong, New York, New York
Galeria DV, San Sebastian, Spain (c)
Mary Boone Gallery, New York, New York
"Paintings and Works on Paper," Jamileh Weber Gallery, Zurich
"Prints and Watercolours," John Berggruen Gallery, San Francisco, California

1998 "Paintings and Works on Paper," Galerie Bernd Klüser, Munich
"Sean Scully: Mirror Images," Timothy Taylor Gallery, London
Bawag Foundation, Vienna (c)
Galerie Haas & Fuchs, Berlin
Mira Goddard Gallery, Toronto
Galleri Weinberger, Copenhagen, Denmark
Galeria Antonia Puyo, Saragossa
Galerie Le Triangle Bleu, Stavelot, Belgium

1999 Galerie Lelong, Paris (c)
"Print Retrospective," Graphische Sammlung Albertina, Vienna
Traveled to Musée du Dessin et de l'Estampe Originale, Gravelines, France
"New Paintings and Works on Paper," Danese Gallery and Galerie Lelong, New York, New York
South London Gallery, London (c)

"Work from the Garner Tullis Workshop,"
Galerie Kornfeld, Zurich
"Barcelona Paintings," Galerie Bernd Klüser,
Munich (c)

2000 "Sean Scully on Paper," The Metropolitan Museum
of Art, New York, New York
Galeria Carles Taché, Barcelona (c)
"Estampes 1983–1999," Musée des Beaux-Arts de
Caen, Caen, France (c)
"Sean Scully Photographies," Galerie de l'Ancien
Collège, Châtellerault, France
Ingleby Gallery, Edinburgh
"Graphics," Galleria d'Arte A+A, Venice

2001 "Barcelona Etchings for Frederico Garcia Lorca,"
Instituto Cervantes, London
"Sean Scully: Light and Gravity," Knoedler & Co.,
New York, New York (c)
"New Works on Paper," Galerie Lelong, New York,
New York
"Sean Scully: Paintings, Drawings, Photographs
1990–2001," Kunstsammlung Nordrhein-
Westfalen, Düsseldorf. Traveled to Haus der Kunst,
Munich; IVAM, Valencia (c)
"Sean Scully Work on Paper," Rex Irwin Gallery,
Woollahra, Australia. Traveled to Dickerson Gallery,
Melbourne
Galerie Lelong, Paris
Le Musée Jenisch, Vevey
"Sean Scully: Walls/Windows/Horizons,"
David Winton Bell Gallery, Brown University,
Providence, Rhode Island
"Wall of Light," Museo d'Arte Contemporaneo de
Monterrey, Mexico. Traveled to Museo de Arte
Moderno, Mexico City (c)

2002 Camara de Comercio de Cantabria, Santander.
Traveled to Ayuntamiento de Pamplona (c)
Galerie Neue Meister, Staatliche Kunstsammlungen,
Dresden (c)
L.A. Louver Gallery, Los Angeles, California
Centro de Arte Helio Oiticica, Rio de Janeiro (c)

2003 "Sean Scully: Wall of Light, Figures,"
Timothy Taylor Gallery, London (c)
Hôtel des Arts, Toulon, France (c)
Galeria Carles Taché, Barcelona (c)
Sara Hildén Art Museum, Tampere, Finland.
Traveled to Stiftung Weimarer Klassik, Weimar;
National Gallery of Australia, Canberra (c)

# Selected Group Exhibitions

(c) *denotes a published catalogue*

1969 "Northern Young Contemporaries,"
Whitworth Art Gallery, Manchester

1970 "London Young Contemporaries." Traveled under
the auspices of the Arts Council of Great Britain

1971 "Art Spectrum North," Laing Art Gallery,
Newcastle-upon-Tyne; City Arts Gallery, Leeds;
Whitworth Art Gallery, Manchester

1972 "John Moores Liverpool Exhibition 8," Liverpool
(prize winner)
"Northern Young Painters," Stirling University,
Scotland

1973 "La Peinture Anglaise Aujourd'hui,"
Musée d'Art Moderne de la Ville de Paris, Paris (c)
"Critics Choice," Gulbenkian Gallery,
Newcastle-upon-Tyne

1974 International Biennal of Art, Menton, France
"British Painting," Hayward Art Gallery, London

1975 Art Fair, Contemporary Art Society, London

1976 "Invitational," John Weber Gallery, New York,
New York

1977 "Four Artists," Nobe Gallery, New York, New York

1978 "Certain Traditions," The British Council, traveling
exhibition, Canada

1979 "New Wave Painting," The Clocktower, New York,
New York
"Fourteen Painters," Lehman College, New York,
New York
"First Exhibition," Toni Birkhead Gallery,
Cincinnati, Ohio

1980 "Marking Black," Bronx Museum of Art, New York,
New York
"New Directions," Princeton University Art
Museum, Princeton, New Jersey

1981 "Arabia Felix," Art Galaxy Gallery, New York,
New York
"New Directions," Sidney Janis Gallery, New York,
New York

1982 "Recent Aspects of All-Over," Harm Boukaert
Gallery, New York, New York
"Abstract Painting," Jersey City Museum,
Jersey City, New Jersey

1983 "American Abstract Artists," national touring
exhibition, USA
"Nocturne," Siegel Contemporary Art, New York,
New York
"Contemporary Abstract painting," Muhlenberg
College, Allentown, Pennsylvania (c)

1984 "An International Survey of Recent Painting and
Sculpture," The Museum of Modern Art,
New York, New York (c)
"Part 1: Twelve Abstract Painters," Siegel
Contemporary Art, New York, New York
"ROSC," The Guinness Hops Store, Dublin

"Currents #6," Milwaukee Art Museum,
Milwaukee, Wisconsin
"Small Works: New Abstract Painting,"
Lafayette College and Muhlenberg College,
Allentown, Pennsylvania
"Hassam & Speicher Purchase Fund Exhibition,"
Academy of Arts and Letters, New York,
New York

1985 "Abstract Painting as Surface and Object,"
Hillwood Art Gallery, C.W. Post Center,
Long Island University, Greenvale, New York
"An Invitational," Condeso/Lawler Gallery,
New York, New York
"Decade of Visual Arts at Princeton: Faculty
1975–1985," Princeton University Museum of Art,
Princeton, New Jersey
"Abstraction/Issues," Tibor de Nagy, Oscarsson
Hood, and Sherry French, New York, New York
"Art on Paper," Weatherspoon Art Gallery,
University of North Carolina at Greensboro
"Masterpieces of the Avant-Garde," Annely Juda
Fine Art/Juda Rowan Gallery, London

1986 "After Matisse," traveling exhibition organized by
Independent Curators, Inc., USA
"An American Renaissance in Art: Painting and
Sculpture since 1940," Fort Lauderdale Museum of
Fine Art, Florida
"Public and Private: American Prints Today,"
Brooklyn Museum of Art, Brooklyn, New York
"Sean Scully and Catherine Lee," Paul Cava Gallery,
Philadelphia, Pennsylvania
"CAL Collects 1," University Art Museum,
University of California, Berkeley, California
"The Heroic Sublime," Charles Cowles Gallery,
New York, New York
"Structure/Abstraction," Hill Gallery, Birmingham,
Michigan
"Detroiters Collect: New Generation," Meadow
Brook Art Gallery, Oakland University, Rochester,
Michigan
"Recent Acquisitions," Contemporary Arts Center,
Honolulu, Hawaii

1987 "Corcoran Biennial," Corcoran Gallery of Art,
Washington, D.C. (c)
"Harvey Quaytman and Sean Scully,"
Helsinki Festival, Helsinki (c)
"Drawing from the 80s – Chatsworth
Collaboration," Carnegie Mellon University Art
Gallery, Pittsburgh, Pennsylvania
"Drawn-Out," Kansas City Art Institute,
Kansas City, Missouri
"Logical Foundations," Pfizer, Inc. New York
Museum of Modern Art, New York, New York
"Magic in the Mind's Eye: Part 1 & 2," Meadow
Brook Art Gallery, Rochester, Michigan

"Works on Paper," Nina Freudenheim Gallery, Buffalo, New York

1988 "17 Years at the Barn," Rosa Esman Gallery, New York, New York
"New Editions," Crown Point Press, San Francisco, California, and New York, New York
"Works on Paper: Selections from the Garner Tullis Workshop," Pamela Auchincloss Gallery, New York, New York
"Sightings: Drawings with Color," traveling exhibition, Pratt Institute, New York, New York

1989 "The Elusive Surface," The Albuquerque Museum, Albuquerque, New Mexico
"Drawings and Related Prints," Castelli Graphics, New York, New York
"Essential Painting," Nelson Atkins Museum, Kansas City, Kansas
"The 1980's: Prints from the Collection of Joshua P. Smith," National Gallery of Art, Washington, D.C. (c)

1990 "Drawings: Joseph Beuys, Paul Rotterdam, Sean Scully, Arnold Herstand & Co.," Anthony Ralph Gallery, New York, New York (c)
"Sean Scully/Donald Sultan: Abstraction/ Representation," Stanford Art Gallery, Stanford University, Stanford, California (c)
"Geometric Abstraction," Marc Richards Gallery, Santa Monica, California
"Artists in the Abstract," Weatherspoon Art Gallery, University of North Carolina at Greensboro (c)

1991 "Small Format Works on Paper," John Berggruen Gallery, San Francisco, California
"Post modern Prints," Victoria & Albert Museum, London
"Group Show," L.A. Louver Gallery, New York, New York, USA
"La Metafisica Della Luce," John Goode Gallery, New York, New York

1992 "Four Series of Prints," John Berggruen Gallery, San Francisco, California
"Recent Abstract Painting," Cleveland Center for Contemporary Art, Cleveland, Ohio
"Collaboration in Monotype from the Garner Tullis Workshop," Sert Gallery, Carpenter Center for the Visual Arts, Harvard University, Cambridge, Massachusetts
"Geteilte Bilder," Museum Folkwang, Essen (c)
"Behind Bars," Thread Waxing Space, New York, New York (c)
"Color Block Prints of the 20th Century," Associated American Artists, New York, New York (c)
"Whitechapel Open," Whitechapel Art Gallery, London
"Painted on Press: Recent Abstract Prints," Madison Art Center, Madison, Wisconsin
"Monotypien, Holzschnitte, Zeichnungen," Europäische Akademie für Bildende Kunst, Trier, Germany
"Monotypes from the Garner Tullis Workshop," SOMA Gallery, San Diego, California

"44th Annual Academy – Institute Purchase Exhibition," American Academy of Arts and Letters Galeria Sergio Tossi, Prato, Italy (c)

1993 "Tutte le strade portano a Roma," Palazzo delle Esposizioni, Rome (c)
"Beyond Paint," Tibor de Nagy Gallery, New York, New York
"Drawing in Black and White," The Museum of Modern Art, New York, New York (c)
Grolier Club, New York, New York
"American and European Prints," Machida City Museum of Arts, Tokyo (c)
"Ausgewählte Druckgraphik," Galerie Bernd Klüser, Munich
"Amerikanische und Europäische Arbeiten auf Papier," Galerie Martin Wieland, Trier, Germany
"Italia–America: L'Astrazione redefinita," Dicastro Cultura, Galleria Nazionale d'Arte Moderna, Republica di San Marino, Italy (c)
"Partners," Annely Juda Fine Art, London (c)
"25 Years," Cleveland Center for Contemporary Art, Cleveland, Ohio (c)
"Modernities," Baumgartner Galleries, Washington, D.C.
"5 One Person Shows," Jamileh Weber Gallery, Zurich

1994 "Recent Painting Acquisitions," The Tate Gallery, London
"Contemporary Watercolors: Europe and America," UNT Art Gallery, Denton, Texas
"For 25 Years Brooke Alexander Editions," The Museum of Modern Art, New York, New York
"Recent Acquisitions: Paintings from the Collection," The Irish Museum of Museum Art, Dublin
"L'Incanto e la Trascendenza," Galleria Civica di Arte Contemporanea, Trent
"British Abstract Art," Flowers East Gallery, London
"Recent Acquisitions: Prints and Photographs," The Cleveland Museum of Art, Cleveland, Ohio
"Paper under Pressure," Sun Valley Centre Gallery, Idaho

1995 "Seven From the Seventies," Knoedler Gallery, New York, New York
"New Publications," Brooke Alexander Editions, New York, New York
"New York Abstract," Contemporary Arts Center, New Orleans, Louisiana
"US Prints," Retretti Art Center, Punkaharju, Finland
"Color + Structure," Galerie Lelong, New York, New York

1996 "XV Salon des los 16," Museo de Antropologia, Madrid
"Balancing Act," Room Gallery, New York, New York
"Nuevas Abstracciones/Abstrakte Malerei heute," Museo Nacional Centro de Arte Reina Sofia, Madrid. Traveled to Kunsthalle Bielefeld, Bielefeld, Germany; Museu d'Art Contemporani de Barcelona, Barcelona

"Bare Bones," TZ Art, New York, New York
"Festival de Culture Irlandaise Contemporaine," École des Beaux-Arts, Paris
"Thinking Print," Museum of Modern Art, New York, New York
"Radierungen. Zur Renaissance einer Technik," Kunsthaus, Hamburg. Traveled to Brecht-Haus, Weissensee, Berlin

1997 "After the Fall: Abstract Painting," Snug Harbor Cultural Center, Staten Island, New York
"British Arts Council Collection," Royal Festival Hall, London
"The Pursuit of Painting," Irish Museum of Modern Art, Dublin
"Prints," Galerie Lelong, New York, New York
"Estampes," Galerie Lelong, Paris
"A Century of Irish Paintings; Selections from the Collection of the Hugh Lane Municipal Gallery of Modern Art, Dublin," The Hugh Lane Municipal Gallery of Modern Art, Dublin. Traveled to The Hokkaido Museum of Modern Art, Sapporo; The Mitaka City Gallery of Art, Mitaka, Tokyo; Yamanashi Prefectural Museum of Art, Yamanashi (c)
"The View From Denver: Werker auf dem Denver Art Museum," Museum Moderner Kunst Stiftung Ludwig, Vienna (c)
"Thirty-Five Years at Crown Point Press: Making Prints, Doing Art," The National Gallery of Art, Washington, D.C., and the Fine Arts Museums of San Francisco, California (c)
"Singular Impressions: The Monotype in America," The National Museum of American Art, Washington, D.C.

1998 "Zeit und Materie," Baukunst, Cologne
"Contemporary Art: The Janet Wolfson de Botton Gift," The Tate Gallery, London
"The Edward R. Broida Collection: A Selection of Works," Orlando Museum of Art, Orlando, Florida
"Photographies," Galerie Lelong, Paris
"On a Clear Day," Graphische Sammlung, Staatsgalerie, Stuttgart
"Arterias: Collection of Contemporary Art Fundacio la Caixa," Malmö Konsthall, Malmö, Sweden
"Large Scale Drawings," Danese Gallery, New York, New York
"Jan Dibbets/Sean Scully fotografias," Galeria Estiarte, Madrid
"Sean Scully/Lawrence Carroll," Lawing Gallery, Houston, Texas
"Group Exhibition," Kerlin Gallery, Dublin
"Corcoran Biennial," Corcoran Gallery of Art, Washington, D.C. (c)
"Sarajevo 2000," Museum Moderner Kunst Stiftung Ludwig, Vienna
"Acquisitions 1997," Conseil général du Val-de-Marne, Hotel du Département, Créteil, France
"20 Jahre. Ausgewählte Werke," Galerie Bernd Klüser, Munich
"Matrix Berkeley 1978–1998," University of California, Berkeley Art Museum & Pacific Film Archive, Berkeley, California

"En Norsk Samling Au Europeisk Kunst,"
Trondheim Kunstmuseum, Norway
1999 "Sammlung Essl: The First View," Museum
Sammlung Essl, Klosterneuburg/Vienna
"Signature Pieces: Contemporary British Prints
and Multiples," Alan Cristea Gallery, London
"Unlocking the Grid: Concerning the Grid in
Recent Painting," University of Rhode Island,
Kingston, Rhode Island
"Drawing in the Present Tense," Parsons School of
Design, New York, New York, and (2000) Eastern
Connecticut State University, Willimantic,
Connecticut
"1999 Drawings," Alexander & Bonin, New York,
New York
"Side by Side," Knoedler & Co., New York,
New York
"Geometrie als Gestalt. Strukturen der modernen
Kunst von Albers bis Paik. Werke der Sammlung
Daimler-Chrysler," Neue Nationalgalerie, Berlin
2000 "New Works," Galerie Jamileh Weber, Zürich
"On Canvas: Contemporary Painting from the
Collection," The Solomon R. Guggenheim
Museum, New York, New York
"L'Ombra della Ragione," Galleria d'Arte Moderna,
Bologna
"September Selections," Knoedler & Co.,
New York, New York
2001 "A Century of Drawing," The National Gallery of
Art, Washington, D.C. (c)
"Watercolor: In the Abstract," The Hyde Collection
Art Museum, Glen Falls, New York. Traveled to the
Michael C. Rockefeller Arts Center Gallery,
Fredonia, New York; The Butler Institute of
American Art, Youngstown, Ohio; Ben Shahn
Gallery, William Paterson University of New Jersey,
Wayne, New Jersey; Sarah Moody Gallery of Art,
Tuscaloosa, Alabama; DePaul University, Chicago,
Illinois
2002 "Augenblik, Foto/Kunst," Museum Sammlung Essl,
Klosterneuburg/Vienna (c)
Fundação Bienal de São Paulo, 25° Bienal de São
Paulo, São Paulo (c)
"Margins of Abstraction," Kouros Gallery,
New York, New York
"177th Annual Exhibition," National Academy of
Design, New York, New York
"No Object, No Subject, No Matter…,"
Irish Museum of Modern Art, Dublin
"Color & Concept," National Gallery of Australia,
Canberra (c)
2003 "Abstraction in Photography," Von Lintel Gallery,
New York, New York
"Divergent," Galerie Lelong, New York, New York
"Streifzüge," Galerie Lelong, Zurich,
2004 "Los Monocromos," Museo Nacional Centro de
Arte Reina Sofia, Madrid (c)

# Public Collections

UNITED STATES AND SOUTH AMERICA
Albright-Knox Art Gallery, Buffalo, New York
Art Institute of Chicago, Chicago, Illinois
Carnegie Museum of Art, Pittsburgh, Pennsylvania
Centro Cultural de Arte Contemporáneo,
    Mexico City
Chase Manhattan Bank, New York, New York
Chemical Bank, New York, New York
Cincinnati Art Museum, Cincinnati, Ohio
Cleveland Museum of Art, Cleveland, Ohio
The Corcoran Gallery of Art, Washington, D.C.
Dallas Museum of Art, Dallas, Texas
Denver Art Museum, Denver, Colorado
First Bank Minneapolis, Minneapolis, Minnesota
Fogg Art Museum, Harvard University Art Museums,
    Cambridge, Massachusetts
The Solomon R. Guggenheim Museum, New York,
    New York
High Museum of Art, Atlanta, Georgia
Hirshhorn Museum and Sculpture Garden,
    Smithsonian Institution, Washington, D.C.
Mellon Bank, Pittsburgh, Pennsylvania
The Metropolitan Museum of Art, New York, New York
Modern Art Museum of Fort Worth, Fort Worth, Texas
Museo de Arte Contemporáneo de Caracas, Venezuela
Museo de Arte Contemporáneo, Monterrey, Mexico
Museo de Arte Moderno, Col. Bosques de Chapultepec,
    Mexico
Museum of Fine Arts, Boston, Massachusetts
The Museum of Modern Art, New York, New York
National Gallery of Art, Washington, D.C.
Orlando Museum of Art, Orlando, Florida
Paine Webber Group, Inc., New York, New York
Philip Morris, Inc., New York, New York
The Phillips Collection, Washington, D.C.
The Saint Louis Art Museum, Saint Louis, Missouri
San Diego Museum of Art, San Diego, California
Santa Barbara Museum of Art, Santa Barbara, California
Smithsonian American Art Museum, Washington, D.C.
The Snite Museum of Art, University of Notre Dame,
    Indiana
Walker Art Center, Minneapolis, Minnesota

EUROPE
Arts Council of Great Britain, London
La Banque européenne d'investissement, Luxembourg
Bayrische Staatsgemäldesammlungen, Munich
Bibliothèque nationale de France, Paris
The British Council, London
Ceolfrith Art Center, Sunderland
Consejería de Cultura, Santander
Contemporary Arts Society, London
Council of National Academic Awards, London
Crawford Municipal Art Gallery, Cork
The DG Bank Collection, Frankfurt

Eastern Arts Association, Cambridge
École municipale d'arts plastiques, Châtellerault
Fitzwilliam Museum, Cambridge
La Fondation Edelman, Lausanne
Fonds départemental d'art contemporain, Conseil général
    du Val-de-Marne, Ivry-sur-Seine
Fundació La Caixa, Barcelona
Fundación Caixa Galicia, La Coruña
Galleria d'Arte Moderna di Bologna
Gallery of Modern Art, László Vass Collection, Veszprém,
    Hungary
Graphische Sammlung Albertina, Vienna
Hôtel des Arts, Toulon
The Hugh Lane Municipal Gallery of Modern Art, Dublin
Hunterian Art Gallery, Glasgow
Irish Museum of Modern Art, Dublin
Kunst und Museumsverein Wuppertal
Kunsthalle Bielefeld, Bielefeld
Kunsthaus Zürich, Zurich
Kunstsammlung Nordrhein-Westfalen, Düsseldorf
Laing Art Gallery, Newcastle-upon-Tyne
Leicestershire Educational Authority, Leicester
Louisiana Museum of Modern Art, Humlebæk, Denmark
Manchester City Art Gallery, Manchester
Musée du Dessin et de l'Estampe Originale, Gravelines
Musée Jenisch, Vevey
Museo Nacional Centro de Arte Reina Sofia, Madrid
Museu d'Art Contemporani de Barcelona, Barcelona
Museum Folkwang, Essen
Museum Moderner Kunst, Stiftung Ludwig, Vienna
Museum Pfalzgalerie, Kaiserslautern
Neue Galerie der Stadt Linz, Linz
Northern Arts Association, Newcastle-upon-Tyne
Ruhr-Universität, Bochum
Saastamoisen Saatio, Helsinki
Sala Rekalde, Bilbao
Sammlung Essl, Klosterneuburg
Sara Hildén Art Museum, Tampere
Staatsgalerie, Stuttgart
Städtische Galerie im Lenbachhaus, Munich
Stiftelsen Focus, Boras
The Tate Gallery, London
Ulster Museum, National Museum & Galleries of
    Northern Ireland, Belfast
Victoria & Albert Museum, London,
Whitworth Art Gallery, Manchester
Zentrum für Kunst und Medien Technologie, Karlsruhe

AUSTRALIA
National Gallery of Australia, Canberra
National Gallery of Victoria, Felton Bequest, Melbourne
Power Institute of Contemporary Art, Sydney

JAPAN
Nagoya City Art Museum, Nagoya
Tokyo International Forum, Tokyo

# Selected Bibliography

Adams, Brooks. "The Stripe Strikes Back." *Art in America*, October 1985, pp. 118–23

Aukeman, Anastasia. "Sean Scully at Bernd Klüser." *ARTnews*, April 1994

Baker, Kenneth. "Abstract Gestures." *Artforum International*, September 1989, pp. 135–38

Barrett, Cyril. "Exhibitions. ROSC, 84." *Art Monthly*, October 1984, pp. 11–14

Barrett, Terry. "Interpreting Art: Reflecting, Wondering, and Responding." McGraw Hill, New York, 2003, pp. 99–110

Barringer, Felicity. "Matisse: He's Kind of Cast a Spell on Me." *ARTnews*, April 1993

Bass, Ruth. "Sean Scully." *ARTnews*, March 1991

Batchelor, David. "Sean Scully." *Artscribe International*, September–October 1989, p. 72

Bell, Tiffany. "Responses to Neo-Expressionism." *Flash Art*, May 1983, pp. 40–46

Benezra, Neal. "Sean Scully." *Sean Scully*, The Art Institute of Chicago, 1987

Bennett, Ian. "Sean Scully." *Flash Art*, January–February 1980, p. 53

—. "Modern Painting and Modern Criticism in England." *Flash Art*, March/April 1980, pp. 24–26

—. "Sean Scully." *Flash Art*, Summer 1989, p. 157

—. "Sean Scully." *Tema Celeste*, January–March 1992, p. 104

Berryman, Larry. "Abstraction of Opposites." *Arts Review*, December 1992

Bevan, Roger. "Scully's Decade." *Antique and New Art*, Winter 1990

—. "Controversy over the Turner Prize." *The Art Newspaper*, November 1991

Bonaventura, Paul. "Sean Scully: Hay que ligar la abstracción a la vida." *RS*, October 1989, pp. 26–34

—. "Interview with Sean Scully." *Exhibition Guide to Sean Scully: Paintings and Works on Paper 1982–88*, Whitechapel Art Gallery, London 1989

—. "It is all a Question of Intensity." *Sean Scully*, Waddington Galleries, London 1992

Bromberg, Craig. "The Untitled Orbit." *Art and Auction*, October 1991

—. "Gefühl ist wieder angesagt. Die Renaissance der abstrakten Malerei in New York." *Artis*, February 1992, pp. 44–49

Burr, James. "Round the Galleries – People and Patterns." *Apollo*, November 1984, p. 354

—. "Sean Scully at the Whitechapel." *Apollo*, June 1989, p. 432

Caldwell, John. "The New Paintings." *Sean Scully*, Museum of Art, Carnegie Institute, Pittsburgh 1985, pp. 17–21 (reprinted in *The Collected Writings of John Caldwell*, San Francisco Museum of Modern Art, 1996)

Cappuccio, Elio. "Interview with Arthur Danto." *Segno*, November 1992

Carrier, David. "Theoretical Perspectives on the Arts,

Sciences and Technology." *Leonardo*, vol. 18, no. 2, 1985, pp. 108–13

—. "Color in the Recent Work." *Sean Scully*, Museum of Art, Carnegie Institute, Pittsburgh 1985, pp. 22–27 (reprinted in David Carrier. *The Aesthete in the City: The Philosophy and Practice of American Abstract Painting in the 1980s*, University Park, Pennsylvania, 1994)

—. "Corcoran Gallery 40th Biennial." *Burlington Magazine*, July 1987, p. 483

—. "Spatial Relations." *Art International*, Autumn 1989, p. 81

—. "Art Criticism and Its Beguiling Fictions." *Art International*, Winter 1989, pp. 36–41

—. "Piet Mondrian and Sean Scully: Two Political Artists." *Art Journal*, Spring 1991 (reprinted in *Sean Scully. Prints from the Garner Tullis Workshop*, Garner Tullis, New York 1991, and David Carrier, *The Aesthete in the City: The Philosophy and Practice of American Abstract Painting in the 1980s*, University Park, Pennsylvania, 1994)

—. "Abstract Painting and Its Discontents." *Tema Celeste*, Autumn 1991, pp. 77–79

—. "Afterlight. Exhibiting Abstract Painting in the Era of its Belatedness." *Arts Magazine*, March 1992, p. 60

—. "Sean Scully: New York and Fort Worth." *Burlington Magazine*, July 1993

—. "Italia/America: L'Astrazione ridefinita." *Segno*, Autumn 1993

—. "Sean Scully. Il pittore della vita moderna/The Painter of Modern Life." *Sean Scully*, Galleria d'Arte Moderna, Villa delle Rose, Bologna, 1996, p. 16

de Circasia, Victor. "Fade into Paint: Sean Scully speaks with critic and curator, Victor de Circasia." *Label Magazine #7* (Italy), Autumn 2002

Combalia, Victoria. "Sean Scully: Against Formalism." *Sean Scully. Twenty Years. 1976–1995*, High Museum of Art, Atlanta, 1995, p. 31

—. "La Importancia y el Lugar de la Pintura de Scully/ The Importance and the Place of Scully's Paintings." *Sean Scully*, Galeria Carles Taché, Barcelona, 1996

Cooke, Lynne. "Sean Scully." *Galeries Magazine*, August–September 1989, pp. 60–63

—. "Sean Scully. Taking a Stand, Taking up a Stance." *Sean Scully. Twenty Years. 1976–1995*, High Museum of Art, Atlanta, 1995, p. 47

Cotter, Holland. "Sean Scully." *Flash Art*, April–May 1985, p. 40

Crichton, Fenella. "Sean Scully at the Rowan." *Art International*, 15 June 1975, p. 58

—. "London." *Art and Artists*, October 1979, pp. 41–48

Cyphers, Peggy. "Sean Scully." *Tema Celeste*, March–April 1991, p. 92

Dannatt, Adrian. "Sean Scully: An Interview." *Flash Art*, May–June 1992, pp. 103–5

Danto, Arthur C. "Astrattismo post-storico." *Tema Celeste* (Italy), April–May 1992

—. "Art after the End of Art." *Artforum International*, April 1993, pp. 62–69

—. "Sean Scully's Catherine Paintings: The Aesthetics of Sequence." *Sean Scully. The Catherine Paintings*, Modern Art Museum of Fort Worth, 1993, pp. 30–46

—. "Between the Lines: Sean Scully on Paper/Zwischen den Linien: Sean Scully auf Papier." *Sean Scully. Works on Paper 1975–1996*, Staatliche Graphische Sammlung, Munich, 1996, pp. 9ff.

—. "The Catherine Paintings de Sean Scully: l'esthétique de la séquence." *Sean Scully*, Galerie Nationale du Jeu de Paume, Paris, 1996, pp. 67ff.

Decter, Joshua. "Sean Scully." *Arts Magazine*, December 1986, pp. 123ff.

Del Renzio, Toni. "London." *Art and Artists*, December 1974, pp. 33–35

Denvir, Bernard and William Packer. "A Slice of Late Seventies Art." *Art Monthly*, March 1980, pp. 3–5

Draper, Francis. "Sean Scully." *Arts Review*, 25 November 1977, p. 714

Dunne, Aidan, *The Irish Times*. "The Painter's Painter; Defender of the Faith." 3 August 2002

Durand, Regis. "Sean Scully: Une abstraction ancrée dans le monde." *Art Press*, February 1991

Eccher, Danilo. "Astrazione trascendente e pauperismo cromatico/Transcendent Abstraction and Chromatic Impoverishment." *Sean Scully*, Galleria d'Arte Moderna, Villa delle Rose, Bologna, 1996, pp. 10ff.

Faure-Walker, James. "Sean Scully." *Studio International*, May–June 1975, p. 238

Faust, Gretchen. "Herstand Group Show." *ARTnews*, Summer 1990

Feaver, William. "London Letter: Summer." *Art International*, November 1972, p. 39

—. "Sean Scully." *Art International*, November 1973, pp. 26, 32, 75

—. "Sean Scully." *ARTnews*, January 1978, p. 133

—. "Sean Scully." *ARTnews*, September 1989, p. 191

Fisher, Susan. "Catherine Lee/Sean Scully." *New Art Examiner*, June 1986, p. 52

Frank, Peter. "Sean Scully at L.A. Louver." *ARTnews*, February 2003

Frémon, Jean. "Sean Scully: la matière de l'âme." *Sean Scully "Place"*, Galerie de l'Ancien Collège, Châtellerault/Galerie Lelong, Paris, 1995

—. "Blasons du Corps/Blazons of the Body." *Sean Scully* (*Repères*, no. 91), Galerie Lelong, Paris, 1997, p. 3

Friedel, Helmut. "Sean Scully – Dark Light." *Sean Scully*, Bawag Foundation, Vienna 1998, pp. 18–23

Gardner, Paul. "Waking Up and Warming Up." *ARTnews*, October 1992, p. 116

Garlake, Margaret. "Double Scully." *Gallery Magazine*, November 1987

—. "Sean Scully." *Art Monthly*, no. 127, June 1989, p. 23

Girard, Xavier. "Affection du tableau." *Sean Scully*, Galerie Nationale du Jeu de Paume, Paris, 1996, p. 41

Glazebrook, Mark. "Sean Scully: Summarising Living and Painting." *Sean Scully. Paintings*, Manchester City Art Galleries, Manchester, 1997, pp. 6–15

Godfrey, Tony. "Exhibition Reviews." *Burlington Magazine*, December 1987, pp. 822–24

Gold, Sharon. "Sean Scully." *Artforum International*, Summer 1977, p. 9

Gooding, Mel. "Scully. Startup. Leverett." *Art Monthly*, December 1987–January 1988, pp. 21–23

Griefen, John. "Sean Scully." *Arts Magazine*, February 1980, p. 35

Gutterman, Scott. "Sean Scully." *Journal of Art*, January 1991

Hagen, Charles. "40th Biennial Exhibition of Contemporary American Paintings." *Artforum International*, October 1987, p. 135

Heartney, Eleanor. "Sean Scully at Danese and Lelong." *Art in America*, November 1999, p. 136

Herzog, Hans-Michael. "The Catherine Paintings at Bielefeld." *Sean Scully. The Catherine Paintings*, Kunsthalle Bielefeld, 1995, p. 8

—. "The Beauty of the Real. H.-M. Herzog interviews Sean Scully/Die Schönheit des Realen. Gespräch mit Sean Scully." *Sean Scully. The Catherine Paintings*, Kunsthalle Bielefeld, 1995, pp. 65–82

—. Interview with Sean Scully, 13 December 1998, *Sean Scully*, South London Gallery, London, 1999 (reprinted in *Sean Scully. New Paintings and Work on Paper*, Danese/Galerie Lelong, New York, 1999, pp. 10ff.)

Higgins, Judith. "Sean Scully and the Metamorphosis of the Stripe." *ARTnews*, November 1985, pp. 104–112

Hill, Andrea. "Sean Scully." *Artscribe International*, September 1979, p. 60

Hughes, Robert. "Earning His Stripes." *Time Magazine*, 14 August 1989, p. 47

Hunter, Sam. "Sean Scully's Absolute Paintings." *Artforum*, November 1979, pp. 30–34 (reprinted in *Sean Scully Paintings 1971–1981*, Ikon Gallery, Birmingham, 1981)

Jarauta, Francisco. "De la geometría a la memoria." *Sean Scully. Obra Grafica 1991–1994*, Galeria El Diario Vasco, San Sebastian, 1994

—. "Sean Scully. Repensar la abstracción/To rethink the Abstraction." *Sean Scully*, Sala de Exposiciones Rekalde, Bilbao, 1997, pp. 9, 47ff.

—. "Variaciones sobre la abstracción/Variations on abstraction." *Sean Scully*, Galeria Carles Taché, Barcelona, 2000

Jeffett, William. "Sean Scully. Reinventing Abstraction." *Artefactum*, Summer 1989, pp. 2–6

Jocks, Heinz-Norbert. "Sean Scully: Kunst setzt voraus, daß man nackt ist und dadurch offener wird," (interview), *Kunstforum International*, vol. 141, July–September 1998, pp. 268–81

Jones, Ben, and Peter Rippon. "An Interview with Sean Scully." *Artscribe International*, June 1978, pp. 27–29

Juncosa, Enrique. "Las Estrategias de Apolo." *Lapiz*, vol. 6, no. 60, 1989, pp. 26–32

—. "Sean Scully." *Tema Celeste*, Winter 1993

—. "Tigers in the Garden." *Sean Scully*, Waddington Galleries, London, 1995

—. "La Emoción como Lenguaje/Emotion as a Language." *Sean Scully*, Galeria Carles Taché, Barcelona, 1996

Kaido, Kazu. "Sean Scully Interviewed." *Sean Scully*, Fuji Television Gallery, Tokyo, 1988

Kipphoff, Petra. "Kritiker-Umfrage." *Art Journal*, January 1985, pp. 8ff.

Klüser, Bernd. "Scully und Irland: Drei Assoziationen." *Sean Scully. The Beauty of the Real*, Galerie Bernd Klüser, Munich, 1995

—. "Über die Schwierigkeit des Einfachen. Bemerkungen zu den Bildern von S. Scully, M. Rothko und B. Newman/The Difficulties of the Simple. Notes on the Pictures of S. Scully, M. Rothko, B. Newman." *Sean Scully. Barcelona Paintings and Recent Editions*, Galerie Bernd Klüser, Munich, 1999

Krauter, Anne. "Sean Scully. Galerie Jamileh Weber." *Artforum International*, Summer 1992, p. 120

Kuspit, Donald. "Sean Scully. Galerie Lelong/Danese." *Artforum International*, September 1999, p. 168

Lamprecht, Susanne. "Zur Malerei von Sean Scully/The Paintings of Sean Scully." *Sean Scully*, Galerie Schmela, Düsseldorf/Mayor Rowan Gallery, London, 1987

Levy, Mark. "The Permutations of the Stripe." *Shift*, vol. 1, no. 2, 1988, pp. 38–41

Lewallen, Constance. "Sean Scully." *Sean Scully*, University Museum of Art, Berkeley, 1987–88

—. "Interview with Sean Scully." *View*, vol. 5, no. 4, Autumn 1988

Lighthill, Amy. "Portrait of the Artist as Lightning Rod." *Sean Scully*, Museum of Art, Carnegie Institute, Pittsburgh, 1985, pp. 6–16

Lingemann, Susanne. "Liebeserklärungen mit der Disziplin von Piet Mondrian." *Art. Das Kunstmagazin*, July 1995, pp. 74–77

Loughery, John. "Sean Scully." *Arts Magazine*, December 1986, p. 122

—. "Affirming Abstraction: The Corcoran Biennial." *Arts Magazine*, September 1987, pp. 76–78

—. "17 Years at the Barn." *Arts Magazine*, April 1988, p. 110

—. "Taking Sides: The Paintings of Sean Scully." *Sean Scully*, Fuji Television Gallery, Tokyo, 1988

Lucie-Smith, Edward. "Sean Scully." *Sean Scully*, South London Gallery, London, 1999

Lüttichau, Mario-Andreas von. "'…it has to be about surface and the way it is painted.' Zur Ordnung von Streifen und Farbflächen bei Sean Scully/The Ordering of Stripes and Surfaces in the Work of Sean Scully." *Sean Scully. Works on Paper 1975–1996*, Staatliche Graphische Sammlung Munich, 1996, pp. 23ff.

MacAdam, Barbara A. "A Stripe Day/La Metafisica della luce." *ARTnews*, February 1992

Madoff, Steven Henry. "Sean Scully at William Beadleston." *Art in America*, March 1983, p. 157

—. "A New Generation of Abstract Painters." *ARTnews*, November 1983, pp. 78–84

—. "An Inevitable Gathering." *ARTnews*, September 1987, p. 183

—. "Wholeness, Partness, and the Gift." *Sean Scully. The Catherine Paintings*, Modern Art Museum of Fort Worth, 1993, pp. 47–53

Martino, Vittoria. "Aus dem Herzen der Finsternis." *Sean Scully. Prints. Catalogue raisonné 1968–1999*, Graphische Sammlung Albertina, Vienna, 1999

Masheck, Joseph. "Stripes and Strokes: On Sean Scully's Paintings." *Sean Scully Paintings 1971–1981*, Ikon Gallery, Birmingham, 1981, pp. 4–15

—. "Piecing Things Together. A Conversation between Sean Scully and Joseph Masheck." *Sean Scully*, David McKee Gallery, New York, 1986 (reprinted in *Modernities*, Penn State Press, Pennsylvania, 1993)

McCarron, John. "Conversation. John McCarron with Sean Scully." *Shift*, vol. 2, no. 3, 1988, pp. 14–19

Meyers, Michelle, *Sean Scully/Donald Sultan. Paintings, Drawings and Prints from the Anderson Collection*, Stanford University Art Gallery and Museum, Stanford, California, 1990

Morgan, Robert C. "Physicality and Metaphor: The Paintings of Sean Scully." *Art Journal*, Spring 1991, pp. 64–66

Name, Daniela. "No calor da Rocinha." *O Globo* (Brazil), 19 September 2002

Newman, Michael. "Sean Scully." *Art Monthly*, October 1981, p. 17

—. "New York Reviews." *Flash Art*, June–July 1979, p. 52

Nibuya, Takashi. "Touching on the Issue of Panic." *Sean Scully*, Fuji Television Gallery, Tokyo, 1988

Noda, Masaaki. "Sean Scully." *Sean Scully. The Light in the Darkness*, Fuji Television Gallery, Tokyo, 1994

Oliver, Georgina. "Sean Scully." *Connaisseur*, December 1973, p. 302

Ostrow, Saul. "Sean Scully at Mary Boone." *Flash Art*, December 1993, p. 113

Pagel, David. "Monumental paintings done with a light touch." *Los Angeles Times*, November 22, 2002

Paparoni, Demetrio. "Sean Scully. A Conversation with Demetrio Paparoni." *Tema Celeste*, April–May 1992, pp. 82ff. (reprinted in *Sean Scully*, Edicions T, Barcelona, 1996)

—. "L'Astrazione ridefinita." *Tema Celeste*, 1994

—. "Beyond Formalism: Sean Scully." *Sean Scully. The Light in the Darkness*, Fuji Television Gallery, Tokyo, 1994

—. "La Forma e lo Spirito." *Sean Scully*, Galleria Gian Ferrari Arte Contemporanea, Mailand, 1994

Peppiatt, Michael, *Espace et Lumière. Conversation avec Richard Meier et Sean Scully*, Paris, 1999

Poirier, Maurice. "Sean Scully." *ARTnews*, January 1987, p. 160

—. *Sean Scully*, Hudson Hills Press, New York, 1990

Power, Kevin. "Cantando solo con Scully/Singing along with Scully." *Sean Scully*, Sala de Exposiciones Rekalde, Bilbao 1997, pp. 17–53ff. (reprinted in *Sean Scully*, Kerlin Gallery, Dublin, 1999, pp. 3ff.)

Princenthal, Nancy. "Irrepressible Vigor: Printmaking Expands." *ARTnews*, September 1990

Puvogel, Renate. "Sean Scully. Neue Arbeiten." *Kunstwerk*, February 1986, pp. 84ff.

Raddo, Elena di. "Sean Scully: Intervista al l'Artiste

Irlandese." *Segno*, Autumn 1994

Rantanen, Mari. "An Interview with Sean Scully." *Harvey Quaytman and Sean Scully*, Helsinki Festival, Helsinki, 1987

Ratcliff, Carter. "Artist's Dialogue: Sean Scully. A Language of Materials." *Architectural Digest*, February 1988, pp. 54, 62ff.

—. "Sean Scully and Modernist Painting. The Constitutive Image." *Sean Scully. Paintings and Works on Paper 1982–88*, Whitechapel Art Gallery, London 1989, pp. 9–31 (reprinted in *Sean Scully*, Galerie Jamileh Weber, Zurich, 1991)

—. "Sean Scully und die moderne Malerei. Die Konstitution des Bildes." *Sean Scully. Gemälde und Arbeiten auf Papier 1982–1988*, Städtische Galerie im Lenbachhaus, Munich, 1989, pp. 9ff.

—. "Sean Scully: The Constitutive Stripe." *Sean Scully. The Catherine Paintings*, Modern Art Museum of Fort Worth, Texas, 1993, pp. 8–29

Rifkin, Ned. "Sean Scully: Twenty Years, 1976–1995." *Sean Scully. Twenty Years. 1976–1995*, High Museum of Art, Atlanta, 1995, pp. 11ff.

—. "Interview with Sean Scully." *Sean Scully. Twenty Years. 1976–1995*, High Museum of Art, Atlanta 1995, pp. 57ff.

Roberts, John. "Patterns and Patterns: Sean Scully and Tony Sherman." *Art Monthly*, September 1979, pp. 11ff.

Rosenthal, Adrienne. "Painting by Sean Scully." *Artweek*, 29 March 1975

Rubenstein, Meyer Raphael. "Books: Sean Scully." *Arts*, March 1991

Saltz, Jerry. "Mayday, Mayday, Mayday." *Art in America*, September 1993, p. 44

Sandler, Irving. "Sean Scully interviewed by Irving Sandler (February 1997)." *Sean Scully. Paintings*, Manchester City Art Galleries, Manchester, 1997, pp. 34–47

Sauré, Wolfgang. "Sean Scully." *Weltkunst*, January 1994, p. 141

Schefer, Jean Louis. "Corps sans figure." *Sean Scully*, Galerie Nationale du Jeu de Paume, Paris, 1996, pp. 7ff.

—. "Cuerpos sin figura/Shapeless Bodies." *Sean Scully*, Sala de Exposiciones Rekalde, Bilbao, 1997, pp. 35–67ff.

Schnock, Frieder. "Sean Scully. Bilder und Zeichnungen." *Nike*, January 1986, p. 42

Schwabsky, Barry. "Sean Scully. Mary Boone Gallery." *Artforum International*, December 1993, p. 78

Schwarz, Arturo. "Italia/America: L'Astrazione ridefinita." *Segno*, Autumn 1993

Scully, Sean, and Mimmo Paladino. "'In at the Deep End' (A Conversation by Telephone)." *Modern Painters*, Summer 1993

Scully, Sean. "Bodies of Light." *The Times Literary Supplement*, 6 November 1998, no. 4988 and *Art in America*, July 1999, pp. 67ff. (reprinted "Against the Dying of his own Light. Mystery and Sadness in Rothko's Work." *Sean Scully. Barcelona Paintings and Recent Editions*, Galerie Bernd Klüser, Munich, 1999, pp. 11–63ff.)

Searle, Adrian. "Recent British Painting. Future Space." *Flash Art*, March–April 1980, pp. 28ff.

—. "The British Art Show." *Artforum International*, April 1980, pp. 87ff.

Semff, Michael. "Die sublime Dialektik des scheinbar immer Gleichen. Pastell und Wasserfarbe bei Sean Scully/The Dialectic's of Sameness: Sean Scully's Pastels and Watercolours." *Sean Scully. Works on Paper 1975–1996*, Staatliche Graphische Sammlung, Munich, 1996, pp. 31ff.

Shone, Richard. "Sean Scully." *Burlington Magazine*, January 1963

Silverman, Andrea. "Sean Scully." *ARTnews*, October 1986, pp. 98ff.

Smith, Alistair. "Sean Scully." *Irish Arts Review Yearbook*, 1994

Sofer, Ken. "Monotypes from the Garner Tullis Workshop." *ARTnews*, November 1987, p. 210

Spalding, Frances. "Unequal Halves." *Arts Review*, September 1993

(unsigned. "S.S."). "Sean Scully at L.A. Louver." *The Art Newspaper*, no. 130, November 2002

Stoddart, Hugh. "Sean Scully." *Contemporary Visual Arts*, 23, May 1999, pp. 30–35

Tatransky, Valentin. "Sean Scully." *Arts Magazine*, February 1980, pp. 35ff.

—. " Sean Scully." *Arts Magazine*, February 1981, p. 35

Tóibín, Colm. "Sean Scully. The Shimmering Richness of the World." *Sean Scully*, Dublin, 1999, pp. 43ff.

Trepp, Judith. "5 One-Man Shows: Jamileh Weber." *ARTnews*, January 1994

Tschechne, Martin. "Sean Scully. Strenge Form, große Gefühle." *Art. Das Kunstmagazin*, July 1998, pp. 16–27

Wei, Lily. "Sean Scully at Knoedler and Galerie Lelong." *Art in America*, January 2002

Welish, Marjorie. "Abstraction, Advocacy of." *Tema Celeste*, January–March 1992, pp. 74–79

Westfall, Stephen. "Recent Aspects of All-Over." *Arts Magazine*, December 1982, p. 40

—. "Sean Scully." *Arts Magazine*, November 1983, p. 35

—. "Sean Scully." *Arts Magazine*, September 1985, p. 40

—. "Sean Scully." *Art in America*, September 1989, pp. 208, 210

Winter, Peter. "Shape Is Not Abstract." *Art International*, Summer 1990, pp. 79–81

Yau, John. "Sean Scully. McKee Gallery/Pamela Auchincloss Gallery." *Artforum International*, April 1991, pp. 124ff.

—. "Défis/State of defiance." *Sean Scully*, Galerie Lelong (*Repères. Cahiers d'art contemporain*, no. 101) Paris 1999 (reprinted *Sean Scully. New Paintings and Work on Paper*, Danese/Galerie Lelong, New York 1999, pp. 4ff.)

Yoskowitz, Robert. "Sean Scully/Martha Alf." *Arts Magazine*, April 1980, p. 24

Zimmer, William. "Heart of Darkness. New Stripe Paintings by and an Interview with Sean Scully." *Arts Magazine*, December 1982, pp. 82ff.

—. "Sean Scully." *ARTnews*, May 1989, pp. 159ff.

Zweite, Armin. "'To Humanize Abstract Painting.' Einige Bemerkungen zu Sean Scullys 'Stone Light'/Reflections on Sean Scully's 'Stone Light'." *Sean Scully. Paintings and Works on Paper*, Galerie Bernd Klüser, Munich, 1993

## Picture Credits

# Index